The *A–Z* *of* ART

First published in 1996 in the USA by
Thunder Bay Press
5880 Oberlin Drive, Suite 400
San Diego, California 92121

This is a Carlton Book
Copyright © Carlton Books Limited 1995

Library of Congress Cataloging-in-Publication Data
cataloguing-in-publication data

Hodge, Nicola, 1957; Anson, Libby, 1962
The A–Z of Art: the world's greatest and most popular artists and
their works
ISBN57145 035 1 (hardcover)
1. Art, I. Hodge, Nicola, II. Anson, Libby, III Title.
1996

Project Editor: Sarah Larter
Project art direction: Russell Porter
Production: Garry Lewis/Heather O'Connell

Printed in Dubai

The A-Z of ART

The world's greatest and most popular artists and their works

Nicola Hodge and Libby Anson

THUNDER BAY

P·R·E·S·S

Contents

Introduction

The intention of *The A–Z of Art* is to provide a popular survey of artists and their work from medieval times to the present day. The book takes a familiarly linear approach to the history of art, apart from a few indivdiuals whose work has been generally incorporated into the cultural mainstream. Many of the names that have been included will be recognizable; others will not. Limiting the number to 386 was at times a frustrating task and inevitably we had to exclude some skilled practitioners. While acknowledging the contribution made by artists in previous centuries, and without attempting to deliver a definitive selection, we have included as many living artists as possible. *The A–Z of Art* is therefore an indispensible guide to the visual arts, containing an unparalleled range of work. Art appreciation is by nature compromising and subjective. Rather than be dictated by the conventions of art history, in many cases we have been guided by personal taste.

In the text we have sought to combine the essential biographical details of each artist with a selective account of their work. The entries are concise and informative, providing the reader with essential knowledge to access the work with sympathy and appreciation. Our aim throughout has been to provide a new approach to art and a point of departure – to excite and inspire those with a limited understanding of art history as well as being a useful reference work for art enthusiasts. The sequential structure promotes an extraordinary juxtaposition of movements, periods, styles and techniques, enabling surprising comparisons between artists and their works.

Choosing one piece to represent each artist was challenging. Each image was chosen either because it is typically representative of a particular artist or because it is a supreme example of the artist's work. The selection is devised to highlight artists working across a broad range of media, from the more traditional means of representation such as painting drawing printing and sculpture, to multimedia and installation. Some of the pieces are not easily reproduced and the work is best appreciated in situ, wherever possible. An "Other Masterpieces" category provides two supplementary examples of each work, complemented by a gallery guide and an extensive subject index.

Nicola Hodge and Libby Anson
1996

Agar Eileen

Born Buenos Aires, Argentina 1899; **died** London, England 1991

The Autobiography of an Embryo

1933–1934; oil on board; 90 x 213.5 cm; Tate Gallery, London, England

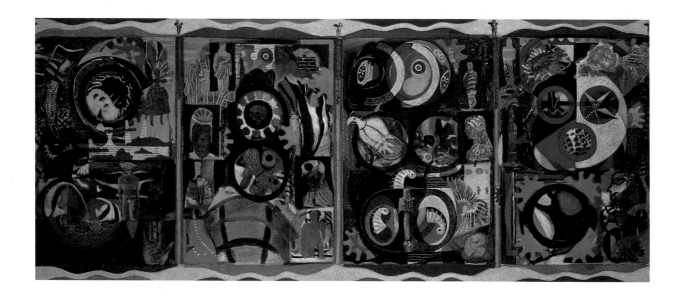

Eileen Agar came to England from Argentina when she was five years old. An independent spirit, she rebelled against her prosperous Victorian upbringing, deciding at an early age that she wanted to be an artist. She was the first woman to join the Surrealist movement and her work featured in the International Surrealist Exhibition, London, 1936. Despite forming long and lasting friendships with her fellow Surrealists, Agar retained a certain distance from them. She used forms of nature to symbolize workings of the unconscious in her paintings and rejected the masculine notion of woman as muse. Her singular imagination was also developed through sculptures and assemblages. After painting **The Autobiography of an Embryo**, Agar was asked how she, who had never had a child, could know anything about it. The artist replied that the girl having the child does not know what is happening inside her, but what was important was to record such extraordinary metamorphosis. The four panels of this large narrative painting are intended to be read from left to right. The circles divide like cells in the process of creation.

Other Masterpieces

ANGEL OF ANARCHY;
1936–1940;
TATE GALLERY,
LONDON,
ENGLAND

THE REAPER;
1936;
TATE GALLERY,
LONDON,
ENGLAND

Crucifixion

1987; oil on canvas; 216 x 183 cm; Tate Gallery, London, England

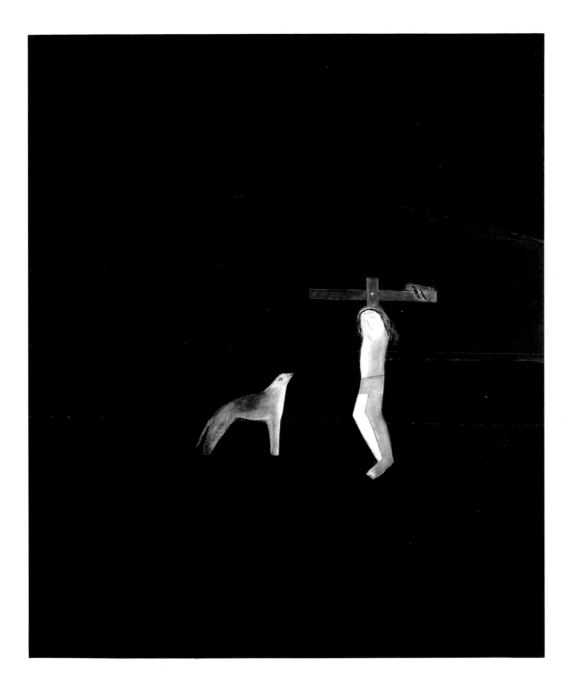

raigie Aitchison is a curious phenomenon among painters. He held his first one man show in 1958 and his themes and inimitable style have barely altered since. He seems to have avoided forming an allegiance with any of the major art movements that have gripped Britain since 1945. **Crucifixion** exemplifies the lifelong theme that has informed much of his work. It is a surprisingly large canvas, dark and reverent. Aitchison's Christ is strangely armless but forms a motif that was logical for the painter, "Everybody knows who he is. He doesn't need arms". The childlike simplicity of this rendition of a potent Christian symbol belies the primitive power of Aitchison's subtlety. Mournfully coloured bands make the minimalist landscape background and infer a depth of field. The hill, like a Calvary, is Goat Fell, a childhood holiday place on the Isle of Arran. The mystical sense of light illuminating the figure, the faithful pose of the dog, the attendant birds and the sparkling star at the centre of the cross are incongruous but appropriate elements contributing to the picture's soul. They form ideas, meanings and associations that strike at the heart of the spectator – whatever his religious beliefs.

Other Masterpieces

MODEL AND DOG;
1974–1975;
TATE GALLERY,
LONDON,
ENGLAND

PORTRAIT OF COMFORT;
1994;
PRIVATE COLLECTION

Albers Josef

Born Bottrup, Germany 1888; **died** New Haven, USA 1976

Homage to the Square: Blue Climate

c.1964; oil on board; 76.2 x 76.2 cm; Tate Gallery, London, England

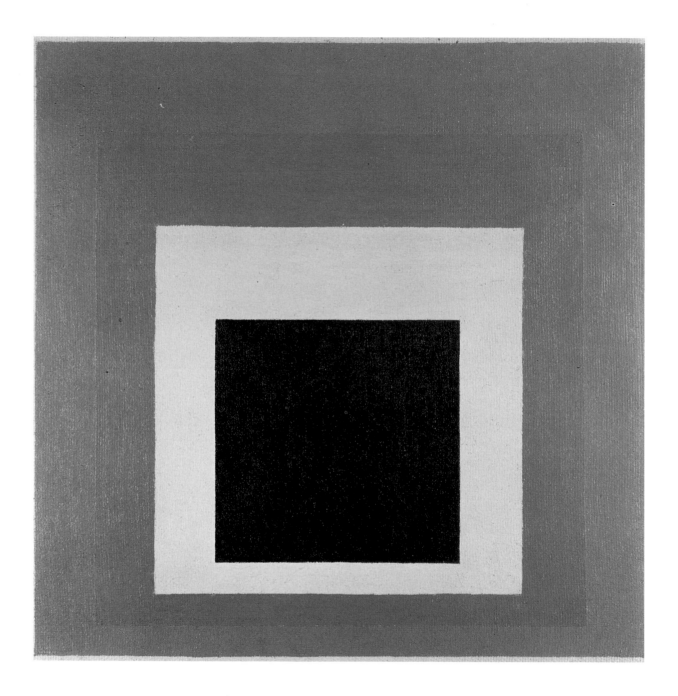

Josef Albers' early academic training in Berlin, Essen and Munich encouraged a formal approach which he later combined with a sense of experimentation developed while studying, and later teaching, at the Bauhaus. During his time in Weimar, Albers worked as a designer of furniture as well as an abstract painter. He refined his abstract style after moving to the USA in 1933, where he also became seduced by colour. In the United States he continued to study and to teach, publishing an influential book on colour theory in 1963. He was regarded as one of the great geometric abstract painters at a time when abstract painting in general had been monopolized by Abstract Expressionists such as Pollock and Rothko. His **Homage to the Square** series of paintings exemplify his cool detached approach to pictorial composition. In **Homage to the Square: Blue Climate** each square hovers on top of the other – there is no chaotic competition between colours, rather a gentle and peaceful receptivity. Through the application of successive different layers of pure colour, Albers manages to create the optical illusion of depth in his work.

Other Masterpieces

HOMAGE TO THE
SQUARE:
APPARITION;
1959;
GUGGENHEIM MUSEUM,
NEW YORK CITY,
USA

SKYSCRAPERS;
1927;
MR AND MRS
JAMES H CLARK,
DALLAS,
TEXAS,
USA

Born Drontyp, Netherlands 1836; **died** Wiesbaden, Germany 1912

Alma-Tadema

A Favourite Custom

1909; oil on wood; 66 x 45.1 cm; Tate Gallery, London, England

After training at the Antwerp Academy, Lawrence Alma-Tadema became a pupil of Baron Hendryk Leys, a historical genre painter. From Leys, Alma-Tadema absorbed a feeling for the realistic rendering of surfaces. In 1863 Alma-Tadema visited Italy where the ruins of Pompeii made a particularly lasting impression. Another civilization was opened to him through a visit to Egypt in 1902.

In 1870, he settled in England where his Neoclassical paintings of ancient civilizations were very popular in Victorian society. He built up a large collection of personal sketches and photographs of archaeological items, jewellery and ornaments to aid his re-creation of the domestic genre of the ancient world. A meticulous worker, he took great care in the application of his paint and eschewed the use of glaze and varnish.

He also reversed the customary method by working from lighter to darker colours on a white ground. This resulted in a remarkable freshness and intensity of colour, which can be seen in **A Favourite Custom**. The painting also displays Alma-Tadema's extraordinary skill at depicting substances, in particular water and marble.

Other Masterpieces

THE ROSES OF HELIOGABALUS;
1888;
PRIVATE COLLECTION

THE FINDING OF MOSES;
1904;
PRIVATE COLLECTION

Altdorfer Albrecht

Born Regensburg, Germany c.1480; **died** Regensburg, Germany c.1538

Landscape at Regensburg

c.1520–1530; painting on wood; 30.5 x 22.2 cm; Alte Pinakothek, Munich, Germany

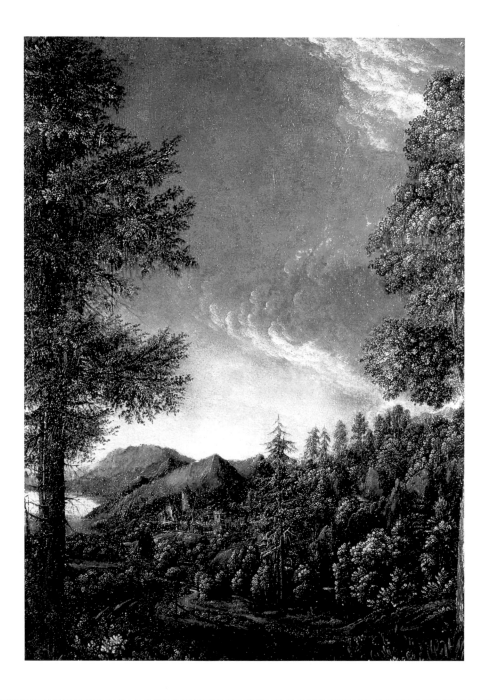

Albrecht Altdorfer held important social positions as architect and councillor in his native city of Regensburg, Bavaria. As a painter he developed a series of works in which landscape predominated. Almost unheard of in its time, he painted scenes that rarely contained human figures. His earliest paintings show the influence of Cranach and Dürer. A trip to the Danube and the Austrian Alps in 1511 produced oil paintings as well as drawings and etchings in which the dramatic possibilities of the landscape were acutely observed by the artist. **Landscape at Regensburg** is a typical work, with its sweeping vista swamped by a mass of forest foliage. A luminous sky with gathering clouds helps to create an atmosphere of unease. This is not the tamed and domesticated landscape scene observed by most artists prior to the fifteenth century.

Altdorfer has given us a glimpse of the wilder side of nature and, as the critic Kenneth Clark observed, in some of Altdorfer's landscapes we have the feeling "that the world has been newly created".

Other Masterpieces

ST GEORGE;
1511;
ALTE PINAKOTHEK,
MUNICH,
GERMANY

BATTLE OF ARBELA;
1529;
ALTE PINAKOTHEK,
MUNICH,
GERMANY

144 Magnesium 119, 1969

1969; metal; 365.8 x 365.8 cm; Tate Gallery, London, England

Carl André is the sculptor of the notorious floorpiece, **Equivalent VIII**, popularly known as **The Bricks**, at the Tate Gallery, London, England. Epitomizing the reductive Minimalist art movement, the work gave prominence to André among the American Minimalists working during the 1960s and 1970s. André attended the Phillips Academy in Andover (1951–1953). On his subsequent visit to Europe, his interest in neolithic sites compounded his admiration for the sculpture of Constantin Brancusi. In the late 1950s, André was introduced to artist Frank Stella who became a close friend, André using his studio to make his work. In keeping with the minimal aesthetic, André explored the notion of negative space by cutting into his sculpture. **Last Ladder**, 1959, was a response to Brancusi's **Endless Column**. He began exhibiting in 1964 and in 1965 he formulated the integration of modular units into a grid structure when, according to writer David Bourdon, "He realized his sculpture had to be as level as water". **144 Magnesium 119, 1969**, one of six versions made in different metals, conforms to this criterion. It becomes part of the environment over which we can walk. It negates any anthropomorphic associations, common in the consideration of "conventional" sculpture.

Other Masterpieces

LAST LADDER;
1959;
TATE GALLERY,
LONDON,
ENGLAND

EQUIVALENT VIII;
1966;
TATE GALLERY,
LONDON,
ENGLAND

Andrea del Sarto

Born Florence, Italy 1486; **died** Florence, Italy 1530

Madonna delle Arpie

c.1515; tempera on wood; 208 x 178 cm; Galleria degli Uffizi, Florence, Italy

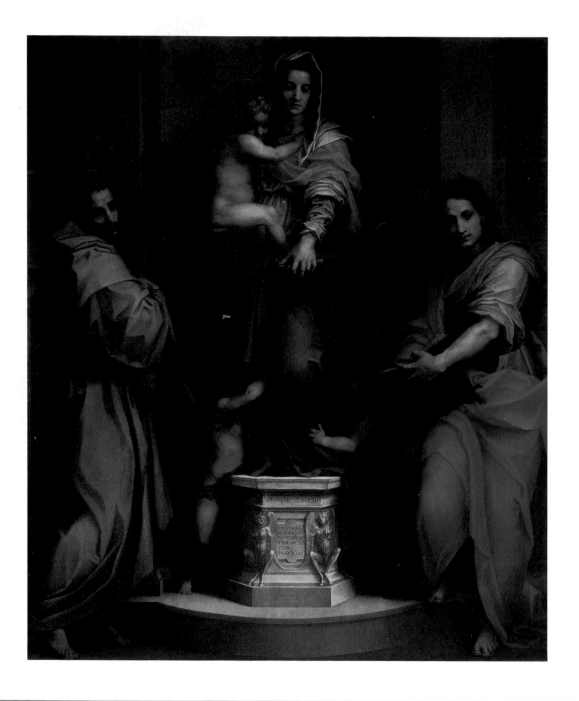

A pupil of Piero di Cosimo, Andrea del Sarto's feeling for tone and colour was more characteristic of the Venetian than the Florentine school. Known because of his excellent draughtsmanship skills as "the faultless painter", Andrea's carefully composed work, mainly fresco paintings, was much admired and studied. At first sight, **Madonna delle Arpie** is typical of the High Renaissance in its balanced composition and grand manner. Closer inspection, however, reveals an underlying tension due to the precariousness of the Madonna's position. She just manages to hold on to the climbing child, the painter's rendition of which is a startlingly naturalistic observation for the time. A soft light pervades this and many other works by the artist, helping to model and sculpt the human forms. Andrea was invited by the French king, Francis I to visit Paris in 1518 but broke his contract to return to Florence the following year. Never quite living up to his earlier promise, Andrea del Sarto's work was nonetheless of great importance to the development of Florentine painting. His life and work were celebrated in the nineteenth century by the English poet Robert Browning.

Other Masterpieces

ASSUMPTION OF THE VIRGIN;
1526;
PALAZZO PITTI,
FLORENCE,
ITALY

MADONNA DEL SACCO;
1525;
SAN ANNUNZIATA CHURCH,
FLORENCE,
ITALY

1962; oil on canvas; 214 x 244.5 cm; Tate Gallery, London, England

The Deer Park

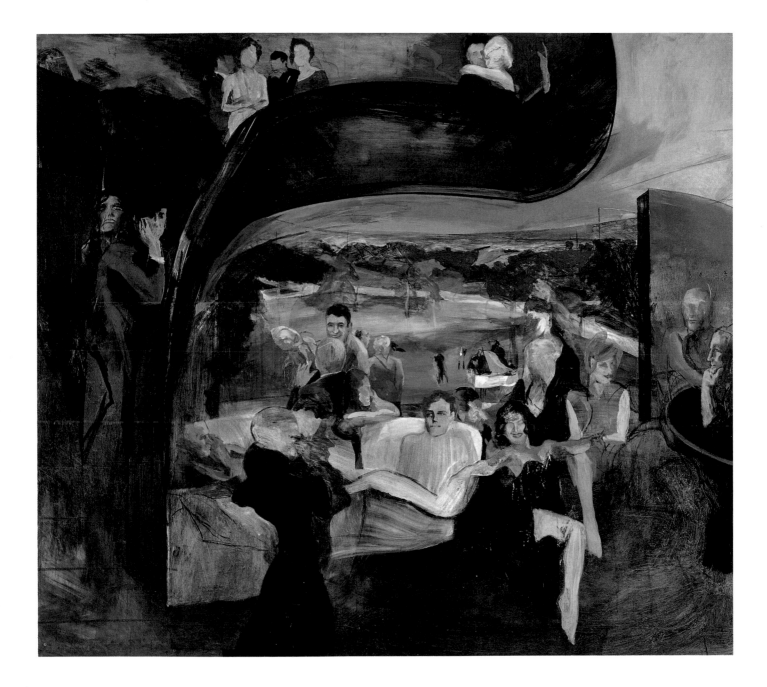

Michael Andrews studied at the Slade School of Art in London under Sir William Coldstream from 1949 until 1953 when he received the Rome Scholarship in painting. After graduating, Andrews taught in a number of key art schools in the capital and has been categorized within a group of artists, termed by R.B. Kitaj in 1976, as the School of London. The connection between them was their, "dedication to the human form". From 1975, Andrews made regular trips to Scotland. The rough, Glenartney landscape and grounds of Drummond Castle provided his subjects and the backdrop to his ideas. He left London for Norfolk in 1977, not returning to live in London until 1992. A second major landscape series resulted from his experience of Ayers Rock, Australia in 1983. Andrews's association with other London artists, such as Bacon, Freud, Auerbach and Kossoff, is reinforced by his paintings of The Colony Room, a club in Soho that was frequented by these artists and their acquaintances. In a similar spirit, **The Deer Park** recalls the revellers featured in Norman Mailer's novel of the same name. It is a dream-like, disjointed image that Andrews produced at a pace. His later work is less painterly, mimicking screenprinted, photographic and collaged imagery.

Other Masterpieces

GOOD AND BAD AT GAMES (TRIPTYCH);
1964–1968;
AUSTRALIAN NATIONAL GALLERY,
CANBERRA,
AUSTRALIA

THE BLUE AND YELLOW OF THE YACHT CLUB;
1969;
WHITWORTH ART GALLERY,
MANCHESTER,
ENGLAND

Angelico Fra

Born Vicchio di Mugelio, Italy, c.1387–1400; **died** Rome, Italy 1455

Noli Me Tangere

c.1442; fresco; 177 cm x 139 cm; Museo di San Marco dell' Angelico, Florence, Italy

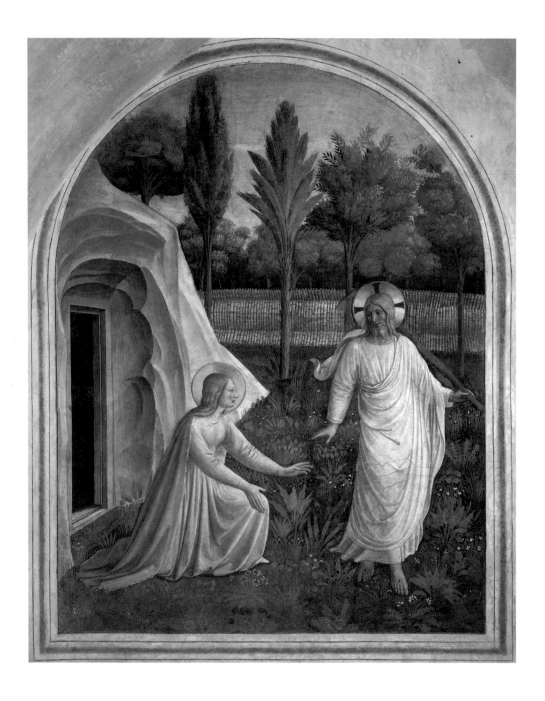

Fra Angelico was a Dominican friar in the monastery at Fiesole. The convent of San Marco was taken over by his Order in 1436, and he was commissioned to decorate the friars' cells with frescoes painted directly on to wet plaster walls. These were intended to stimulate prayer and meditation rather than to be a factual record of the Biblical story. He wanted to represent the sacredness of Christ in all its glory and simplicity; although he understood the principles of perspective, as seen here in the rendition of the tomb door, these were often sacrificed for a simple style. In the nineteenth century Angelico's painting captured the imagination of the pre-Raphaelites, who saw in them the charm of a pure faith. In this fresco, Christ appears to Mary Magdalene. She has been weeping after discovering that his tomb is empty.

A figure appears. At first she mistakes him for a gardener as he is carrying a hoe. Suddenly realizing who it is, she goes to embrace him. But he moves away, telling her not to touch him – literally **"Noli Me Tangere"**.

Other Masterpieces

LINAIUOLI MADONNA; COMMISSIONED 1433; MUSEO DI SAN MARCO, FLORENCE, ITALY

CHRIST GLORIFIED IN THE COURT OF HEAVEN; c.1435. NATIONAL GALLERY, LONDON, ENGLAND

1555; oil on canvas; 70 x 94 cm; Museum Narodowe, Poznan, Poland

Three Sisters Playing Chess

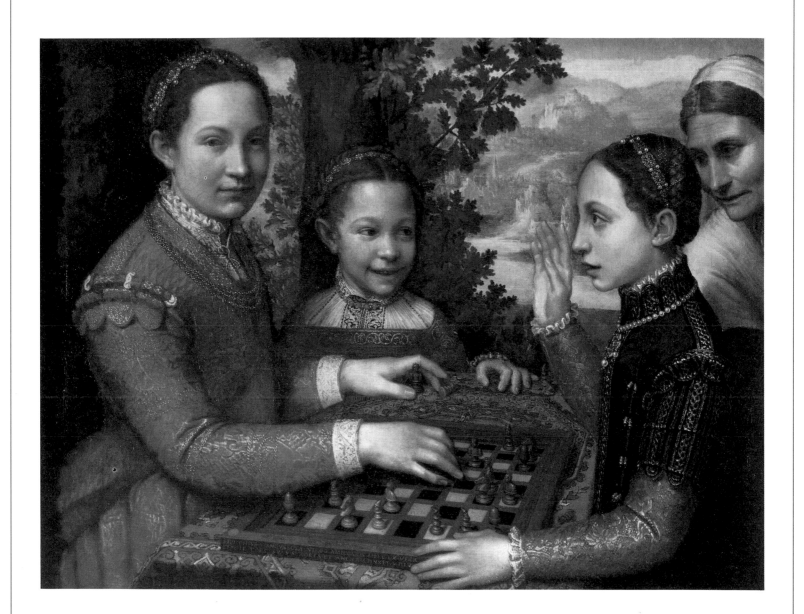

The best-known female artist of the sixteenth century, Sofonisba Anguissola was born into a noble Italian family. Her mother died young, leaving her wealthy husband with five talented daughters. Unusually, this liberal father gave his daughters a full classical education, which included learning to paint. It was this enlightened attitude that enabled Anguissola to earn her own living as a portrait painter in the Spanish court and helped her to transcend the constraints of her class and gender. In **Three Sisters Playing Chess** Anguissola breaks with tradition by concentrating on those scenes or models available to her. Placing her sisters in a domestic setting gives the portrait an immediacy, which allowed the contemporary Italian art historian Vasari to attribute to her the development of the conversational portrait, as opposed to the formal frontal or profile portrait. Although there are undoubtedly technical faults with the composition, particularly the perspective, each of the sisters comes across as a well-realized individual. Their relationship to each other is rendered with a tenderness and informality.

Other Masterpieces

SELF-PORTRAIT;
1561;
COLLECTION OF
EARL SPENCER,
ALTHORP,
ENGLAND

**PORTRAIT OF A
YOUNG NOBLEMAN;**
EARLY 1560s;
WALTERS ART GALLERY,
BALTIMORE,
USA

Antonello da Messina

Born Messina, Italy c.1430; **died** Messina, Italy c.1479

Portrait of a Young Man

c.1475; oil on canvas; 35.6 x 25.4 cm; National Gallery, London England

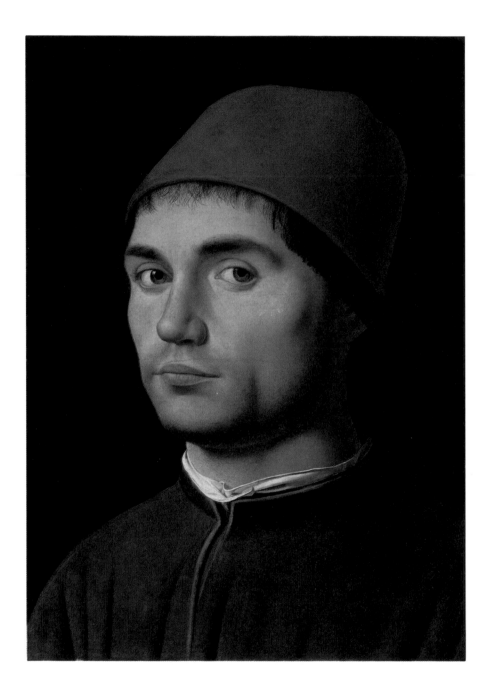

Antonello da Messina was a Sicilian, the only major southern Italian painter of the fifteenth century. He was greatly influenced by various aspects of the work of the Flemish painters, particularly their attention to detail and the play of light on surfaces. Although there is no evidence to suggest that he actually visited Flanders, he probably came across the work of artists from the Netherlands while working in Naples.

In 1475 he went to Venice, where he passed on to Giovanni Bellini the oil painting technique that he had learnt from masters such as van Eyck. This knowledge was communicated in turn to many other contemporary painters, significantly influencing the future development of the Venetian school. Generally, the figures in Antonello's work are bathed in strong light, highlighting their features and every tuck and fold of their robes. **Portrait of a Young Man** displays this virtuoso technique, giving the painting its intense realism. Other works, such as **St Jerome in his Study**, with its sweeping perspective onto a far distant landscape show his ability to render a complex architectural construction.

Other Masterpieces

ST SEBASTIAN;
c.1475;
GEMALDEGALERIE,
DRESDEN,
GERMANY

ST JEROME IN HIS STUDY;
c.1445–1446;
NATIONAL GALLERY,
LONDON,
ENGLAND

People, Birds and Sun

1954; oil on canvas; 173 x 242.8 cm; Tate Gallery, London, England

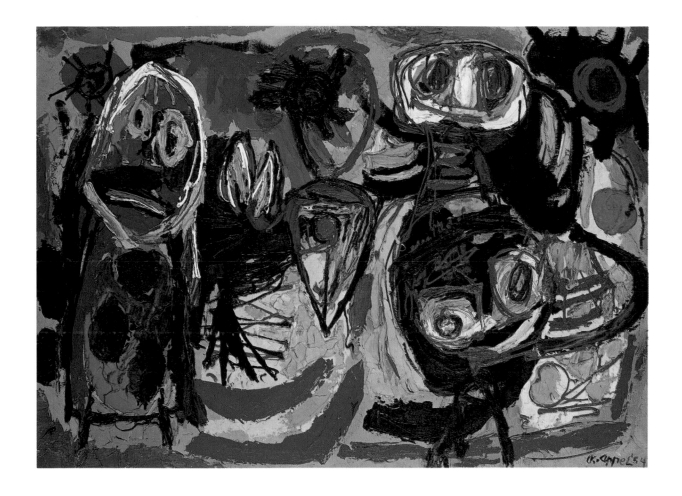

Other Masterpieces

V ibrant use of colour and wild dramatic brush strokes are the notable characteristics of this Dutch painter. In 1948 Appel helped to found the short-lived international CoBrA, composed of artists from Copenhagen, Brussels and Amsterdam – hence its name. In its dedication to expressive figuration this group was partly a reaction to what its members perceived as the lifeless nature of post-war abstraction. Among the sources of inspiration for CoBrA was the art of children. In **People, Birds and Sun**, painted in 1954, Appel covers the large canvas with a series of hurriedly applied gestural marks, smearing paint straight from his tube and from palette. The unfettered energy invested in the making of the painting is echoed by the direct, primitive expression of its subject. In this childlike vision, big-eyed people painted with matchstick arms and legs swirl round and round, all tangled up with bits of beak and the rays of the sun. This is nature seen from the child's viewpoint: at once both frightening and fascinating.

ANIMAL WORLD;
1948;
COLLECTION OF
 THE ARTIST

RED NUDE;
1960;
DONALD MORRIS
 GALLERY,
 NEW YORK CITY,
 USA

Arp Jean

Born Strasbourg, France 1887; **died** Basel, Switzerland 1966

Constellation According to the Laws of Chance

1930; oil on wood relief; 54.9 x 69.8 cm; Tate Gallery, London, England

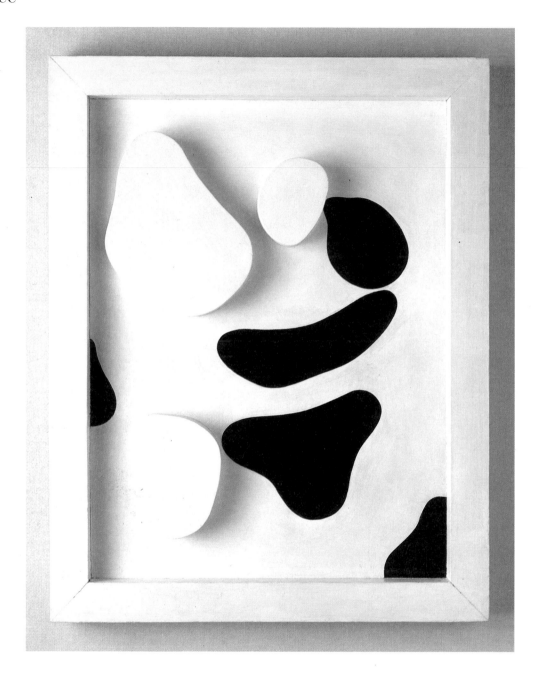

Jean Arp, also known as Hans Arp, was a sculptor who also worked as a graphic artist, painter and writer. His wide ranging interests allowed him to be involved with several of the most important movements of the first half of the twentieth century. These included exhibiting with Der Blaue Reiter artists – led by Marc, Kandinsky and Macke – and, after moving to Zurich in 1916, the Dada movement. Here, Arp's interest in art's potential for spontaneity found expression though his participation in the avant-garde happenings at the Cabaret Voltaire. During the 1920s and re-located in Paris, Arp started work on a series of painted wooden reliefs with his artist wife Sophie Täuber. These works, like **Constellation According to the Laws of Chance** shown here, were almost abstract, whilst at the same time quite clearly based on natural forms. The random nature of the pieces, with their poetic sensitivity is characteristic of Arp's work which, like his subject matter, spread organically into other areas including free-standing sculptures, drawings, tapestry, poetry and prose.

Other Masterpieces

CONFIGURATION;
1927–1928;
KUNSTMUSEUM,
 BASEL,
 SWITZERLAND

TORSO;
1931;
MULLER-WIDMANN
 COLLECTION,
 BASEL,
 SWITZERLAND.

Bunker in Armagh. 17

1985; pastel on black paper; 120.5 x 151 cm; collection of the artist

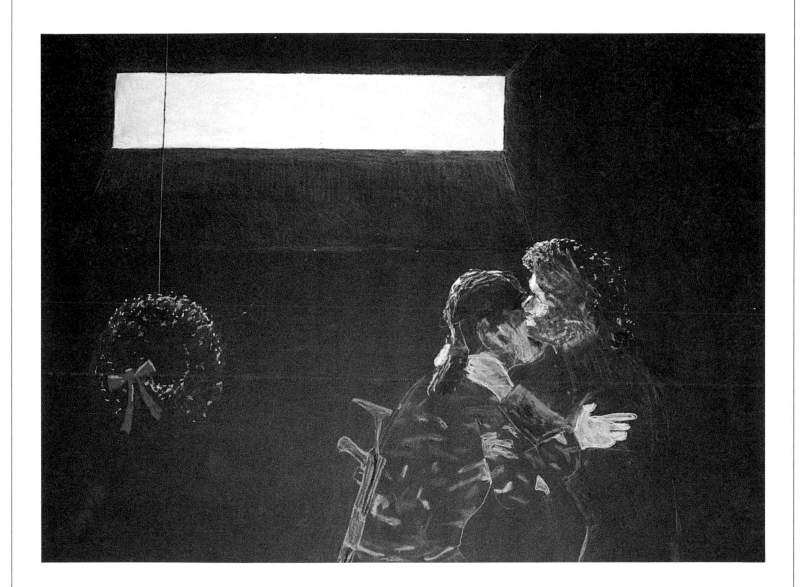

Terry Atkinson has an established reputation as a painter, lecturer, writer and activist whose radical artistic methods and theoretical views have made him a prominent figure in the Conceptual Art movement in Britain. He studied in 1959 at Barnsley School of Art and at the Slade School of Art in London from 1960–64. Atkinson's art is most clearly identified by his involvement from 1968 with Art & Language, of which he was a founding member with Michael Baldwin, Harold Hurrell and David Bainbridge. Based on Marxist theory and Wittgensteinian philosophy and working as a corporate identity, their strategies for production were textually based examinations of art's role in society and the critical arena. Their work, encouraged and influenced by American artist Joseph Kosuth, aimed to make clear, "that art is didactic as opposed to transcendental". Atkinson left the group in 1975 and has since concentrated on writing and series of paintings that incorporate both personal, political and historical elements. **Daughter having returned from an armed mission being greeted by her mother near a Christmas wreath**, the full title of **Bunker in Armagh. 17**, is one of a number of works based on British attitudes to Northern Ireland. "The whole idea of the bunker," he said, "was a metaphor for my own fixed positions."

Other Masterpieces

THE STONE–TOUCHERS 1;
1984–1985;
GIMPEL FILS GALLERY,
 LONDON,
 ENGLAND

DISTEMPER YELLOW
 AXE–HEAD ENOLA GAY
 MUTE;
1990;
NORWICH GALLERY,
 NORWICH,
 ENGLAND

Auerbach Frank

Born Berlin, Germany 1931

Euston Steps – study

1980–1981; oil on hardboard; 122.6 x 152.7 cm; Arts Council Collection, London, England

Frank Auerbach was sent to England from Germany in 1939, never to see his immediate family again. In 1947, he became a British citizen and moved to London. From 1948–1952 he studied at St Martin's School of Art in London and at the Borough Polytechnic under David Bomberg whose teaching, he recalled, instilled, "an atmosphere of research and of radicalism that was extremely stimulating". Auerbach trained at the Royal College of Art in London from 1952–1955. Since 1954, Auerbach has worked in the same studio in Primrose Hill, London. He includes in his subjects his immediate environment, **Euston Steps**, for example, and the people close to him. In spite, or because of, this narrow range, his work has an intensity that is the result of numerous reworkings and the application of successive layers of charcoal or impasto, each a fresh attempt at perception. Sculpting the souls rather than the visual realities of his subjects, the raw, physicality of the paint is like clay under his direction. Somewhere within the thick, sensual pigment, the material substance of the original subject, and the painting as an object, is obscured; a presence becomes tangible above all.

Other Masterpieces

HEAD OF E.O.W.V.;
1961;
PRIVATE COLLECTION,
 ON LOAN TO THE TATE
 GALLERY,
 LONDON,
 ENGLAND

STUDY AFTER TITIAN II,
 TARQUIN AND
 LUCRECE;
1965;
PRIVATE COLLECTION

c.1620; oil on canvas; 103 x 164 cm; Harold Samuel Collection, Corporation of London, England

Winter Landscape with a Frozen River and Figures

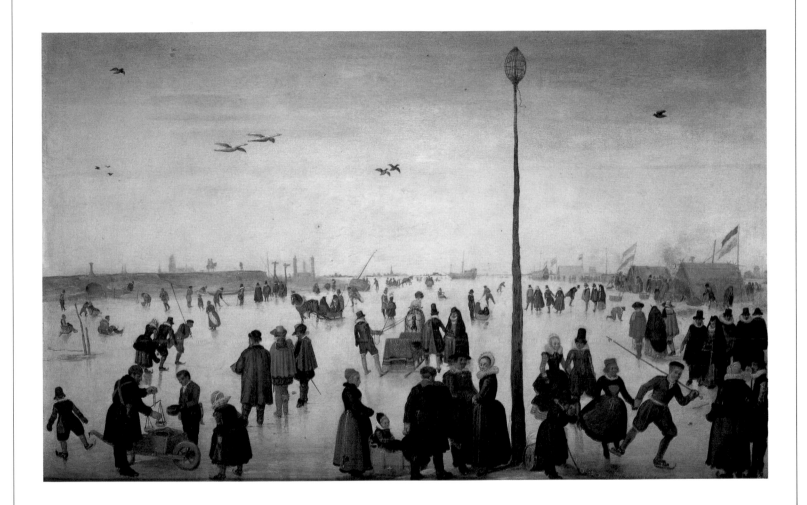

Hendrick Avercamp was a Dutch landscape painter who worked in Kampen. He concentrated on minutely rendering the details of wintry landscapes animated by crowds of tiny figures and played a significant part in the development of realistic landscape tones and colours. He lent naturalism to scenes with deep recession, hitherto divided into fantasy colours by the late sixteenth century Flemish school. His work is often compared with contemporary Jan Bruegel because of the similarity of subject matter. His paintings, such as **Winter Landscape with a Frozen River and Figures**, provide a fascinating insight into the social activities of the seventeenth century in the Netherlands. Avercamp brings to life a whole town or community by showing them engaged in a range of pursuits in the wintry conditions. Some are enjoying themselves tobogganing, or skating on the frozen river, others work, conveying their goods by sledge or horse. Many simply stand around and chat. The light in this work is typically carefully observed. His nephew, Barent Avercamp was his pupil and imitator.

Other Masterpieces

FROZEN RIVER;
c.1625;
BOYMANS-VAN
BEUNINGEN MUSEUM,
ROTTERDAM,
NETHERLANDS

**A SCENE OF THE ICE
NEAR A TOWN;**
c.1615;
NATIONAL GALLERY,
LONDON,
ENGLAND

Ayres Gillian

Born London, England 1930

Woodbines of Sweet Honey

1984; oil on canvas; 600 x 120 cm; collection of the artist

At the age of fourteen, Gillian Ayres made the decision to become a painter. She studied at London's Camberwell School of Art from 1946–1950 and exhibited her work the following year in the Young Contemporaries exhibition. Her strength, from her years as a student, has been her determination to resist the teaching she received, emphasizing a systematic approach to figuration. Instead, she has consistently followed her intuitive and freely expressed method of working in an abstract style. Her interest in artistic developments of the post-war period in Europe were personified via her contact with the painter Roger Hilton. The exciting explorations and working methods of the American Abstract Expressionists, most notably Jackson Pollock, inspired her to reject the conventional techniques of easel painting. An influential teacher and example to younger artists, Ayres has worked on both large-scale and small-scale works, changing from acrylic to oil paint in 1978. **Woodbines of Sweet Honey** reveals Ayres's skill for managing her medium and adapting her compositional structure to the unusual shape of the support. Her colours remain clear and gestural brushwork distinct, despite the range of pigment and depth of impasto.

Other Masterpieces

BREAK-OFF;
1961;
TATE GALLERY,
LONDON,
ENGLAND

LURE;
1963;
ARTS COUNCIL OF GREAT
BRITAIN,
LONDON,
ENGLAND

Born Dublin, Ireland 1909; **died** Madrid, Spain 1992

Triptych

1972; oil on canvas; 198 x 147 cm; Tate Gallery, London, England

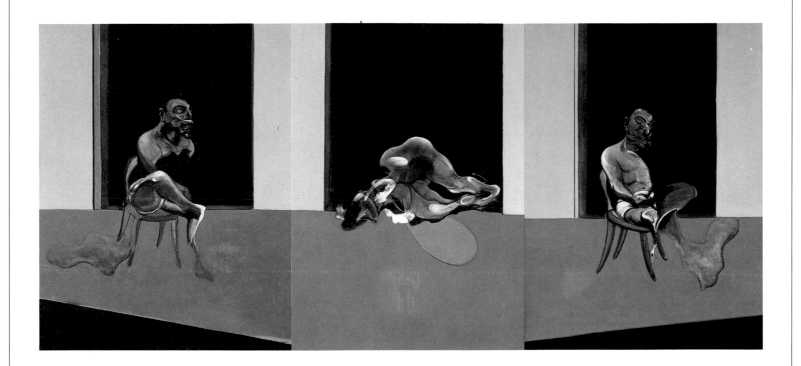

Born of English parents, Francis Bacon came to London from Dublin in 1925. He established himself as a furniture designer and interior decorator. In 1929, on his return to London – after travelling to Berlin and Paris from 1927–1928 – he began painting. He was declared unfit for military service in 1943 and in 1944, after destroying his earlier works, produced the painting with which he declared his career as an artist began. The painting, a triptych, **Three Studies for Figures at the Base of a Crucifixion**, provided a format and subject that was to recur in Bacon's oeuvre, as shown by **Triptych** completed nearly thirty years later. He settled in London in 1950. Despite having no formal art training, Bacon exploited the artistic achievements of the past, particularly those of Velasquez and Rembrandt, to formulate his art. The innovations of Eadweard Muybridge's photographs of figures in motion also had a profound effect on his work and the human cry was an emotive subject he investigated to startling effect. Bacon's technical abilities have produced some of the most powerfully disturbing and controversial images of twentieth-century European painting.

Other Masterpieces

STUDY FROM THE
HUMAN BODY –
FIGURE IN MOVEMENT;
1982;
MARLBOROUGH FINE ART,
LONDON,
ENGLAND

POPE II;
1951;
KUNSTHALLE,
MANNHEIM,
GERMANY

Balla Giacomo

Born Turin, Italy 1871; **died** Rome, Italy 1958

Girl Running on the Balcony

1912; oil on canvas; 125 x 125 cm; Collection Galleria Civica d'Arte Moderna, Milan, Italy

Italian painter Giacomo Balla was one of the founders of Futurism, signing the Futurist Manifesto which was published in 1910. In this document Balla, along with artists including Umberto Boccioni and Carlo Carrà, outlined their primary objective to depict movement, which they saw as symbolic of their commitment to the dynamic forward thrust of the twentieth century. Futurism celebrated the machine – the racing car was

heralded as the triumph of the age – and early futurist paintings were concerned with capturing figures and objects in motion. In **Girl Running on the Balcony**, Balla attempts to realize movement by showing the girl's running legs in repeated sequence. Other paintings, such as **Dog on a Leash**, got to grips with the problem of recreating speed and flight by superimposing several images on top of each other. Inevitably, the advances

that were made by this short-lived movement were eventually to be overtaken by the art of cinematography. Futurism was finished by the First World War, after which Futurist ideals became increasingly associated with Fascism. Balla began to plough an independent path, at first toward abstraction and, after 1931, toward figuration.

Other Masterpieces

AUTOMOBILE AND
NOISE;
1912;
COLLECTION PEGGY
GUGGENHEIM,
VENICE,
ITALY

DOG ON A LEASH;
1912;
MUSEUM OF MODERN ART,
NEW YORK CITY,
USA

Katia Reading

1968–1976; oil on canvas; 179 x 211 cm; Private Collection

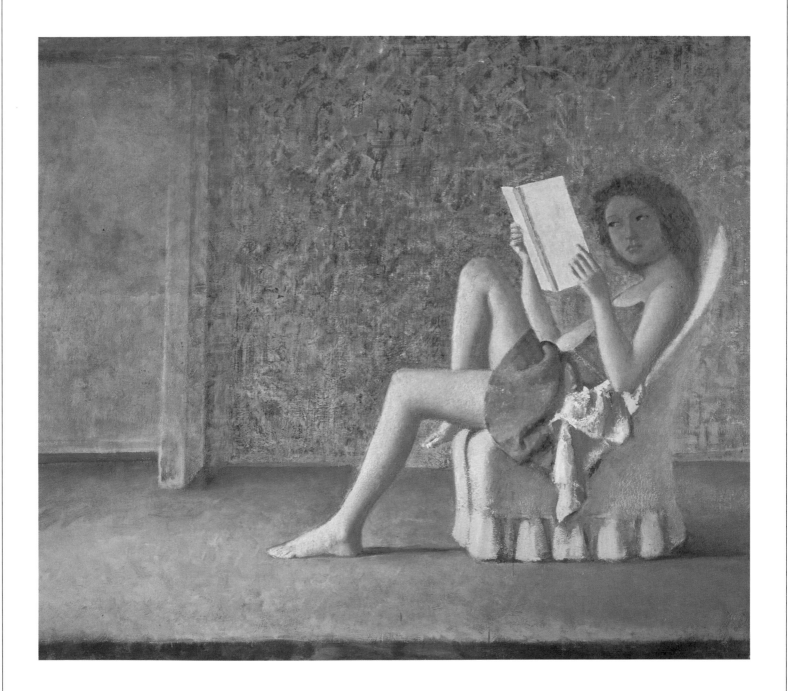

Balthus looked to the Austro-German poet Rainer Maria Rilke, a friend of his mother's, for paternal and cultural influence. Balthus's love of children's literature and illustrations persisted into his adult life. He was a precocious artistic talent and his lifelong interest in the art of the Orient was also initiated at an early age. He came into contact with Japanese and Chinese prints via the interest shown in him by the painter Bonnard after Balthus moved to Paris in 1924. He favoured working in an impressionistic manner copying from old masters, in particular Poussin, Masaccio and Piero della Francesca, rather than receiving direct tuition. Images of sexuality and intimacy, particularly of adolescent girls recur. **The Guitar Lesson**, 1934, set the tone for the preoccupations which developed in his art. Undertones of the erotic and of violence pervade curiously theatrical, contrived settings. In 1943 Balthus moved to Switzerland. Living privately and in seclusion Balthus re-invented his technique many times. **Katia Reading** seems to have been produced in an age quite distant from our own. It reveals the strangely naïve, chalky quality of his work which, during the 1970s, shows an increased interest in light and decoration.

Other Masterpieces

THE LIVING ROOM;
1941–1943;
MINNEAPOLIS INSTITUTE
 OF ARTS,
 MINNEAPOLIS,
 USA

LE LEVER;
1955;
SCOTTISH NATIONAL
 GALLERY OF
 MODERN ART,
 EDINBURGH,
 SCOTLAND

Bartolommeo Fra

Born Florence, Italy c.1472; **died** Florence, Italy c.1517

Madonna and Child

c.1540; fresco; Museo di San Marco dell'Angelico, Florence, Italy

Fra Bartolommeo studied to be a painter in Florence before his interest in mysticism allowed him to become influenced by the charismatic and fiery Dominican priest Savonarola. In 1500, after Savonarola was burnt as a heretic, Bartolommeo became a monk, entering the monastery of San Marco where he resumed painting in 1504. Bartolommeo's friendship with Raphael and visits to Rome and Venice helped strengthen his careful compositions and enrich his palette. In **Madonna and Child** the circular composition focuses the attention on the relationship between mother and son. Bartolommeo eliminates unnecessary details – the Madonna is wearing a plain cloak – and this simplification helps give the work its note of religious intimacy. It is for this particular contribution that Bartolommeo is so well regarded. He was painting at a time when Raphael, Michelangelo and Leonardo had already made their presence felt. This was hardly an auspicious time for any artist and, in his early forties, Bartolommeo was so overwhelmed when he saw Michelangelo and Raphael's work in the Vatican that he refused to take part in any artistic creation there himself.

Other Masterpieces

PIETA;
c.1511–1512;
PALAZZO PITTI,
 FLORENCE,
 ITALY

THE VIRGIN ADORING
 THE CHILD WITH ST
 JOSEPH;
c.1500;
NATIONAL GALLERY,
 LONDON,
 ENGLAND

Adieu

1982; oil on canvas; 250 x 300 cm; Tate Gallery, London, England

Georg Baselitz was a pioneer of the Expressionist revival. He moved to West Berlin after 1956 because he was expelled from the East Berlin School for "socio-political immaturity". His first solo show in East Berlin caused a scandal due to its erotically allusive content. He became apolitical choosing to paint insignificant subjects claiming that "the object expresses nothing... painting is autonomous". His focus was on the formal qualities of painting and the work's physical identity as such. He sought to explore the boundaries between figuration and abstraction. Since the end of the 1960s, Baselitz has turned his images upside-down to "set imagination free". **Adieu** is a strident example of this idiosyncrasy. His intention is that the spectator will consider the purely pictorial or abstract qualities of the painting before seeking to analyse the content of the picture. The monumental wood carvings of heads and figures which he began in 1979 reflect his fascination with African sculpture. They possess a primitive and pagan resonance, which complements his paintings.

Other Masterpieces

ADLER;
1972;
PRIVATE COLLECTION

FRAU AM STRAND;
1980;
COLLECTION GALERIE
NEUENDORF,
HAMBURG,
GERMANY

Bassano
Jacopo da Ponte

Born Bassano, Italy c.1510; **died** Bassano, Italy c.1592

The Adoration of the Kings

c.1540; oil on canvas; 149 x 224 cm; Burghley House Collection, Lincolnshire, England

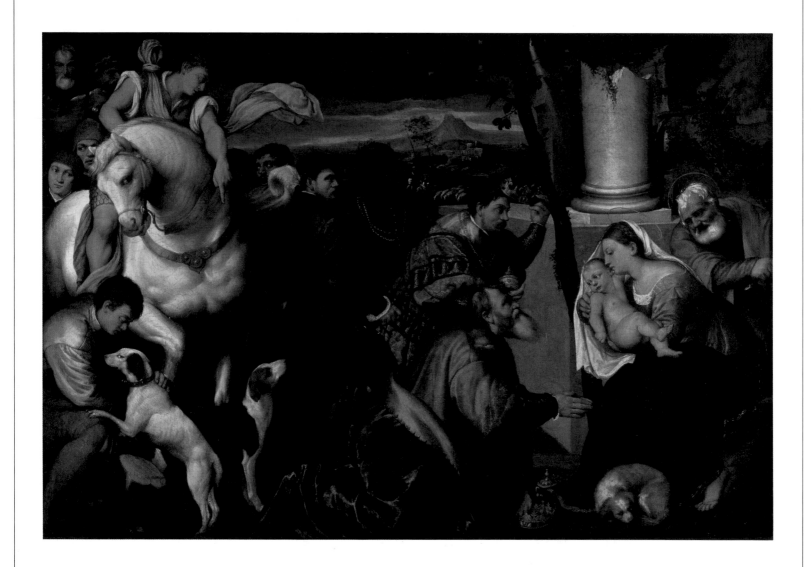

Jacopo Bassano came from a distinguished family of Venetian painters, his father Francesco the Elder and son, Francesco the Younger, also achieved success as artists. Working from Bassano, a small town set in the hills behind Venice, Jacopo Bassano drew inspiration from his rural surroundings. In his use of warm colour, thicker handling of paint and dramatic lighting effects, Bassano was also clearly influenced by Venetian masters such as Titian and Veronese. His portraits and religious paintings are notable for their realistic landscape details. **The Adoration of the Kings** shows how Bassano applied his robust treatment to biblical subjects; the Holy Family are depicted as poor country people and there is little to delineate them from the visiting kings. The artist seems to be especially drawn to the animals in this composition. In his many large, rustic genre scenes depicting people at work, Jacopo Bassano reveals what really interested him, namely the details of everyday country life. His animals – cattle, donkeys, dogs, rabbits, sheep, goats and even turkeys – are acutely observed and feature in his paintings to an unprecedented extent.

Other Masterpieces

THE WAY TO THE
 CALVARY;
c.1540;
NATIONAL GALLERY,
 LONDON,
 ENGLAND

THE ANIMALS ENTERING
 THE ARK;
c.1590;
MUSEO DEL PRADO,
 MADRID,
 SPAIN

Born Damvillers, France 1848; **died** Paris, France 1884

Jules Bastien-Lepage

The Haymakers

1877; 180 x 195 cm; size; Musée du Louvre, Paris, France

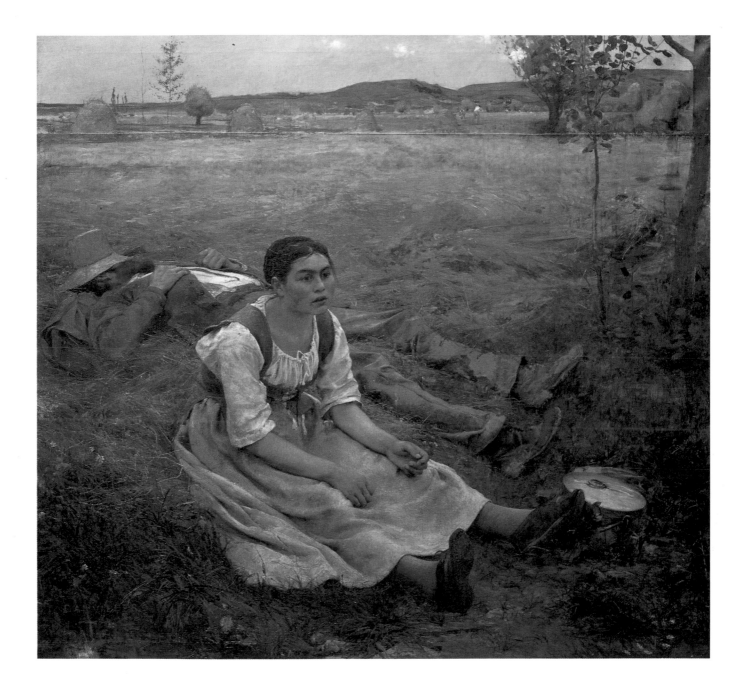

The sentimentality of Bastien-Lepage's most famous works such as **The Haymakers** made him popular with his contemporaries and the public, and it is thought he may have influenced artistic styles in England and France during his lifetime. He is best remembered for his scenes of rural life and the portraits – among his sitters was Sarah Bernhardt – that he exhibited during the 1870's, and although he died young he made enough of an impact on the art world to be compared with Millet and have the French writer Emile Zola write about the measure of influence and popularity of his work. His paintings are now exhibited in many of the major art institutions around the world and are still very much in evidence throughout his native land. **The Haymakers** is generally regarded as his masterpiece, and the craft of his painting is beautifully executed in this wonderfully observed rural scene. The influence of the Barbizon School may be detected, but this realism was a perfect deflection to the impressionist revolution, which was to part with tradition after Bastien-Lepage's death.

Other Masterpieces

SARAH BERNHARDT;
1879;
MUSEE FABRE,
MONTPELLIER,
FRANCE

JOAN OF ARC;
1879;
METROPOLITAN MUSEUM
OF ART,
NEW YORK CITY,
USA

Beardsley
Aubrey Vincent

Born Brighton, England 1872; **died** Menton, France 1898

Isolde

1895; pen, ink and watercolour; 28 x 17.7 cm; Fogg Art Museum,
Harvard University, Massachusetts, USA

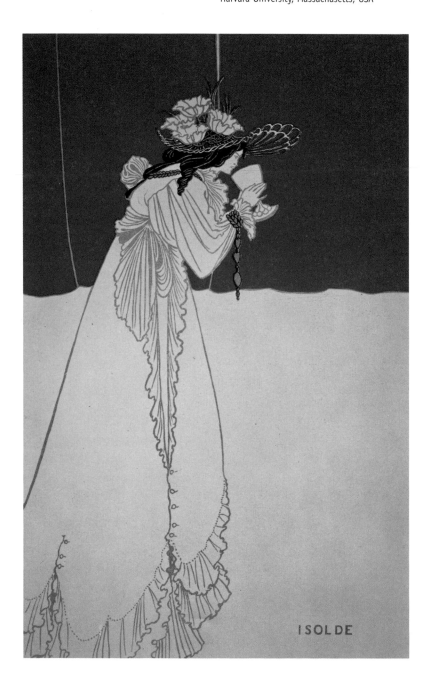

I SOLDE

In the 1890s the decorative style of Art Nouveau was identified as the new expression for design and experimentation with materials, not only in the fine and applied arts but in architecture too. Aubrey Beardsley was a prodigious talent whose striking black and white illustrations owe their sophistication and economy of means to the impression made on him by Japanese art and by Whistler. Working as an insurance clerk he was originally encouraged to draw by Pre-Raphaelite artist Burne-Jones in 1891, but he did not achieve fame with his inimitable style until 1894, exemplified by **Isolde**. The publications of his controversial illustrations for Oscar Wilde's *Salome* and the first volume of *The Yellow Book* confirmed his skill for originality in mustering the grotesque and the ornamental with refined and economic draughtsmanship.

The suggestion of depravity that pervades these deceptively elegant works echoes the decadence and fin-de-siècle atmosphere of the time and Beardsley has been recognized as a leading figure in the Aesthetic movement of this period.

Other Masterpieces

THE EYES OF HEROD;
1893;
FOGG ART MUSEUM,
 HARVARD UNIVERSITY,
 MASSACHUSETTS,
 USA

SELF-PORTRAIT;
c.1892;
BRITISH MUSEUM,
 LONDON,
 ENGLAND

Quappi with Parrot

1936; oil on canvas; 110.5 x 65.5 cm; Stadtisches Museum, Mülheim an der Ruhr, Germany

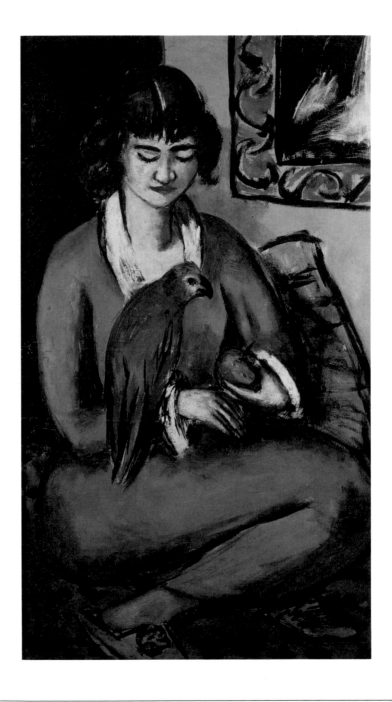

An outsider who never subscribed to any particular school, Max Beckmann is nevertheless regarded as one of this century's greatest figurative painters. During his service in the First World War, Beckmann suffered a nervous breakdown. After being dismissed as a "degenerate artist" by the Nazis from a teaching post, Beckmann left Germany in 1937 to settle in Amsterdam. From this point on he resolved to put what he saw as the individual's tragic fight against evil at the centre of his work. Initially he concentrated on graphics, producing a large number of prints and woodcuts, before reverting to paint. The artist's hard-edged, expressionistic still lifes, portraits, landscapes and figure compositions draw upon everyday life as well as mythical scenes for inspiration. Beckmann's metaphorical paintings with their claustrophobic interiors, mutilated figures, monstrous birds and fish are a critique of modern urban society and an attempt to find some spiritual meaning within it. **Quappi with Parrot**, a portrait of his second wife, Mathilde, was painted in the 1930s, and shows characteristic strong modelling of form. In 1947 Beckmann moved to the United States where for the last three years of his life he experienced a new vitality and optimism.

Other Masterpieces

PORTRAIT OF HEINRICH GEORGE AND HIS FAMILY; 1935; NATIONALGALERIE, BERLIN, GERMANY

THE THEATRE BOX; 1928; STAATSGALERIE STUTTGART, GERMANY

Bell Vanessa

Born London, England 1879; **died** Charleston, England 1961

The Tub

1917; oil on canvas; 180.3 x 164.4 cm; Tate Gallery, London, England

Vanessa Bell was a student at the Royal Academy between 1901 and 1904, where she was taught by John Singer Sargent. She became part of the intellectual circle known as the Bloomsbury Group, which included her sister, the writer Virginia Woolf, her husband Clive Bell and fellow artist Duncan Grant. Bell left her husband for Grant and the pair then settled at Charleston in East Sussex. This old country house is full of paintings and decorations by the couple. Both artists were called upon by Roger Fry to design and decorate furniture, fabric and pottery for the Omega Workshops. Vanessa Bell was overwhelmed by the seminal Post-Impressionist exhibition of 1910, remarking that it was as if, "one might say things one had always felt instead of trying to say things that other people told one to feel". Her work developed a Post-Impressionist style between 1912 and 1918, making for a new informality in her portraits and using arbitrary configurations as the basis for her large paintings. **The Tub** is a simplified, unusual and striking composition which has a monumentality due to the use of an upright, near life-size figure.

Other Masterpieces

A CONVERSATION;
1913–1916;
COURTAULD INSTITUTE,
LONDON,
ENGLAND

MRS ST JOHN
HUTCHISON;
1915;
TATE GALLERY,
LONDON,
ENGLAND

Born Port Seton, Scotland 1942

1985; oil on canvas; 122 x 122 cm; Beaux-Arts Collection, London, England

The Bride, the Oyster and the Singing Red Fish

John Bellany attended Edinburgh College of Art, moving to London in 1965 to study at the Royal College of Art. The underlying themes of his painting have remained consistent throughout his artistic career. From his earliest work he has portrayed the environment of his youth in potent images of fishermen, the sea and the myths and characters populating the tight-knit community of the harbour.

His Calvanistic upbringing imbues his art with a reverence for religious belief, which is narrated via compositions that speak of mortality and of good and evil. Following years of self-destruction in the 1970s, revealed in paintings full of angst, Bellany survived a liver transplant operation in 1988. Subsequent work reveals a renewed zest and vitality. It celebrates a spiritual, physical and artistic rebirth in vibrant watercolours,

glowing canvases and lyrical etchings and drawings. Allegorical diptychs and triptychs recur in Bellany's more recent work, which reflects the artist's voyage through life. These visual metaphors are "odysseys" conveyed in rich, poetic, visual language. **The Bride, the Oyster and the Singing Red Fish**, typifies Bellany's subject matter, skilled painterly techniques and the debt he owes to the stylistic influence of Max Beckmann.

Other Masterpieces

CELTIC FEAST;
1974;
SHEFFIELD CITY ART
GALLERIES,
SHEFFIELD,
ENGLAND

LOVERS BY THE SEA;
1993;
FLOWERS EAST GALLERY,
LONDON,
ENGLAND

Bellini Gentile

Born Venice, Italy c.1429; **died** Venice, Italy c.1507

Procession in Piazza San Marco

1490; oil on canvas; 367 x 745 cm; Galleria dell'Accademia, Venice, Italy

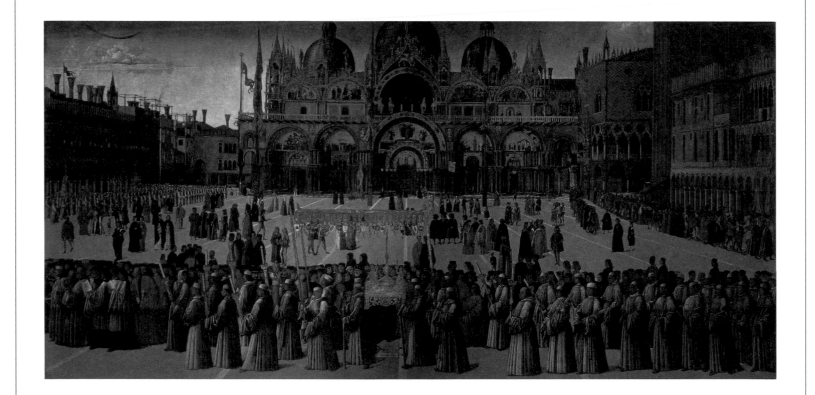

Gentile Bellini was highly honoured during his lifetime in Venice. He enjoyed the position of the town's official painter, becoming a Knighthood of the Empire in 1469 and the court painter to the Turkish ruler Sultan Mahomet II in Constantinople. He is now probably best known for his large-scale narrative paintings, commissioned as decorations for the Scuole – powerful charitable clubs of the time.

These pictures are a minutely detailed record of the buildings, costumes, decoration and personalities of fifteenth-century Venice. Indeed, his reputation for accuracy is such that the depiction of the Byzantine mosaics on the front of San Marco church in this painting is used as the basis for most discussion of the originals, which were subsequently destroyed. In **Procession in Piazza San Marco**, members of the Scuole of San Giovanni Evangelista are represented in the foreground, in their white habits. They are participating in the procession of the Holy Cross in St Mark's Square, Venice, on April 25, 1444, while the women watch from the windows. During the procession, a merchant threw himself to the ground in front of the Cross to pray for his dying son; miraculously, the boy recovered from his illness immediately afterward.

Other Masterpieces

THE MIRACLE OF THE CROSS;
c.1500;
GALLERIA DELL'ACCADEMIA, VENICE, ITALY

THE HEALING OF PIETRO DEI LUDOVICI;
c.1501;
GALLERIA DELL'ACCADEMIA, VENICE, ITALY

Born Venice, Italy c.1430; **died** Venice, Italy 1516

Doge Leonardo Loredan

c.1501–1504; tempera on wood; 61 x 44.5 cm; National Gallery, London, England

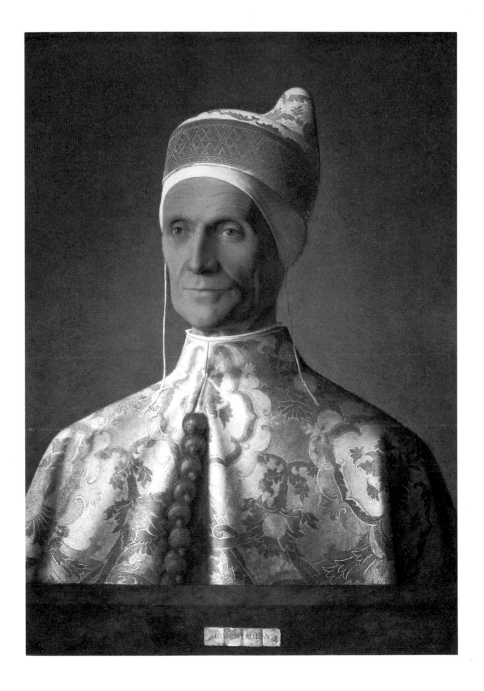

Brother of Gentile and son of Jacopo, Giovanni was probably the greatest of the Bellini dynasty. He was the pre-eminent teacher of his generation, with a sizeable workshop staffed by pupils and assistants, among whom were Giorgione and Titian. Like his brother, he became chief painter to the State, although Titian tried desperately to usurp him. In 1506, when Giovanni was 76, Dürer wrote that he was "very old but still the best in painting". Here, Bellini portrays the elected ruler of Venice, the **Doge Leonardo Loredan**. In this style of portraiture he was strongly influenced by a characteristic Flemish attention to detail and texture, and especially the play of light on the surface of the subject. The Doge is exquisitely portrayed in his ceremonial robes, made in an old-fashioned style but from a newly imported material – damask – which has gold thread running through it. Instead of using gold leaf, Bellini paints the surface roughly so as to catch the light and give a metallic finish – a revolutionary technique at the time.

Other Masterpieces

THE MADONNA OF THE MEADOW;
c.1500–1505;
NATIONAL GALLERY,
LONDON,
ENGLAND

THE AGONY IN THE GARDEN;
c.1465;
NATIONAL GALLERY,
LONDON,
ENGLAND

Bernini Gianlorenzo

Born Naples, Italy 1598; **died** Rome, Italy 1680

Ecstasy of Saint Theresa

c.1650; white marble; lifesize; Santa Maria della Vittoria, Rome, Italy

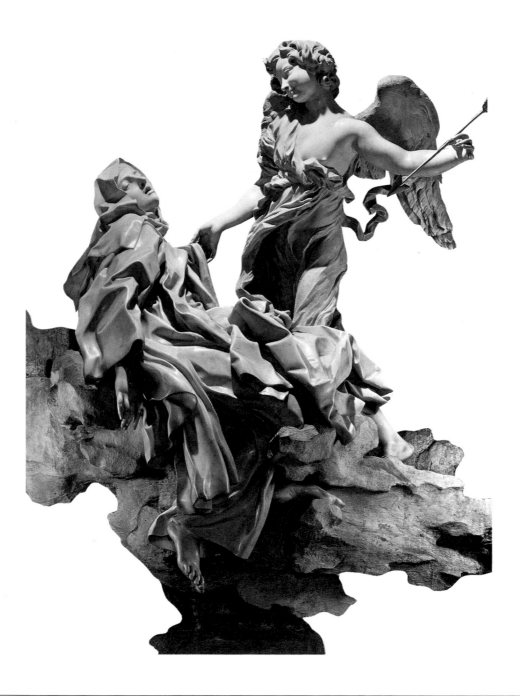

Bernini was a sculptor, painter and architect and a formative influence as an outstanding exponent of the Italian Baroque. He was an exceptional portrait artist and owes to his father his accomplished techniques in the handling of marble and also an impressive list of patrons that included the Borghese and the Barbarini families. Bernini originally worked in the late Mannerist tradition but rejected the contrived tendencies of this style. By 1624 he had adopted an expression that was passionate and full of emotional and psychological energy. His figures are caught in a transient moment from a single viewpoint, bursting into the spectator's space. In 1644 such interpretation reaches maturity in his rendition of the vision and **Ecstasy of Saint Theresa**. The Spanish nun swoons in heavenly rapture at the point of an angel's arrow.

The work is a prime example of Bernini's vision of a decorative whole combining different materials and colours within an architectural space. A succession of powerful patrons in Rome and in Paris assured his reputation as an entrepreneurial artist who captured the spirit of the Counter-Reformation. His extreme and intense characterizations have fallen in and out of favour but his Baroque legacy remains intact.

Other Masterpieces

BRONZE BUST OF POPE GREGORY XV; 1622; MUSEO CIVIOCO, BOLOGNA, ITALY

NEPTUNE AND TRITON; 1620; VICTORIA AND ALBERT MUSEUM, LONDON, ENGLAND

Born Krefeld, Germany 1921; **died** Düsseldorf, Germany 1986

1983–1985; basalt, clay and felt; Tate Gallery, London, England

The End of the Twentieth Century

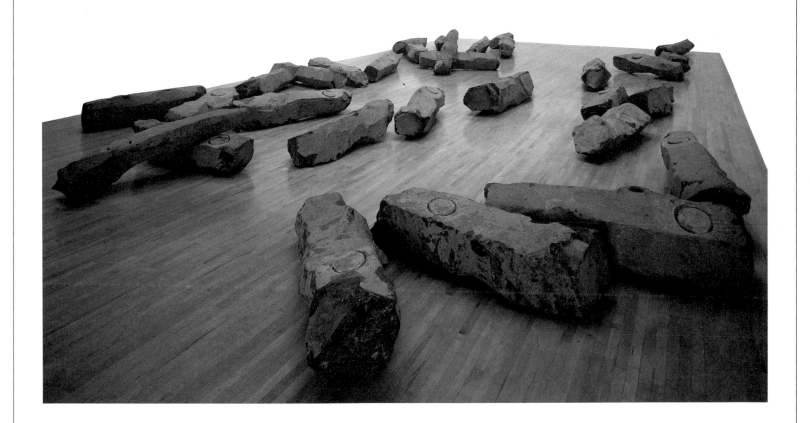

J oseph Beuys is credited with being one of the most influential figures in twentieth century European art. He was certainly the first significant artist to come out of post-war Germany. Not a sculptor in the conventional sense, he strove to communicate an "expanded theory of sculpture". In 1943, he was saved from death by Tartars when, as a pilot, he was shot down over the Crimea. They wrapped him in felt and fat and revived him with honey and horse's milk. This now mythical story underlies many of Beuys's conceptual strategies. Materials and objects of symbolic significance are juxtaposed, or a performance is created to present artifice as a metaphor for life and survival. **The End of the Twentieth Century**, one of Beuys's last, large scale installations, comprizes thirty one blocks of basalt rock, each one bearing a deliberately inflicted "wound" re-filled with rock, clay and felt. Beuys revolutionized artistic thinking with his oft quoted axioms, "Everybody is an artist", being the most familiar. Beuys meant that humans are creative beings, in art, science or procreation. His work is sophisticated, if somewhat obscure. However, his enigmatic persona and philosophies, at once personal and universal, have made him a charismatic mentor.

Other Masterpieces

FAT BATTERY;
1963;
TATE GALLERY,
LONDON,
ENGLAND

FELT SUIT;
1970;
TATE GALLERY,
LONDON,
ENGLAND

Bingham George Caleb

Born Virginia, USA 1811; died Kansas City, Missouri, USA 1879

Raftsmen Playing Cards

1847; oil on canvas; 71 x 96.5 cm; St Louis Art Museum, Missouri, USA

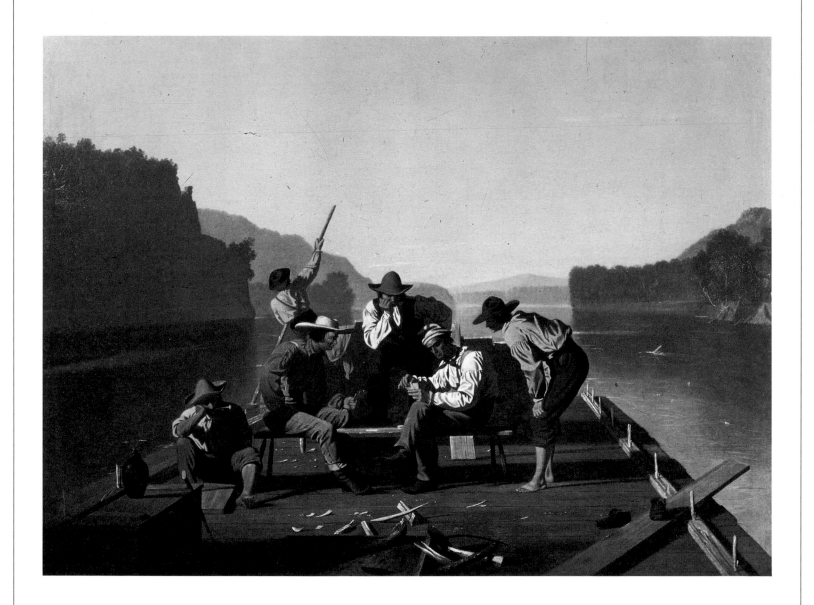

George Caleb Bingham had a technical facility for painting that he developed over a remarkably short space of time. After only a few months training at the Pennsylvania Academy of Fine Arts, he travelled to Europe and around the United States before settling in Missouri. In the 1830s Bingham was producing rather wooden portraits but, by 1845, his style had developed to such an extent that his work was unrecognizable. **Raftsmen Playing Cards** is typical of the dreamy lyricism of Bingham's mature work. With these paintings of North American frontier life, often of views of the Missouri river, Bingham focuses on everyday scenes. In an age when the camera was not widely available, Bingham provides an interesting insight into his fellow citizens in Missouri and their way of life. In 1856 he followed in the footsteps of a number of other American artists choosing Düsseldorf as a place to study. Unfortunately, on returning home, his style deteriorated due to an adoption of a dry academic technique. Eventually, Bingham moved into politics.

Other Masterpieces

FUR TRADERS DESCENDING THE MISSOURI; 1845; METROPOLITAN MUSEUM OF ART, NEW YORK CITY, USA

THE COUNTY ELECTION; c.1851; ST LOUIS ART MUSEUM, MISSOURI USA

Self-Portrait with Badges

1961; oil on hardboard; 172.7 x 120.6 cm; Tate Gallery, London, England

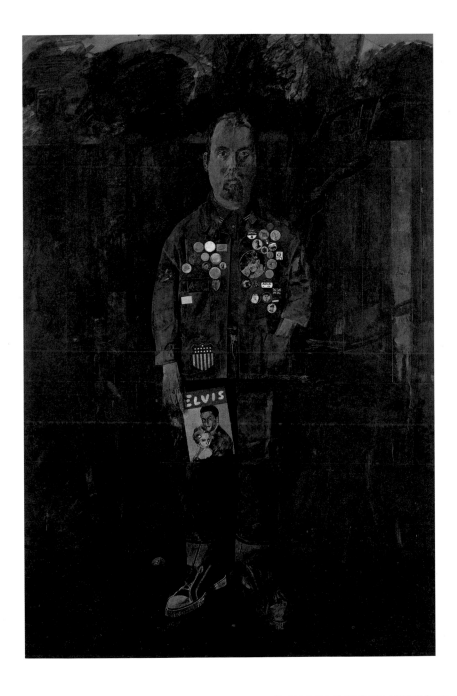

Peter Blake received a first-class diploma from the Royal College of Art, London in 1956. He is considered one of the leading Pop Artists of his generation. Blake's appropriation of popular culture within his oeuvre extends to his incorporation of real ephemera in his painted constructions. He is known for focusing on popular icons – The Beatles, Marilyn Monroe and Elvis Presley – and wrestling heroes with names such as Irish Lord X, and Masked Zebra Kid. The pin-up girl was also a recurring subject, sometimes disguised as Tarzan's Jane, Ophelia or Titania. In these, using photographic sources, Blake exploits his technical dexterity, relishing his ability to mimic the translucency of young skin and moist lips with paint. The results make covetable items. Blake's work centres on nostalgia and the structure of his assemblages, collages and paintings suggests the kaleidoscopic nature of recollections jumbled in the mind, heightened by fantasy, clarified by sensuous detail. In the early to mid-1970s, Blake produced a collection of souvenir pieces for friends, real and imagined. His skill at portraiture is shown in **Self-Portrait with Badges**, a tentative interpretation of himself as a forlorn figure, covered in symbols of his interests.

Other Masterpieces

THE TOY SHOP;
1962;
TATE GALLERY,
 LONDON,
 ENGLAND

TARZAN, JANE, BOY AND
 CHEETAH;
1966;
GALERIE MEYER-
 ELLINGER,
 FRANKFURT,
 GERMANY

Blake William

Born London, England 1757; **died** London, England 1827

The River of Life

c.1805; pen and watercolour on paper; 305 x 336 cm; Tate Gallery, London, England

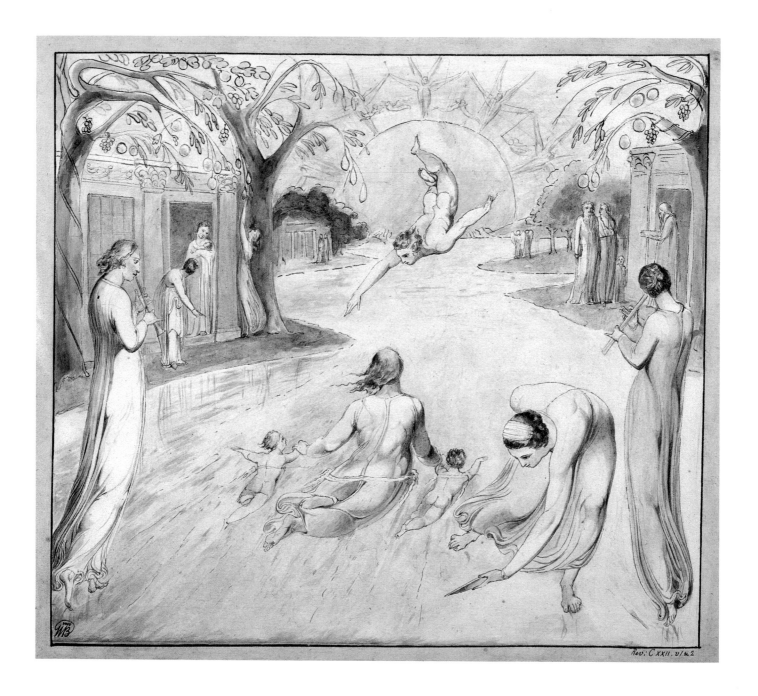

William Blake was a poet, illustrator, engraver, draughtsman, writer and painter whose efforts, due to their idiosyncratic and unorthodox nature, were largely unappreciated in his own lifetime. The knowledge Blake gained from working as an engraver enabled him to produce his own work in which he surrounded one of his poems with his own hand-coloured illustration. A powerful imagination is evident in every aspect of Blake's work. Among his most important works are the **Illustrations of the Book of Job** (1825), and the hundred or so watercolours to Dante's *Divine Comedy*. **The River of Life** is a clear, bright watercolour in which Blake imagines the stream described in the Revelation of St John winding its way through paradise. A deeply mystical man, Blake claimed he had visionary experiences that prompted him to invent his own belief system in which the creator of the universe, whom he renamed Urizen, wrought vengeance on mankind through Jesus, renamed Orc. His social and political conscience railed against the prevailing academic painting of the eighteenth century. He saw it as representing all that he came to despise about the rational, materialistic age in which he found himself.

Other Masterpieces

THE ANCIENT OF DAYS;
1794;
BRITISH MUSEUM,
 LONDON,
 ENGLAND

PITY;
1795;
TATE GALLERY,
 LONDON,
 ENGLAND

Born Basel, Switzerland 1827; **died** San Domenico, Italy 1901

Island of the Dead

1886; oil on wood; 80 x 50 cm; Museum of Art, Leipzig, Germany

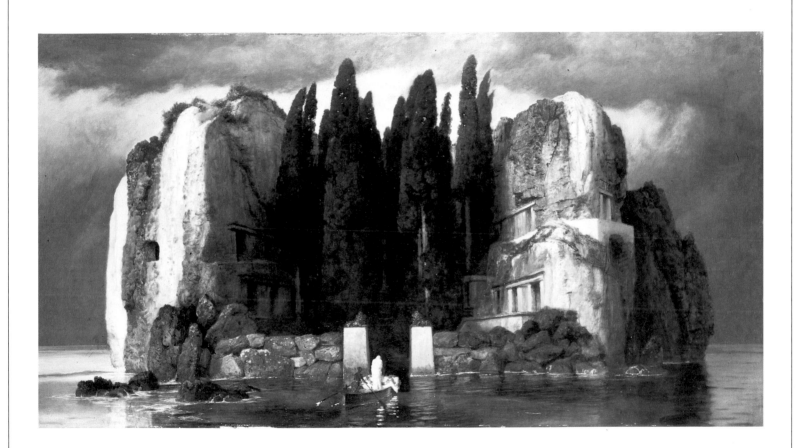

With Ferdinand Hodler, Arnold Böcklin was a leading Swiss painter during the nineteenth century. He trained extensively in Germany, Paris and Flanders, spending a period in Rome between 1850 and 1857. Apart being in Munich from 1871 and 1874, he remained in Italy until his death. Böcklin's emphatic idealism, heightened with romantic and symbolic overtones, was to prove influential to a number of artists, including Max Klinger and Franz von Stuck. Stylistically, the Modernist camp opposed the near naturalistic interpretation of landscape, nymphs and satyrs. Böcklin's treatment of his subject matter was critically received by the German Impressionists. In 1905, their principal supporter, Meier-Graefe, declared that in relation to reality, Böcklin's paintings were irrelevant, fanciful and technically, "wrong".

Böcklin made several versions of **Island of the Dead.** It has a monumentality and grandeur reminiscent of German painter Caspar David Friedrich's sublime landscapes. The enigmatic, morbid theatricality of the scene and the mysterious shrouded figure that, by implication, could represent the viewer's future, would have appealed to the European fin-de-siecle decadents.

Other Masterpieces

PAN IN THE REEDS;
1857;
NEUE PINAKOTHEK,
 MUNICH,
 GERMANY

TRITON AND NEREID;
1873–1874;
KUNSTMUSEUM,
 BASEL,
 SWITZERLAND

Boltanski Christian

Born Paris, France 1944

Reserve of the Dead Swiss

1990; tin boxes and newsprint; Centre Julio Gonzalez, Valencia, Spain

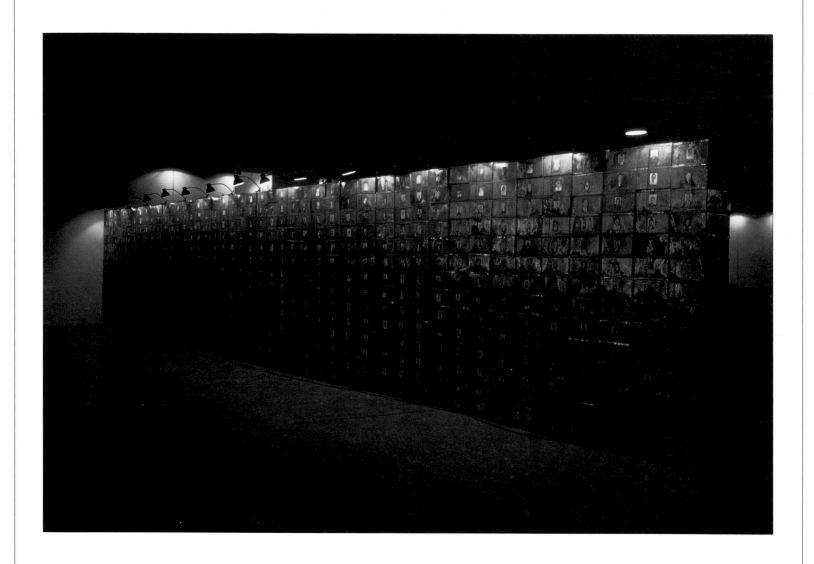

The resonant, emotional power of Christian Boltanski's work is largely based on the associations that the viewer brings to his installations. Our propensity to keep traces — clothes, documents and memorabilia — of the people who have affected our lives, long after their death, forms the investigative basis of Boltanski's work. The poverty of Boltanski's materials is linked to Arte Povera; notions of survival and social experience that stem from concepts explored by Joseph Beuys. Autobiographical connotations, indicative of the artist's Jewish-Catholic upbringing, often emerge. **Reserve of the Dead Swiss** typically uses numerous photographic portraits of people whom the spectator knows to be dead. Mounted on stacks of rusted tin containers, the wall they create appears like a mass memorial at a crematorium. The nature of the images, often taken from the Second World War period, instils a fear that here are archival pictures from the holocaust. This fantasy is heightened by the sense of interrogation implied by the intensity of the lights directed from above. These obscure, rather than clarify, individual faces. What we cannot know about the lives of those displayed we fabricate in our imagination, as if the whole history of each were contained in the boxes we witness.

Other Masterpieces

INVITATION TO IMAGE MODEL (MODEL IMAGE);
1976;
GALERIE SONNABEND,
PARIS,
FRANCE

HOTEL CHASE (ALTAR TO THE CHASE HIGH SCHOOL);
1987;
MUSEUM OF CONTEMPORARY ART,
LOS ANGELES,
USA

Born Birmingham, England 1890; **died** London, England 1957

Trees in Sun, Cyprus

1948; oil on canvas; 63.9 x 76.5 cm; Tate Gallery, London, England

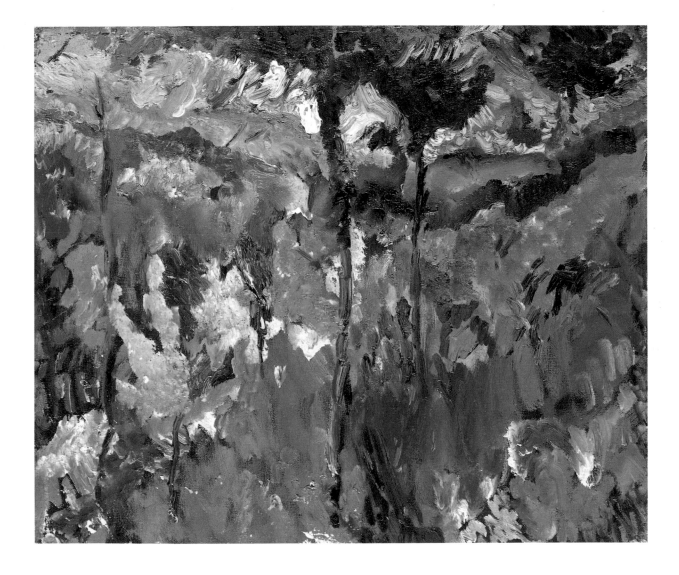

During the first phase of his career, David Bomberg produced large canvases typical of the geometric and angular compositions prevalent at the beginning of the twentieth century. The Cubist paintings of Braque and Picasso were clearly influential, as well as the ideals of dynamism promoted by the Futurist movement. After a brief flirtation with Vorticism, a British art movement founded by Wyndham Lewis and developed in reaction to Cubism and Futurism, Bomberg went on to form the London Group in 1913. A group dedicated solely to mounting exhibitions, it nevertheless became identified in the 1950s with a new school of English painting known as the social realists, or "Kitchen Sink" painters. In the 1920s Bomberg started to make representational paintings, such as the Palestine paintings (1923–1927) and these, with other later works, including **Trees in Sun, Cyprus** moved toward a more expressionistic style, with their loose, lively brushwork and strong colours. Toward the end of his career and after having sealed his reputation as an important artist, David Bomberg taught for eight years in London.

Other Masterpieces

IN THE HOLD;
1913–1914;
TATE GALLERY,
LONDON,
ENGLAND

THE MUD BATH;
1914;
TATE GALLERY,
LONDON,
ENGLAND.

Bonheur Rosa Frances

Born Bordeaux, France 1822; **died** near Fontainebleau, France 1899

Ploughing in the Nivernais

1849; oil on canvas; 173 x 260 cm; Musée Nationale du Chateau de Fontainebleau, France

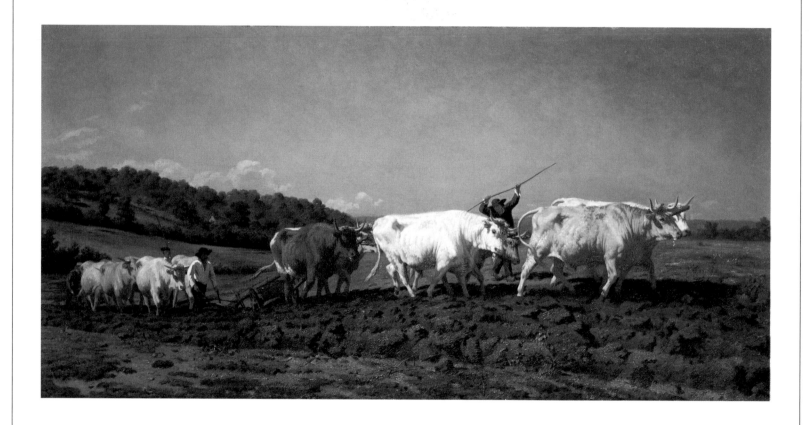

Despite painting in a genre completely dominated by male artists, Rosa Bonheur developed into an extremely successful and well regarded landscape and animal painter. Bonheur's mother died young. Left to her own devices in a household where her father was also a painter, she had space and time to realize her artistic potential. Important also to the development of her practice was a radical political outlook – a utopian socialism which legitimised her activities as a woman and as an artist. Close anatomical studies of animals, whether on the dissecting table or at work in the fields, inspired her strong drawing. Conventional ideas of decency and decorum dictated that her visits to the Paris horse market for example were generally made in disguise. However, Rosa Bonheur enjoyed dressing as a man and spent most of her time in men's clothes. A prototype feminist, she once declared that the only males who attracted her were the bulls she painted. Her energetic and unsentimental painting **Ploughing in the Nivernais** was her first major success; a later work, **The Horse Fair** was the largest animal painting ever to have been produced.

Other Masterpieces

THE HORSE FAIR;
1853;
METROPOLITAN MUSEUM
OF ART,
NEW YORK CITY,
USA

GATHERING FOR THE
HUNT;
1856;
PIONEER MUSEUM,
STOCKTON,
USA

Born Fontenay-aux-Roses, France 1867; **died** Le Cannet, France 1947

Mirror on the Washstand

1908; oil on canvas; 120 x 97 cm; Pushkin Museum, Moscow, Russia

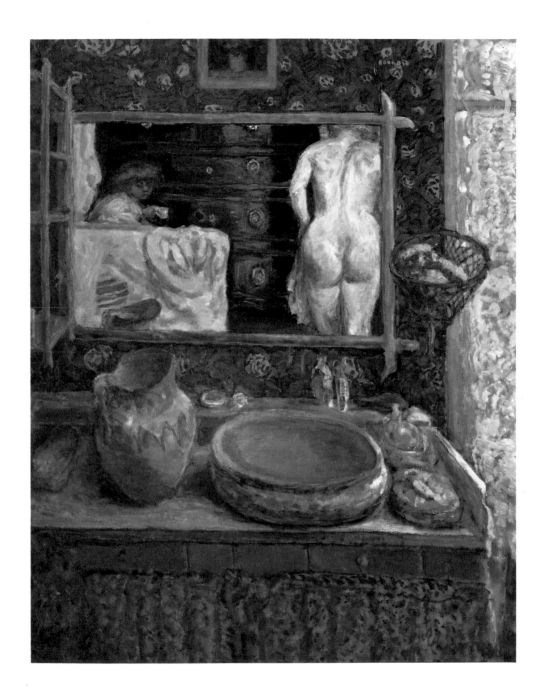

Pierre Bonnard came to Paris in 1888 where he studied at the Academie Julien and the Ecole des Beaux-Arts. He met Denis, Vuillard and others who, influenced by Gauguin's expressive use of colour and pattern, formed a group called the *Nabis*, from a Hebrew word meaning prophets. He exhibited and was associated with the group until 1899. Representational modelling and perspective were rejected in favour of decoration and flat, rhythmical description of form. This was inspired by Art Nouveau and the current vogue for Japanese prints. He admired the exuberance and passion in the work of Van Gogh and in 1903, in support of artistic developments of similar intensity, he co-founded the Salon d'Automne, organized by the Fauves. What he learnt from these artists he subtly absorbed within his own refined, intimate paintings of interiors.

Mirror on the Washstand reveals Bonnard contemplating a typical domestic subject. Bathed in the southern light of Le Cannet, where he worked from 1926, he often used Marthe, his wife, as his model. Although the spirit of the work is cognisant of the achievements of Impressionism he constructed a shimmering recollection rather than a direct record of his subject.

Other Masterpieces

THE TABLE;
1925;
TATE GALLERY,
LONDON,
ENGLAND

NUDE IN A BATHROOM;
1932;
COLLECTION OF MRS
WOLFGANG
SCHOENBORN,
NEW YORK CITY,
USA

Bosch Hieronymous

Born Hertogenbosch, Netherlands c.1450; **died** Hertogenbosch 1516

The Garden of Earthly Delights

c.1504; oil on panel; 220 x 195 cm; Museo del Prado, Madrid, Spain

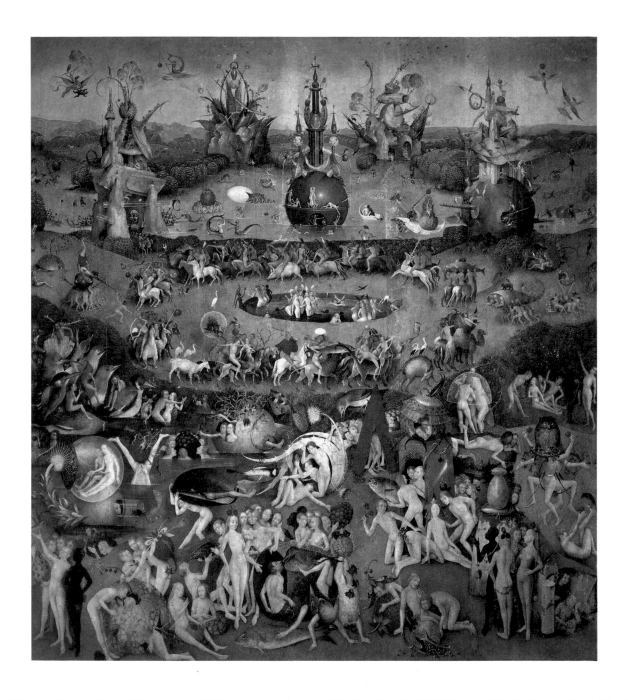

Hieronymous Bosch produced some of the most inventive fantasy paintings that have ever existed. His obsessive and nightmarish vision has its antecedents in the Gothic twilight world of the late Middle Ages and, although the allegorical medieval world view is now lost, there have been many recent attempts to "read" his pictures, not least by those who have attempted to interpret Bosch by dream analysis.

The Garden of Earthly Delights demonstrates Bosch's dazzling ability to build up a hugely detailed landscape through a series of bizarre exaggerations and distortions. The complete work consists of four paintings on a series of folding panels; the outer panel reveals the **Third Day of Creation** when closed. Inside, **The Garden of Earthly Delights** is flanked on the left by the **Garden of Eden** and on the right by **Hell**. A wild sexual orgy features in the central panel, where lust is shown to be the cause of man's downfall. There are over a thousand figures in this work altogether. Standing alone in its lifetime, Bosch's work has a timeless and modern quality that greatly endeared him to Surrealists in the twentieth century.

Other Masterpieces

HELL (RIGHT WING OF A TRIPTYCH); c.1510; MUSEO DEL PRADO, MADRID, SPAIN

LAST JUDGEMENT; 1504; AKADEMIE DER BILDENDEN KUNSTE, VIENNA, AUSTRIA

Born Florence, Italy c.1445; **died** Florence, Italy 1510

Venus and Mars

1483; oil on canvas; 69 x 173.5 cm; National Gallery, London, England

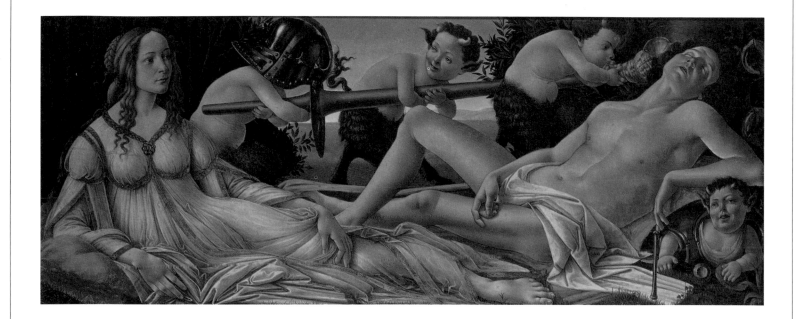

Botticelli initially trained as a goldsmith and then probably became a pupil of Filippo Lippi. When he was aged about 30 he began to enjoy the patronage of the Medici family, for whom he painted his best-known mythological works, **Primavera** and the **Birth of Venus**. In **Venus and Mars**, Botticelli playfully portrays Mars, the God of War, utterly vanquished by Venus, the Goddess of Love and Beauty. At the time of painting there was much ribald entertainment in poetry about men's exhaustion after sexual activity. The canvas could have formed the back of a chest or bench that was put in the bedroom on the occasion of a wedding – this may account for its unusual shape. Botticelli paints his subjects with marble-like skin and harsh lines, which correspond with the Florentine obsession with sculpture, but he softens this with curly hair and delicate material. He combines archaic figures with contemporary artefacts – modern armour and costume – and alludes to his patrons, the Vespucci family, with the wasps (*vespe* in Italian) buzzing around Mars' head.

Other Masterpieces

THE BIRTH OF VENUS;
1485;
GALLERIA DEGLI UFFIZI,
 FLORENCE,
 ITALY

MYSTIC NATIVITY;
1500;
NATIONAL GALLERY,
 LONDON,
 ENGLAND

Boucher François

Born Paris, France 1703; **died** Paris, France 1770

Woman at her Toilet

1769; oil on canvas; 102 x 80 cm; Agnew & Sons, London, England

The son of a Parisian painter and lace designer, François Boucher began his career engraving the pictures of Antoine Watteau. After winning the Prix de Rome of the Academy, Boucher spent four years in Italy where he could indulge his love of Italian Rococo painting, in particular the work of Tiepolo. In 1765, restored to Paris, he obtained the patronage of Louis XV's mistress Madame de Pompadour and through her influence became the king's official court painter. In work that unashamedly pandered to the frivolous and hedonistic excesses of the Parisian aristocracy, Boucher's highly decorative paintings delight in revealing the luxuriousness of the costumes and the elegance of the surroundings. **Woman at her Toilet** is one of his more intimate portraits, in which the artist's concern is with capturing the delicate surface details. In his many variations of pastoral and mythological themes, Boucher focuses on the female body. Much in demand in their time, these erotic paintings uncover fleshy and voluptuous women in a variety of provocative poses. Boucher was also highly regarded as a decorator and designed interiors, tapestries, theatrical productions, porcelain and even slippers.

Other Masterpieces

MADAME DE POMPADOUR;
1759;
WALLACE COLLECTION,
LONDON,
ENGLAND

RECLINING GIRL;
1752;
ALTE PINAKOTHEK,
MUNICH,
GERMANY

Born Honfleur, France 1824; **died** Deauville, France 1898

The Beach

1867; oil on canvas, 41 x 64 cm; Christie's, London, England

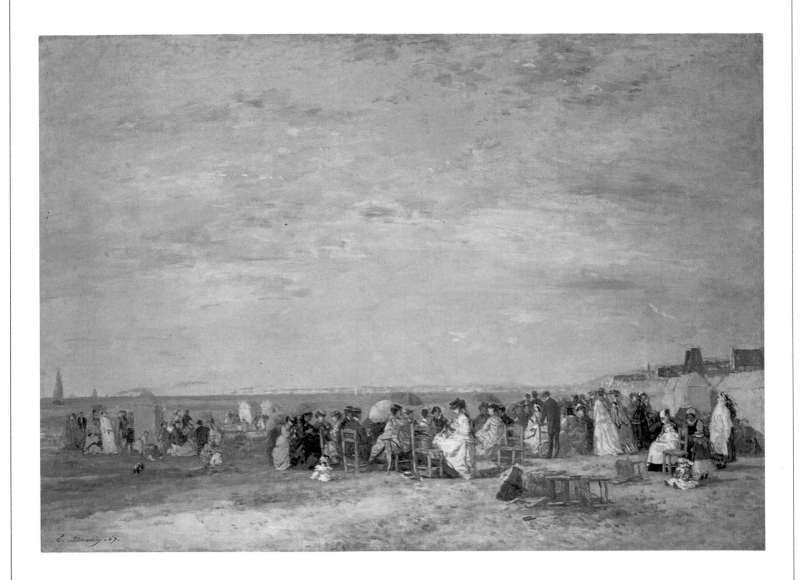

Born into a seafaring family, Eugène Boudin is mostly known for his paintings of sea and sky. Although often described as the "the painter of beaches", the beach itself in his painting **The Beach** only occupies the bottom third of the canvas and it is the large, luminous sky that predominates in the work. Boudin worked directly from nature on the Normandy coast and in particular at the fashionable resorts of Deauville and Trouville. His seascapes and beach scenes were painted at many different times of the year and in a variety of changing weather conditions. Responsible for introducing Claude Monet to this method of painting outdoors, Monet returned the compliment by painting the beach at Trouville several years later. Boudin's overriding concern was light, and in his dabs of pure colour and loose and delicate brushwork, he prefigured Impressionism, marking the link between Corot and the Impressionists. Indicative of the esteem in which he was held by the Impressionists, Boudin was included in their first exhibition in 1874.

Other Masterpieces

THE BEACH AT TROUVILLE;
1898;
MUSEE D'ORSAY,
PARIS,
FRANCE

THE BEACH AT TROUVILLE;
1863;
PHILLIPS COLLECTION,
WASHINGTON DC,
USA

Bourgeois Louise

Born Paris, France 1911

Cumul I

1969; white marble; 56.5 x 127 x 121.9 cm; Beauborg Museum, France

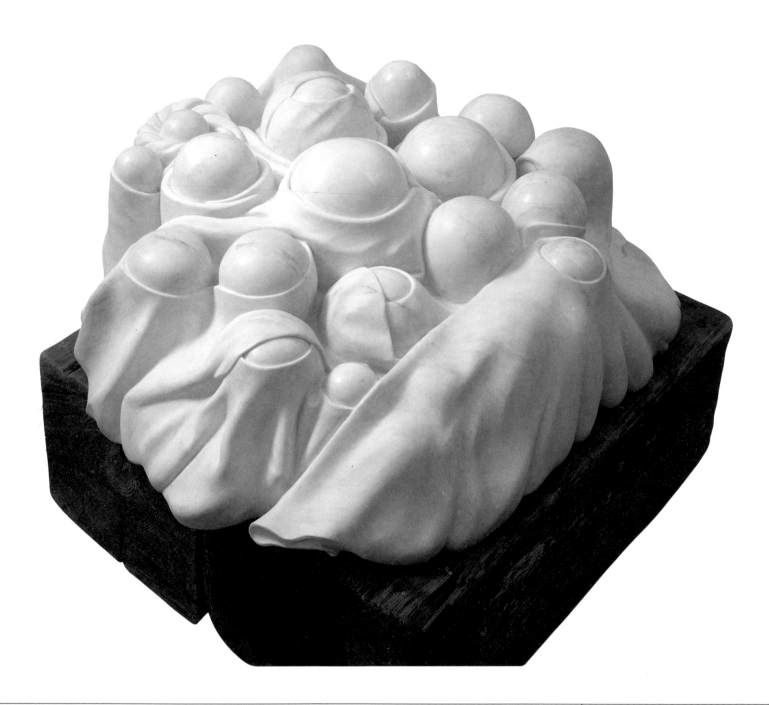

Louise Bourgeois completed two years' art training in Paris, before moving to the USA in 1938. Her early work was two-dimensional; she began to make sculpture in the late 1940s. Since her early, painted wooden constructions, she has used a range of materials, including bronze, marble and latex, producing work that appears abstract but highly suggestive of the body and of its sexual implications. The idea for the **Cumul** series came to her when she flew over the Sahara desert and noticed, "little huts nestling together near water – a metaphor of loneliness and togetherness". Taking the name from cumulus clouds, Bourgeois worked on the series obsessively. **Cumul I** is a marble piece that, through its amorphic form and budding shapes, emphasizes physicality and the human need to touch and be touched. Bourgeois experienced an unhappy childhood and her work often seeks to address primal notions of intimacy, loss and separation. She has also recently created installations known as **Red Rooms**, which correspond to the emotionally fraught spaces that she inhabited in her own childhood. Bourgeois's work has long been neglected; she has only recently received the attention she deserves as one of the most significant sculptors of the twentieth century.

Other Masterpieces

ONE AND OTHERS;
1955;
WHITNEY MUSEUM OF
AMERICAN ART,
NEW YORK CITY,
USA

CELL (THREE WHITE
MARBLE SPHERES);
1993;
ROBERT MILLER GALLERY,
NEW YORK CITY,
USA

The Last Supper

1464; triptych, tempera on wood; 88.5 x 71.5 cm (sides) 180 x 150 cm (middle); Saint Peters, Louvain, Belgium

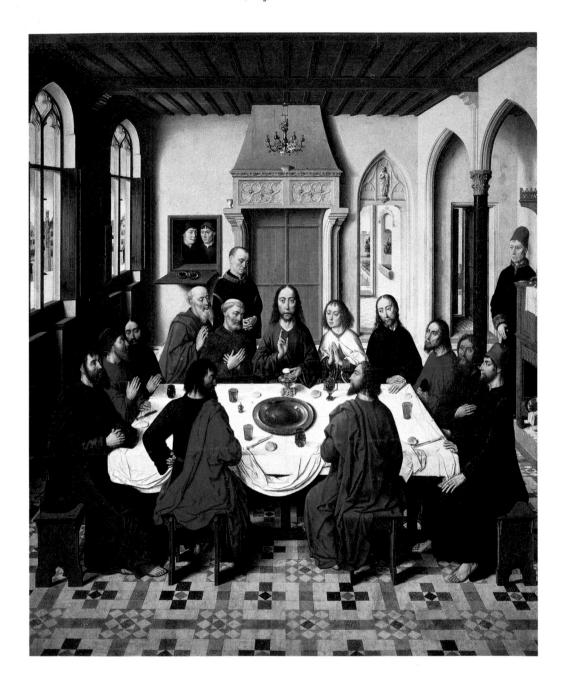

It is likely that Dieric Bouts trained in Brussels and Bruges and in both cities would have seen works by Jan van Eyck and Rogier van der Weyden. He was also friendly with Petrus Christus. Records show that he married into a prominent and wealthy family from Louvain, where he made his home. **The Last Supper** is a fine example of clearly delineated perspective, one of Bouts's defining characteristics; it has its focal point above Christ's head. Although this evinces a strong Italian influence, the style and setting are very much northern. The sober colours, gawky, bony figures and the dour faces could not be further from the classical ideal of beauty that was taking root in Italy at this time. It was a Flemish custom to have dinner guests seated round all sides of the table, and for them to use the tablecloth to wipe their mouths on, hence the swathes of material.

The interior space is utterly plausible, an effect heightened by the landscape visible through the windows and the trompe l'oeil in the background; this could be a double-portrait on the far wall, or two figures peering through a hatch.

Other Masterpieces

THE ENTOMBMENT;
c.1450–1460;
NATIONAL GALLERY,
LONDON,
ENGLAND

PORTRAIT OF A YOUNG
MAN;
1462,
NATIONAL GALLERY,
LONDON,
ENGLAND

Boyce Sonia

Born London, England 1962

Missionary Position II

1985; watercolour pastel and crayon on paper; 123 x 183 cm; Tate Gallery, London, England

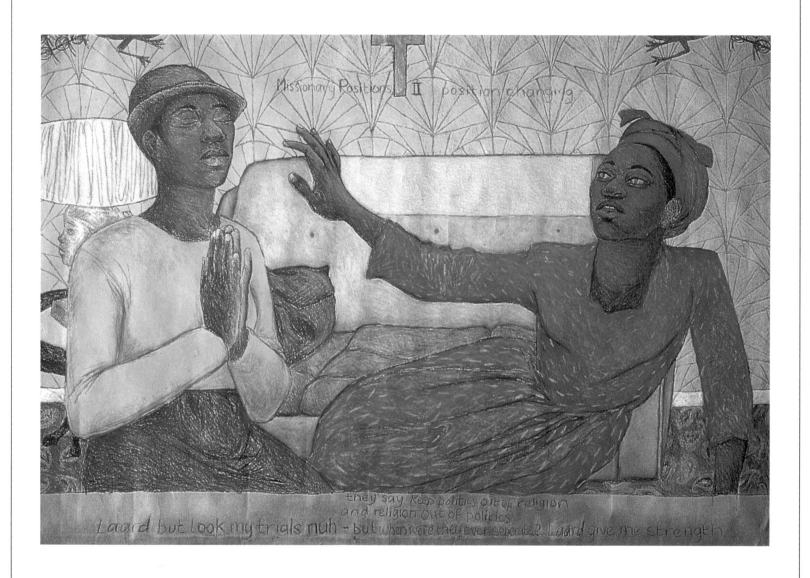

Sonia Boyce's family comes from the Caribbean. Growing up in Britain, in a culture in which her family are immigrants, has been a formative influence on her art. Her work, as can be seen in **Missionary Position II** discusses the issues raised by life experienced from such a perspective. Boyce graduated from Stourbridge College in 1983. As a black woman artist operating in white, male-dominated, British society, gender, familial and racial relationships have overtly influenced her work. Using her art as a political activity, she and other women artists – such as Lubaina Himid, Sutapa Biswas and Claudette Johnson – have sought recognition not only for their own practice but for the work of all black artists working in Britain. To make her concerns about the, "Disabling categories of race" more specific, she referenced her family and herself in large-scale drawings. These date from the mid 1980s and illustrate a particular narrative that belongs within her personal, cultural history. Experimentation with surface design and colour as conventional pictorial devices developed into work with collage, photocopying and installations.

Other Masterpieces

FROM TARZAN TO RAMBO...;
1987;
TATE GALLERY,
LONDON,
ENGLAND

DO YOU WANT TO TOUCH?;
1993;
CENTRE 181 GALLERY,
LONDON,
ENGLAND

1957–1958; oil on canvas; 149.9 x 175.3 cm; Gift of Tristan Buesst, National Gallery of Victoria, Melbourne, Australia

Shearers Playing for a Bride

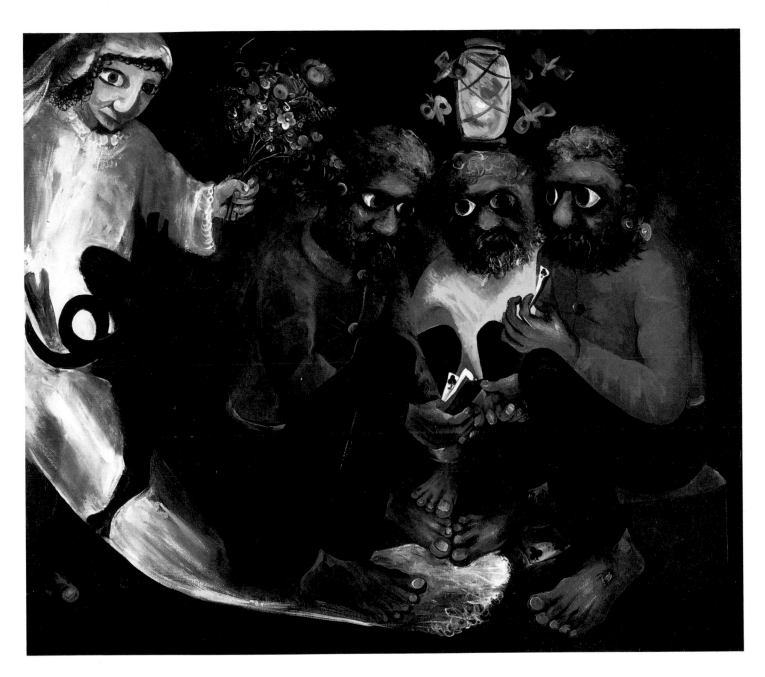

Arthur Boyd has described his childhood, although spent in poverty, as idyllic. He began painting at an early age, sketching at every opportunity. Seeing a van Gogh postcard and an early Kokoschka painting as a child proved of lasting influence, particularly to his expressive handling of paint and colour. In 1937, a meeting with painter, Jo Bergner, a Polish immigrant, brought to Boyd's awareness a different culture beyond the insular society of his own. During Boyd's time in the army, beginning in 1940, his work became more politically oriented and some of it was confiscated by officials. After he left the army, Boyd embarked on religious paintings, finding inspiration in prints by Bosch and Bruegel and paintings by Stanley Spencer, combined with the imagery of South Melbourne. Between 1952–1955, he experimented with an abstract mode that provided a complete contrast to the series of paintings, of which **Shearers Playing for a Bride** is one, based on the Aborigines. Boyd signed the Antipodean Manifesto in 1959, declaring his support for a "National Realism". He moved to England in the same year and his paintings have since included mythological themes in addition to reconsidering his past inside of landscape imagery.

Other Masterpieces

THE MOCKERS;
1945;
ART GALLERY OF NEW
SOUTH WALES,
AUSTRALIA

PERSECUTED LOVERS;
1957;
ART GALLERY OF SOUTH
AUSTRALIA,
AUSTRALIA

Brancusi Constantin

Born Hobitza, Romania 1876; **died** Paris, France 1956

Sleeping Muse I

1909; white marble; 17.8 x 27.9 x 20.3 cm; The Hirshhorn Museum and Sculpture Garden, Smithsonian Institution, Gift of Joseph H Hirshhorn, 1966, Washington DC, USA

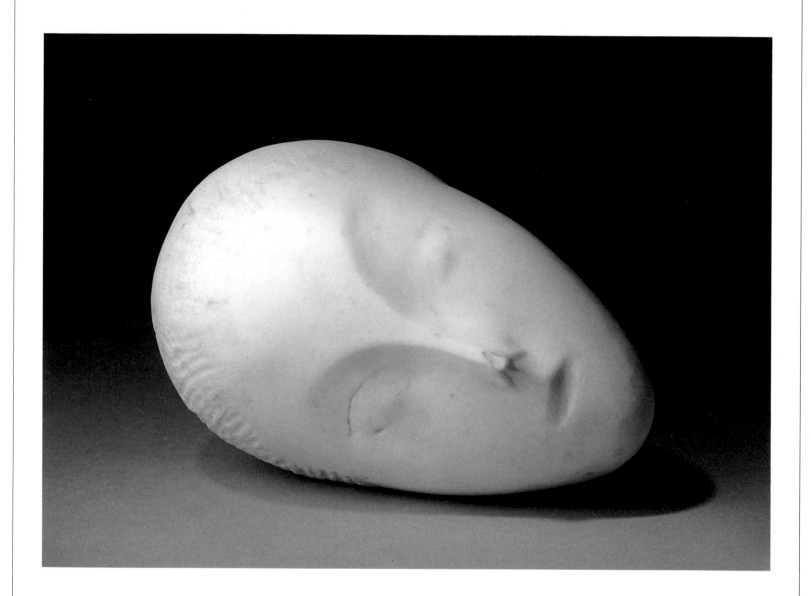

Constantin Brancusi was a Romanian sculptor who trained initially as a carpenter and stonemason. He settled in Paris in 1904 where his early influences included African as well as oriental art. Although Rodin was another early influence, Brancusi decided he wished to make much simpler work and began an evolutionary search for pure form. While never entirely rejecting the natural world, Brancusi undoubtedly succeeds in conveying a sense of gravity by reducing his work to a few basic elements. Paradoxically, this process also tends to highlight the complexity of thought that has gone into its making. Witness the studied serenity and distilled eroticism of **Sleeping Muse I**, for example. In contrast to his many polished works in marble and bronze are his roughly hewn works in wood. Brancusi did much to encourage a revival of carving and great respect for an artist's materials. During his later years, he polished the surface of his earlier works. Monumental, subtle and intimate, Brancusi's sculptures are rightly now considered to be the work of a modern master.

Other Masterpieces

ADAM AND EVE;
1921;
SOLOMON R GUGGENHEIM
MUSEUM,
NEW YORK CITY,
USA

PRINCESSE X;
1915–1916;
MUSEE NATIONAL D'ART
MODERNE,
PARIS,
FRANCE

Born Argenteuil-sur-Seine, France 1882; **died** Paris, France 1963

Guitar and Jug

1927; oil on canvas; 81 x 116.5 cm; Tate Gallery, London, England

Georges Braque developed his painting skills while working for his father, a house decorator. He moved to Paris in 1900 to study where he was drawn to the work of the Fauve artists, including Matisse, Derain and Dufy, as well as the late landscapes of Cézanne. Meeting Picasso marked a huge turning point in Braque's development and together they evolved as leaders of Cubism. After a brief interlude in which he was called up to fight in the First World War, Braque's style developed in the direction he was to follow for the rest of his life. In establishing the principle that a work of art should be autonomous and not merely imitate nature, Cubism redefined art in the twentieth century. Braque's large compositions incorporated the Cubist aim of representing the world as seen from a number of different viewpoints. He wanted to convey a feeling of being able to move around within the painting. The still life subject remained his chief preoccupation from 1927 to 1955. **Guitar and Jug** is an example of Braque's later introduction of objects derived from observation of the real world into his Cubist framework. Typically, Braque here deploys a narrow range of muted and earthy colours.

Other Masterpieces

THE PORTUGUESE;
1911;
KUNSTMUSEUM,
BASEL,
SWITZERLAND

STUDIO VI;
1952;
GALERIE MAEGHT,
PARIS,
FRANCE

Bratby John

Born London, England 1928; **died** London, England 1992

Still-Life with a Chip Frier

1954; oil on hardboard; 130 x 93 cm; Tate Gallery, London, England

John Bratby has a mixed reputation but is popularly known as one of the so-called "Kitchen Sink" School of painters who came to prominence within the British art scene during the 1950s. Bratby trained at the Royal College where he quickly achieved notoriety for painting college dustbins rather than concentrating on traditionally academic subject matter. He achieved early success with his first exhibition in 1954.

He won awards in 1956 and 1958 while representing Britain at the Venice Biennale. His work during the 1950s accords with the gritty realism that was prevalent in English literature at the time. In painterly terms this view of the world manifested itself in images of domestic life and tableaux created on table-tops and window ledges with everyday items. Bratby's thick paint, bright colours and apparent disregard for careful draughtsmanship is typified by **Still Life with a Chip Frier**. His style was considered shocking and led to accusations of vulgarity. This seems most appropriate with regard to his latest paintings featuring his second wife, Patti. However, his work has been widely collected and in the 1960s and 1970s he received a number of commissions for portraits of well-known figures.

Other Masterpieces

WINDOW, SELF-PORTRAIT, JEAN AND HANDS;
1957;
TATE GALLERY,
LONDON,
ENGLAND

GLORIA WITH ANGST;
1960;
LAING ART GALLERY,
NEWCASTLE-UPON-TYNE,
ENGLAND

Born Florence, Italy 1503; **died** Florence, Italy 1572

Agnolo Bronzino

c.1550; oil on canvas; 114 x 94 cm; Galleria degli Uffizi, Florence, Italy

Eleanora Toledo and her Son

Agnolo Bronzino was the leading court painter of the Florentine school in the middle of the sixteenth century. A Mannerist, Bronzino was a pupil of Jacopo Pontormo, with whom he worked on frescoes. Continuing his master's interest in light, Bronzino developed a rich feeling for colour: his paintings are distinguished by a sudden burst of raspberry-red or icy-blue. His allegorical and religious works reveal an unprecedented interest in the female form. Unwilling to give his subjects any particular spiritual significance, Bronzino seemed especially drawn to the nude in seductive paintings that maintain a sense of critical detachment. In large allegorical works, such as **Venus, Cupid, Folly and Time**, his pale, elongated nudes pose against a backdrop of symbolic figures and luxurious fabric. As court painter to the first absolute ruler Cosimo de Medici, Bronzino undertook the portrait of his wife and son, **Eleanora Toledo and her Son**. In this work, Bronzino reveals his skills as a draughtsman, brilliantly conveying the rigid hauteur of his aristocratic sitters as well as capturing the detailed patterning of Eleanora's dress.

Other Masterpieces

VENUS, CUPID, FOLLY AND TIME;
c.1550;
NATIONAL GALLERY, LONDON, ENGLAND

GUIDABALDO DELLA ROVERE;
1530;
PALAZZO PITTI, FLORENCE, ITALY

Brown Ford Madox

Born Calais, France 1821; **died** London, England 1893

The Last of England

1855; oil on wood panel; 82.5 x 75 cm; Birmingham City Museums and Art Gallery, England

Ford Madox Brown's considerable technical skills were acquired during his training in Antwerp, Paris and Rome. Settling in London in 1845, Brown came into contact with the Pre-Raphaelite Brotherhood but he never joined them. Although he shared the Brotherhood's desire to emulate the sincerity they found in early Renaissance art, Brown's deepening social conscience was a barrier to full acceptance by the group.

The Last of England shows Brown's keen interest in social issues. Moved by the sight of emigrants leaving England and with Woolner, as the only sculptor to join the Brotherhood, about to depart for Australia, Brown keenly empathized with their plight. He used himself and his second wife as models for the circular composition. Attention is focused on the couple as they reflect upon the fate that they may have in store.

The starkness of their situation is further emphasized by the realistic details, such as the ship's nets and rigging. Brown recreated the scene in the open air on dull days "to insure the peculiar look of light all round, which objects have on a dull day at sea".

Other Masterpieces

WORK;
1860–1863;
CITY OF MANCHESTER ART
 GALLERY,
 MANCHESTER,
 ENGLAND

AN ENGLISH AUTUMN
 AFTERNOON;
1852–1854;
BIRMINGHAM CITY
 MUSEUMS AND ART
 GALLERY,
 BIRMINGHAM,
 ENGLAND

1524; oil on canvas; 37 x 27 cm; Museo del Prado, Madrid, Spain

Jan Bruegel was the son of Pieter Bruegel. He made a prolonged visit to Italy in 1590 during which Cardinal Frederigo Borromeo became his patron. In 1595 he travelled with his patron to Milan where the Cardinal was appointed Archbishop. In 1596 Bruegel returned to Antwerp. He was a highly accomplished painter who drew inspiration from flower, landscape and Garden of Eden subjects. His landscapes were different from his father's, the younger man specializing in small wooded scenes, featuring an array of animals and mythological figures. His mature style reveals a painstaking attention to detail, which elicited the admiration of his contemporaries, including Rubens, with whom he collaborated. In **Still Life of Flowers** the blooms have been arranged with meticulous precision. Bruegel has carefully selected the flowers for their differing sizes and textures, reinforcing the balanced composition through his use of strong chiaroscuro. His ability to conjure the smooth surfaces of petals and the polished finish he applied to other subjects, led to his nickname, "Velvet" Bruegel. His son Jan the Younger (1601–1678) was also a painter.

Other Masterpieces

THE GARDEN OF EDEN;
c.1620;
VICTORIA AND ALBERT
 MUSEUM,
 LONDON,
 ENGLAND

A BASKET OF FLOWERS
WITH A SILVER GILT
TAZZA;
FITZWILLIAM MUSEUM,
 UNIVERSITY OF
 CAMBRIDGE,
 ENGLAND

Bruegel Pieter

Born Brögel, Netherlands c.1525; **died** Brussels, Belgium 1569

Tower of Babel

1563; tempera on wood; 114 x 155 cm; Kunsthistorisches Museum, Vienna, Austria

Pieter Bruegel the Elder was the most important member of a family of painters and the greatest of the early Netherlandish artists. A late medieval, fantasy style revealing the influence of Bosch is typical of Bruegel's early work, of which the intriguing and ingenious **Tower of Babel** is an outstanding example. After joining the studio of Pieter Coecke who encouraged him to develop his landscapes, Bruegel travelled through France and Italy between 1552 and 1554. His drawings of mountain scenery, made while in the Alps, formed the basis for later compositions. In the late 1550s he started work on the genre scenes and huge landscapes for which he is best known. Given the nickname "Peasant Bruegel" because of his habit of adopting disguise to enter these rowdy celebrations of rural life, Bruegel's close-up observations are at once affectionate and satirical. In 1563, settled in Brussels and with patronage, Bruegel started work on a series which took the months of the year as his theme. In his evocation of atmosphere and feeling he showed a new sensitivity toward landscape.

Other Masterpieces

HUNTERS IN THE SNOW; 1569; KUNSTHISTORISCHES MUSEUM, VIENNA, AUSTRIA

PEASANT WEDDING FEAST; c.1566–1567; KUNSTHISTORISCHES MUSEUM, VIENNA, AUSTRIA

Edward # Burne-Jones

King Cophetua and the Beggar Maid

1884; oil on canvas; 292 x 136 cm; Tate Gallery, London, England

Edward Burne-Jones's original intention was to enter the church but he changed his mind while studying at Oxford University with William Morris who became his friend. Both men were much influenced by their reading of Ruskin and the Pre-Raphaelite pictures they saw at the Royal Academy. After studying under his hero, Dante Gabriel Rossetti, Burne-Jones paid his first visit to Italy in 1859. In 1862 he went back to Italy with Ruskin, and the work he produced on his return showed the influence of Botticelli and Mantegna. Burne-Jones's dreamy, romantic style is strongly associated with the second phase of the Pre-Raphaelites. His highly decorative paintings draw upon mysticism and an imagined literary past and represent a retreat from nineteenth-century industrialism. His popularity was at its height in the 1880s and **King Cophetua and the Beggar Maid** dates from this period. The painting tells the story of a king who searches far and wide for a bride, only to fall in love with a woman disguised as a beggar. Burne-Jones designed stained glass windows and tapestries for William Morris, for whom he also illustrated books.

Other Masterpieces

THE BEGUILING OF MERLIN;
1874;
LADY LEVER ART GALLERY,
PORT SUNLIGHT,
ENGLAND

PERSEUS AND THE GRAIAE;
1892;
STAATSGALERIE,
STUTTGART,
GERMANY

Burra Edward

Born London, England 1905; **died** Rye, England 1976

Harlem

1934; watercolour; 55.2 x 42 cm; Cecil Higgins Art Gallery, Bedford, England

Edward Burra was a sickly child and illness plagued him throughout his life. His formative education was undertaken at home. From 1921–1923 he studied at Chelsea Polytechnic and for a further two years at the Royal College of Art, London. He had a liking for the quirky and the absurd, which explains why the work of the Dadaists, Surrealists and German artists, particularly George Grosz, proved inspirational to him. Due to illness tempering his own experiences, he delighted in the vitality of the other, more colourful lives he observed on his travels and on the cinema screen. The social scene and licentiousness of the streets, bars and nightclubs were of particular and lasting fascination to him. When he had the opportunity to visit America, in 1933, the watercolour paintings he made in response, such as **Harlem**, satirize the characters and the local urban environment without being critical or referencing political issues; a hint of menace pervades Burra's bright tonality. Such lighthearted illustrations are contrasted by works produced after 1936 in response to the Spanish Civil War and the Second World War. Burra's later paintings focus on landscape and still life.

Other Masterpieces

THE SNACK BAR;
1930;
TATE GALLERY,
 LONDON,
 ENGLAND

MEDUSA;
c.1938;
MANCHESTER CITY ART
 GALLERIES
 MANCHESTER,
 ENGLAND

Born Basel, Switzerland 1949

City

1985; drawing; 272 x 379 cm; Tate Gallery, London, England

M iriam Cahn has lived and worked in West Berlin since training in Basel and Paris in the 1960s and 1970s. Primarily working on paper, using black chalk, Cahn relies on her physicality and intuition to create her drawings from the chalk dust. In describing the process that produces her work, Cahn refers to putting herself "as a whole person, as a whole woman, into certain moods" before settling down to work on the floor. The scraping of the chalk dust from a larger block is part of the ritualistic preparation, the results of which rely on the artist pushing her body into the piece. Cahn has described her creative process as similiar to reading tea leaves, initialling her works LIS, which stands for Lesen in Staub (reading in the dust). Panoramic landscape such as **City**, blurry female figures, children, animals and mask-like faces are common threads in her drawings. Cahn works in a series, no individual picture taking precedence – the direct emotional strength of her work is most evident when the work is viewed as a whole. Miriam Cahn has also made site-specific work on German autobahns and produced large watercolours referring to nuclear explosions.

Other Masterpieces

WOLKEN SERIES;
1988;
HAUS AM WALDSEE,
 BERLIN,
 GERMANY

ATOM BOMB SERIES;
1988;
HAUS AM WALDSEE,
 BERLIN,
 GERMANY

Calder Alexander

Born Philadelphia, USA 1898; **died** New York City, USA 1976

The Black Eye

1961; painted sheet metal and rod; 69 x 172.6 cm; Phillips, London, England

Alexander Calder developed the mobile as a three-dimensional kinetic art form, having appropriated the idea from Russian Constructivist Alexander Rodchenko. Calder originally trained as an engineer before studying at the Art Students League in New York City, where he specialized in making sculpture from welded metal. He spent time in Europe from 1926, being impressed by the formal qualities and tonal implications of Mondrian's work and the art of Joan Miró. Their respective influences can be seen in Calder's subsequent work, which elegantly combines elements of abstraction, surrealism and constructivism. He joined the Abstraction-Creation group in 1931 and held his first exhibition of "mobiles", a name suggested by Duchamp, in 1932. Calder was also producing static, sculptural constructions, or "stabiles", as entitled by Jean Arp. The mobiles that followed were wind-driven, an advance that Calder preferred to the earlier motorized or hand-driven pieces. **The Black Eye** is a classic piece, made during a period when Calder's stabiles had reached monumental proportions as public works of art.

Other Masterpieces

ANTENNAE WITH RED AND BLUE DOTS;
1960;
TATE GALLERY,
LONDON,
ENGLAND

PERFORMING SEAL;
1950;
MUSEUM OF
CONTEMPORARY ART,
CHICAGO,
USA

Joseph in his Workshop

c.1425; oil on wood; 64.5 x 27.3 cm; Metropolitan Museum of Art, Cloisters Collection, New York City, USA

Art historians have argued for centuries over whether Campin was the same man as the Master of Flémalle, whose contribution to artistic styles was as revolutionary as van Eyck's. Known to be active from 1406, Campin was based in Tournai, a prosperous manufacturing and trading city. He used the city and its bourgeois citizens as a source for much of his painting. Joseph in his Workshop, is the right wing of the triptych of **The Annunciation** and aptly illustrates the sometimes convoluted symbolism of northern European art. The mousetrap on the windowsill of St Joseph's workshop is thought by some to be an allusion to a well-known doctrine of the time, according to which the Devil was tricked by the marriage of the Virgin Mary rather as mice are fooled by cheese in a mousetrap. St Joseph is located within a thoroughly domestic setting, in a style resolutely naturalistic. Having made the two mousetraps, it appears he is making a cover for a footstool, into which would be placed a hot pan to warm the feet. The minutely detailed townscape that can be seen in the background is almost like a picture hanging on the back wall.

Other Masterpieces

WERL ALTAR;
1438;
MUSEO DEL PRADO,
MADRID,
SPAIN.

THE VIRGIN AND CHILD BEFORE A FIRESCREEN;
c.1400–1425;
NATIONAL GALLERY,
LONDON,
ENGLAND.

Canaletto Antonio

Born Venice, Italy 1697; **died** Venice, Italy 1768

A Regatta on the Grand Canal

c.1747–1750; oil on canvas; 85 x 134.5 cm; Fine Arts Gallery of San Diego, San Diego, USA

Antonio Canaletto originally worked as a theatrical scene painter for his father. In 1719, he visited Rome where he was influenced by Panini, the leading exponent of view paintings. Tiepolo, the supreme Rococo painter, and Piazetta also made strong impressions upon him. At this time Venetian artists were courted by the whole of Europe; by the age of thirty, Canaletto had established a lucrative market in Britain for his views of the canals and buildings of his native city. He based himself in London for ten years from 1746. The topographical tradition in which he worked dates back to the narrative cycles of the Venetian Scuole painters who, like Canaletto, celebrated the public life of the city. To ensure an accurate representation, Canaletto used a camera obscura. This reflects an image on to paper from which the draughtsman can then trace round the edges. **A Regatta on the Grand Canal** records the pageantry and splendour of a Venetian festive occasion. This atmospheric composition demonstrates his skill in rendering light and shade, and his seemingly effortless ability to suggest a mass of people.

Other Masterpieces

THE STONEMASON'S YARD;
1726–1730;
NATIONAL GALLERY,
LONDON,
ENGLAND

VENICE: THE BASIN OF ST MARK'S ON ASCENSION DAY;
c.1740;
NATIONAL GALLERY,
LONDON,
ENGLAND

1817; white marble; 173 x 97.2 x 75 cm; National Gallery of Scotland, Edinburgh, Scotland

Antonio Canova was a leading artist working within the Classical movement that dominated European sculpture from the end of the eighteenth century through to the Victorian era. He settled in Rome in 1781, producing works of antique and mythological subjects and enjoyed the patronage of the Buonaparte family. In 1815 the sixth Duke of Bedford, one of his British patrons, commissioned Canova to create the group of **The Three Graces**, a celebrated sculpture, which recently achieved media attention by being saved from export out of Great Britain in autumn 1994. The intention was for the statue to be housed in a purpose-built temple at Woburn Abbey, main home of the dukes of Bedford.

It is probably the most famous of Canova's Neoclassical works and many preliminary drawings, prints and terracotta models exist to reveal the breadth of preparation that went into its creation. The unblemished smoothness of the marble heightens the languid sensuality of the figures. Soft lines and gestures flow rhythmically through the upper portion of the group, focusing on the attitude of the heads and emphasizing a mannered artificiality that exudes sentimentality.

Other Masterpieces

CUPID AND PSYCHE,
1787–1793,
MUSEE DU LOUVRE,
PARIS,
FRANCE

PAULINE BONAPARTE BORGHESE AS VENUS,
1807,
BORGHESE GALLERY,
ROME,
ITALY

Caravaggio
Michelangelo Merisi da

Born Bergamo, Italy c.1572; **died** Porto Ercole, Italy 1610

Supper at Emmaus

c.1601; oil on canvas; 139 x 195 cm; National Gallery, London, England

After a lacklustre apprenticeship Caravaggio went to Rome. By 1592 he was causing scandal, not only because of his volatile character and temper but because of his controversial painting methods. He rejected the lengthy preparations traditional in central Italy, preferring instead to work in oils directly from the subject – half-length figures and still life – as practised by the Venetians. He aimed to make paintings that depicted the truth and he was critically condemned for being a naturalist. In spite of adverse reactions, Caravaggio was commissioned to produce a number of large-scale paintings. However, certain of these after 1600 were made only to be rejected by patrons on the grounds of indecorum or theological incorrectness. His innovatory work nevertheless gained strong support and was a welcome antidote to Mannerism, or the limp compromises wrought by lesser artists working on religious themes. **Supper at Emmaus** is an example of Caravaggio's virtuoso talent. Not only are the protagonists and the still life rendered equally with impeccable technique but the attitude of the apostles as they react to Christ is a remarkable interpretation. The circumstances and heightened emotion of the narrative are given further expression with dramatic chiaroscuro and powerful foreshortening.

Other Masterpieces

CONVERSION OF ST PAUL;
1600–1601;
CERISI CHAPEL, STA MARIA DEL POPOLO,
ROME,
ITALY

BACCHUS;
c.1593;
GALLERIA DEGLI UFFIZI,
FLORENCE,
ITALY

Night Movements

1987–1990; steel stained green, varnished and waxed; 276 x 211 x 229 cm; Tate Gallery, London, England

Anthony Caro is recognized as a leading pioneer in the development of British sculpture of the post-war era. He was educated at the University of Cambridge (1937–1944), where he studied engineering, attending Farnham School of Art during vacations. His competence as a sculptor was developed by studying at the Regent Street Polytechnic and at the Royal Academy Schools from 1947 to1952. While still a student, he was employed as an assistant to Henry Moore. His mind was set on a figurative course, admiring Picasso's sculpture and the painting of Bacon, de Kooning and Dubuffet. However, less than a decade later, following a trip to New York, he oriented his ideas toward a radical alternative in abstracted, constructed steel sculpture. The work he produced during the 1960s was the stuff of revolution in artistic terms. He constructed his pieces in a similar way to a painter composing an abstract painting. Independent elements – planes, shapes, and lines – coloured and combined together form an autonomous whole, occupying a defined space on the ground, rather than elevated on a base or pedestal. **Night Movements** reveals the figurative tendencies that have returned to Caro's work from the 1950s.

Other Masterpieces

EARLY ONE MORNING;
1961;
TATE GALLERY,
LONDON,
ENGLAND

YELLOW SWING;
1965;
TATE GALLERY,
LONDON,
ENGLAND

Carrà Carlo

Born Quargnento, Italy 1881; **died** Milan, Italy 1966

Lot's Daughters

1919; oil on canvas; 110 x 80 cm; Private Collection

A signatory with Balla of the Futurist Manifesto in 1910, Carlo Carrà's earliest work showed the Futurist's preoccupation with movement. During his Futurist phase, Carrà studied the work of Giotto, noting in particular the earlier Italian artist's magical stillness of form. **Lot's Daughters** with its simple, sculpted, solid forms is a work that was produced in 1915 when Carrà was strongly influenced by Giotto.

In 1917, while recovering from a nervous disorder in a military hospital, Carrà met Giorgio De Chirico and out of this encounter Pittura Metafisica evolved. This movement sought to define a new way of looking at reality, of looking beyond what is in front of our eyes to the "metaphysical aspect" of things. Placing disturbing and incongruous imagery such as faceless mannequins and outsize fish in claustrophobic rooms, Carrà's

work of this period has a distinctly Surrealist feel. From 1921, he reverted to a more contemplative style while assimilating some of the heightened realism of his friend Giorgio Morandi. Carrà taught at the Milan Academy and was a leading influence on Italian painters between the two wars.

Other Masterpieces

THE BEWITCHED ROOM;
1917;
COLLECTION DR EMILIO
JESI,
MILAN,
ITALY

WOMAN WITH DOG;
1938;
GALLERIA NAZIONALE
D'ARTE MODERNA,
ROME,
ITALY

c.1587; oil on canvas; 130 x 97 cm; Museo del Prado, Madrid, Spain

The Assumption of the Virgin

Annibale Carracci was the greatest painter of the Carracci family, which included his brother Agostino and cousin Ludovico. In 1585 all three artists founded an Academy in Bologna which went on to establish itself as the school for seventeenth-century Baroque painting, and which included Guido Reni and Domenichino amongst its pupils. In 1595 Annibale Carracci went to work for Cardinal Farnese in Rome on the decoration of the Farnese palace. This series of frescoes, taking subjects from classical mythology, helped establish Carracci's reputation, ranking alongside Michelangelo's Sistine Chapel ceiling and Raphael's decorations in the Stanze in importance. **The Assumption of the Virgin** captures the dramatic moment of the occasion, revealing through its figures something of the artist's keen observational skills. In his smaller works he featured ideal classical landscapes. Everything in a Carracci composition is balanced; each element contributes to the overall harmonious design. To achieve this end, Carracci attempted to revive the Classical tradition while drawing upon the naturalistic advances he admired in the works of Titian. Annibale Carracci was an important influence on many artists, including Nicolas Poussin and Caravaggio.

Other Masterpieces

THE VIRGIN MOURNING CHRIST;
c.1605;
NATIONAL MUSEUM,
NAPLES,
ITALY

CHRIST APPEARING TO ST PETER ON THE APPIAN WAY,
1601–1602,
NATIONAL GALLERY,
LONDON,
ENGLAND

Carrington Leonora

Born Clayton Green, England 1917

Baby Giant

c.1948; oil on canvas; Private Collection

Leonora Carrington now lives and paints in Mexico and the States. In the 1930s and 1940s she was closely associated with the Surrealists, producing paintings on childhood themes featuring magical elements. In 1942 Carrington settled in Mexico where she worked alongside Varo, a female Spanish painter who shared her interest in fairytales and alchemy. Carrington's central concern is with women's creativity, using her work to explore the female psyche. Investigating her interior life, she draws upon the intermediate state between sleeping and waking. Her narrative paintings of figures and animals in the landscape show the influence of the Early Renaissance and contain allegorical images from mythic and literary sources that do not lend themselves to easy interpretation. **Baby Giant** depicts an outsize infant towering over the landscape. In her hands she is cupping an egg, while birds flap in and around her protective shawl. It is a curious image that refuses absolute meaning, while suggesting creativity and nurturing as well as the more malign face of nature.

Other Masterpieces

THE INN OF THE DAWN HORSE (SELF PORTRAIT);
1936–1937;
COLLECTION PIERRE MATISSE,
PARIS
FRANCE

THE MAGIC WORKS OF THE MAYAS;
1963;
NATIONAL MUSEUM OF ANTHROPOLOGY,
MEXICO CITY,
MEXICO

Mother and Child

1893; pastel on paper; 81 x 65 cm; Pushkin Museum, Moscow, Russia

Mary Cassatt studied art in Philadelphia between 1861 and 1865 before travelling to Europe and settling in Paris in 1874. Here she made contact with Manet and the Impressionists, with whom she exhibited at the Salon and elsewhere between 1877 and 1881. Degas was a lifelong friend and her admiration for his work was reflected in her own pastel studies. With Degas she shared an interest in Japanese art and composition. This is explicitly revealed in the character of her lithographs and etchings, print being a medium in which she excelled. Perhaps because of her subjects, or her gender, or both, Cassatt has not been recognized for the talented artist she was. A recurring motif was the relationship between mother and child, softly delineated to express sensitivity but tautly contained to keep sweetness in check.

Degas wrote, in around 1890, that her preoccupation was the study of, "reflections and shadows on skin and costumes for which she has the greatest feeling and understanding". In **Mother and Child**, the focus of attention is the emotional tie between baby and mother, who is totally enraptured by her infant. Cassatt's vision is projected like a photograph, capturing an instant that defies words or description.

Other Masterpieces

LA LOGE;
c.1882;
NATIONAL GALLERY,
 WASHINGTON DC ,
 USA

LADY AT THE TEA TABLE;
1885;
METROPOLITAN MUSEUM
 OF ART,
 NEW YORK CITY,
 USA

Castagno Andrea del

Born Castagno, Italy c.1422; **died** Florence, Italy 1457

Portrait of Dante

1447; fresco; Palazzo del Proconsolo; Florence, Italy

Andrea del Castagno was a Florentine painter in the mould of Masaccio but whose work reveals a close affinity with the sculpture of Donatello. His earliest work dates from 1442 when he worked on a series of frescoes in Venice. He returned to Florence two years later where he carried out most of his important work. After undertaking commissions for the cathedral, Castagno was asked by the Carducci family to decorate a room in their villa. For this commission, Castagno chose to paint a series of famous men and women, of which **Dante** is one. These portraits are distinguished by their size, literally larger than life and the shallow, fake marble surround which enhances the impression of these as three-dimensional rather than as two-dimensional pieces. Realistic and monumental, these portraits were an astounding leap forward and were of great significance to later Florentine artists such as Leonardo da Vinci and Michelangelo. Castagno also painted an impressive **Last Supper**, which again is notable for the intense realism of its figures.

Other Masterpieces

DAVID,
c.1450,
NATIONAL GALLERY
 OF ART,
 WASHINGTON DC,
 USA

BOCCACCIO,
c.1450,
CONVENT OF ST
 APOLLONIA,
 FLORENCE,
 ITALY

After Lunch

1975; acrylic on canvas; 244 x 213.4 cm; Tate Gallery, London, England

Patrick Caulfield studied at Chelsea School of Art in London from 1956 to 1960. The next three years were spent at the Royal College of Art, in the year below David Hockney, Derek Boshier and Allen Jones, leading Pop artists of their generation. The New American Painting exhibition at the Tate Gallery in 1959 had a major impact on young British artists. Caulfield was particularly impressed by the lyrical and evocative work of Philip Guston. Caulfield's own, as yet unresolved personal style, was nevertheless recognized for its potential and his work was included in the Young Contemporaries exhibition of 1961. Rather than celebrate popular culture, Caulfield sought to provide a critique of it, to explore the mechanics of the imagery used in a consumer society from a culture where everything is mass-produced. His paintings began to mimic printed rather than painted imagery, wrought in household paint on board rather than oil on canvas. His pictures, such as **After Lunch**, appear like clichés from *Ideal Home* advertisement photos – chic but rather empty. The inclusion of still life or a scenic view – here as an incongruous photographic image – is a reference to traditional, art historical subject matter.

Other Masterpieces

STILL LIFE WITH RED AND WHITE POT; 1966; HARRY N. ABRAMS FAMILY COLLECTION, NEW YORK CITY, USA

POTTERY; 1969; TATE GALLERY, LONDON, ENGLAND

Cézanne Paul

Born Aix-en-Provence, France 1839; **died** Aix-en-Provence, France 1906

Still Life with Plaster Cast

c.1895; oil on paper on board; 70 x 57.3 cm; Courtauld Institute Galleries, London, England

The son of a banker, Paul Cézanne moved to Paris in 1861 where he met Camille Pissarro and worked to get his painting accepted by the Salon. Cézanne's early paintings, influenced by Daumier and Delacroix, were dark and dramatic, the paint roughly applied with a palette knife. In 1870 he retired to L'Estaque in the south of France where his landscapes showed a new subtlety. Of the older generation of painters only Pissarro was interested in Cézanne, both men taking part in the First Impressionist Exhibition of 1874. Cézanne shared the Impressionists' fascination with light, but his work is significant for exploring beyond the surface analysis of colour and tone to articulate the underlying forms. His radical reappraisal of the relationship between surface and depth can be seen in **Still Life with Plaster Cast**. The upper half of the twisting plaster figure is seen from a different dimension to the apples on the table, which in turn are viewed separately from the floor. Cézanne recreates the picture space to show how these objects exist independently while combining to make up the whole. The single most important influence on Cubism, Cézanne prepared the way for painting in the twentieth century.

Other Masterpieces

BATHERS;
1898–1905,
PHILADELPHIA MUSEUM
OF ART;
USA

LA MONTAGNE SAINTE-VICTOIRE;
1886–1888;
COURTAULD INSTITUTE,
LONDON,
ENGLAND

1989; colour Polaroid; 51 x 61 cm; courtesy of the Zelda Cheatle Gallery, London, England

Meat Abstract No 4

Helen Chadwick trained at Brighton Polytechnic before completing an MA at Chelsea College of Art. In 1978, she had her first solo show in London. Much of her work focuses on the body and she made use of a wide variety of media – backlit projections, casts, prints – to explore her concerns. She was an artist whose work literally tended to transform its environment. In the mid-1980s, her giant glass case containing rotting and fermenting vegetable matter commanded space at the Institute of Contemporary Arts. It split and leaked through the floorboards. Her molten chocolate fountain, **Cacao**, cast a sickly sweet pall over the Serpentine Gallery – while her work, **Piss Flowers**, cast first in white plaster, then in bronze, derived from urinating in the snow and pushed at boundaries beyond the literal. In 1992, she made an acclaimed television film about the artist Frida Kahlo. **Meat Abstract No 4** is a recent, richly coloured and unnerving photo-work, in which she has juxtaposed the natural with the artificial: the animal insides and outsides with the electric bulb and synthetic, luxuriant material. She manages to combine wit with seriousness, pleasure with revulsion and curiosity with satisfaction. Her early death was a tragic loss to the art world.

Other Masterpieces

EGO GEOMETRIA SUM IX: HIGH SCHOOL – AGE 13; 1983; ARTS COUNCIL OF GREAT BRITAIN, LONDON, ENGLAND

CACAO; 1994; BRITISH COUNCIL, LONDON, ENGLAND

Chagall Marc

Born Vitebsk, Russia 1887; **died** Saint Paul-de-Vence, France 1985

The Poet Reclining

1915; oil on canvas; 77.2 x 77.5 cm; Tate Gallery, London, England

From a devout Jewish background, Marc Chagall entered art school in St Petersburg in 1907. Throughout his career he worked as a signpainter, and the influence of these techniques are evident in his paintings. His early style combined the primitive representation of folk art with the more sophisticated influence of Gaugin and the Fauves, whose work he saw in St Petersburg. In 1910 Chagall went to Paris.

Back in his home town of Vitebsk by 1914, Chagall joined the Knave of Diamond group. Declaring their admiration for French painting, the group mounted an exhibition designed as a protest against the Moscow Art School. After the revolution in 1917, Chagall briefly became director of Vitebsk art school before designing murals for the Jewish State Theatre in Moscow. In works such as **The Poet Reclining**, Chagall painted rural scenes remembered with a childlike nostalgia. His richly coloured lyrical paintings depict objects and people in unusual juxtapositions, often floating in space. His later work produced designs for the ballet, stained glass windows and paintings for the ceilings of the Paris Opera.

Other Masterpieces

I AND THE VILLAGE;
1911;
MUSEUM OF MODERN ART,
NEW YORK CITY,
USA

PARIS THROUGH THE
WINDOW;
1913;
SOLOMON R GUGGENHEIM
MUSEUM,
NEW YORK CITY,
USA

1738; oil on canvas; 45.4 x 37 cm; Glasgow Art Galleries and Museums, Glasgow, Scotland

Jean-Baptiste Chardin trained in the Rococo tradition, and worked as a restorer, although from an early age his own work bore little relation to this prevailing French style. Chardin was a master of simple still life and genre painting. Using ordinary subjects, Chardin avoided sentimentality by concerning himself with morality, namely the importance of truth, education and the dignity of labour. Many of Chardin's genre paintings, such as **The Scullery Maid**, feature a woman engaged in a single task. The room is empty and seemingly windowless. In his depiction of a hard and frugal existence, the artist emphasizes the maid's industry. The unfussy intensity of Chardin's still life give his work a remarkably modern feel. Even the humblest of objects such as a metal pan, a loaf of bread, or a pear, have a significance beyond the representational. Chardin was elected a member of the French Academy in 1728. He became its treasurer and hung exhibitions there over the next twenty years. Finding favour once the ornate court art's popularity was on the wane, Chardin's timeless compositions had an enormous influence on Courbet and Manet.

Other Masterpieces

THE HOUSE OF CARDS;
c.1736–1737;
NATIONAL GALLERY,
LONDON,
ENGLAND

SELF-PORTRAIT;
1771;
MUSEE DU LOUVRE,
PARIS,
FRANCE

Water Bearer

1981; oil and pastel on canvas; 207 x 170 cm; Tate Gallery, London, England

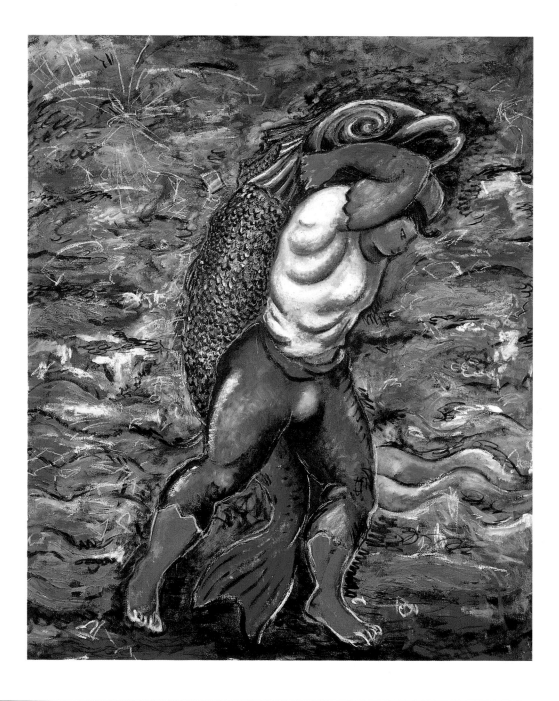

Sandro Chia was one of a generation of Italian artists who rejected the minimal and conceptual concerns of artists during the 1970s. In the early 1980s, Chia and his contemporaries, the Italian Transavant-garde, proved influential to other European and American artists in their concern to return to figuration and to revive interest in traditional materials. Resurrecting subject—matter based in the physical, as opposed to intellectual, world had an impact on the art market; painting became a more saleable art form and established artists, whose work had been neglected, were again fashionable. Chia trained at the Instituto d'Arte, (1962-1967) and the Accademia di Belle Arti, Florence (1967-1969). He references his wide, art-historical knowledge to formulate his painting and transforms artistic traditions to "make them new". A Neo-Expressionist spirit is at the heart of his approach, which is energetic and decorative. The heroic figures of his images, such as those in **Water Bearer**, often refer to the artist himself. Here, the fish is a visual metonym for water, a symbolic metaphor for virility, perhaps, or the life affirming load one carries. The work reveals Chia's imaginative technical abilities and his skill in the evocation of emotionally charged colour.

Other Masterpieces

THE IDLENESS OF
SISYPHUS;
1981;
MUSEUM OF MODERN ART,
NEW YORK CITY,
USA

CROCODILE TEARS;
1982;
ANTHONY D'OFFAY
GALLERY,
LONDON,
ENGLAND

1979; mixed media; 14.4 x 14.4 x 14.4 metres, San Francisco Museum of Modern Art, San Francisco, USA

J udy Chicago was educated at the University of California, Los Angeles between 1962 and 1964. A pioneering American feminist, Chicago came to prominence in the 1970s through work that challenged orthodox notions of what constitutes art, while promoting women as artists. She chose to explore women's sexuality, often through explicit images based on female bodily functions. In 1972, with Miriam Shapiro, she was the driving force behind Womanhouse, a collective project to convert an abandoned Los Angeles house into a space for performances and installations dealing specifically with the female experience. Her **Fantasy Rejection Drawings** (1974) were based on female genitalia and intended as a coded reference to woman's strength and vulnerability. Her most celebrated work, **The Dinner Party**, represented the collective effort of around four hundred women, whose contributions ranged from embroidery to ceramic decoration. The result was an elaborate, triangular table to which thirty nine famous women – drawn from art and history – are gathered together for an imaginary dinner party to celebrate female achievement. Chicago referred to the multimedia piece as, "a sort of reinterpretation of the Last Supper from the point of view of those who'd done the cooking."

Other Masterpieces

SHEET CLOSET (FROM **WOMANHOUSE**, RECORDED ON FILM); 1971; CALIFORNIA INSTITUTE OF THE ARTS, VALENCIA, USA

FANTASY REJECTION DRAWING (FROM THE **REJECTION QUINTET**); 1974; SAN FRANCISCO MUSEUM OF MODERN ART, SAN FRANCISCO, USA

Chillida Eduardo

Born San Sebastian, Spain 1924

Modulation of Space

1963; metal; 546 x 698 mm; Tate Gallery, London, England

Eduardo Chillida is a leading abstract sculptor of the twentieth century. He studied architecture at Colegio Mayor Jienez in Madrid (1943–1946), training that formed a solid basis from which to formulate his art. In 1947, he studied drawing at a private academy and moved to Paris in 1948. He returned to Spain in 1951. Chillida's small- and large-scale sculptures and public plazas have the same monumental grandeur to them.

Forged from unyielding materials – steel, iron, stone – each appears to interlock with the space around it. Like pieces of giant jigsaws, his public and private sculptures seem to be waiting for the final bit to complete each form. Such gaps are positive, unifying elements. **Modulation of Space** is a descriptive title, suggesting that its function is to affect the space around it, while acknowledging that it exists because of it.

Chillida works with people in mind, in spite of his work being non-figurative. His pieces, "steles", are often conceived as memorials to specific ideas or individuals – Giacometti, Neruda and Goethe, for example. He also strives to express concepts such as liberty and tolerance and to reference his passion for Greek sculpture and the spirit of the Basque people.

Other Masterpieces

MONUMENT OF BASQUE RIGHTS;
1980;
VITORIA,
 GASTEIZ,
 SPAIN

OUR FATHER'S HOUSE;
1986–1988;
GUERNICA,
SPAIN

c.1948; oil on canvas; 49.5 x 40 cm; Private Collection

Piazza d'Italie: Malincornia

Giorgio de Chirico studied painting in Athens and Munich. In Germany he discovered Nietzsche and the imaginative work of Bocklin and Klinger, which destroyed his interest in naturalistic painting. From 1911 to 1915 de Chirico was in Paris and first began to develop his metaphysical style. **Piazza d'Italie: Malincornia** exemplifies his innovative approach to landscape. The square is deserted but for a classical sculpture and an ominous human shadow. Time is suspended, focusing attention on the empty stage. In asking the viewer to consider what lies beyond physical appearance, de Chirico remarked that "dead voices speak to us from nearby, but they sound like voices from another planet". De Chirico met Carlo Carrà and formed Pittura Metafisica while both artists were recovering in hospital from injuries sustained during the First World War. The paintings that de Chirico produced in this period are characterized by their claustrophobic interiors and the juxtaposition of incongruous objects. His often bizarre and mysterious works were greatly admired by the Surrealists. De Chirico continued to make work that expressed his metaphysical concerns until the late 1920s when, in a complete volte-face, he embraced a new mannered naturalism.

Other Masterpieces

THE PHILOSOPHER AND THE POET;
1915;
CONTE ALFONSO OROMBELLI, MILAN, ITALY

THE ARCHAEOLOGISTS;
1927;
PRIVATE COLLECTION, VENICE, ITALY

Christo

Born Gabrovo, Bulgaria 1935

Wrapped Reichstag

1978; Project for Der Deutsche Reichstag, Platz der Republik, Reichstag Platz,
Schiedemann Strasse, Friedens Allee, Berlin, Germany

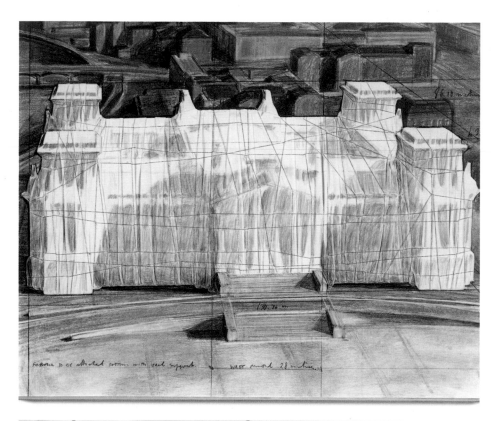

Christo Javacheff was born into a Bulgarian industrialist family. On the same date, June 13, his wife and collaborator, Jeanne-Claude, was born in Casablanca. Christo studied at the Fine Arts Academy in Sofia (1953–1956) and then arrived in Prague, undertaking a brief period of study at the Vienna Fine Arts Academy. In 1920, Man Ray wrapped a sewing machine in material and tied it with string; Christo went to Paris in 1958 where, in a similarly Surrealist spirit, he developed his idea to make art of objects, enigmatically packaged and wrapped. At the beginning of the 1960s, Christo expanded his artistic ambitions to include the wrapping of public buildings. He settled in New York in 1964. His out-sized, dramatic projects were recognized as a significant contribution to a period when "Happenings" had taken art beyond the modernist arena. Christo first conceived the **Wrapped Reichstag** project in 1971, before the Berlin Wall came down – a major artistic and political achievement. Like all Christo's projects, the funds raised were made by selling many elaborate preliminary drawings and maquettes. He also made art of the landscape itself, such as Running Fence, Sonoma and Marin Counties, California, 1972–1976.

Other Masterpieces

VALLEY CURTAIN;
1970–1972;
COLORADO,
USA

**THE PONT NEUF
WRAPPED;**
1975–1985;
PARIS,
FRANCE

Born Baerle, Netherlands c.1410; **died** Bruges, Belgium c.1472

Lamentation over the Dead Christ

c.1460; oil on wood; 98 x 188 cm; Museé Royeaux des Beaux-Arts de Belgique, Brussels, Belgium

Petrus Christus grew up in the northern Netherlands where there were no reputable painting workshops. In order to train as a panel painter, he had to travel south to Bruges, where he became a citizen in 1444. It is almost certain that Christus used a version of the same subject by Roger van der Weyden as the basis for this **Lamentation over the Dead Christ**. However, Christus broke new ground by integrating figures into their setting. They are not depicted as a block of people artificially placed in the foreground of a landscape, but rather in small clusters set apart from one another as if they actually inhabit the scene. His figures have a self-contained quality that gives the scene an appropriate sense of melancholy. Because masters of workshops and their apprentices collaborated so closely, and the cult of the individual painter did not exist at the time, it makes it difficult to ascertain precisely who painted what. What is certain is that Christus was one of the greatest fifteenth-century painters of northern Europe. He was probably Jan van Eyck's pupil, and after van Eyck's death became the foremost master in Bruges.

Other Masterpieces

PORTRAIT OF A LADY; c.1470; STAATLICHE MUSEEN ZU BERLIN, GERMANY.

PORTRAIT OF A YOUNG MAN; c.1450–1460; NATIONAL GALLERY, LONDON, ENGLAND.

Cimabue Giovanni

Born Florence, Italy 1240; **died** Florence, Italy 1320

Madonna and Child Enthroned

c.1280; tempera on panel; 385 x 223 cm; Galleria degli Uffizi, Florence, Italy

Cimabue is revered as the greatest Florentine artist before Giotto, whom it is believed that he taught. He worked within the Byzantine tradition – religious figures portrayed flatly and stiffly within a hierarchical setting. Under the influence of Romanesque sculptors and the nascent classical revival in Rome, he made the first tentative steps toward a more realistic style based upon personal observation. Cimabue's early contribution to the movement toward greater naturalism is qualified by doubts over many of the works assigned to him. The only work that is reliably attributed to him is **Saint John** in the Pisa Cathedral, although it is highly probable, because of its style, that **Madonna and Child Enthroned** is also one of his works. In this image he uses fine gold lines to model the drapery, emphasizing the rhythmic qualities within the composition. He has attempted to paint the architectonic throne receding in space, he even paints a foot overhanging the platform – not because he was aware of the rules of perspective but through careful observation.

Other Masterpieces

SAINT JOHN;
c.1302;
PISA CATHEDRAL,
PISA,
ITALY

MADONNA AND CHILD;
c.1280;
MUSEE DU LOUVRE,
PARIS,
FRANCE

Born Nancy, France 1600; **died** Rome, Italy 1682

The Adoration of the Golden Calf

1660; oil on canvas; 122 x 157 cm; Manchester City Art Galleries, Manchester, England

Claude Lorraine is thought to have first trained as a pastry cook but other details of his early life remain uncertain. He lived in Rome from the age of 27 and it was there that he began to produce some of the great classical landscapes on which his reputation rests. Less concerned than his contemporary Nicholas Poussin with the construction of his compositions, Claude concentrates on the evocation of mood and atmosphere. His many large compositions of biblical, mythological and pastoral subjects evince calmness and a wistful nostalgia. This is largely because of the artist's ability to recreate soft and subtle lighting effects. Claude worked outside and made numerous studies of dawn and dusk, which are acclaimed for their free handling. He mainly conceived of his paintings in pairs. **The Adoration of the Golden Calf**, however, is not part of a pair. It retells the biblical story of Aaron's construction of a heathen image, although for Claude, the spacious Roman countryside becomes the real subject of the work. Claude Lorraine was a great inspiration to other later landscape artists, in particular Turner whose **Dido Building Carthage** was a homage to the Frenchman.

Other Masterpieces

LANDSCAPE WITH AENEAS AT DELOS;
1672;
NATIONAL GALLERY,
LONDON,
ENGLAND

SEAPORT, WITH THE EMBARKATION OF THE QUEEN OF SHEBA;
1648;
NATIONAL GALLERY,
LONDON,
ENGLAND

Clemente Francesco

Born Naples, Italy 1952

Midnight Sun II

1982; oil on canvas; 200 x 250.8 cm; Tate Gallery, London, England

Francesco Clemente began painting in the late 1970s, achieving recognition in the early 1980s as one of the Italian Transavant-garde painters. He, like his contemporaries Cucchi, Chia and Paladino, was keen to redress the balance in favour of painting that employed the figure as an expressive site of meaning. Figuration had been neglected in the 1960s and 1970s under the weight of attention given to Conceptualism and Arte Povera. In addition to Clemente's revival of traditional art media – oil paint on canvas, watercolour, pastel and fresco – his significance lies in the metaphysical and cross-cultural aspects of his work. He has travelled widely and spent periods of time absorbed in different cultures; he maintains studios in Madras, Rome and New York. In the nostalgic spirit of post-modernism, he draws freely on art from the past and the ghosts of his Italianate history. In addition he freely plagiarizes imagery of non-European philosphies and religions, leading to the criticism of him as a pasticheur. **Midnight II** appears to be a bizarre erotic or spiritual hallucination, with the artist represented in the narrative. It is one of Clemente's, "endless stream of images that seem to generate each other".

Other Masterpieces

PARADIGM;
1988;
SPERONE WESTWATER
 GALLERY,
NEW YORK CITY,
USA

MEDITATION: IMPROBUS;
1992–1994;
GALERIE BRUNO
 BISCHOFBERGER,
MUNICH,
GERMANY

Born East Bergholt, England 1776; **died** London, England 1837

Seascape Study with Rain Clouds

1824–1828; oil on paper laid on canvas; 222 x 310 cm; Royal Academy of Art, London, England

The son of a prosperous Suffolk mill owner, John Constable was, with Joseph Turner, the major English landscape painter of the nineteenth century. Constable admired Claude and Ruisdael for their ability to draw directly from nature. After a spell at the Royal Academy, Constable returned to Suffolk and, declaring that there was "room enough for a natural painture [sic]", began an intense study of his native countryside. Constable was not a natural draughtsman. Making sketches outside in the fields in the summer, he then tried to reproduce the exact time and weather conditions of a particular moment in his London studio during the winter months. He was a painter of the particular rather than the general and wanted to show that "no two days were alike, nor even two hours; neither were there ever two leaves of a tree alike".

Regarded by Constable as preparatory work for his large paintings, his oil sketches, including the inspired **Seascape Study with Rain Clouds** are now greatly valued in their own right. Constable never travelled abroad, but his large composition, **Haywain**, caused a great stir when it was exhibited at the Paris Salon in 1824.

Other Masterpieces

HAYWAIN;
1821;
NATIONAL GALLERY,
LONDON,
ENGLAND

THE LEAPING HORSE;
1825;
VICTORIA AND ALBERT
MUSEUM,
LONDON,
ENGLAND

Cooper Eileen

Born Glossop, England 1953

Baby Talk

1985; oil on canvas; 121.9 x 91.4 cm; Jason Rhodes Gallery, London, England

Eileen Cooper studied at Goldsmiths' College and the Royal College of Art in the 1970s. Her paintings take women as their central theme and often depict the mother-child relationship. There is a strong narrative thread in Cooper's paintings which are at once autobiographical and universal, containing stories that defy any single or obvious interpretation. Cooper's paintings, with their use of vivid colours and primitive figures engaged in simple rituals, are celebratory in tone. Some commentators have been critical of her uncomplicated vision suggesting that in her presentation of "a golden age where even the fish get tickled pink with enjoyment", she ignores the harshness and brutality of life. Cooper herself has remarked that her paintings are not "restricted to a logical description of the world". **Baby talk** comes from a series of startling orange red and blue paintings made in 1987 in which Cooper explores her own status as a mother. The babies only form part of the picture: they begin to investigate the world giving the mother figure space to continue with her own activities.

Other Masterpieces

IF THE SHOE FITS;
1987;
JASON RHODES GALLERY
LONDON,
ENGLAND

CRAWLING WOMAN;
1990;
JASON RHODES GALLERY.
LONDON,
ENGLAND

Born Nyack, New York, USA 1903; **died** Flushing, Michigan, USA 1972

Guiditta Pasta

1950; mixed media in a box; 305 x 457 x 10 cm; Tate Gallery, London, England

Joseph Cornell had no formal art training. In the 1930s he became known for his assemblages, most commonly glass-fronted boxes in which he juxtaposed an assortment of disparate objects and artefacts. Exquisitely arranged, these compilations featured a surprising and often random collection of items including matchboxes, postage stamps, compasses and newspaper cuttings. His work sometimes utilized heavy picture frames and also mirrors. In a reference to his own work, Cornell said, "these shadow boxes become poetic theatres or settings wherein are metamorphosed the elements of a childhood pastime". After the Second World War, Cornell associated with the Surrealists and his work was featured in their exhibitions at the Julian Levy Gallery in New York. He also made a number of Surrealist films.

Giuditta Pasta is dedicated to the memory of Guiditta Pasta, a famous Italian opera singer. Wooden tracts support two loose balls above a row of wine glasses – three containing rock crystals and balls, symbolizing air, water and ice. While the box is a metaphor for a private world sealed in time and space, the two globe-like panels – representing the northern and southern hemisphere – allude to a world outside.

Other Masterpieces

CHOCOLATE MENIER;
1952;
NEW YORK UNIVERSITY
COLLECTION,
NEW YORK CITY,
USA

HOTEL DU NORD;
c.1953;
WHITNEY MUSEUM OF
ART,
NEW YORK CITY,
USA

Corot Jean-Baptiste-Camille

Born Paris, France 1796; **died** Paris, France 1875

Recollections of Mortefontaigne

1864; oil on canvas; 65 x 89 cm; Musée du Louvre, Paris, France

Known as Camille Corot, this painter of landscape and portraits trained in the classical tradition of Nicholas Poussin. Corot went to Italy in 1825 and returned there several times. The sketches he made on these visits have a remarkable freshness, although these were never seen by Corot as anything other than reference material for his large compositions. The direct, bold Italianate landscapes of the early part of his career were superseded in the 1850s by hazy wooded and waterside scenes which, with their soft grey-green tones and dreamy atmosphere, found immediate favour with the French public. **Recollections of Mortefontaigne** was painted after a visit to the great park just north of Paris. Watteau had also gone there for inspiration. In setting this scene against the lake in the early morning, Corot evokes an air of sleepy tranquillity. The painting's title refers to the image as a mere recollection; the painter attempts to capture this ephemeral scene as he remembers it. His late portraits and studies of women, such as **Woman with a Pearl**, were free of his diffuse style and are much admired.

Other Masterpieces

PEASANTS UNDER THE TREES AT DAWN;
c.1840–1845;
NATIONAL GALLERY,
LONDON,
ENGLAND

THE LADY IN BLUE;
1874;
MUSEE DU LOUVRE,
PARIS,
FRANCE

c.1517–1519; oil on canvas; 38.1 x 30.5 cm; National Gallery, London, England

A ctive chiefly in the small northern Italian town of Parma, Correggio was regarded by his successors as the most "progressive" and innovative painter of his period. The sensuous handling of the nude, and the soft modelling of flesh and draperies made him popular in the eighteenth century as a precursor of Rococo style. The formal qualities of Correggio's early paintings suggest that he may have studied Mantegna's work in Mantua. Similarly, Correggio employed illusionist techniques for various commissions undertaken within architectural spaces. In the **Assumption of the Virgin** in the dome of Parma Cathedral, c.1520, such daring trompe l'oeil effects are employed with dramatic foreshortening, rendered in fresco enlivened by tempera. The influence of the Renaissance masters, Raphael and Michelangelo is likely to have inspired Correggio indirectly via drawings and prints familiar throughout Italy. The impression made upon him by Leonardo is evident in the sweet lyricism with which **The Magdalene** is depicted. Correggio's sensitive interpretations of religious themes are elegantly composed. The apparent ease with which they are constructed lends a simple grace to complex figure groups as seen, for example in the **St George Altar**.

Other Masterpieces

HOLY NIGHT;
c.1530;
GEMALDEGALERIES,
DRESDEN,
GERMANY

MERCURY INSTRUCTING CUPID;
c.1525;
NATIONAL GALLERY,
LONDON,
ENGLAND

Cotán Juan Sánchez

Born Toledo, Spain 1561; **died** Granada, Spain 1627

Still Life with Quince, Cabbage, Melon and Cucumber

c.1602; oil on canvas; 69 x 84 cm; San Diego Museum of Art, San Diego, California, USA

Juan Sánchez Cotán was amongst the earliest of all European still life painters. He was a disciple of the artist Blas de Prado and an acquaintance of El Greco. Cotán became a friar at the age of 43, by which time he was already renowned for his dramatic still life. Based on strict mathematical principles, Cotán made his arrangements of fruit and vegetables within a frame. In **Still Life with Quince, Cabbage, Melon and Cucumber** this framing device appears to be a shelf or a window. Strong perspective and dramatically lit forms help to further the illusion. In hanging the produce from strings, Cotán refers to the contemporaneous practice of keeping the fruit from rotting, while adding an extra note of realism to the arrangement. This is one of five still lifes bought by King Phillip III from the estate of Archbishop of Toledo. In 1813 it was taken by King Joseph Bonaparte with him into exile in America. Exhibited in America in 1818, this wonderful painting was only rediscovered in 1945. Cotán also painted religious works.

Other Masterpieces

THE BEARDED WOMAN
OF PENARANDA
(BRIGIDA DEL RIO);
1590;
MUSEO DEL PRADO,
MADRID,
SPAIN

STILL LIFE WITH GAME
FOWL, FRUIT AND
VEGETABLE;
1602;
MUSEO DEL PRADO,
MADRID,
SPAIN

c.1804; watercolour on paper; 31.7 x 23.2 cm; Victoria and Albert Museum, London, England

Chirk Aqueduct, Wales

John Sell Cotman was a watercolourist and oil painter whose work was unusually stark and austere for the early nineteenth century. Cotman left Norwich for London in 1798, where he worked as a copyist. He continued to produce architectural and archaeological drawings throughout his career. In 1800 he exhibited at the Royal Academy. His painting tours of Wales and the West Country were followed by visits to Yorkshire between 1803 and 1805. For watercolours such as **Chirk Aqueduct, Wales**, Cotman laid clean flat washes of pure colour, mainly working indoors from pencil notes made outside. This landscape could have been the product of Cotman's tour of Wales in 1802, although there is no evidence that he actually visited the site. He probably transplanted the image of the aqueduct from a print. It is clear from the work that he was especially drawn to the rhythms of the arched shapes, and it is this sense of pattern and abstraction of form that makes his work so distinctive. In the later years his work lost some of its freshness when he began to mix paste with his watercolours.

Other Masterpieces

DUNCOMBE PARK;
1808–1810;
TATE GALLERY,
LONDON,
ENGLAND

GRETA BRIDGE;
1807;
BRITISH MUSEUM,
LONDON,
ENGLAND

Courbet Gustave

Born Ornans, France 1819; **died** Tour de Pietz, France 1877

Burial at Ornans

1850; oil on canvas; 315 x 668 cm; Musée du Louvre, Paris, France

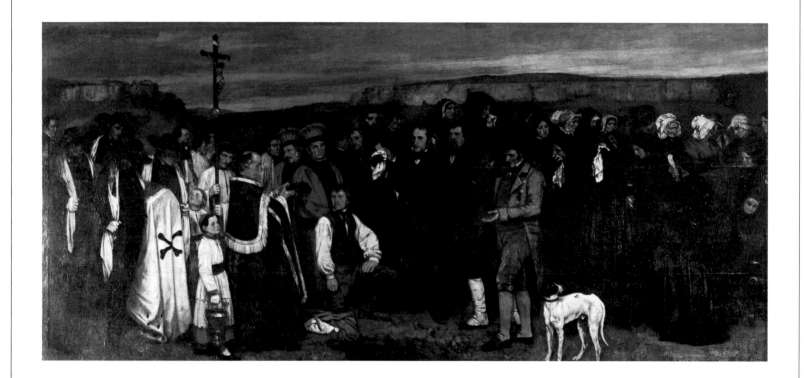

Courbet is credited with giving the name Realism to the style of painting with which he revolutionized art in Paris in 1860. He came to Paris in 1839 and, instead of official art training, copied seventeenth century naturalist paintings by Caravaggio, Velasquez, Ribera and Zurbaran. Following their example Courbet claimed to be a disciple only of truth. His principles condemned the pretentiousness of official, academic commissions and shunned the exotic elements of Romanticism. He alludes to these concerns in **Bonjour Monsieur Courbet**, a painting considered shocking because the artist depicts himself like a tramp being greeted by a patron. He concentrated on subjects from contemporary life for their pictorial rather than emotional value, earning praise from the political socialist Proudhon and from the novelist Emile Zola. **The Burial at Ornans**, exhibited at the Salon of 1850, is a monumental composition which caused outrage when it was first exhibited. The painting concentrates on the burial as a secular occasion and Courbet's depiction of the community was criticised for being "common, trivial and grotesque". His paintings of landscapes, still-life and nudes are, however, no less remarkable for their chiaroscuro, impasto and rich colouring.

Other Masterpieces

THE PAINTER'S STUDIO;
1855;
MUSEE DU LOUVRE,
PARIS,
FRANCE

PROUDHON AND HIS
CHILDREN;
1865;
PETIT PALAIS,
PARIS,
FRANCE

Valley with Winding Stream

1778; watercolour on paper; 37.1 x 53 cm; Victoria and Albert Museum, London, England

John Robert Cozens was a pupil of his father Alexander, who is best known for his method of composing landscapes out of accidental ink blots. Both father and son were associated with William Beckford, a leading protagonist of the trend towards sensibility of feeling in landscape in the late eighteenth century. John Cozens was more concerned to convey the poetry and drama that he found in landscape than he was with exact representation. He almost exclusively painted in watercolour, there is only one surviving oil painting, adopting a muted palette of predominantly blue-green and blue-grey. His work influenced Turner and Girtin and, in particular, Constable who referred to him as "the greatest genius that ever touched landscape". Cozens visited Switzerland and Italy, where he was especially drawn to the grandeur of the Italian lakes and the Swiss Alps. **Valley with Winding Stream** shows how his watercolours manage to emphasize the monumentallity of the landscape at the expense of detail. There is a melancholic aspect to Cozens, which eventually was to overwhelm him. Psychiatric problems brought about his death when he was only forty-five years old.

Other Masterpieces

VIEW OF LAKE ALBANO; c.1778; ASHMOLEAN MUSEUM, OXFORD, ENGLAND

VALLEY OF THE EISAH NEAR BRIXEN IN THE TYROL; c.1776; WHITWORTH ART GALLERY, MANCHESTER, ENGLAND

Cragg Tony

Born Liverpool, England 1949

On the Savannah

1988; bronze; 225 x 400 x 500 cm; Tate Gallery, London, England

Tony Cragg, came to prominence in the early 1980s with his wall-pieces fashioned from multicoloured fragments of plastic items. He studied at Gloucestershire School of Art, Wimbledon School of Art and the Royal College of Art, London. The wall-works were a sculptural response to the energy that surged back into figurative painting as a reaction against the minimalism and conceptualism that had knocked the tactile passion out of art since the end of the 1960s. Cragg's interest is in industry and the resulting products that shape our environment. Plastic, in particular, has become emblematic of a culture based on consumerism and obsessive materialism. Cragg exploits the unlikely, but nevertheless valid, aesthetic potential of the materials he uses. To emphasize our "metaphysical" relationship to the manufacturing processes on which we rely, Cragg has often created assemblages of scrap and rubbish, the detritus of mass production. **On the Savannah** is a graceful family of forms. The large-scale pieces derive from "the idea of mutation", here a metamorphosis of vessels commonly used within a science laboratory.

Other Masterpieces

BRITAIN SEEN FROM THE NORTH;
1981;
TATE GALLERY,
LONDON,
ENGLAND

COMPLETE OMNIVORE;
1993;
MARIAN GOODMAN
GALLERY,
NEW YORK CITY,
USA

Lucas Cranach the elder was of the same generation as fellow countryman, Dürer, but not much is known of his initial years or about his training. He was painting in Vienna in around 1500 where he produced portraits and religious panels of considerable inventiveness. His importance lies, however, in his ability to integrate figures within a natural environment. This is probably most significantly shown in his **Rest on the Flight to Egypt**, 1504, which combines charming fantasy with the familiar religious narrative. The so-called Danube School is thought to have originated from the inspiration engendered by such painting. After 1505 the poetic lyricism and inventiveness of Cranach's art diminished when he became court painter to the Elector of Saxony in Wittenberg. The formal requirements of commissioned portraits and religious works extracted fluidity and original spirit from Cranach's work. However, his paintings were fashionable and his friendship with Martin Luther gained him notoriety. His nudes, as in **Adam and Eve**, are more curious than classical. Their contrived gestures, awkward deportment and occasional, partial clothing often places them in the realm of the erotic.

Other Masterpieces

CUPID COMPLAINING TO VENUS;
EARLY 1530s;
NATIONAL GALLERY,
LONDON,
ENGLAND

THE NYMPH OF THE FOUNTAIN;
1534;
WALKER ART GALLERY,
LIVERPOOL,
ENGLAND

Crivelli Carlo

Born Venice, Italy c.1430; **died** c.1495

The Annunciation, with St Emidius

1486; oil on canvas; 207 x 146 cm; National Gallery, London, England

Despite training in Venice, Crivelli remained at a distance from the developing Venetian tradition, living in Ascoli, Ancona and other towns of the Marches. Crivelli always signed himself as a Venetian painter, though he never actually returned to Venice. His work suggests little knowledge of the developing Renaissance art in Tuscany, or the startling work being produced in Umbria by Piero della Francesca.

Crivelli's style shows a number of diverse influences. In his decorative handling of gold as well as in the stiff, linear quality to his figures, he owes much to the International Gothic style. He was also influenced by the sculptural qualities he discovered in the paintings of Mantegna. Combining such different elements, Crivelli's religious paintings have a concentration and a dramatic intensity that can be quite clearly seen in **The Annunciation, with St Emidius**. In rendering the grand decorative facade of the architectural construction in such deep perspective, the artist reveals his knowledge of the contemporary science of foreshortening. Patterned carpets, a peacock's tail and strategically placed fruit indicate Crivelli's mastery of ornamentation and trompe l'oeil.

Other Masterpieces

MADONNA AND CHILD;
c.1472;
METROPOLITAN MUSEUM
OF ART,
NEW YORK CITY,
USA

**LA MADONNA DELLA
RONDINE;**
c.1490–1492;
NATIONAL GALLERY,
LONDON,
ENGLAND

Born Dordrecht, Netherlands 1620; **died** Dordrecht, Netherlands 1691

Dordrecht, Evening

c.1650; oil on canvas; 98 x 138 cm; Kenwood House, London, England

There were six or seven painters in the Cuyp family, although Aelbert Cuyp was the most original and accomplished. He was influenced by earlier Dutch landscape painters, in particular Van Goyen. Cuyp never visited Italy himself, but it is likely he learned from Dutch painters such as Jan Both who had been there. From these painters Cuyp assimilated an Italianate handling of light. In his use of golden light, Cuyp revealed the influence of Claude and became known as the Dutch Claude. By the 1640s, Cuyp was producing much larger canvases in which he showed an interest in different effects of light at various times of the day. He painted a wide range of subjects, including portraits, still life, landscapes and town scenes, but is best known for portraying cows shown grouped on the lowlands or simply chewing the cud. **Dordrecht, Evening** is one of many paintings that Cuyp made of the watery landscape in and around in his native town. Cuyp's work was much admired in the nineteenth century by Constable and Turner.

Other Masterpieces

CATTLE WITH HORSEMAN AND PEASANTS; c.1650; NATIONAL GALLERY, LONDON, ENGLAND

THE MAAS AT DORDRECHT; c.1660; NATIONAL GALLERY OF ART, WASHINGTON DC, USA

Dali Salvador Felipe Jacinto

Born Figueiras, Spain 1904; **died** Barcelona, Spain 1989

Lobster Telephone

1936; mixed media; 178 x 330 mm; Tate Gallery, London, England

In 1922 Salvdor Dali entered the Special School of Painting, Sculpture and Engraving in Madrid. By 1926 he had been expelled for extravagant behaviour. Such artistic anarchy set the tone for his life. He was quick to explore a variety of avant-garde trends, working his way through phases of Cubism, Futurism, Purism and the metaphysical style of de Chirico. Self-portraits abound. From the late 1920s the influence of Picasso, whom he met in Paris, became increasingly important and he dallied between using a classical, figurative style and working in a Cubist manner. Individual and perverse features make their way into the paintings, heralding a dramatic change in 1927. A crisis in his ideas about representation coincided with his entanglement with Surrealism. Works of 1929 are the culmination of his exploration into desires, dreams and the unconscious mind. Freudian symbolism and other elements combined to produce extraordinary imagery that seemed to be the visual equivalent of hallucinatory experience. Translated into sculpture, this was realized in such incongruous juxtapositions as the **Lobster Telephone**. He was repudiated by Breton and other, more traditional Surrealists when from the late 1930s he adopted a more classical style.

Other Masterpieces

SOFT CONSTRUCTION WITH BOILED BEANS; PREMONITION OF CIVIL WAR; 1936; PHILADELPHIA MUSEUM OF ART, USA

THE PERSISTENCE OF MEMORY; 1931; MUSEUM OF MODERN ART, NEW YORK CITY, USA

Honoré Daumier

Washerwoman

1863–1864; oil on panel; 49 x 33.5 cm; Musée d'Orsay, Paris, France

Honoré Daumier was a caricaturist who employed his graphic skills satirizing bourgeois French life and politics in the nineteenth century. He studied painting and lithography in Paris before making his living as a cartoonist for various satirical journals. His attacks on the government resulted in a short spell of imprisonment, after which he attempted to establish himself as an oil painter. Retaining his radical political sympathies and a keen sense of injustice, Daumier painted ordinary people going about their daily life. **Washerwoman** exemplifies his unsentimental approach, other subjects included the occupants of a third class railway carriage and the audience at a theatre. Boldly painted with harsh brush strokes, his compositions have a dramatic intensity due to the strong chiaroscuro. His sketches and oil paintings of **Don Quixote** are reminiscent of Goya and Rembrandt in their free handling and intensity of light and shadow. Daumier made watercolours and wash drawings of the Courts of Justice. He also worked as a sculptor on a number of clay busts and statuettes. Toward the end of his life, he started to go blind.

Other Masterpieces

THE REPUBLIC;
1845;
MUSEE DU LOUVRE,
PARIS,
FRANCE

LA FINE BOUTEILLE;
1856–1860;
NATIONAL MUSEUM,
STOCKHOLM,
SWEDEN

David Jacques-Louis

Born Paris, France 1748; **died** Brussels, Belgium 1825

Madame Récamier

1800; oil on canvas; 174 x 244 cm; Musée du Louvre, Paris, France

Jacques-Louis David was the most important and successful of the Neoclassical painters. He trained in the Rococo tradition of his distant relation, Franççois Boucher. After winning the Prix de Rome in 1774, David spent six years there. This inspired an enthusiasm for ancient sculpture which, combined with his admiration for the work of Nicholas Poussin, formed the basis of his Neoclassical style.

The Oath of Horatii, shown in Rome and Paris in 1784 indicated the depth of David's rejection of the Rococo tradition. A monumental work expressing an austerity that commended it to the leaders of the Revolution, it helped to establish David himself as a revolutionary leader. It was followed by other cool classical compositions featuring the martyrs of the revolution, such as **The Death of Marat** (1793). David also painted portraits including that of the famous beauty and conversationalist, **Madame Récamier**, which, with its cool colouring and elegant simplicity, is a Neoclassical masterpiece. In 1798 David met Napoleon and became an ardent Bonapartist, fleeing to Brussels after the Battle of Waterloo in 1895. Gérard, Gros and Ingres were among David's many pupils.

Other Masterpieces

THE OATH OF HORATII; 1784; MUSEE DU LOUVRE, PARIS, FRANCE

THE DEATH OF MARAT; 1793; MUSEES ROYAUX DES BEAUX-ARTS DE BELGIQUE, BRUSSELS, BELGIUM

This, That and The Other

1985; 2 parts: laminated hardboard and canvas, galvanized steel; 228 x 396 x 182 cm;
Private Collection, London, England

Richard Deacon undertook his art training in London at St Martin's School of Art, from 1969 to 1972, and then at the Royal College of Art, from 1974 to 1977. He studied art history at Chelsea School of Art during 1979. Along with Tony Cragg, Deacon is recognized as one of the most significant British sculptors of his generation. Although his work is essentially abstract, there is a sense of figuration in the linear constructs and biomorphic forms that distinguish his work. Rather than focus on a particular range of subjects within the real world, Deacon works as a "fabricator", exploring the convoluted nature of sculpture itself by emphasizing the manufacturing process. He uses a variety of materials – metal, wood and, occasionally, cloth – and employs a diverse range of construction methods – welding, riveting and gluing – to create complex structures that somehow seem familiar. As in **This, That and The Other**, the interplay of solid shapes and fluid lines sets in motion interior relationships within the piece. Deacon enquires into the nature of forms in space and of the hidden spaces within those forms. The associations that we bring to our experience of this enquiry also becomes an integral part of it.

Other Masterpieces

FISH OUT OF WATER;
1987;
LISSON GALLERY,
 LONDON,
 ENGLAND

STRUCK DUMB;
1988;
TATE GALLERY,
 LONDON,
 ENGLAND

Degas Hilaire Germain Edgar

Born Paris, France 1834; **died** Paris, France 1917

Woman Ironing

c.1885; oil on canvas; 81 x 75 cm; Walker Art Gallery, Liverpool, England

Degas abandoned a training in law to study art. His tutor was a pupil of Ingres and passed the exemplary draughtsmanship of the eighteenth century master onto Degas. In 1856 the artist visited various Italian cities where he took the opportunity to study and copy the drawings and frescoes by great Renaissance artists. He returned to produce works with historical themes wrought in a classical manner and exhibited these with the Impressionists. Contact with Manet's circle from 1861 encouraged Degas to concentrate on scenes from contemporary life, particularly those that offered the opportunity to depict movement. Contemporary experiments with photography and the current vogue for Japanese prints made an impression on Degas' composition. Unusual angles of vision, off-centre focal points, figures cut by the frame and a reassertion of linear qualities contributed to Degas' inimitable style. Degas is best known for his exquisite pastel studies of the ballet, theatre and circus. Drawing allowed him to work rapidly, capturing transient activity, a passing mood, a languid yawn. Degas has been accused of misogyny in his dispassionate treatment of women. **Woman Ironing** demonstrates Degas concern only to express what was real with a technical ability that remains unsurpassed

Other Masterpieces

AWAITING THE CUE;
1879;
PRIVATE COLLECTION,
NEW YORK CITY,
USA

AT THE RACES;
1869–1872;
MUSEE DU LOUVRE,
PARIS,
FRANCE

Liberty Leading the People

1830; oil on canvas; 260 x 325 cm; Musée du Louvre, Paris, France

By the early 1850s Eugène Delacroix had affirmed the position he had held as the leader of the Romantic movement – albeit a rebellious one. He visited Morocco in 1832 and considered himself a dandy. He was denied membership of the Academie des Beaux-Arts until 1857 despite being regarded as a key artist by all but the most conservative critics and had received numerous state commissions throughout his career. In addition to directing large decorative mural projects he produced many memorable, smaller works. In his later years he wrote the bulk of his celebrated *Journal* and continued to publish art criticism. He was probably the last great artist to consider himself primarily as a history painter, preferring to tackle exotic or heroic major themes. **Liberty Leading the People** is one such triumphant composition. It appears like an allegory but was conceived to act like a poster illustrating the contemporary life of the Revolution. The avant-garde of his time respected him as an older, independent artist and Baudelaire was included among his loyal admirers. He is often regarded as the greatest colourist of French painters.

Other Masterpieces

ALGERIAN WOMEN;
1833;
MUSEE DU LOUVRE,
PARIS,
FRANCE

MASSACRE AT CHIOS;
1823;
MUSEE DU LOUVRE,
PARIS,
FRANCE

Delaunay Robert

Born Paris, France 1885; **died** Montpelier, France 1941

Windows Open Simultaneously

1912; oil on canvas; 457 x 375 cm; Tate Gallery, London, England

Robert Delaunay started to paint in 1904. His early work showed the influence of the Neo-Impressionists and the Fauves but in 1908, enlarging upon Cubist principles, he began his own influential investigation into colour. Delaunay's painting **Saint Séverin** (1909) is regarded as the starting point of his new theories of colour. Believing he could create movement and depth purely through contrasts of colour, Delaunay declared that "colour is form and subject". His paintings of the city of Paris and the Eiffel Tower echoed these concerns. He generally worked in series and moved beyond the conventional notions of landscape to show the dynamism of city life, often from a high vantage point. **Windows Open Simultaneously** (first part of Triptych, 3rd motif) uses contrasting colours to break up space in an entirely new way.

The poet Apollinaire was the first person to use the term Orphism to describe this movement, which was also closely related to music. His wife, Russian-born Sonia Terk Delaunay, was also a notable artist. Delaunay was a considerable influence on the Blaue Reiter group.

Other Masterpieces

THE EIFFEL TOWER;
1910;
GUGGENHEIM MUSEUM,
NEW YORK CITY,
USA

PARIS, STE SEVERIN;
1909;
PRIVATE COLLECTION,
USA

Born Grandville, France 1870; **died** Paris, France 1943

Homage to Cézanne

1900; oil on canvas; 180 x 240 cm; Musée d'Orsay, Paris, France

Maurice Denis was a member of the Nabis and an exponent of the contemporary Symbolist ideologies. He met with future Nabis artists Vuillard and Roussel at the Lycée Condorcet, before attending the Atelier Balla and the Academie Julian. Here he met Bonnard and Serusier, with whom he formed the Nabis in 1888. **Homage to Cézanne**, an unusually naturalistic painting, illustrates, in detail, identifiable members of the Nabis paying respect to the earlier master's work. Denis participated in group exhibitions and exercised considerable versatility, producing not only easel and large-scale decorative paintings but also designs for stained glass, stage-sets and theatrical costumes. These were in addition to illustrations, prints and numerous articles, including a published history of religious art in 1939. His collected art dictums prefigured those of Modernist art theorist Clement Greenberg. Denis probably made his most valuable contribution to the history of painting when he stated that before it is anything else, "...a picture...is essentially a flat surface, covered with colours assembled in a certain order".

Other Masterpieces

THE BLESSING OF THE
BOATS;
c.1895;
JOSEFOWITZ COLLECTION,
 SWITZERLAND

BATHERS;
1899;
MUSEE DU PETIT PALAIS,
PARIS,
FRANCE

Derain André

Born Chatou, France 1880; **died** Garches, France 1954

Barges on the Thames

1906; oil on canvas; 81.3 x 99 cm; City Art Gallery, Leeds, England

André Derain first became acquainted with fellow painter Maurice de Vlaminck when he was a student. Derain met Henri Matisse in 1899 and introduced his friend Vlaminck to Matisse a couple of years later. Although all three artists recognized the important similarities between them it was not until 1905 that they entered the Salon d'Automne for the first time as part of a larger group. The boldness of these painters' work led to their nickname of the Fauves (wild beasts). Derain's work of this period, with its expressive use of pure colour and mosaic surfaces, marked him out as one of the most original and important of the Fauves. **Barges on the Thames** is one of a number of Derain's works that took London landmarks as its theme. In his use of strong colour Derain transforms the scene, making the setting subordinate to its lively expression. Between 1908 and 1910, Derain's work showed the influence of Cubism. He met Picasso and worked with him at Cadaquès. After 1919, Derain retreated from the avant-garde and reverted to a more traditional style, adopting an altogether more restrained and sombre palette.

Other Masterpieces

FISHING BOATS,
COLLIOURE;
1905;
METROPOLITAN MUSEUM
OF ART,
NEW YORK CITY,
USA

ST PAUL'S FROM THE
THAMES;
1906–1907;
MINNEAPOLIS INSTITUTE
OF ARTS,
MINNEAPOLIS,
USA

1951; oil on canvas; 143.5 x 113 cm; Acquavella Contemporary Art Inc, New York City, USA

Albuquerque II

Richard Diebenkorn, like painter Robert Motherwell, swam calmly against the tide of Abstract Expressionism that saturated the American art scene of the 1950s and 1960s. The contemporary fascination with popular culture also left Diebenkorn's art unscathed. The subtle nuances of the European Modernist movement, however, infused his work. Sensitivity and compositional structure, informed by emotional and sensual concerns, infiltrated his painting. **Albuquerque II** was produced shortly before Diebenkorn radically changed direction toward figuration. This beautiful abstract is at once soft and hard, elegantly composed and grounded by the rich ultramarine wedge near the base. The visible element of drawing in the painting was realized more overtly in his subsequent representational style, which influenced successive generations of Californian artists. Diebenkorn's respect for the Modernists – Henri Matisse in particular – and the bold canvases of the colour-field painters, Clifford Still and Barnett Newman for example, resulted in later canvases that have much in common with the Symbolist tradition of equivalents; sensation and harmony are described in terms of colour, line and form.

Other Masterpieces

CITY SCAPE 1;
1963;
MUSEUM OF MODERN ART,
SAN FRANCISCO,
CALIFORNIA,
USA

OCEAN PARK NO.66;
1973,
ALBRIGHT–KNOX ART
GALLERY,
BUFFALO,
NEW YORK STATE,
USA

Dine Jim

Born Cincinnatti, USA 1935

Jumps Out at You, No?

1993; etching and softground with hand-colouring; paper, 53.2 x 71.2 cm, image 31.5 x 53.6 cm; edition of seventy five; Jim Dine and the Alan Cristea Gallery, USA

A prominent figure in the genesis of Pop Art in America, Jim Dine worked in the spirit of Dada as a multimedia artist. A negation of the traditional boundaries of art became the basis for his work. He trained at the University of Cincinnati, at the Boston Museum School and graduated from Ohio University in 1958. Dine propelled the Duchampian notion of the "ready-made" into his practice. Like Robert Rauschenberg, he created assemblages by attaching objects - a piece of clothing or a domestic appliance - to painted canvases. Items of the real world thereby became displaced from it; they were integrated with, and distinguished as, fine art objects. This was a concept he took further via his involvement with "Happenings", beginning at the end of the 1950s. These psychodrama collaborations heralded the all-embracing cultural aspects of Pop, while remaining cognisant of the physical action that is so much a part of Abstract Expressionist practice. A precursor of Performance Art, they were oriented toward combining the visual arts with free improvization. From the mid-1970s, Dine turned to a more traditional, representational mode of painting and printmaking, embodying himself in the image of the robe as in **Jumps Out At You, No?**

Other Masterpieces

THE TOASTER;
1962;
WHITNEY MUSEUM OF
AMERICAN ART,
NEW YORK CITY,
USA

CHILD'S BRIGHT BLUE WALL;
1962;
ALBRIGHT-KNOX ART
GALLERY,
BUFFALO,
NEW YORK STATE,
USA

Born Untermhausen, Germany 1891; **died** Singen, Germany 1969

Die Grosstadt

1928; (centre panel); mixed media on wood; 181 x 200 cm; Galerie der Stadt, Stuttgart, Germany

Otto Dix studied in Dresden, where his early work declared an interest in pictorial realism and a refusal to idealize his subjects. In 1914 he was called up to fight in the First World War. At the front he experienced the horrors of trench warfare and gas attacks. He returned to study in Dresden and Düsseldorf, producing collages from materials chosen for their ugliness. His anti-war compositions, fifty etchings published as **The War** in 1924, and a large painting of trench life, now lost, are unsparing in showing the decay and carnage of the trenches. His triptych **Die Grosstadt** (Metropolis) depicts the corruption of modern urban society and in particular its night life. In his portraits, Dix investigates human nature with the critical detachment of a surgeon. It was this determination to root out truth as well as an unflinching attention to detail that led to Dix's inclusion in the New Objectivity movement with Beckmann and Grosz. After being appointed a professor at the Dresden Academy, Dix was dismissed by the Nazis in 1933. In the 1930s he slipped back into Romanticism, before entering a post-Second World War phase of Expressionism with religious overtones.

Other Masterpieces

HOMAGE TO BEAUTY;
1922;
VON DER HEYDT-MUSEUM,
WUPPERTAL,
GERMANY

THE ART DEALER ALFRED FLECHTHEIM;
1926;
NATIONAL GALERIE,
BERLIN,
GERMANY

Donatello

Born Florence, Italy c.1386; **died** Florence, Italy 1466.

St George

c.1417; white marble; 209 x 67 cm; Museo Nazional dell Bargello, Milan, Italy

Donatello was the greatest Florentine sculptor before Michelangelo, and the most influential artist of the fifteenth century. Along with Masaccio and his friend Brunelleschi he was the leading figure of a new humanist movement which relocated man to the centre of the Universe; with this came a dramatic shift in how objects and people could be represented. These artists made sense of a rapidly changing world through their own observations and styles, galvanized by an increasing knowledge of ancient Rome and Greece. From 1416 he worked on this sculpture of **St George**, commissioned by the Guild of Armourers whose patron saint it represents. It was destined for a space on the outside of the church of Or San Michele in Florence. Donatello portrays St George as a heroic, lifelike figure, calm yet alert, watching warily for approaching danger. More significant is the relief below of St George killing the dragon; this is the earliest known example of the new science of perspective being used to create a believable space for the figures to inhabit.

Other Masterpieces

HEROD'S FEAST;
1427;
SIENA CATHEDRAL,
ITALY

MAGDALEN;
c.1455;
BAPTISTRY,
FLORENCE,
ITALY

Jean Dubuffet

Villa sur la Route

1957; oil on canvas; 81.3 x 100.3 cm; Scottish National Gallery of Modern Art, Edinburgh, Scotland

J ean Dubuffet gave up his wine business in 1942 to devote himself to his art. Primarily a painter and printmaker, Dubuffet believed that art was a spontaneous and primitive process that emerged from immersion in the materials. This led him to coin the term Art Brut to describe the raw art made by children and the mentally ill, which he greatly admired and did much to support. **Villa sur la Route** was one of 24 paintings that Dubuffet worked on during his five months in Vence in 1957. Characteristically, it draws upon the simplifed and expressive forms of children's drawings, as well as the direct and energetic scribbles of graffiti. Building up several layers, he creates a densely textural work, scratching through to earlier colours as well as leaving drips and dollops of paint on top. He continued to experiment with materials such as sand, cement and glass to produce an extraordinary range of textural surfaces. In the late 1960s Dubuffet turned to sculpture. In the late 1970s and early 1980s he pieced together huge collages featuring his raw and energetic linear work.

Other Masterpieces

WHITE COW, GREEN BACKGROUND;
1954;
MUSEE NATIONAL D'ART
 MODERNE,
 PARIS,
 FRANCE

RANDOM SITE WITH 3 PERSONAGES;
1981;
MUSEE NATIONAL D'ART
 MODERNE,
 PARIS,
 FRANCE

Duccio di Buoninsegna

Born Siena, Italy c.1255; **died** Siena, Italy c.1318

The Maesta – Christ Washing the Disciples' Feet

1311; tempera on wood; 100.5 x 53 cm; Museo dell'Opera del Duomo, Siena, Italy

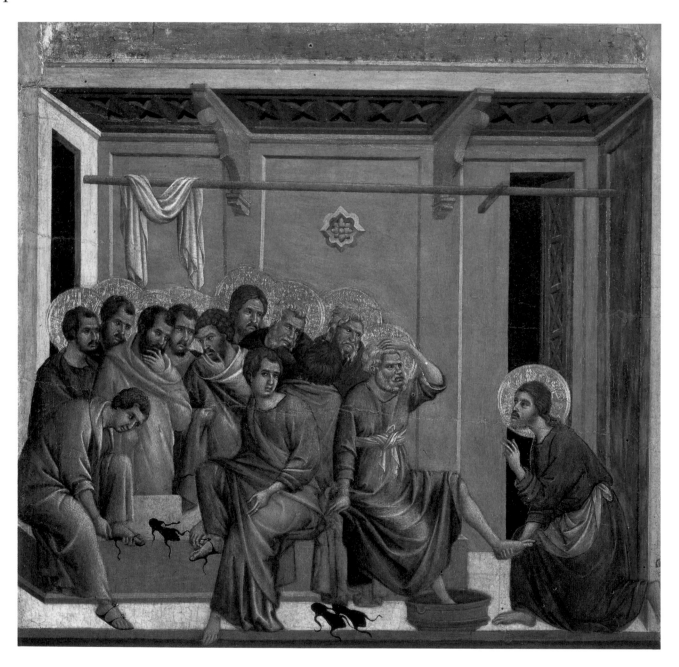

Duccio's workshop was predominant in Siena at the turn of the fourteenth century. The artist is renowned for injecting new life into the Byzantine artistic style, which is characterized by rather stilted but elegant elongated figures, while showing a clear debt to Greek art, particularly in the modelling of the figures and the fall of the drapery. Duccio's **Maesta**, a double-sided altarpiece made up of over sixty scenes, was installed in Siena cathedral in 1311. It was the artist's most prestigious commission. In this scene, Christ warns Peter that washing his feet will cleanse his entire body yet leave a part of him unclean. Peter raises his hand to his head in disbelief, while the other disciples look on in consternation. Their range of ages, temperaments and expressions is noteworthy as is the composition of the group itself. Movement and the tactile qualities of materials are also well-rendered, in particular the disciple stretching forward to take off his sandal. Duccio here begins to fuse two elements – graceful narrative and faithful observation.

Other Masterpieces

RUCELLAI MADONNA;
1285–1899;
GALLERIA DEGLI UFFIZZI,
FLORENCE,
ITALY.

THE VIRGIN AND CHILD WITH SAINTS;
c.1315;
NATIONAL GALLERY,
LONDON,
ENGLAND.

Marcel Duchamp

1966; oil and lead wire and glass; 264.8 x 175.6 cm; Tate Gallery, London, England

The Bride Stripped Bare By Her Bachelors, Even – The Large Glass

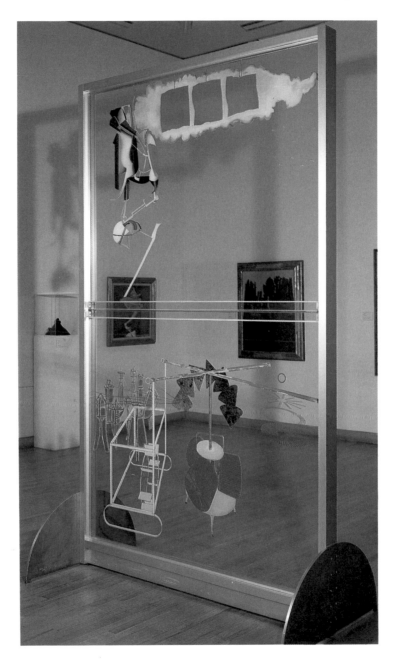

Duchamp is usually associated with his ready-made sculptures, which feature one or two everyday objects, a urinal, for example, or a stool topped by a bicycle wheel. The artist's designation of these objects as art proved a highly influential ideology which remains pertinent for many artists working today. However, Duchamp first achieved notoriety for **Nude Descending a Staircase**, 1912, a painting in which he combined the principles of Cubism and Futurism. With Picabia, Duchamp was the leader of the New York Dada movement and his invention of the ready-made was a manifestation of Dada's anti-art dictum. In 1915 Duchamp began creating his major work, **The Bride...** He declared it "definitively unfinished" in 1923. This was another manifestation of his abandonment of conventional media and his interest in three-dimensional objects suggesting the technology of machines or instruments. These appeared to be scientific gadgets but neither functioned as such nor served any purpose. **The Bride...** is elaborate and impressive, concocted of oil, varnish, lead and dust mounted between glass panels. It is an obscure, symbolic work, a coded representation of the sexual act as a mechanistic and endlessly frustrating procedure.

Other Masterpieces

FOUNTAIN;
1917;
SIDNEY JANNIS GALLERY,
NEW YORK CITY,
USA

IN ADVANCE OF A BROKEN ARM;
1915;
YALE UNIVERSITY ART GALLERY,
NEW HAVEN,
CONNECTICUT
USA

The Pier and Promenade at Nice

c.1924; oil on canvas; 38 x 46.5 cm; Musée National d'Art Moderne, Paris, France

Raoul Dufy studied in Le Havre, where his early work showed the influence of Impressionism. He moved to Paris in 1900 where he met Georges Braque and Henri Matisse. Matisse's painting **Luxe, Calme, et Volupté** had a great impact on Dufy who regarded it as "a miracle of the creative imagination at play in colour and line". Adopting the newly formed ideas of Fauvism, Dufy started to produce paintings with strong colour and heavy black outlines. He only exhibited with the Fauves twice – in 1906 and 1907. In 1908 he worked with the Braque, before turning to themes that showed upper class life. After 1920, Dufy's work is characterized by joyous scenes of racecourses, regattas and esplanades, typified by **The Pier and Promenade at Nice**. Painted in vibrant colours, these works are distinguished by their lively, frivolous, decorative style and their rapid, calligraphic brush strokes. Dufy also designed textiles and ceramics. He was essentially a light-hearted artist who never dwelt on the sad or unseemly side of life.

Other Masterpieces

PLACARDS AT
 TROUVILLE;
1906;
MUSEE NATIONAL D'ART
 MODERNE,
 PARIS,
 FRANCE

THE ARTIST AND HIS
 MODEL IN THE STUDIO
 AT LE HAVRE;
1929;
STEDELIJK MUSEUM,
 THE HAGUE,
 NETHERLANDS

Born Nuremberg, Germany 1471; **died** Nuremberg, Germany 1528

Wing of a Hooded Crow

1512; watercolour on vellum with gold; 19.7 x 20.1 cm; Graphische Sammlung Albertina, Vienna, Austria

Albrecht Dürer's father, a goldsmith, undoubtedly introduced him to detailed drawing with silverpoint, a medium of which he became a precocious master, shown by his remarkable self-portrait made in 1484. He was apprenticed in 1486 to the leading Nuremburg painter and book illustrator, Wolgemut. The master taught him the techniques of his trade which included woodcut. Dürer was also in contact with humanist thinkers who widened his vision of the world. He travelled across Italy, which brought him into contact with the paintings of Bellini, Leonardo's drawings and Mantegna's engravings, all of which had their effect on his work. He sought the company of scholars in preference to artisans and he inevitably became occupied with contemporary thought on perspective, proportion and beauty. **Wing of a Hooded Crow** is an exquisite example of Dürer's refined observation, graphic and colourist skills. He acknowledged the legacy of the Reformation but, more importantly, he introduced Italian Renaissance forms and ideas to the North, reinforcing his practical achievements by producing a number of theoretical treatises.

Other Masterpieces

MELENCOLIA I;
1514,
WHITWORTH ART
GALLERY,
MANCHESTER,
ENGLAND.

SELF-PORTRAIT;
1498;
MUSEO DEL PRADO,
MADRID,
SPAIN

Dyck
Sir Anthony van

Born Antwerp, Belgium 1599; **died** London, England 1641

Charles I

c.1632–1633; oil on canvas; 100 x 81.8 cm; Philip Mould Historical Portraits Ltd, London, England

Anthony van Dyck trained in Antwerp where he became chief assistant to Rubens. He visited Britain briefly from 1620 to 1621, before touring Italy where he undertook a number of church commissions. He returned to Antwerp in 1625 and started to develop his portraiture before settling in England in 1631. His years in England were enormously successful. Welcomed into the court of Charles I, van Dyck received a knighthood and unlimited access to the aristocracy as models for his portraits. Among the best known of his English portraits are his various paintings of **Charles I**. In these works, van Dyck strives hard to flatter the King, lending him dignity and intelligence. Sensitive to his royal sitter's individuality, van Dyck's portrait betrays something of the artist's own introspective disposition. Beneath the elegant and refined surface of this and many other of his portraits, there is a hint of nervous tension. His portraits established the style of British portraiture for the next 200 years, through Lely, Reynolds and Gainsborough to Lawrence. Van Dyck also painted a number of religious and mythological subjects.

Other Masterpieces

LORD JOHN AND LORD BERNARD STUART;
c.1638;
NATIONAL GALLERY,
LONDON,
ENGLAND

CHARLES I IN HUNTING DRESS,
c.1635;
MUSEE DU LOUVRE,
PARIS,
FRANCE

The Champion Single Sculls

1871; oil on canvas; 81.9 x 117.5 cm; The Metropolitan Museum of Art, Purchase,
The Alfred N Punnett Endowment Fund and George D Pratt, 1934

Thomas Eakins was a prodigious draughtsman who studied art at the Pennsylvania Academy of Fine Arts, as well as anatomy at Jefferson Medical College. He travelled from Philadelphia to Paris in 1866 and entered the Ecole des Beaux-Arts, where he was influenced by the realism of Manet. Four years later in Spain, his exposure to the works of Velázquez and Ribera also had an impact on his painting style. On his return home, Eakins became one of the major American Realists. He was also a highly regarded art teacher, insisting that his students draw from the nude and attend anatomy lessons. Eakins pursued his own interest in scientific realism and his objective and faithful representations of surgeons operating caused an uproar when they were first shown. **The Champion Single Sculls (Max Schmitt in a Single Scull)** focuses on a single rower. Eakins loved sports, as demonstrated by other works that feature boxing and baseball. Above all, this work shows Eakins' ability to render a human figure based on sound anatomical knowledge. As a photographer, Eakins also continued Eadweard Muybridge's pioneering experiments concerning movement through sequential photography.

Other Masterpieces

STARTING OUT AFTER RAIL;
1874;
MUSEUM OF FINE ARTS, BOSTON, MASSACHUSETTS
USA

BASEBALL PLAYERS PRACTISING;
1875;
MUSEUM OF ART, RHODE ISLAND, USA

Eardley Joan

Born Warnham, England 1921; **died** Killearn, Scotland 1963

Catterline in Winter

c.1963; oil on hardboard; 120.7 x 130.8 cm; Scottish National Gallery of Modern Art, Edinburgh, Scotland

Joan Eardley moved to Glasgow from the south of England when war broke out. Her involvement with the war effort prevented her from receiving her post-graduate diploma from Glasgow School of Art until 1948. With it she received a scholarship to travel to France and Italy. Returning to "the living part of Glasgow", she became involved in the local community, making studies of the tenements and of the children she befriended. Her work provides a socio-documentary record of the poor environment, which is poignant without being voyeuristic or sentimental. In 1950 Eardley visited the east Scottish fishing village of Catterline where she settled in 1956. Here she produced some of her most evocative images, focusing on the local land and seascapes and the changes wrought by the seasons. She often incorporated detritus into her paintings to increase an understanding of her experience. Her zest for the elements, for what was primitive and for humanity is comparable to that of van Gogh. The vigour and intensity of her vision is revealed in the fury and colour of **Catterline in Winter**, which verges on the abstract and confirms how she valued nature as her "greatest influence".

Other Masterpieces

STREET KIDS;
1950;
SCOTTISH NATIONAL
GALLERY OF
MODERN ART,
EDINBURGH,
SCOTLAND

SALMON NET POSTS;
c.1961–1962;
TATE GALLERY,
LONDON,
ENGLAND

1897; oil on canvas; 78.5 x 100 cm; Musée des Beaux-Arts, Liége, Belgium

Death and the Masks

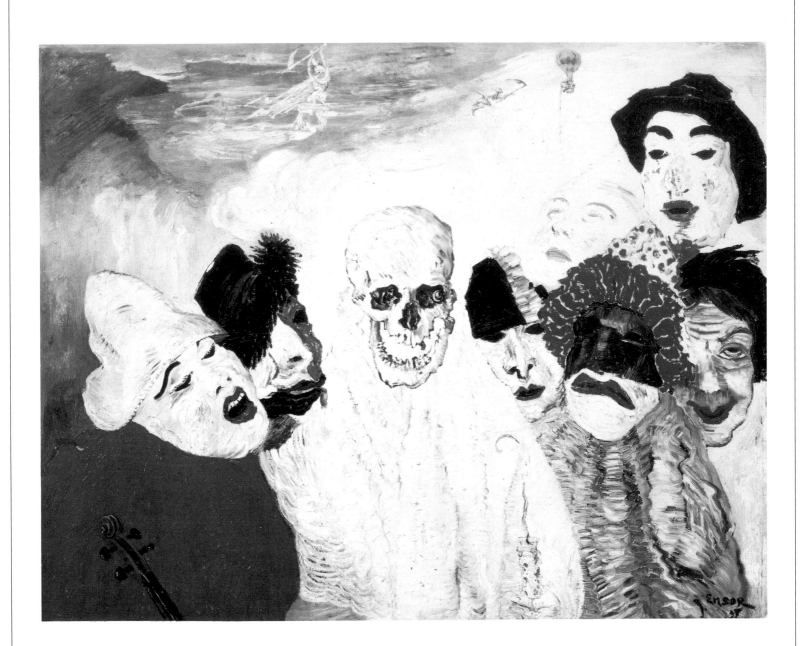

In 1884 Ensor co-founded the international exhibiting group, Les Vingt. His relations with it were not entirely peaceful and he became increasingly isolated. He was an original but controversial talent and his feelings towards hostile critics and an uncomprehending public can be best explained by paintings such as **Death and the Masks.** Full of garishness and striking imagery it is constructed with slab-like handling of paint and crisply outlined forms. It represents a transitional phase which was partly the result of Ensor's changing position within artistic circles in Brussels. The painting incorporates the luminosity and graphic linear qualities that characterized his work from the early 1890s. It also looks forward to the increasingly facile, less inventive work made after 1900. The symbolism of masks, skeletons and pierrots in his work conveys the traditional meanings of dissimulation, death and despair. They are inventive devices of satirical, social criticism and reveal his cynicism. They link together theatrical tragedy and the grotesque, forcing the passage of Symbolism toward Expressionism and influenced the development of the Surrealist movement.

Other Masterpieces

**CHRIST'S ENTRY INTO
BRUSSELS;**
1888–1889;
KONINKLIJK MUSEUM
VOOR SCHONE
KUNSTEN,
ANTWERP,
BELGIUM

THE RAY;
1892;
MUSEES ROYAUX DES
BEAUX-ARTS,
BRUSSELS,
BELGIUM

Epstein Sir Jacob

Born New York City, USA 1880; **died** London, England 1959

Genesis

1931; seravezza marble; 162.5 x 83.8 x 78.7 cm; Permanent loan of Granada Television Group, Whitworth Art Gallery, Manchester, England

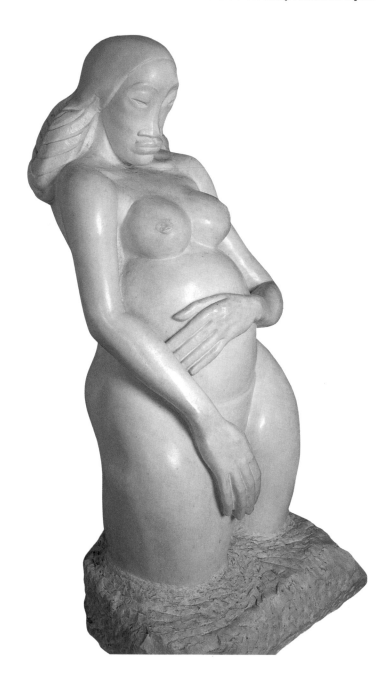

Jacob Epstein was born of Russian-Polish Jewish parents. He studied at the Ecole des Beaux-Arts in Paris and at the Académie Julian. Visits to the Louvre engendered an interest in ancient and particularly primitive art, of which he was to became a notable collector. This and his knowledge of Rodin's work influenced the expressive power of his sculpture. He settled in London in 1905 and received a knighthood in 1954. His exploitation of nudity within his carving, emphasized by his rigorous handling of stone, marble and bronze, roused many objections, particularly when applied to religious subjects. However, the consternation did not reduce his reputation as a robust and imaginative talent, sculpting in the Romantic tradition. He was a founder member of the London Group of artists in 1913 and his association with the Vorticists resulted in his creation of mechanistic figures such as **The Rock Drill**. Epstein began carving **Genesis** in 1929, "...with," he claimed, "no hesitations and no preliminary studies". The subject, pregnancy, was as controversial as the crude, anti-naturalistic carving. It is a raw, primitive vision and a bold testament to motherhood.

Other Masterpieces

JACOB AND THE ANGEL;
1940;
TATE GALLERY,
LONDON,
ENGLAND

ST MICHAEL AND THE DEVIL;
1957;
COVENTRY CATHEDRAL,
COVENTRY,
ENGLAND

Sea and Sun

Born Brühl, Germany 1891; **died** Paris, France 1976

1925; oil on canvas; 54 x 37 cm; Scottish National Gallery of Modern Art, Edinburgh, Scotland

Max Ernst received no formal training as an artist, originally studying philosophy and psychiatry at the University of Bonn. During a visit to Paris in 1913 he met Macke, Delaunay, Apollinaire and Arp and began to develop a practice that involved working in a variety of media. Ernst founded the Cologne Dada group in 1919, introducing found objects into his fantasy-inspired ensembles. He was also responsible for a technique known as frottage, which involved drawing on a sheet of paper over a rough surface to allow the texture underneath to come through. **Sea and Sun** was painted in 1925, the year after the Surrealist movement was launched. Nature for Ernst was never a benign force; the single red eye casts a disturbing, all-seeing presence over the landscape. In paintings that frequently referred to nightmares and hallucinatory experiences, Ernst continued to make irrational and bizarre juxtapositions of unrelated objects. Max Ernst was a leading Surrealist who, like many others, went to live in the United States during the Second World War. His last years were spent in France.

Other Masterpieces

TWO CHILDREN ARE
THREATENED BY A
NIGHTINGALE;
1924;
MUSEUM OF MODERN ART,
NEW YORK CITY,
USA

PETRIFIED CITY;
1933;
CITY OF MANCHESTER ART
GALLERIES,
MANCHESTER
ENGLAND

Eyck Jan van

Active from 1422; **died** Bruges, Belgium 1441

The Arnolfini Marriage

1434; oil on oak panel; 81.8 x 59.7 cm; National Gallery, London, England

Jan van Eyck was the greatest artist of the early Netherlands school. He held high positions throughout his career, including court painter and diplomat in Bruges. So outstanding was his skill as an oil painter that the invention of the medium was at one time attributed to him, with his brother Hubert, also a painter. Van Eyck exploited the qualities of oil as never before, building up layers of transparent glazes, thus giving him a surface on which to capture objects in the minutest detail and allowing for the preservation of his colours. Nowhere is this better displayed than in this portrait of Giovanni di Arrigo Arnolfini, a merchant from Lucca and a frequent visitor to Bruges, and his wife Giovanna Cenami. The signature on the back wall – "Jan Van Eyck was here, 1434"– and his reflection in the mirror has led many to believe that he was a witness to their marriage. The carving of Saint Margaret, the patron saint of childbirth, on the bed, and the presence of the dog – a traditional symbol of faithfulness – accentuate the marital theme.

Other Masterpieces

A MAN IN A TURBAN;
1433;
NATIONAL GALLERY,
LONDON,
ENGLAND

MADONNA OF CANON VAN DER PAELE;
1436;
GROENINGEMUSEUM,
BRUGES,
BELGUIM

1895; oil on canvas; 36.5 x 39 cm; National Gallery of Scotland, Edinburgh, Scotland

Roses

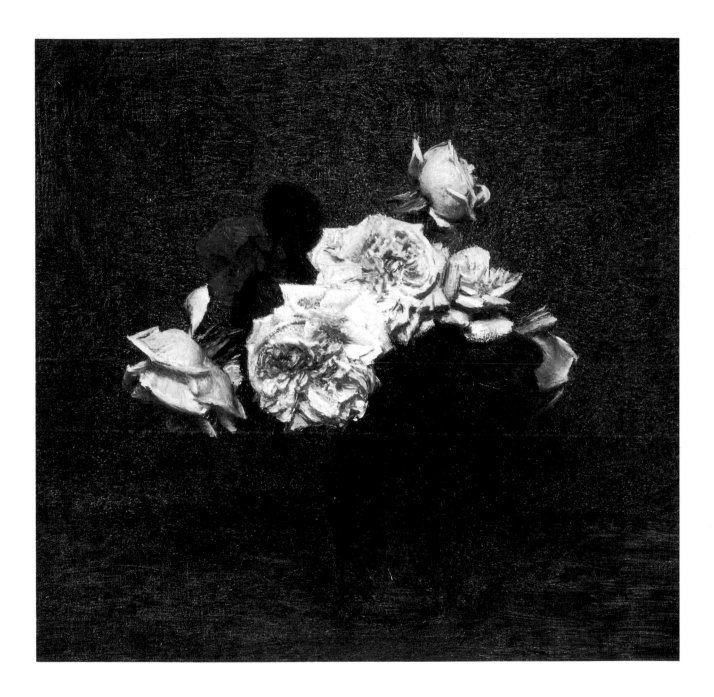

Henri Fantin-Latour studied painting under both his father and Gustave Courbet. He exhibited regularly at the Paris Salon from 1861, but was also included, with Manet, Cézanne and Whistler, in the Salon des Refusés (1863). This was held as a protest against the number of works rejected by the Salon that year. A romantic streak, fuelled by a passion for the music of Wagner, meant that he began to move away from a hitherto academic approach. Fantin-Latour painted figure subjects, portrait groups and still life. His groups of figures include **Homage to Delacroix** (1864), a celebration of the great French Romantic painter and **Homage to Manet** (1870), which shows Manet and other leading artists of the period grouped round a portrait of Delacroix. His still life, such as **Roses**, were painted in the meticulous Dutch manner. Each petal of these cultivated blooms has been minutely observed. The delicacy of the pink flowers is further heightened by the dark background from which they emerge. Fantin-Latour was friendly with most of the avant-garde French painters of his time and was an admirer of the Pre-Raphaelites.

Other Masterpieces

HOMAGE TO MANET;
1870;
MUSEE DU LOUVRE,
PARIS,
FRANCE

WHITE ROSES IN A GLASS VASE;
c.1890;
GUILDHALL ART GALLERY,
CORPORATION OF
LONDON,
ENGLAND

Feininger Lyonel

Born New York City, USA 1871; **died** New York City, USA 1956

Gelmeroda

1926; oil on canvas; 100 x 80 cm; Museum Folkwang, Essen, Germany

Born to German-American parents, Lyonel Feininger moved to Germany in 1887. He studied music in Berlin before working as a cartoonist for various magazines. On a visit to Paris in 1911, Feininger became acquainted with Robert Delaunay and with Cubism. Delaunay's study of the poetic possibilities of colour greatly influenced Feininger. The two men also shared an interest in using urban architecture as the basis for their paintings. In 1913 Feininger was invited by Frans Marc to exhibit with Der Blaue Reiter. Feininger's romantic streak found natural allies in Klee and Kandinsky. He taught at the Bauhaus but was forced to return to the States when named as a degenerate artist by Hitler. His best works are his visionary abstractions of architecture and seascapes. **Gelmeroda** is from a series of thirteen paintings that take the village church at Gelmeroda as a starting point. Here, the tiny foreground figures are dwarfed by a building seen simultaneously from several points of view. Feininger gradually eliminates any natural elements from the series; the later work is simply composed of a number of delicate, superimposed, translucent planes.

Other Masterpieces

GATE-TOWER II;
1921;
STAATLICHE KUNSTHALLE,
KARLSRUHE,
GERMANY

THE STEAMSHIP ODIN II;
1927;
MUSEUM OF MODERN ART,
NEW YORK CITY,
USA

Born New York City, USA 1948

Pizza Eater

1982; oil on canvas; 150 x 150 cm; Mary Boone Gallery, New York City, USA

Eric Fischl's reputation belongs to the 1980s, when a return to figuration usurped the monopoly that Conceptual and Minimal art had on American painting through the 1960s and 1970s. He studied at the California Institute of the Arts, 1969 to 1972. Fischl followed in the spirit of the Social Realist painters of the 1930s, his work comprises scenes taken from a voyeuristic perspective. The viewer takes a complicit position as witness to the complicated narratives that unfold. A recurring mise en scène is of invaded privacy or emergent sexuality, as in **Pizza Eater**. A young girl, on the point of puberty, wanders naked through the sand, unaware of, or having contrived to orientate the males' gaze toward her. Typically, neither the beginning nor the end of this story is explained nor suggested and we are left with a sense of unease.

Our response to the picture is dictated by our knowledge of contemporary society. Fischl seeks to denounce the attitudes that prevail in American culture, particularly toward women. His technique, which has been criticized on the grounds that it reveals a lack of skill, exacerbates the emotional awkwardness of his subjects and allows us some distance from the intimacy of the situation.

Other Masterpieces

BAD BOY;
1981;
SAATCHI COLLECTION,
LONDON,
ENGLAND

SLEEPWALKER;
1979;
THOMAS AMMANN,
ZURICH,
SWITZERLAND

Fontana Lucio

Born Santa Fé, Argentina 1899; **died** Varese, Italy 1968

Spatial Concept Waiting

1958; pastel on canvas; 163.8 x 123.6 cm; Tate Gallery, London, England

Lucio Fontana lived in Milan as a child and studied at the Brera Academy from 1927 to 1929. Fontana is noted for his controversial, slashed and otherwise vacant canvases of the 1960s, such as **Spatial Concept Waiting**. He first exhibited abstract sculptures from 1930 and turned his attentions to painting in the 1940s, often producing a series of monochrome pieces. He issued the White Manifesto in Milan in 1946 to coincide with his series of white paintings. A year later Fontana founded the Spazialismo group, reflecting his exploration of integrating spatial relationships with the development of two-dimensional media. He is connected with Dadaist ideology, producing as he did, works that would appear to negate traditional notions of art and aesthetics. His work is minimal to the point of presenting a negative presence. A slash in a bland, "colourless" canvas is less about violence than absence, a denial of creative application. The overt simplicity and reductive nature of Fontana's work belies great sophistication and has proved influential to successive generations of conceptual artists.

Other Masterpieces

SPATIAL CONCEPT;
1959–1960;
STADTISCHES MUSEUM,
MUNCHENGLADBACH,
GERMANY

NEW YORK, 15;
1962;
PRIVATE COLLECTION

Jean Fouquet

Mary and Child

c.1460s; wood panel; 91.8 x 83.3 cm; Koninklijk Museum voor Schöne Kunsten, Antwerp, Belgium

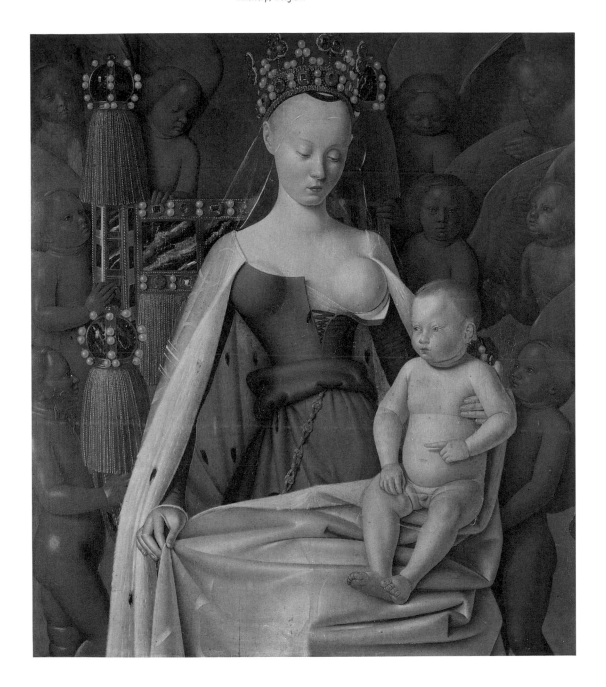

Like Italy and the Netherlands in the fifteenth century, France too had its share of art schools and eminent painters. Jean Fouquet, based in Tours, was perhaps their greatest painter during the fifteenth century. He trained in Bourges and Paris between 1435 and 1445. It is almost certain that he visited Italy, where he gained his knowledge of perspective and Piero della Francesca's pictorial lighting effects. On his return to France, in 1475, he became an artist at the French court. **Mary and Child** may in fact be a portrait of King Charles VII's mistress, Agnes Sorel, who along with Etienne Chevalier, the Treasurer of France, painted on the left panel of this diptych, were the most powerful French courtiers of the time. The naturalistic facial features, the crown's jewels and throne adornment all show the influence of the French miniaturist tradition.

The delicately rendered folds of the Virgin's robe can be explained by the fact that Fouquet also designed marble sculpture, despite his apparent disregard for anatomical correctness. The icy stark whiteness of the Virgin's skin contrasts with the green and fiery red of the cherubim and seraphim close behind. It makes for a dramatic and intensely serious devotional piece.

Other Masterpieces

SAINT MARGARET AND
OLIBRIUS;
c.1450;
MUSEE DU LOUVRE,
PARIS,
FRANCE

PORTRAIT OF JUVENAL
DES URSINS;
c.1460;
MUSEE DU LOUVRE,
PARIS,
FRANCE

Fragonard Jean Honoré

Born Grasse, France 1732; **died** Paris, France 1806

The Stolen Kiss

c.1788; oil on canvas; 45 x 55 cm; Hermitage, St Petersburg, Russia

Fragonard is synonymous with eighteenth century rococo style. He was, in fact, an artist of great versatility who worked in a variety of styles and used a range of techniques. These were a result of the breadth of the teaching he received and the works he studied on his travels. He was tutored by both Chardin and Boucher and when in Rome he studied under Tiepolo, whose influence in regard to the use of grandeur and spatiality can be detected in Fragonard's larger works. While in Italy he developed competent landscape paintings. Once back in Paris in 1761, he painted historical themes in the Grand Manner, becoming a member of the Academy in 1765. The elegance of the aristocracy and their gay abandonment to life's pleasures is portrayed with verve by Fragonard. Healthy foliage and outrageously fussy, decorative clothing all receive the same, painterly treatment; delicate observations of Watteau meet the robust fleshiness of Rubens. His images are rich, erotic and fanciful. In **The Stolen Kiss**, Fragonard rescues the subject from sentimentality, suggesting a more gallant approach. Subsequent attempts to conform to Neoclassical taste failed. He died in poverty.

Other Masterpieces

THE PROGRESS OF LOVE;
c.1770;
FRICK COLLECTION,
NEW YORK CITY,
USA

THE SWING;
c.1768;
WALLACE COLLECTION,
LONDON,
ENGLAND

Born New York City, USA 1928

Helen Frankenthaler

Black Frame I

1992; acrylic on printed proof; 78.75 x 101.6 cm; collection of the artist

Helen Frankenthaler attended the Bennington College in Vermont in 1949 and later studied under abstract painter Hans Hoffman. In 1951, she discovered the work of Jackson Pollock. This led, in the early 1950s, to the development of her own Abstract Expressionist style known as "stain-soak". These large paintings involved the application of washes and stains to unprimed canvas and were produced on the floor. The result of this innovatory technique was a delicate and fluid merging of forms, which have an ambiguous and improvisational quality due to the unpredictable absorbency of the canvas. Her key work from this period, **Mountains and Sea** (1952), influenced the stain paintings of Kenneth Noland and Morris Louis. **Black Frame I** is a recent work that makes use of much stronger colour. Acrylic paint is used to create a sensuous and lyrical painting that seems to refer to seascape, while the overall effect is of a joyous, abstract composition, in which the artist's pleasure is revealed through the expressive brushstrokes. Helen Frankenthaler was married to fellow Abstract Expressionist Robert Motherwell from 1958 until 1971.

Other Masterpieces

MOUNTAINS AND SEA;
1952;
ON LOAN TO THE
 NATIONAL GALLERY
 OF ART,
 WASHINGTON DC,
 USA

DOOR;
1976–1979;
TATE GALLERY,
 LONDON,
 ENGLAND

Freud Lucian

Born Berlin, Germany 1922

Standing By The Rags

1988–1989; oil on canvas; 168.25 x 138.5 cm; Tate Gallery, London, England

The grandson of psychoanalyst Sigmund, Lucian Freud came to England in 1932. He studied at the Central School of Arts and Crafts, London, (1938 –1939) and at the East Anglian School of Painting and Drawing, Suffolk until 1942. He then went on to study part-time at Goldsmiths' College, London. Freud's early work was in a harsh, realistic style, but painted with a flatness that lent emphasis to lineation. Quirky, surreal elements infiltrated his portraits and still life. An unnerving distortion and washed-out palette added to their potent charge. From the late 1950s, Freud's style began to alter, to satisfy his need for paint "to work as flesh does". In his dedication to the human form, Freud has been bracketed as a painter of the School of London. However, his personal approach to his subjects – his mother, his daughters, friends and life models – is completely original. His paintings are probing investigations of people most commonly illuminated by electric light, their skin, their expressions, their moods and their discomfort under scrutiny. **Standing By the Rags** reveals how his paint-work has become increasingly impastoed, almost as if he is moulding or sculpting from the very substance of what it is to be human.

Other Masterpieces

GIRL WITH ROSES;
1947–1948,
THE BRITISH COUNCIL
 COLLECTION,
 LONDON,
 ENGLAND

**NAKED MAN WITH HIS
 FRIEND;**
1978–1980;
ASTRUP FEARNLEY
 MUSEUM,
 COPENHAGEN,
 DENMARK

c.1833; oil on canvas; 72.5 x 94 cm; Museum der Bildenden Kunst, Leipzig, Germany

Caspar David Friedrich was a Romantic landscape painter who spent most of his life in Dresden. He trained at the Academy in Copenhagen, where he began to produce paintings that demonstrated his particular interest in light and the changing seasons. His landscapes were not, as he himself remarked, "the faithful representation of air, water, rocks and trees ... but the reflection of the soul and emotion in these objects". In using landscape as a vehicle to convey deep, emotional feelings, there are parallels between Friedrich and his fellow countryman, Altdorfer, painting some three hundred years earlier. For Friedrich, nature was of religious and often symbolic significance. In **The Stages of Life** the sweeping perspective from the figure in the foreground right out to the ships on the horizon, not only suggests distance but the passage of time. The golden sunset imbues this melancholic scene with a sense of nostalgia. The empty, arctic wasteland depicted in another important symbolic work, **Wreck of the Hope**, conveys a profound sense of despair and desolation. In his attention to detail, Friedrich foreshadowed the work of the Pre-Raphaelite Brotherhood in the late 1840s.

Other Masterpieces

WINTER LANDSCAPE;
1811;
NATIONAL GALLERY,
LONDON,
ENGLAND

THE WRECK OF THE
HOPE;
1824;
KUNSTHALLE,
HAMBURG,
GERMANY

Frink Dame Elisabeth

Born Thurlow, England 1930; **died** Woolland, England 1993

Rolling Horse

1978; cast bronze; 17.8 x 35.6 cm; Private Collection

Elisabeth Frink achieved national recognition as a celebrated sculptor of the post-war period. She trained at Guildford School of Art (1947–1949) and at Chelsea School of Art, London from (1949–1953). While Paolozzi and William Turnbull were translating the aftermath of war into abstractions deviating from the real horror, Frink was producing more traditional images of death and human suffering,

exuding pathos without sentimentality. Such genuine expression, although recognized, was not critically acclaimed, unlike the pioneering developments of Moore and Caro. Inspired by the art of Rodin and Giacometti, Frink's belief in the emotional charge of her work was her strength and guiding principle. The power and noble grandeur of her human figures was echoed in the many equine subjects she produced.

Rolling Horse is an unusual example of Frink's interpretation of the animal, not poised or watchful, but caught in an unguarded moment, full of natural, untethered energy. Her figures and heads of the 1980s and early 1990s became more stylized and imbued with a stereotypical masculinity in marked contrast to the sensitivity of her earlier work.

Other Masterpieces

WALKING MADONNA;
1981;
SALISBURY CATHEDRAL,
SALISBURY,
ENGLAND

RISEN CHRIST;
1992–1993;
LIVERPOOL CATHEDRAL,
LIVERPOOL,
ENGLAND

Born Briansk, Russia 1890; **died** Waterbury, USA 1977

1970–1971; acrylic; 114.9 x 83.5 cm; Tate Gallery, London, England

Linear Construction No. 2

Under the name of Naum Pevsner, the artist entered Munich University in 1910, originally to study medicine. He then transferred to natural sciences and attended art history lectures. In 1912 he moved to an engineering school. He met with Kandinsky before going to Paris in 1913. At the outbreak of war, and until 1917, the artist lived in Norway under the name Gabo, making relief and sculptural constructions.

He returned to Moscow to join his brother, Antoine Pevsner, plus Tatlin, Malevich and Kandinsky to form the Russian Constructivists. In 1920 Gabo's personal theory of abstraction was published in the Realistic Manifesto, to coincide with an exhibition of his work. Gabo later explained, "...we were convinced that what we were doing represented a new reality". He and the Constructivists saw that sculpture and architecture were closely linked.

His time in Berlin – 1922 to 1932 – and the contact he had with the De Stijl and Bauhaus artists confirmed his thinking. The mechanics of forms existing in space and the tensions set by sustaining this equilibrium are epitomized by **Linear Construction No. 2**. Constructed from transparent plastic with nylon threads, the piece satisfies Gabo's "search for an art of pure space".

Other Masterpieces

HEAD NO. 2;
1917;
TATE GALLERY,
LONDON,
ENGLAND

MODEL FOR "COLUMN";
1920–1921;
TATE GALLERY,
LONDON,
ENGLAND

Gainsborough Thomas

Born Sudbury, England 1727; **died** London, England 1788

The Morning Walk

c.1785; oil on canvas; 236.2 x 179.1 cm; National Gallery, London, England

Although Gainsborough's professed first love was landscape, it is for his elegant portraits of eighteenth century aristocracy that he is most popularly known. He was brought up in rural Sudbury and unlike his contemporary and rival, Reynolds, he did not travel abroad to study works of the great masters. He did go to London in 1740 where he worked with the French engraver, Gravelot, returning to Sudbury in 1746. He established himself in Ipswich in 1752 as a portrait painter, including landscape elements into the genre where possible, seen most clearly in his painting **Mr and Mrs Andrews**. When he moved to Bath in 1760 he was able to develop this aspect of his work, focusing on full-length portraits, producing paintings of inimitable style and sophistication. The influences of engraving and of Dutch landscape art are revealed in Gainsborough's command of a free and spontaneous technique. The debt he owes to Van Dyck is shown in his interpretation of the married couple in **The Morning Walk**. Gainsborough's perceptive grasp of character and natural feeling for harmonious composition make for a beautiful image. The painting throughout is sensitively handled, charming and delicate without succumbing to sentiment.

Other Masterpieces

MR AND MRS ANDREWS;
c.1748–1749,
NATIONAL GALLERY,
 LONDON,
 ENGLAND

PORTRAIT OF MISS HAVERFIELD;
c.1780,
 WALLACE COLLECTION,
 LONDON,
 ENGLAND

1914; plaster; 31.7 cm; Kettles Yard, University of Cambridge, Cambridge, England

Bird Eating Fish

Born Henri Gaudier, the artist visited England in 1906 on a travelling scholarship and, on receipt of a second, undertook business studies in Bristol and Cardiff. During this time he kept sketchbooks, making drawings of architecture, plants, birds and animals. In 1909, he spent some time in Nuremberg and Munich. He returned to Paris in 1910 and met Sophie Brzeska; he adopted their joint names as his own. They were living in London from 1911 and gradually began to make significant contacts within artistic and literary circles. Key among these were artists Wyndham Lewis and Jacob Epstein. Following the example of the latter, Gaudier-Brzeska began stone carving. He was a significant figure within both the London Group and the Vorticists. A number of different interests and influences combined to make his stylized sculpture so compelling. He brought together the romanticism of Rodin, the crude forms of "primitive" arts and cultures, the sophistication of Brancusi and the formal concerns of Cubism. He amalgamated these influences to make extraordinary interpretations of the natural world such as **Bird Eating Fish**. His potential was cut short by his death in action with the French army.

Other Masterpieces

CROUCHING FIGURE;
1913–1914;
WALKER ART CENTER,
 MINNEAPOLIS,
 USA

SEATED WOMAN;
1914;
MUSEE NATIONAL D'ART
 MODERNE,
 PARIS,
 FRANCE

Gauguin Paul

Born Paris, France 1848; **died** Tahiti 1903

Two Women on a Beach

1891; oil on canvas; 69 x 91 cm; Musée d'Orsay, Paris, France

As an ambitious stockbroker, Gauguin's initial interest in art was as a patron of the Impressionists. In 1876 he began exhibiting his own work and in 1883 gave up his business to be a professional painter. He settled in Brittany in 1886, becoming a central figure in a circle of artists whom he influenced with his strong personality and aesthetic ideals. Notable among these was Van Gogh with whom a troubled friendship ended in Gauguin fleeing to Paris. He had often fantasized about escaping the responsibilities and burdens of living in a civilized society. Encouraged by his brief sojourns to Martinique and Panama in 1887–1888, and resenting his inability to support a wife and family as an artist, he left for Tahiti in 1891. The lure of the exotic and the primitive fuelled his art, became his life and ultimately his death – over-indulgence in paradise gave him syphilis. His pursuits reflect the fin-de-siècle decadence and the interests of the Symbolists in Paris.

Two Women on a Beach shows Gauguin's response to his "savage" surroundings. Flat areas of colour and clear outlines reveal his awareness of Japanese prints and of stained glass techniques.

Other Masterpieces

D'OU VENONS-NOUS? QUE SOMMES NOUS? OU ALLONS NOUS?; 1897; MUSEUM OF FINE ARTS, BOSTON, MASSACHUSETTS, USA

VISION AFTER THE SERMON; 1888; NATIONAL GALLERY OF SCOTLAND, EDINBURGH

Born Fabriano, Italy 1370; **died** Rome, Italy 1427

Adoration of the Magi

1423; wood panel; 173 x 220 cm; Galleria degli Uffizi, Florence, Italy

Gentile da Fabriano was the leading exponent of the International Gothic Style, which originated in the courts of Burgundy and France. By the early 1400s this had spread south across the Alps to Italy. It was a courtly art – richly coloured, highly decorative and textured and crammed with details of costumes, animals and paraphernalia associated with aristocratic society. His paintings were as charming as they were opulent and, although outwardly religious, were really chronicles of their time. They clearly reflected the lifestyle and aspirations of the patrons who commissioned them. Da Fabriano worked in at least two courts, the Doge's Palace in Venice from 1408, and the Papal Court in Rome. From 1422 to 1425 he was in Florence, where he executed his best known work, the sumptuous **Adoration of the Magi**. From there he moved on to Sienna and Orvieto, before his last trip to Rome. The artist combines a religious narrative with the study of a hilly Tuscan landscape and its vegetation. The viewer's eye is drawn toward the same destination as the travellers – a castellated town.

Other Masterpieces

FLIGHT INTO EGYPT; (PART OF THE ADORATION OF THE MAGI) 1423; GALLERIA DEGLI UFFIZI, FLORENCE, ITALY

MADONNA (PART OF THE QUARATESI ALTARPIECE); 1425; ROYAL COLLECTION, WINDSOR, ENGLAND

Gentileschi Artemisia

Born Rome, Italy 1593; **died** Naples, Italy 1652

Judith and Holfernes

c.1620; oil on canvas; 199 x 162.5 cm; Galleria degli Uffizi, Florence, Italy

Artemisia Gentileschi worked mainly in Florence and later in Naples where she finally settled. She was taught by her father Orazio, a follower of Caravaggio, who in turn engendered a Caravaggesque realism and feel for dramatic subject matter in his spirited daughter. Gentileschi joined her father in England and worked with him in the late 1630s on the decorations at Queen's House in Greenwich, London. She encountered a good deal of prejudice as a woman artist in the seventeenth century – this was reinforced by the unusual and dramatic events of her life, including a much sensationalized trial in which she accused her teacher of raping her many times. The story of the Jewish heroine **Judith** decapitating Nebuchadnezzar's general, **Holofernes**, after being offered to him as hostage was popular among Caravaggio's circle. Gentileschi painted it herself several times. In this version, she portrays Judith as a courageous and determined woman whose violent act is unromanticized. Criticized in her time for depicting heroines who failed to conform to prevailing notions of elegant and delicate femininity, Gentileschi's contribution to art has only recently been properly recognized.

Other Masterpieces

SELF-PORTRAIT AS LA PITTURA;
1630;
COLLECTION OF HER MAJESTY ELIZABETH II, ENGLAND

SUSANNA AND THE ELDERS;
1610;
SCHONBORN COLLECTION, POMMERSFELDEN, GERMANY

Théodore Géricault

Raft of the Medusa

1819; oil on canvas; 491 x 716 cm; Musée du Louvre, Paris, France

Théodore Géricault was a painter and graphic artist who became a leading figure in the Romantic movement in France. He left the studio of Vernet in 1810 to study under Guérin, whose pupils also included Eugène Delacroix. Delacroix became a great friend of Géricault and was strongly influenced by his art. Géricault visited Italy in 1816 and was in England from 1820 to 1822. His paintings of contemporary life reflected the poverty he saw in London, as well as his keen interest in racing and riding. Horses figure repeatedly in Géricault's paintings; whether in combat, racing or just rearing, they reveal a typical Romantic preoccupation with drama and heightened emotion. His most celebrated work, the vast **Raft of the Medusa**, was shown at the Paris Salon in 1819. The painting is based on an actual shipwreck which cast a raft of survivors adrift, whose numbers then began to dwindle daily. Géricault is unsparing in his treatment of their plight: he visited hospitals and morgues to lend realism to his depiction of the dying and the dead. Between 1822 and 1823 Géricault painted a number of uncompromising and moving portraits of inmates at a Paris asylum.

Other Masterpieces

THE MAD WOMAN;
1822–1823;
MUSEE DE BEAUX-ARTS,
LYONS,
FRANCE

HORSE FRIGHTENED BY
LIGHTNING;
c.1813;
NATIONAL GALLERY,
LONDON,
ENGLAND

Ghiberti Lorenzo

Born Florence, Italy c.1378; **died** Florence, Italy 1455

The Story of Jacob and Esau

1425–1452; bronze; 40 x 40 cm; Opera del Duomo, Florence, Italy

When Lorenzo Ghiberti was twenty-one years old, the Guild of Cloth Makers announced a competition for the making of the second set of bronze Baptistery doors in Florence. A year later, the little-known Ghiberti was declared the winner, having beaten Brunelleschi and other eminent artists. Ghiberti's workshop – the training ground for the next generation of artists, Donatello and Uccello among them – received enough commissions to guarantee security. The first set of doors was completed in 1424, after twenty-one years of work; the second set took from 1425 to 1452. **The Story of Jacob and Esau** is one scene from the cycle of the Old Testament used for Ghiberti's second set of doors. He includes numerous episodes from the same narrative as if they were occurring concurrently; the setting is a beautiful architectural structure. Ghiberti conveys a psychological relationship between the figures in order to give a feeling of authenticity to the scene. We can almost hear the conversation between the women (bottom left) and feel the unease of the woman on the far right as she watches her son's blessing. These bronzes, which synthesized expression and drama with movement and lucidity, inspired successive Renaissance artists. Michelangelo referred to them as, "the Gates of Paradise".

Other Masterpieces

BAPTISM OF CHRIST;
1427;
SAN GIOVANNI,
 SIENA,
 ITALY

SAINT MATTHEW;
c.1420;
ORSANMICHELE,
 FLORENCE,
 ITALY

Domenico Ghirlandaio

An Old Man and his Grandson

c.1490; oil on canvas; 57.4 x 46 cm; Musée du Louvre, Paris, France

Domenico Ghirlandaio trained as a goldsmith. In 1490, the Duke of Milan received a report that described a handful of good artists available for work in one region. Of Domenico Ghirlandaio it was suggested that he was a notable painter of panels and a master of fresco. It went on to commend his work and to describe him as an efficient and prolific artist. Ghirlandaio employed hordes of assistants – one of whom was Michelangelo – in his prosperous, family-run business. Ghirlandaio is best-known for his frescoes, in which he often set religious subjects in a secular setting and in which he included recognizable portraits. His largest commission, completed in 1490, depicting scenes from the lives of the Virgin and St John the Baptist, was in the Santa Maria Novella, Florence. Ironically, in **An Old Man and his Grandson**, one of his best works, the identity of the protagonists remains a mystery. This naturalistic double portrait is an intimate and moving portrayal of a tender relationship between doting age and attendant youth. The loving young boy is oblivious to the old man's unfortunate physiognomy, a symptom of rhinophyma, from which he suffered.

Other Masterpieces

GIOVANNA ALBIZZI TORNABUONI;
1488;
EDSEL FORD COLLECTION,
DETROIT,
MICHIGAN,
USA

ADORATION OF THE MAGI;
1487;
GALLERIA DEGLI UFFIZI,
FLORENCE,
ITALY

Giacometti Alberto

Born Stampa, Grisons, Switzerland 1901; **died** Chur, Switzerland 1966

Jean Genet

1954; oil on canvas; 64.7 x 54 cm; Tate Gallery, London, England

Alberto Giacometti trained as an artist in Geneva and settled in Paris in 1922. Although he is primarily associated with the Existentialist philosophies of Jean-Paul Sartre, he was also significantly involved with contemporary avant-garde art developments in Paris. His initial interest in Cubism and primitive sculpture gave way in the early 1930s to a more active participation with the Surrealists, headed by André Breton.

Giacometti's jointed sculpture of this time, **Woman with her Throat Cut**, is in striking contrast to the later work for which he is best known. Its content, however, offers some indication of the artist's tendency to morbidity. His expulsion from the Surrealist movement in 1935 was a result of a dramatic change of direction. When Giacometti exhibited again, in 1948, his sculpture consisted largely of skeletal figures, excessively tall or extremely small. Each the width of the passage of a prolonged gaze, these spectres seem to be willing themselves not to exist. Giacometti's painting represents an equally powerful striving to sculpt a physical presence, in the knowledge that reproducing the essence of humanity with paint is impossible. It is appropriate that the subject of this passionately wrought portrait is writer **Jean Genet**, Sartre's protégé.

Other Masterpieces

FEMME DE VENISE IX;
1956;
TATE GALLERY,
LONDON,
ENGLAND

PORTRAIT OF YANAIHARA;
1961;
GALERIE BEYELER,
BASEL,
SWITZERLAND

Fear

1984; photomap on paper; 422 x 652 cm; Tate Gallery, London, England

Gilbert and George first met while they were both studying sculpture at St Martin's School of Art in London in the late 1960s. Since then they have worked as one. Their united activities first came to prominence with their notorious performance pieces as "living" and "singing sculptures". Dressed in a particular style of suit, without which they are not publicly recognized, they offered themselves as art. In 1969 this meant "performing", with hands and faces covered in metallic paint, to the song Underneath the Arches, originally by music-hall stars Flanagan and Allan. Photo and video pieces based on the pair gradually becoming drunk on Gordon's Gin followed. Their conservative appearance adds to the irony of their parodies of British taste and traditions. A narcissistic element is retained in more recent work, which makes overt reference to gay sexuality.

Since the early 1970s their photo-pieces, now large, highly coloured composite "pictures", such as **Fear**, appear to take provocative views to extremes. This has often been interpreted as a shocking celebration, rather than criticism, of right-wing, neo-fascist, racist and nationalist activity. The artists, however, claim to be, "trying to define the new morality".

Other Masterpieces

ENGLAND;
1980;
TATE GALLERY,
LONDON,
ENGLAND

THE NATURE OF OUR LOOKING;
1970;
TATE GALLERY,
LONDON,
ENGLAND

Giorgione
Giorgio da Castelfranco

Born Castelfranco, Italy c.1477; **died** Venice, Italy 1510

The Sleeping Venus

c.1507; oil on canvas; 108 x 175 cm; Gemaldegalerie, Dresden, Germany

Neither Giorgione's life nor his paintings are well-documented. There are few historical references to him and only a handful of paintings can be directly attributed to him. A pupil of Giovanni Bellini, his own work was assisted by Titian. He was a romantic figure – handsome, musical and poetic – who died of the plague in his early thirties. Leonardo da Vinci and Vasari believed him to be one of the founders of "modern art". In his work, subject matter is less important than inherent mood. Here, **The Sleeping Venus** is absorbed in private reverie. She lies resting in an idyllic country vista, a setting that the city-dwelling Venetians would have fully appreciated, given their penchant for retreating to the countryside. Giorgione was one of the earliest artists to complete work for private patrons rather than for churches or public commissions. The landscape may have been finished by Titian upon Giorgione's death. He is also thought to have painted in a cupid – who sat at the sleeping Venus' feet – that, because of ensuing damage, was painted out again years later.

Other Masterpieces

MADONNA AND CHILD WITH ST LIBERALE AND ST FRANCIS; c.1504; CHURCH OF SAN LIBERALE, CASTELFRANCO, ITALY

THE TEMPEST; c.1530; GALLERIA DELL'ACCADEMIA, VENICE, ITALY

Born Florence, Italy c.1266; **died** Florence, Italy 1337

St Francis Preaching to the Birds

c.1296–1297; fresco; 270 x 200 cm; Upper Church, Assisi, Italy

Giotto was the son of a farmer. The painter Cimabue allegedly spotted him making rudimentary drawings of sheep and invited him to work with him. Under Cimabue's tutelage, Giotto quickly developed his own style, overshadowing that of his master. Dante wrote, "Cimabue was thought to hold the field in painting; but now Giotto is all the cry and Cimabue's style is badly dimmed". He became something of a legend in his own lifetime. Poets and commentators were united in their praise of his revolutionary naturalistic and narrative style. He broke free from the stylized linearity of the Byzantine tradition, and introduced solid forms and a sense of depth into his compositions. Giotto's understanding of colour and the way it changes in response to light has continued to ensure his reputation as a "modern" painter. **St Francis Preaching to the Birds** was part of a cycle of frescoes that he designed for the Upper Church in Assisi. It shows his humanistic approach and his ability to invest sacred figures with compassion and genuine emotion.

Other Masterpieces

THE MOURNING OF
CHRIST;
c.1306;
SCROVEGNI CHAPEL,
PADUA,
ITALY

MADONNA AND CHILD;
c.1310;
GALLERIA DEGLI UFFIZI,
FLORENCE,
ITALY

Girtin Thomas

Born London, England 1775; **died** London, England 1802

White House, Chelsea

1800; pencil and watercolour on paper; 30 x 51.5 cm; Tate Gallery, London, England

Thomas Girtin did much to promote watercolour painting to a fine art in its own right. His watercolours were greatly admired during his short lifetime, not least by his friend Turner. The two men worked together for Dr Monro, copying topographical drawings, including those of Canaletto. The most important technical innovation for which Girtin had responsibility was the abandonment of the practice of monochrome underpainting. He favoured loose washes of pure colour, often applied to a semi-absorbent off-white paper. This gave his landscapes a freshness and daring that at times surpassed the work of Turner. Girtin travelled around Britain producing watercolours of landscape in his direct style. In 1801–1802 he visited Paris and made a number of etchings of the city. On his return to England he exhibited a vast panoramic painting of London. This work is now lost, but there are several sketches for it in the British Museum. Poetic and soft-edged, his painting of the **White House, Chelsea** is one of his finest works.

Other Masterpieces

A WINDING ESTUARY;
1798;
TATE GALLERY,
 LONDON
 ENGLAND

PORTE ST DENIS;
1802;
COLLECTION OF SIR
 EDMUND BACON,
 ENGLAND

Untitled

1989; mixed media; 30 x 16 x 51.5 cm; Tate Gallery, London, England

Robert Gober graduated in Fine Art from Middlebury College in Vermont in 1976. He moved to New York where he worked as a carpenter and a performer with a multimedia dance company. From 1978, in addition to painting, he also made plaster figures and small model houses. In 1984 Gober produced handmade replicas of household objects – sinks, doors, playpens, bags of cat-litter, wallpaper and body parts.

He sited such objects and the body parts, cast from life, such as **Untitled**, the leg seen here, in room installations. Often these support other forms. Candles stand erect, drain holes burrow through, or a musical score is overlaid on the surface. Despite the hyperrealism of the leg, hairy, clothed and wearing an unremarkable shoe, its singularity and situation is initially humourous then incongruous and unnerving. Such work is laced with diverse contemporary meanings, bound with memories from childhood and gay erotic encounters. Perversion and subversion reside in Gober's skillful craftsmanship, **The Wedding Gown** being a prime example. Other installations incorporating newspapers, doorways and other seemingly banal items make tangible Gober's description of his work as "natural history dioramas about contemporary human beings".

Other Masterpieces

DOOR WITH LIGHTBULB;
1992;
S & J VANDERMOLEN,
 GHENT,
 BELGIUM

SLANTED PLAYPEN;
1987;
PAULA COOPER GALLERY,
 NEW YORK CITY,
 USA

153

Goes Hugo van der

Born Ghent, Belgium 1440; **died** Brussels, Belgium 1482

The Portinari Altarpiece

c.1478; panel; 253 x 141 cm; Galleria degli Uffizi, Florence, Italy

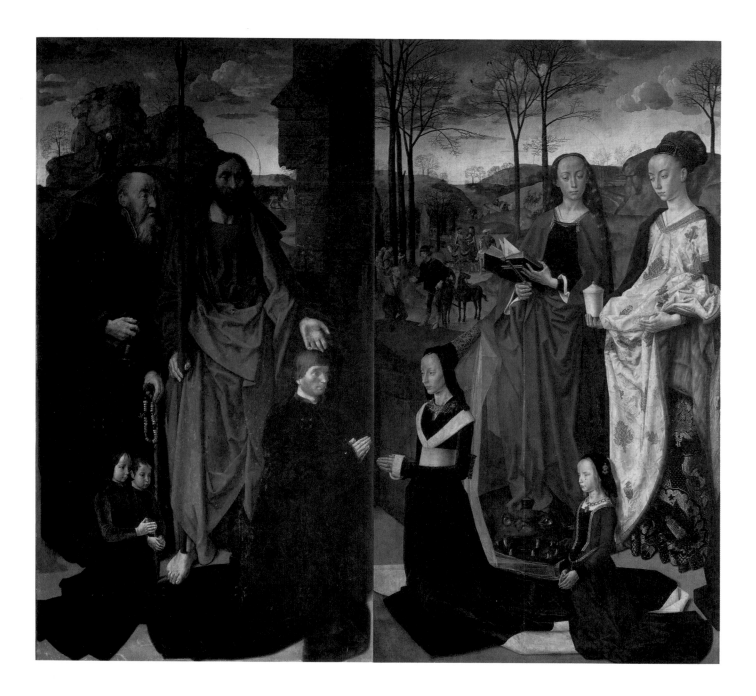

Hugo van der Goes was one of the most gifted of the Early Netherlandish painters. His realism was recognized for its insight into psychological and religious intensity. He worked in the Guild of Ghent from 1467 and became Dean in 1473. He chose to take holy orders and join a monastery near Brussels from about 1477, but he lived a privileged life, continuing to travel and paint. He was prone to fits and suicidal depressions, contemporary chroniclers suggesting this was because he knew he would never match the brilliance of van Eyck's **Ghent Altarpiece**. He died in 1482. This is the left-hand wing of the unusually large **Portinari Altarpiece**, which was commissioned by Tommaso Portinari, the head of the Medici bank in Bruges, and is believed to be van der Goes's greatest work. Upon completion in 1478, it was delivered to Florence. In this panel the patron's wife, Maria Baroncelli, and daughter, Margherita, are kneeling, and behind them are grouped their patron saints. In the background the three Magi can be seen on their way to Bethlehem, which acts as a prelude to the Nativity scene depicted on the central panel of the altarpiece.

Other Masterpieces

THE FALL OF MAN;
c.1470;
KUNSTHISTORISCHES
MUSEUM,
VIENNA,
AUSTRIA

DEATH OF OUR LADY;
c.1470;
GROENINGEMUSEUM,
BRUGES,
BELGIUM

Prisoners Exercising

1890; oil on canvas; 80 x 64 cm; Pushkin Museum, Moscow, Russia

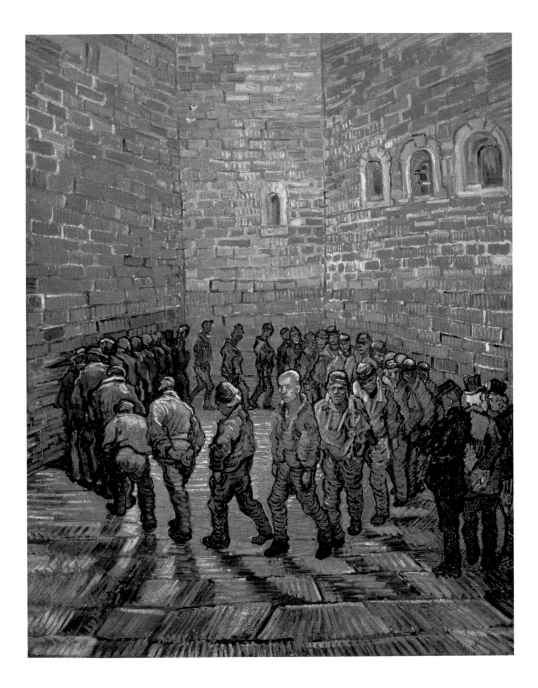

Vincent van Gogh was an extraordinary Post-Impressionist whose contribution to painting was not recognized during his lifetime. The son of a Protestant pastor, his religious beliefs were a strong influence on his work. He became a lay preacher in 1878, working amongst the Belgian miners of Borinage. He made his decision to become an artist after returning home to his parents in Etten in 1881. Until the end of his life a frenzied and prolific creative output ensued, charged with spiritual joy, anguish and religious fervour. The constant flow of correspondence with his brother Theo, who funded his living, provides a comprehensive diary and passionate expression of his activities and thoughts. He was impressed by the social subject matter and realist style of Millet. His meeting with Gauguin and other Post-Impressionist artists in Paris in 1886 was the catalyst for a dramatic change in his work. He settled in Arles in 1888, producing many purely coloured, stormy canvases and ink drawings, done in conditions of great poverty. Periods of recurrent mental disturbance led him to an asylum in St Rémy de Provence. **Prisoners Exercising** dates from this time, almost symbolic of the psychological trauma which imprisoned him until his suicide.

Other Masterpieces

SELF-PORTRAIT;
c.1886;
MUSEE DU LOUVRE,
 PARIS,
 FRANCE

THE ARTIST'S ROOM IN
 ARLES';
1889;
MUSEE DU LOUVRE,
 PARIS,
 FRANCE

Goldsworthy Andy

Born Cheshire, England 1956

Maple Leaf Lines

1987; maple leaves in a stream; Ouchiyama-Mura, Japan

Andy Goldsworthy's stunning site-specific sculptural work has established his reputation as the leading environmental artist working in Britain. He trained at Bradford College of Art from 1974 to 1975 and Preston Polytechnic from 1975 to 1978. Unlike more conceptually oriented land artists such as Richard Long and Ian Hamilton Finlay, Goldsworthy works directly with natural forms in their environment. He combines and juxtaposes contrasting shapes, textures and colours to exploit their aesthetic qualities. The raw materials of his sculpture are the leaves, seeds, ice, loose stones and branches he finds. The installations and objects he produces are widely diverse in form and scale but are, without exception, of ephemeral beauty. They endure only in photographs. His early work was made in Grizedale Forest, which is now a major sculpture park for forest-generated art. Goldsworthy's international reputation is based on the ingenuity and simplicity of pieces such as **Maple Leaf Lines**. Goldsworthy exploits the shapes and saturated hues in nature to startling effect, making one wonder why artists ever needed to turn to artificial materials.

Other Masterpieces

DOME OF STICKS
 LEAVING A HOLE
 WITHIN A HOLE IN
 RIVER ROCK;
1991;
SCAUR WATER,
 DUMFRIESSHIRE,
 SCOTLAND

BAMBOO LEAVES EDGING
 A ROCK FOR THE
 RISING SUN;
1991;
OUCHIYAMA-MURA,
 JAPAN

Born Chicago, USA 1922

The Go-Ahead

1985–1986; acrylic on canvas; 304.8 x 487.9 cm; Saatchi Collection, London, England

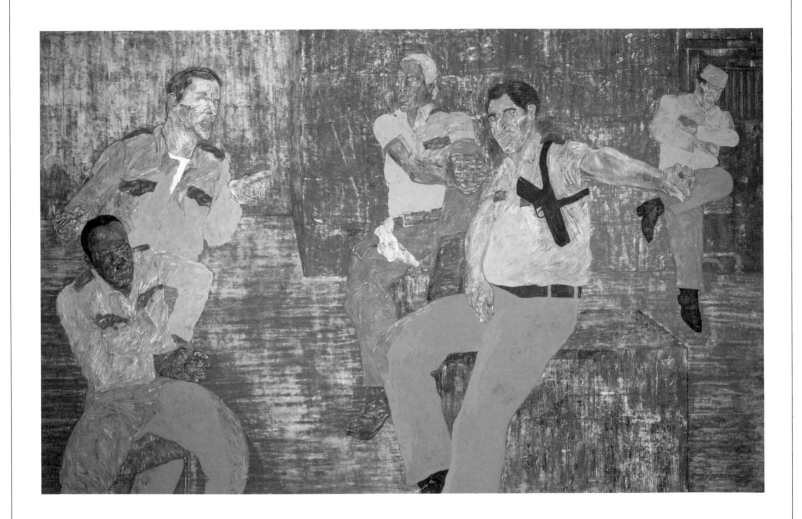

Leon Golub studied at the Art Institute of Chicago, between 1946 and 1950, and lived in Paris from 1959–1964. The imposing physical presence of his contemplative images, worked on the floor in acrylic on unstretched linen, is due to their large scale and high tonality. His political paintings present a paradox between form and content; although his themes focus on the horrors of war, such as mercenaries and interrogations, the paintings are elegant figurations with their foundations in classicism. Golub's ideas stem from media reports of the war in Vietnam and the immediacy with which violence and the perpetrators of torture are brought into the living room. The shocking dramas that Golub reconstructs are similarly direct and confrontational. Rather than focus on the specifics of El Salvador and Nicaragua, for example, they allude to universal themes of domination and power. Even **The Go-Ahead**, although not a scene of explicit action, is an evocative, disturbing image, with impending menace implicit in the attitudes and uniforms of the protagonists against a harsh, blood-coloured background.

Other Masterpieces

INTERROGATION II;
1981;
ART INSTITUTE OF
 CHICAGO,
 USA

PRISONERS I;
1985;
PRIVATE COLLECTION

Gorky Arshile

Born Khorkom, Armenia 1904; **died** Sherman, USA 1948

Agony

1947; oil on canvas; 101.6 x 128.3 cm; A. Conger Goodyear Fund, Museum of Modern Art, New York City, USA

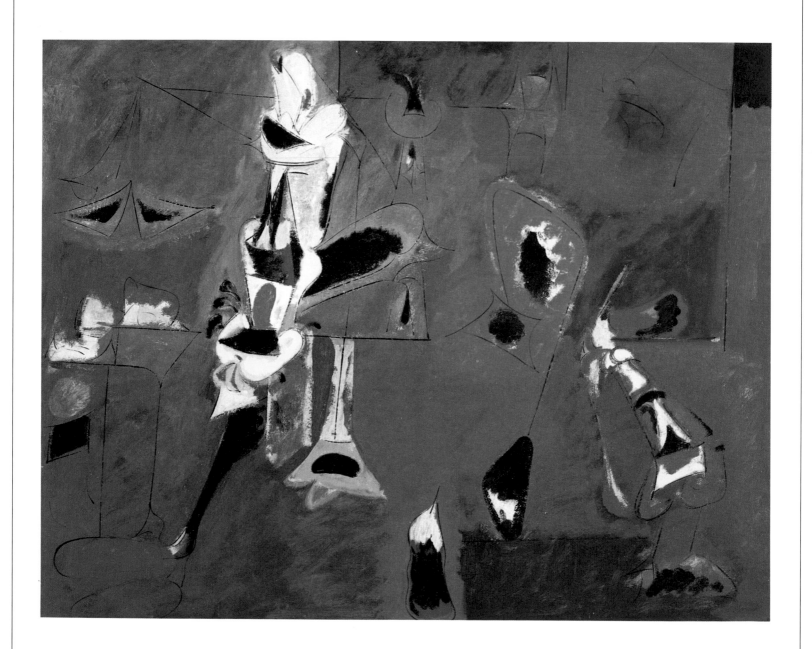

Arshile Gorky (born Vosdanik Adoian) has been credited with providing the link between European Surrealism and avant-garde art in America. He fled to the United States in 1920 after his mother's death as a result of the Turkish persecution of Armenians during the First World War. This enforced uprooting led to a preoccupation with his own identity. He adopted his familiar pseudonym and embraced the modernist art achievements of Miro, Picasso and Cézanne, seemingly insecure in his own potential for originality. His work was an eclectic mix of styles. Roberto Matta and André Breton particularly impressed Gorky and he adopted wholeheartedly the tenets of the Surrealists, most notably that of biomorphism, the creation of abstracted, organic – as opposed to geometric – forms. The automatic and intuitive nature of Gorky's approach had a specific impact on the development of Abstract Expressionism. Gorky interpreted form and translated it into organic, linear concoctions, suspended in fluid colours that melt and fuse. The dreamy lyricism of **Agony** belies its title, a reference, perhaps to the inner conflicts, exacerbated by the personal disasters – a fire, an operation and a car crash – that led to his suicide.

Other Masterpieces

WATERFALL;
1943;
TATE GALLERY,
LONDON,
ENGLAND

THE BETROTHAL II;
1947;
WHITNEY MUSEUM OF
AMERICAN ART,
NEW YORK CITY,
USA

1985; mixed media; 18.8 x 11.9 cm; Tate Gallery, London, England

Untitled (for Francis)

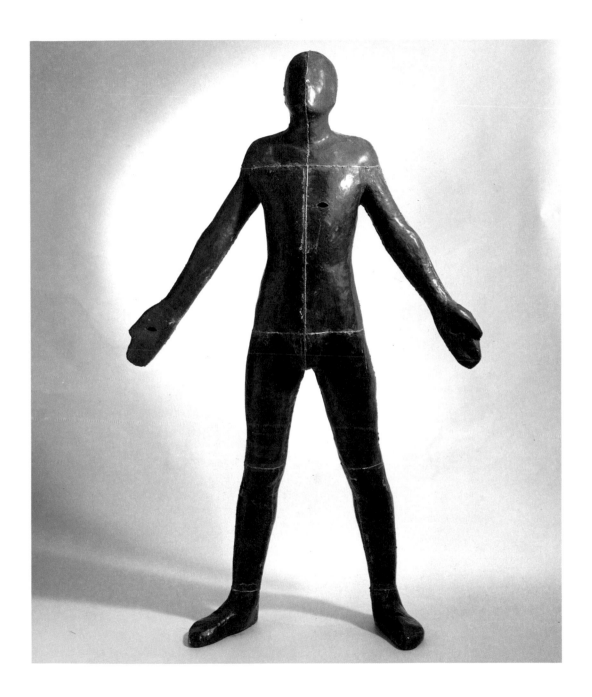

Anthony Gormley has achieved international renown as a figurative sculptor whose work generates admiration both in and out of the gallery context. He has remained faithful to his inimitable brand of representation for a number of years; his reputation has been established on the lone, lead figures that proliferate in his work. These faceless, featureless, humanoid forms are cast originally from his own body. Sheets of lead are laid and then welded on to a hollow plaster body-cast. The subsequent symmetry of the joins makes a grid-like map of the body. This echoes the poses and individual modifications the respective figures assume. This is true of **Untitled (for Francis)**, the attitude of which could be interpreted as welcoming, submissive, or ecstatic. The phlegmatic nature of each piece, at once vulnerable and heroic, belies the emotional strength that Gormley's vision for them has. The physical context into which these figures are sited – the city walls of Derry, the crypt of Winchester Cathedral, for example – gives them a power, a rootedness that is uplifting and universally understood. With regard to the use of the body in art, Gormley's aim is to place it, "in the sublime space created by modernism".

Other Masterpieces

BRICKMAN (MODEL);
1987;
LEEDS CITY ART GALLERY,
 ENGLAND

OUT OF THIS WORLD;
1983–1984;
BRITISH COUNCIL
 COLLECTION,
 LONDON,
 ENGLAND

Goya Francisco

Born Saragossa, Spain 1746; **died** Bordeaux, France 1828

Execution of the Defenders of Madrid, 3rd May 1808

1814; oil on canvas; 266 x 345 cm; Museo del Prado, Madrid, Spain

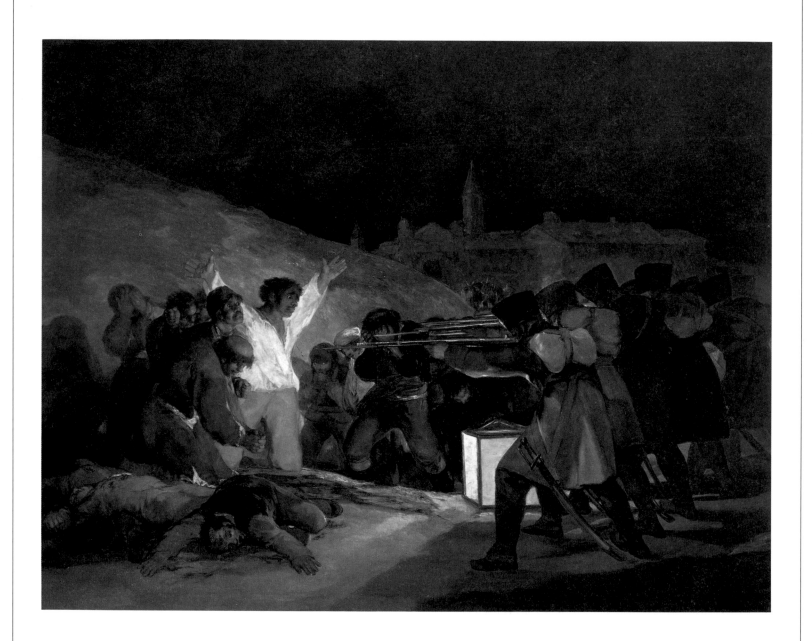

The most influential painter and graphic artist of the eighteenth century, Francisco Goya y Lucientes enjoyed a long and successful career. It is believed he visited Italy in 1771 to undertake commissions for churches, before settling in Madrid. Here he was influenced by Mengs' analytical approach to portraiture and by the decorative realism of Tiepolo. At first, Goya followed a conventional path, becoming a fashionable court painter to King Charles IV and producing charming if satiric works. The invasion of Spain by Napoleon's armies in 1808, however, offered him very different subject matter. **Execution of the Defenders of Madrid, 3rd May 1808** is one painting of a pair which depict two days in the people's resistance to French troops. Goya completed these works several years after the executions and yet manages to convey the scene with blood-red freshness. The expressions of panic and terror on the faces of the ordinary victims is reinforced by the harsh light reflected off the white shirt of the man kneeling.

Goya exerted a major influence on the development of painting, inspiring artists as diverse as Delacroix, Manet, Daumier, Käthe Kollwitz and Picasso.

Other Masterpieces

DONA ISABEL DE PORCEL;
BEFORE 1805;
NATIONAL GALLERY,
LONDON,
ENGLAND

THE NAKED MAJA;
c.1797–1798;
MUSEO DEL PRADO,
MADRID,
SPAIN

Born Leyden, Netherlands 1596; **died** The Hague, Netherlands 1656

Jan van Goyen

River Scene with an Inn

1630; oil on wood; 40 x 81 cm; Victoria and Albert Museum, London, England

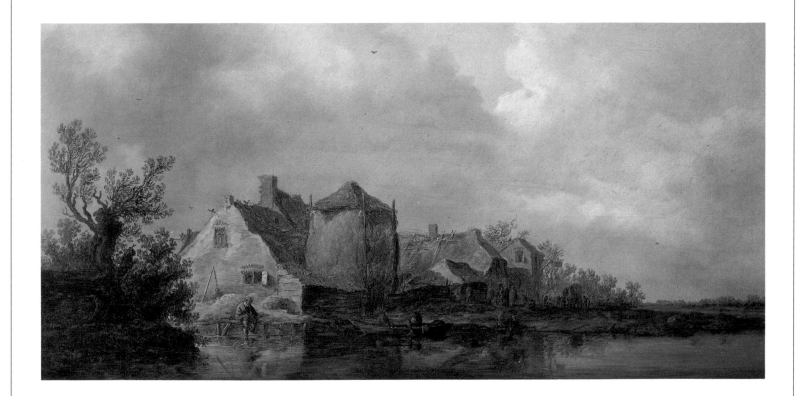

Jan van Goyen, with Salomon van Ruysdael, helped to establish the early school of Dutch landscape painting. He was the father-in-law and teacher of the Dutch genre painter, Jan Steen. Van Goyen visited France as a young man, before travelling extensively in Holland. On his trips he made sketches and drawings of various identifiable landmarks which he used as the basis for later paintings. After 1630 his work underwent a marked change. He simplified his compositions and began to adopt an almost monochrome palette. Later work is richer in colour and displays the poetic sensibility associated with the next generation of Dutch landscape painters, such as Jacob van Ruisdael. A prolific output did not, however, prevent van Goyen from dying insolvent. **River Scene with an Inn** provides a typical view of the Dutch lowlands.

Van Goyen focuses on the low horizon and the reflections created in the expanse of water. The figure sitting on the fence lends the painting an air of wistful contemplation and nostalgia, reinforced by the warm glow of the setting sun.

Other Masterpieces

A WINDMILL BY A
RIVER;
1642;
NATIONAL GALLERY,
LONDON,
ENGLAND

A RIVER SCENE WITH A
HUT ON AN ISLAND;
1640-1645;
NATIONAL GALLERY,
LONDON,
ENGLAND

Greco El

Born Crete, Greece 1541; **died** Toledo, Spain, 1614

Christ Driving the Traders from the Temple

c.1600; oil on canvas; 106.3 x 129.7 cm; National Gallery, London, England

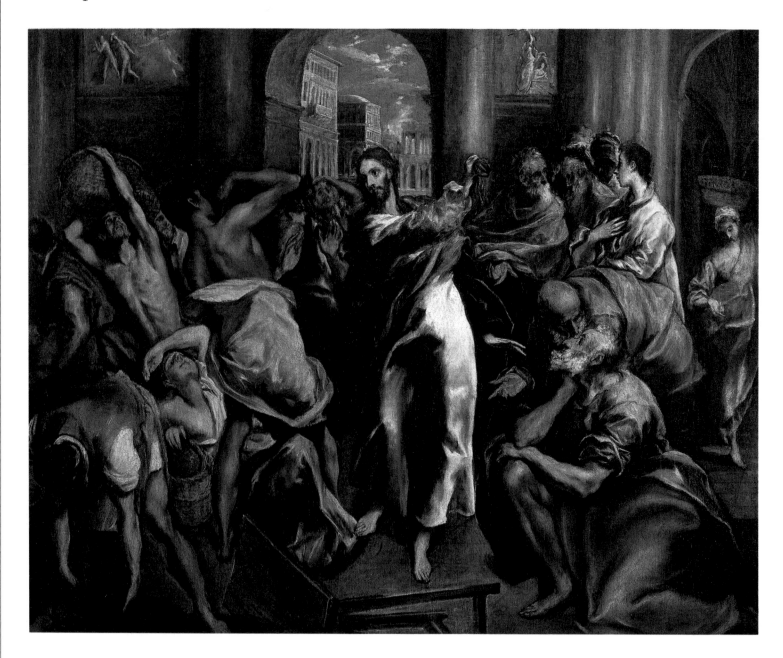

In Crete, which was a Venetian colony at this time, El Greco, (real name Domenikos Theotocopoulos), painted religious icons in the Byzantine tradition. In about 1560 he went to Venice, where he became a pupil of Titian. He also worked in Rome before settling in Toledo, c.1570. His early work, with its dramatic use of light and shade, reveals a strong Venetian influence. El Greco gradually evolved his mannered, highly

individual style, featuring dynamic and distorted compositions with elongated figures, sweeping movement, as well as cold to acidic colours. The depth of the artist's fervent spiritual beliefs was reflected in his increasingly ecstatic and visionary treatment of the many religious subjects he painted. El Greco painted several versions of **Christ Driving the Traders from the Temple**. The story comes from the Gospel of St

Matthew and depicts Christ purifying the house of prayer through the expulsion of the moneychangers and merchants. Despite its traditional and solemn subject matter, El Greco injects vigour into the scene, making it powerfully his own. Characteristically, the figure of Christ is elongated – his dramatic gesture and contrasting red robe occupy centre stage, while the other figures recoil from and rotate around him.

Other Masterpieces

THE BURIAL OF COUNT ORGAZ; 1586; SAN TOME, TOLEDO, SPAIN

RESURRECTION; c.1595; MUSEO DEL PRADO, MADRID, SPAIN

Born Madrid, Spain 1887; **died** Paris, France 1927

The Bay

1921; oil on canvas; 686 x 975 mm; Tate Gallery, London, England

Juan Gris studied in Madrid before settling in Paris in 1906. Here he worked as an illustrator for French magazines. Meeting Picasso was a significant turning point and, from 1912, Gris became a leading Cubist. His work developed from the objective study of simplified, precise forms based on everyday items. His work was more calculated and intellectual than that of either Picasso or Braque. Like them, he collaged paper materials to represent their original function, not simply for their textural qualities. His logical approach was summarized in his own words, "Cézanne turns a bottle into a cylinder...I make a bottle – a particular bottle – out of a cylinder". During the last part of his career, he expressed an increasing preoccupation with colour. He also worked as a book illustrator, designed sets for Diaghilev and made several polychrome – multi-coloured – sculptures. **The Bay** seems to conform to Gris's notion of himself as a classical painter. The harmonious composition is set on a stage; the curtain is drawn aside to reveal a selection of carefully delineated objects in a well-ordered combination of curves and straight lines.

Other Masterpieces

THE CHESSBOARD;
1915;
ART INSTITUTE OF
 CHICAGO,
 CHICAGO,
 USA

**STILL LIFE WITH GUITAR
AND CLARINET;**
1920;
KUNSTMUSEUM,
 BASEL,
 SWITZERLAND

Grosz George

Born Berlin, Germany 1893; **died** Berlin, Germany 1959

Suicide

1916; oil on canvas; 100 x 77.5 cm; Tate Gallery, London, England

George Grosz trained at the Dresden Academy between 1909 and 1912 before serving in the army in 1914. He was eventually declared "permanently unfit for service" and discharged. In 1917, Grosz was one of the founders of the Berlin Club Dada, a movement identified with political radicalism that paralleled the Zürich Dada movement of 1916. Throughout his career, Grosz published collections of pen and ink drawings in which he directed his biting satire against the moral and social disintegration of society under the Weimar Republic. His oil paintings, such as **Suicide**, lay bare this aggressive social realism through brutal images of the modern city and those forced to exist on its margins. Here, Grosz presents a number of scenarios in one frightening image. A body hangs from a lamp post and the rotting corpse of a bowler-hatted businessman is overseen by the impassive stare of a prostitute. Grosz's fragmented approach to the picture space, rendered in garish complementary colours, is designed to show the artificial nature of urbanity. He also exploits theatrical elements that he found in the paintings of de Chirico and Carrà. Grosz lived in the USA between 1933 and 1959, dying just after his return to Berlin.

Other Masterpieces

PORTRAIT OF MAX
HERRMANN-NEISSE;
1927;
MUSEUM OF MODERN ART,
NEW YORK CITY,
USA

PILLARS OF SOCIETY;
1926;
STAATLICHE MUSEEN,
NATIONALGALERIE,
BERLIN,
GERMANY

Mathis Grünewald

The Mocking of Christ

1503; oil on panel; 109 x 73.5 cm; Alte Pinakothek, Munich, Germany

Little is known about Mathis Grünewald's early life, although he is believed to have trained in Alsace. He was court painter to the Archbishop-Elector of Mainz from 1508, after which he became court painter to the Elector of Mainz himself. His series of religious paintings for the Isenheim altarpiece is generally regarded as his masterpiece. Although familiar with Renaissance ideas such as perspective and solidity, Grünewald only makes use of them to heighten the emotional impact of his work. He brings a unique and subjective interpretation to late medieval German art, whether this is expressed through his serene and tender Madonnas or the more tortured emotion of his various crucifixions.

The Mocking of Christ is a brutal and haunting image. This detail focuses on Christ's suffering. The bloodstained bandages wrapped around his head and neck and the knotted rope directly reflect his subjugation and abuse. Grünewald's interest is to lay bare the emotional truth of Christ's torment. Grünewald was, with his contemporary Dürer, one of the greatest German painters of the sixteenth century.

Other Masterpieces

THE CRUCIFIXION;
c.1515;
UNTERLINDEN MUSEUM,
COLMAR,
GERMANY

ST ANTHONY AND ST
PAUL;
c.1515;
UNTERLINDEN MUSEUM,
COLMAR,
GERMANY

Guardi Francesco

Born Venice, Italy 1712; **died** Venice, Italy 1793

Doge Embarking on the Bucintoro

1793; oil on canvas; 67 x 100 cm; Musée du Louvre, Paris, France

Francesco Guardi was a contemporary of Canaletto and quite possibly his pupil. Like Canaletto, Guardi concentrated on painting views of his native Venice, initially with the idea of selling them to tourists. His landscape painting gradually evolved away from the architectural precision of Canaletto and closer to Turner. In his mature work, Guardi's vision of Venice is subjective and concentrated on the rendering of atmospheric effects, such as that of light on water. **Doge Embarking on the Bucintoro** records an actual ceremonial event, but is most notable for its evocation of atmosphere. Suffused with light, Venice appears out of the water like a mirage surrounded by a host of bobbing boats. This airy and poetic interpretation is given added potency through the use of loose and dynamic brushstrokes. Guardi collaborated with his brother Giovanni on some religious pictures – an altarpiece dating from after his brother's death in 1777 was only recently discovered. The great decorative Venetian painter, Tiepolo, was Guardi's brother-in-law. Guardi's son, Giacomo, continued his workshop after his father's death.

Other Masterpieces

ASCENT IN A BALLOON; 1783; STAATLICHE MUSEUM, BERLIN, GERMANY

AN ARCHITECTURAL CAPRICE; c.1770; NATIONAL GALLERY, LONDON, ENGLAND

Philip # Guston

Black Sea

1977; oil on canvas; 173 x 297 cm; Tate Gallery, London, England

Philip Guston's family moved to California in 1919. A correspondence course in cartoon drawing given to him by his mother introduced him to art. His expulsion in 1928 from Los Angeles Manual Arts High School, where he became friends with Jackson Pollock, ended his formal training. He subsequently travelled around America, being influenced by the artists and artistic movements he discovered through his own studies. His admiration for the monumentality of Italian art, especially the Renaissance masters and for Mexican mural art, led him to become involved in a number of mural projects during the 1930s.

From 1950 Guston worked in an Abstract Expressionist mode. In 1966 he brought his painting back into contact with "common objects, things rooted in the tangible world". **Black Sea**, for example, illustrates an obsession with the soles and heels of hobnail boots. At the time the cartoon-like simplicity of his painting was not admired. However, his subject matter, the Ku Klux Klan for example, reveals an underlying seriousness made more poignant by being rooted in a style owing a debt to contemporary underground magazines, comics and popular culture.

Other Masterpieces

THE RUG;
1979;
MUSEUM OF MODERN ART,
 NEW YORK CITY,
 USA

COURTROOM;
1970;
MCKEE GALLERY,
 NEW YORK CITY,
 USA

Haacke Hans

Born Cologne, Germany 1936

A Breed Apart

1978; photograph on paper; 91 x 91 cm; Tate Gallery, London, England

Jaguar
a breed apart

An employee may have an incentive to remain with his employer, no matter how he is treated, in order to qualify for urban residence; and it has been argued that contract workers' rights to work in urban areas are so tenuous that, regardless of how uncongenial their employment or how poor their pay, they are forced to stay in their job for fear of being endorsed out of their area and back to the homelands.

UK Parliamentary Select Committee on African Wages. 1973

Leyland Vehicles. Nothing can stop us now.

Leyland advertising slogan

Photo: Leyland

Hans Haacke's significance lies in the socio-political criticism of his art. He studied at the State Art Academy, Kassel, from 1956 to 1960 and briefly in Paris and Philadelphia. Haacke specializes in works made for a specific place. Using text, photographs and installation he recreates a new interpretation of the cultural, political and corporate connotations and relevant personalities suggested by the location.

In this way he exposes to public view, and offers for consideration, the normally tacit implications of the issues associated with the space. Such controversial means of exposure have met with adverse responses, but within the context of art, Haacke's critique of contemporary society has retained composure. **A Breed Apart** is one of a series of works by which Haacke attempted to subvert the advertising campaigns of companies whose

glossy, glamourous image and philanthropic support for the arts belies their treatment of employees or their arms deals abroad. In 1993, Haacke's contribution to the Venice Biennale was **Germania**, a site-specific work in which he dug up the floor of the empty exhibition pavilion with a road drill. The smashed stone floor communicated more eloquently than words.

Other Masterpieces

TAKING STOCK;
1983–1984;
GILBERT AND LILA
SILVERMAN
COLLECTION,
MICHIGAN,
USA

THE CHOCOLATE MASTER;
1981;
GILBERT AND LILA
SILVERMAN
COLLECTION,
MICHIGAN,
USA

Born Antwerp, Belgium c.1580; **died** Haarlem, Netherlands 1666

Man with a Cane

1633; oil on canvas; detail; 71.2 x 61 cm; Kenwood House, London, England

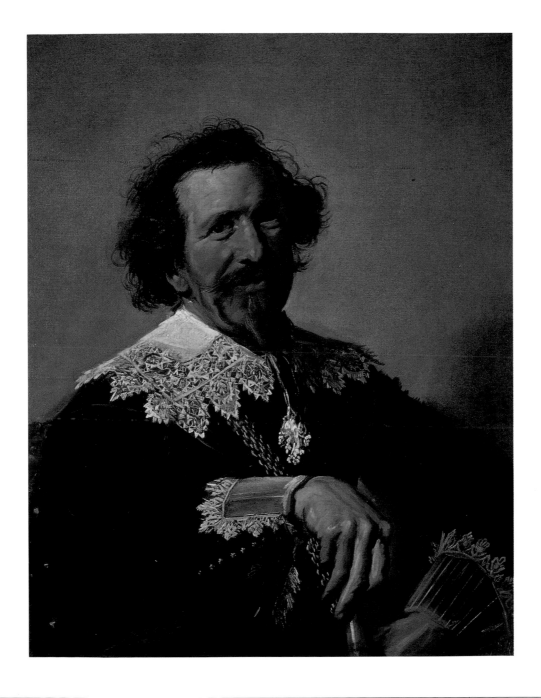

Frans Hals was a painter who was ahead of his time. A contemporary of Rubens and Rembrandt, his seemingly spontaneous style could almost have come from a nineteenth century Impressionist's hand. In 1591, Hals's parents settled in Haarlem and there he remained for the rest of his life. He is known for his extraordinary skills as a portraitist and although these were much in demand, particularly during the 1630s, he struggled financially throughout his career and died destitute. As little is known about him, it is intriguing to speculate on the influences to which he owes his inimitable painting technique. However, all that can be said with certainty is that he was aware of Caravaggio's innovatory work in Italy. In **Man with a Cane**, Hals captures the adventurous spirit of the merchant Pieter van den Broecke in a way that was unsurpassed by painters of the time. Without idealizing his subject, Hals crystallizes the vitality of a warm character with apparent ease. By the 1660s, Hals's lively approach had become tempered, his tonality darker. Most memorable are the **Regents and Regentesses of the Old Men's Alms House** (1664). These are sensitive and poignant group portraits, serving as prophetic images, indicative of Hals's own sad demise.

Other Masterpieces

THE LAUGHING CAVALIER;
1624;
WALLACE COLLECTION,
LONDON,
ENGLAND

HEAD OF A YOUNG BOY;
c.1625;
ROYAL PICTURE GALLERY,
MAURITSHUIS,
THE HAGUE,
NETHERLANDS

Hambling Maggi

Born Sudbury, England 1945

Max Wall and his Image

1981; oil on canvas; 167.6 x 121.9 cm; Tate Gallery, London, England

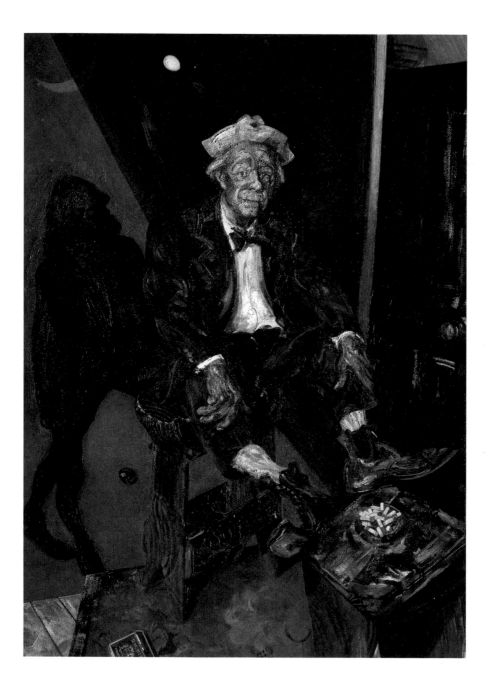

Maggi Hambling is a versatile artist whose painting and sculpture cannot be defined in terms of a particular style or movement. Her fierce independence as an artist is complemented by her androgynous appearance and a vibrant personality that thrives on parties and living the good life. Her paintings are appropriately shot through with vitality. Her sunset pictures and abstracts based on laughter are brilliantly coloured and suffused with emotional intensity. From 1960, Lett Haines and Cedric Morris encouraged her development and her attendance at the Ipswich School of Art from 1962 to 1964. She went on to study at the Camberwell School of Art and The Slade School of Art. Her period as first Artist in Residence at the National Gallery in 1980 to 1981 established her as a significant contemporary artist. **Max Wall and his Image** is one of a number of portraits of the comedian that helped to secure popular recognition of her multifarious skills. Hambling also created a significant series of paintings devoted to her fascination with the Greek myth of the Minotaur. Despite its gruesome implications, Hambling injected sensitivity into the subject. "In the end", she has said, "there is only the physical reality of paint."

Other Masterpieces

MAX AND ME (IN PRAISE OF SMOKING); 1982; BIRMINGHAM CITY MUSEUMS AND ART GALLERY, BIRMINGHAM, ENGLAND

MINOTAUR SURPRISED WHILE EATING; 1986–1987; TATE GALLERY, LONDON, ENGLAND

1964; oil and acrylic, mixed media on wood; 121.9 x 162.6 mm; Tate Gallery, London, England

Interior II

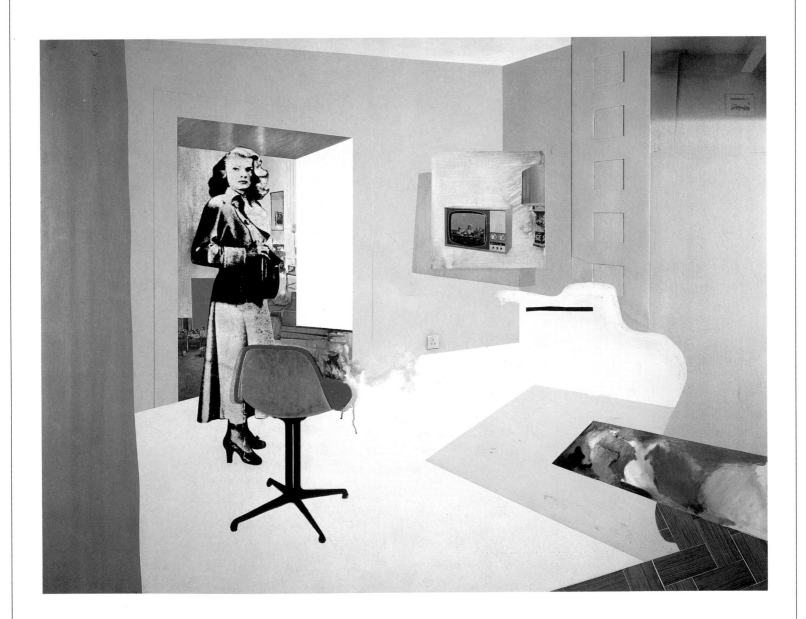

Richard Hamilton's art training did not follow the straightforward course enjoyed by his contemporaries. It was interrupted by war, expulsion from art school and his marriage. However, after he graduated from the Slade School of Art in London, in 1951, he devised an exhibition at the Institute of Contemporary Arts (ICA) in London and co-founded the Independent Group at the ICA in 1952. The group's discussions and exhibition at The Whitechapel Art Gallery in 1956, This Is Tomorrow, signified the arrival of Pop Art in Britain. Hamilton's work was the eclectic juxtaposition of traditionally wrought and mechanically reproduced imagery. **Interior II** combines collage, paint and metal relief on panel, producing a composite image that accesses elements of nostalgia and the ultramodern. There is no doubt that this is pure artifice rather than illusion. In 1963, he first visited the USA and collaborated with Marcel Duchamp; he has since worked with artists Dieter Roth and Rita Donagh. Hamilton's engagement with issues surrounding Northern Ireland have led to the production of numerous politically oriented paintings.

Other Masterpieces

JUST WHAT IS IT THAT MAKES TODAY'S HOMES SO DIFFERENT, SO APPEALING?; 1956; COLLECTION E. JANSS, LOS ANGELES, USA

I'M DREAMING OF A WHITE CHRISTMAS; 1967–1968; KUNSTMUSEUM, BASEL, SWITZERLAND

Haring Keith

Born Kutztown, USA 1958; **died** New York City, USA 1990

Untitled

1989; acrylic and enamel on canvas; 182.8 x 182.8 cm; Estate of Keith Haring

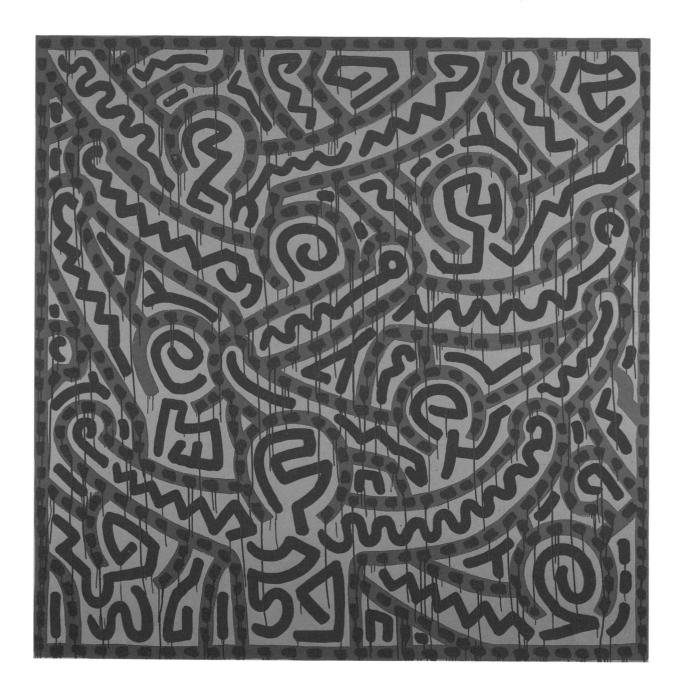

Keith Haring's earliest artistic creations as a child came from television cartoons. His high-school education was followed by attendance at the Ivy School of Art in Pittsburgh and, from 1978, a year's study at the New York School of Visual Arts. Among his teachers were experimental artist Keith Sonnier and Conceptual artist Joseph Kosuth. In 1980, Haring eschewed more conventional outlets available to him to display his creativity and became a graffiti artist. He covered advertisements in the New York subway with stylized, marker pen and chalk drawings. His subjects were wide-ranging but had in common references to popular culture in a nuclear age. The strength of his graphic abilities, as shown by **Untitled** is contained in the linear element that dominated his complex images backed by saturated grounds. These have commercial, rather than expressive roots, marking the transition of Haring's art from subway to T-shirts, badges, murals, official adverts and posters throughout the materialist 1980s. His universal popular imagery derived from a variety of ethnic and cultural sources, without being applicable to one in particular.

Other Masterpieces

IGNORANCE = FEAR;
1989;
ESTATE OF KEITH HARING

SILENCE = DEATH;
1989;
PRIVATE COLLECTION

Mona **Hatoum**

Light Sentence

1992; 36 wire mesh lockers, electric motor, lightbulb; 198 x 185 x 490 cm; Jay Joplin,
White Cube, London, England

M ona Hatoum was forced by war to leave her native Beirut in 1975. Since then she has lived and worked in Britain extending her practice through various disciplines, installation, performance, video and sculpture. Her work has a political edge and discusses the physical, cultural and ethical boundaries which she has challenged or crossed. She often uses herself "as a site of metaphor or allegory for social constraints" engaging in ritualistic performances that are physically demanding and often futile. Film footage of the interior of her own body forms the basis of a controversial manifestation of these preoccupations. Since 1989 Hatoum has concentrated on making installations and sculpture that implicate the viewer. In the absence of human presence, a sense of foreboding, torture and imprisonment pervades pieces such as **Light Sentence**. This minimalist construction comprises the wire skeleton of an institutional locker-room and a bare light bulb that mechanically patrols the length of the cage. The travelling light source throws sinister shadows of a perpetually changing grid that engulfs the spectator, reinforcing feelings of entrapment.

Other Masterpieces

CORPS ETRANGER;
1994;
MUSEE NATIONAL D'ART
 MODERNE,
 PARIS,
 FRANCE

INCOMMUNICAD;
1993;
TATE GALLERY,
 LONDON,
 ENGLAND

Hausmann Raoul

Born Vienna, Austria 1886; **died** Limoges, France 1971

The Art Critic

1919; photomontage, colour pencil and newsprint; 31.8 x 25.4 cm; Tate Gallery, London, England

The son of a painter, Raoul Hausmann moved to Berlin in 1901. Here, in 1918, he was one of the founders of the Berlin Dada movement, with George Grosz and John Heartfield. Hausmann edited the first issues of their magazine *Der Dada* which, with its disordered typography, anticipated the development of a new artistic method, known as photomontage. As a method of collage which involved pasting superimposed photographs, photomontage showed an awareness of Cubist assemblage while retaining a distinctly political and satirical edge. Hausmann explained that "this term translates our aversion at playing the artist, and, thinking of ourselves as engineers ... we meant to construct, to assemble our works." **The Art Critic**, with its absurd and defaced figure, furthers this anti-art theme. He was a close friend of Kurt Schwitters, who, like Hausmann, experimented with sound-poems and typography. German artist Hannah Höch was Hausmann's companion during the Dada era. Her witty collages are of equal merit to Hausmann's and sometimes featured portraits and photographs of herself, Hausmann and other Dada luminaries. After the decline of Dada, Hausmann abandoned painting for photography, writing and the study of optics.

Other Masterpieces

MEN ARE ANGELS AND
LIVE IN HEAVEN;
c.1918;
BERLINISCHE GALERIE,
BERLIN,
GERMANY

GURK;
1919;
KUNSTARCHIV ARNTZ,
HAAG,
GERMANY

Bathers

1940; oil on canvas; 83 x 96.5 cm; Kunstmuseum, Bonn, Germany

Erich Heckel was a German Expressionist whose graphic work, in the form of drawings, lithographs, woodcuts and engravings, is of equal importance to his painting. Between 1904 and 1906, Heckel studied architecture in Dresden, where he met Ernst Ludwig Kirchner and Karl Schmidt-Rottluff, with whom he founded a group known as Die Brücke (The Bridge) in 1905. Declaring Cézanne, Van Gogh, Munch and primitive art to be their inspiration, the group began to produce paintings and graphics that combined a radical simplification of form with an increasingly strident colour sense. Like the Fauves, Die Brücke artists took their subjects directly from nature. Heckel's painting **Bathers** emphasizes harmony, the human figures are depicted as part of their natural surroundings. Although Die Brücke broke up in 1913, certain basic features of their expressive common style continued to influence Heckel's work. He served as a Red Cross orderly in the First World War, during which time he met Max Beckmann and the Belgian artist James Ensor. In later years, Heckel's style became more decorative and lyrical. Between 1949 and 1955, Heckel taught at the Karlsruhe Academy of Art.

Other Masterpieces

SLEEPING NEGRESS;
1908;
YALE UNIVERSITY ART
 GALLERY,
 NEW HAVEN,
CONNECTICUT,
USA

**LANDSCAPE IN
 THUNDERSTORM;**
1913;
TEL AVIV MUSEUM,
 ISRAEL

Heem
Jan Davidsz de

Born Utrecht, Netherlands, 1606; **died** Antwerp, Belgium c.1683

Still Life of Dessert

1640; oil on canvas; 149 x 203 cm; Musée du Louvre, Paris, France

Jan Davidsz de Heem was part of a family of talented Dutch still life painters that included his father, David, and his son, Cornelis. He worked in Utrecht and Leyden before moving to Antwerp at a time of religious conflict. **Still life of Dessert** features the apparent remains of a sumptuous feast. In typical Baroque fashion, the composition emerges from dark shadow, in sharp contrast to the brilliant white cloth in the foreground. With plates and salvers poised precariously on the table, the picture has been contrived to give the impression of casual abandon. The luscious fruit and pies are deeply tempting and a testament to de Heem's skill of rendition. Henri Matisse made copies of this painting and was greatly influenced by it. Fruit, fancy goblets, shining metal dishes, luxurious cloth and a profusion of flowers were frequently featured in De Heem's still lifes. Less commonly, he included a human figure in his compositions, surrounded by memorabilia in the form of books and pictures. De Heem is widely regarded as the greatest Dutch still life painter.

Other Masterpieces

STILL LIFE WITH A NAUTILUS CUP;
1632;
BARBER INSTITUTE OF FINE ARTS,
UNIVERSITY OF BIRMINGHAM,
ENGLAND

STILL LIFE WITH A LOBSTER;
c.1645;
WALLACE COLLECTION,
LONDON,
ENGLAND

1934; stone; 23 x 18.9 cm; Tate Gallery, London, England

Mother and Child

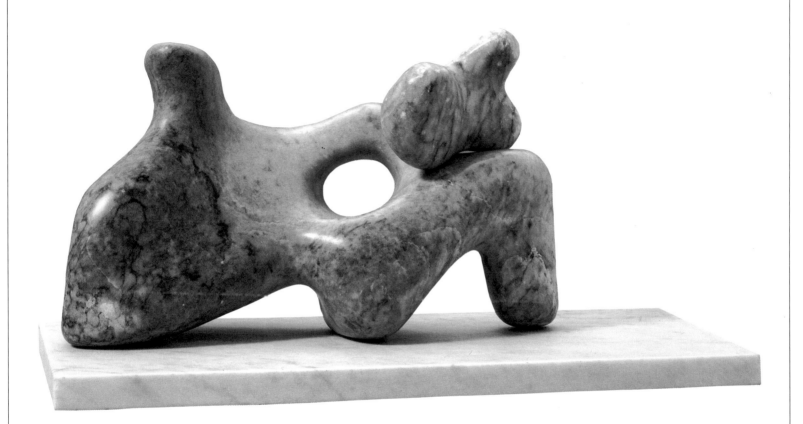

Barbara Hepworth trained at Leeds and the Royal College. She made both representative and abstract work but it is for the latter that she became best known. Trips to Italy and to Paris in the 1920s and 1930s introduced her to marble-carving techniques and to the work of eminent artists including Arp, Mondrian and Brancusi. In 1934 she abandoned figuration but continued to use nature and the **Mother and Child** theme as her inspiration. Her bronze and marble forms were conceived originally as abstract responses to her own vision of life. At this time, living in London, she came into contact with the artist, Naum Gabo, a refugee whose work affected her deeply. In 1939 she and her second husband the painter Ben Nicholson, settled in St Ives, Cornwall where they became the nucleus of an artistic community. Neolithic stones standing on the moors and the rugged coastline with its towering rocks and curving inlets made an impact on her ideas. She pierced holes in, hollowed out and painted forms, complementing their mass and volume by adding the tension of taught strings or wires. As somewhat of an outsider, that she gained recognition in a field dominated by men is a remarkable achievement.

Other Masterpieces

PELAGOS;
1946;
TATE GALLERY,
 LONDON,
 ENGLAND

SQUARES WITH TWO CIRCLES;
1963;
TATE GALLERY,
 LONDON,
 ENGLAND

Heron Patrick

Born Leeds, England 1920

Untitled 10–11 July

1992; oil on canvas; 198.1 x 274.3 cm; Tate Gallery, London, England

Patrick Heron has described Matisse's **Red Studio** as, "the most influential single picture in my career". As he wrote, in 1958, that "Space in colour is the subject of my painting", his early admiration for Matisse's masterpiece is significant. Heron's art training was minimal – he attended the Slade School of Art part-time for two years. He worked as an assistant in the Bernard Leach Pottery in St Ives (1944–1945) and came into contact with Ben Nicholson and Barbara Hepworth. An art critic as well as a practitioner, his views were published in his book, *The Changing Forms of Art* (1955). Until 1956, he produced figurative painting. This developed into a concern to make the paint, colour and spatial organization take precedent over content. Striped paintings of the late 1950s gave way to the "formal vocabulary" of square and lozenge shapes.

An emphasis on drawing returned to his work during the 1960s. Works made through the 1980s and 1990s, **Untitled 10–11 July**, for example, provide a softer, looser focus on his primary concern, colour. However, there is a return to the graphic qualities of earlier work, emphasizing the unifying element of the ground on which the linear patterns rest.

Other Masterpieces

HORIZONTAL STRIPE PAINTING;
1957–1958;
TATE GALLERY,
LONDON,
ENGLAND

CADMIUM WITH VIOLET, SCARLET, EMERALD, LEMON AND VENETIAN:
1969;
TATE GALLERY,
LONDON,
ENGLAND

1967; painted papier maché, wood and cord; 12.4 x 206 x 302.9 cm; Tate Gallery, London, England

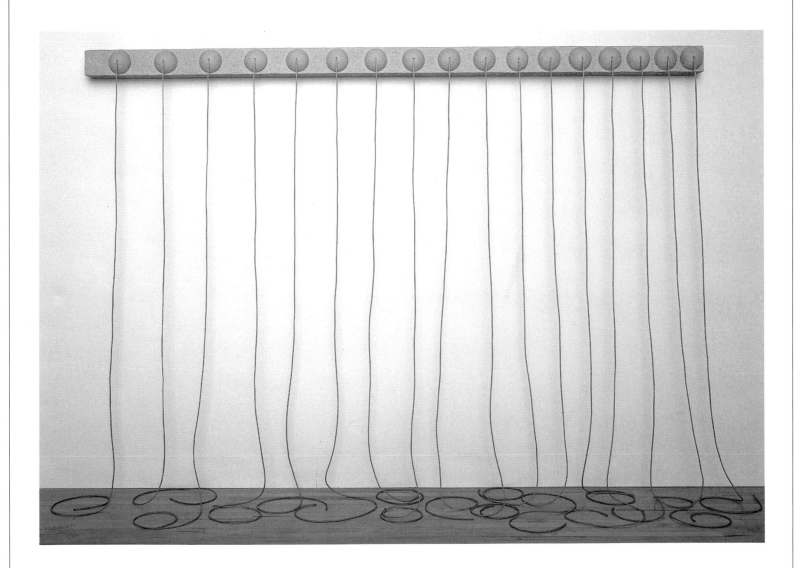

Eva Hesse fled Germany in 1939 after the Nazi pogrom. Her family settled in New York City where she received US citizenship in 1945. Disturbing events in her early life – the war years, her parents' divorce and her mother's suicide – may have established an obsession with the past, which she meticulousy recorded in diaries. She studied art, first at Cooper Union and then at Yale between 1957 and 1959. At this stage,

Hesse had not made sculpture. She used drawing as a means of sustaining her practice and as a way of exploring her deep personal anxieties. Her drawings display a broad range of styles, from the early, dark, pen and ink washes of irregular rectangles and bulging circles to the later, sharply-defined, 'machine' inspired pieces. Hesse began to make freestanding minimilist sculpture after a trip to Germany in 1964. Her monochrome piece,

Addendum, was first shown in Finch College Museum as part of a 'Serial Art' show in 1967. The logical arrangement of 17 semi-spheres is designed to contrast with the random fall of the cords. Elegant, erudite and erotic, Hesse's work continued to excite until her untimely death from a brain tumour at the age of 34.

Other Masterpieces

HANG UP;
1966;
COLLECTION OF MR AND
MRS VICTOR W. GANZ,
NEW YORK CITY,
USA

REPETITION NINETEEN III;
1968;
MUSEUM OF MODERN ART,
NEW YORK CITY,
USA

Hiller Susan

Born New York City, USA 1942

Midnight Euston

1983; c-type monograph, enlarged from photobooth image; 61 x 52 cm;
Arts Council Collection, London, England

Until Susan Hiller experienced a "kind of crisis of conscience" she studied as an anthropologist. Through her work as an artist she investigates the significance of common experience and cultural artefacts and explores the processes of the imagination. Since the late 1960s Hiller has worked in a variety of media; painting, sculpture, installations, photography, audio and video works. She has lived in London since 1973. Memorial plaques, postcards, wallpaper and photo-booth portraits become the materials by which she investigates the gaps between dreams and real experience, the unspoken and unrecorded word. Death, desire and language are major themes. **Midnight Euston** is a piece which defines the artist, as subject, in terms of time and space. The booth becomes a mini-theatre where Hiller re-enacts herself with the camera as her mirror. Hiller combines the elements of the face together with automatic writing; at the same time she is obliterating and embellishing it with an indecipherable message. She has developed the notion of signals communicated by language into dramatic audio-visual installations, which surround the spectator in unknown territory, allowing them to participate as creator of their own narrative.

Other Masterpieces

BELSHAZZAR'S FEAST;
1983;
VIDEO TRANSMITTED ON
CHANNEL FOUR TV,
LONDON, ENGLAND,
JANUARY 1986

AN ENTERTAINMENT;
1990;
TATE GALLERY,
LONDON,
ENGLAND

c.1572; oil on panel; 76.8 x 59.6 cm; Walker Art Gallery, Liverpool, England

Queen Elizabeth I (Pelican Portrait)

Nicholas Hilliard is the first English artist whose life is reliably documented. The son of an Exeter goldsmith, he trained and worked for a while as a goldsmith himself. By 1560 he was practising as a limner, a painter of portraits in miniature; these were often mounted in lockets or worn on the end of jewelled chains. It was a precise art which combined the need for fine brushwork with an unerring eye for detail. He was appointed as limner and goldsmith to Queen Elizabeth I in 1562. This portrait is one of the few full-size portraits attributed to Hilliard. It has helped to define the popular image of Queen Elizabeth, while providing a record of the courtly grace of the Elizabethan age. It is known as the **"Pelican Portrait"** because the pendant around the Queen's neck features a pelican. A traditional Christian symbol of Christ's sacrifice, the pelican has been known to feed its young on its own blood and is therefore an appropriate symbol for a Queen who saw herself as mother of her people. Until overtaken by his pupil Isaac Oliver, Hilliard was the most successful limner in England.

Other Masterpieces

PORTRAIT OF AN UNKNOWN MAN;
c.1588;
VICTORIA AND ALBERT MUSEUM, LONDON, ENGLAND

QUEEN ELIZABETH I (ERMINE PORTRAIT);
1585;
HATFIELD HOUSE, HERTFORDSHIRE, ENGLAND

Hilton Roger

Born Northwood England 1911; **died** St Just, England 1975

Oi, Yoi, Yoi

1963; oil on canvas; 152.4 x 127 cm; Tate Gallery, London, England

Roger Hilton's declared goal was to "reinvent figuration". His attempts to do so have established his significant contribution to the development of post-war painting in Britain. Hilton trained at the Slade School of Art in London. During the 1930s he attended the Academie Ranson in Paris, where he began to absorb the influence of progressive artistic ideas. Hilton served in the Commandos during the war. He was captured and held prisoner until 1945. By 1950 he had returned to Paris and the influence of the painters of the Paris School was reinforced by his study of Mondrian's work in Amsterdam and the Hague. He had travelled there with Constant Nieuwenhuys, a painter of the CoBra group whom Hilton referred to as a "humanized Mondrian". Hilton's own abstract, "neo-plastic" paintings became more severe, forceful compositions of line produced from a reductive palette. Impressed by his first visit to St Ives in 1956, he rented a studio at Newlyn, and settled in Cornwall in 1965. He had announced that, "Abstraction in itself is nothing", and his work began orienting toward colourful figuration, beginning with the landscape and culminating in the vitality of recognizable subjects such as the dancing woman of **Oi, Yoi, Yoi.**

Other Masterpieces

LARGE ORANGE, NEWLYN, JUNE 1959; 1959; THE SYNDICS OF THE FITZWILLIAM MUSEUM, CAMBRIDGE, ENGLAND

MARCH, 1961; 1961; WHITWORTH ART GALLERY, MANCHESTER, ENGLAND

Born Bristol, England 1965

Damien Hirst

1991; shark in a glass case; 210 cm x 640 x 213 cm; Saatchi Collection, London, England

The Physical Impossibility of Death in the Mind of Someone Living

Damien Hirst has attracted controversy and respect in equal amounts. He is one of a generation of artists who have broken the boundaries between art and moral, ethical respectability. Initially noted for his work as a curator of alternative exhibitions while still a student at Goldsmiths College (1986–1989), it is for his art that he has achieved international recognition. **The Physical Impossibility of Death in the Mind of Someone Living** is an oft quoted, notorious example of his work. A tiger shark, one of the most feared creatures in the sea, is preserved in formaldehyde in a glass tank and rendered a passive museum object, an icon for contemplation. Face to face with a killer, we ponder on the wonder that death preserved can look so alive. Hirst has specialized in using vitrines and animals living – butterflies and maggots– dead and dismembered – sheep and cows, conveying a mood at once confrontational, clinical and distanced. Hirst's conceptual work is less about conventional aesthetics and more about a willingness to take risks and explore the ambiguities inherent in human thoughts and desires. He has stated, "I sometimes feel I have nothing to say. I often want to communicate this".

Other Masterpieces

**OTHER MASTERPIECES
ACETIC ANHYDRIDE;**
1991;
SAATCHI COLLECTION,
LONDON,
ENGLAND

A THOUSAND YEARS;
1990;
SAATCHI COLLECTION,
LONDON,
ENGLAND

Garden Cove

1952–1953; oil on canvas; 44 x 108 cm; Arts Council Collection, London, England

I von Hitchens applied the principles of structural design to his painting. He coupled this with the exploration of colour as an integral element of pictorial composition. By his own admission he was "...a sucker for noble art" and his early admiration for Puvis de Chavannes and Piero della Francesca is reflected in his mural and stained glass designs. Hitchens studied at the London's Royal Academy and held his first solo exhibition in 1925. The influence of Cézanne's painting and, by the early 1930s, of Braque's Cubism was complemented in Hitchens' work by exuberant colour experimentation inspired by Matisse. From 1940 onward West Sussex was his home and the inspiration for his painting. What interested him was not the subject but the ways in which he could express it without resorting to descriptive realism.

By orchestrating shapes and formal elements within two-dimensional space he painted a parallel for the natural world, evoking mood and creating beauty with lyrical, soft-edged abstractions. His so-called "tone poems" were barely tainted by changing artistic fashions. **Garden Cove** exemplifies this tendency and established his reputation within a painting tradition that was intimately English.

Other Masterpieces

WINTER LAWN AND FIR TREES;
1978;
WADDINGTON GALLERIES,
LONDON,
ENGLAND

FLOWER PIECE;
1943;
SHEFFIELD CITY ART GALLERIES,
SHEFFIELD,
ENGLAND

The Avenue at Middelharnis

1689; oil on canvas; 103.5 x 141 cm; National Gallery, London, England

Meindert Hobbema was both a friend and pupil of Jacob van Ruisdael. The two artists occasionally painted the same view, although Hobbema's landscapes lack the heightened drama of his master's. Hobbema achieved little recognition in his lifetime. He became an excise officer in 1668 and thereafter spent more time inspecting wine casks than painting. Originally thought to date from the late 1660s, this example of his work is dated 1689, and features Middelharnis, a village in South Holland whose flat and ordered lowlands have changed little over the centuries. The foreshortening of the avenue of young poplar trees draws us into the picture. The image of a path or road to suggest a journey and the passage of time is not new, but is used to especially powerful effect here. In Hobbema's tranquil scene, a man strolls with his dog, another tends his plants, two more stop for a chat. The brilliant contrast between the red roofs of the houses and the greyish-green foliage is one of the painting's many notable features. What makes this a truly exceptional painting is that the details combine to increase the harmony of the overall composition.

Other Masterpieces

STORMY LANDSCAPE;
c.1663;
WALLACE COLLECTION,
LONDON,
ENGLAND

THE WATERMILL WITH A
RED ROOF;
c.1670;
CHICAGO ART INSTITUTE,
CHICAGO,
USA

Hockney David

Born Bradford, England 1937

Man Taking a Shower in Beverly Hills

1964; acrylic on canvas; 167.3 x 167 cm; Tate Gallery, London, England

David Hockney delights in contradictions. His name is synonymous with slick acrylic or coloured pencil portraits, renditions of still-life, or variations on the theme of men in showers, as seen here in the stylized **Man Taking a Shower in Beverly Hills**, and swimming pools with spaghetti-like reflections. In the early 1960s, Hockney was an innovative student at The Royal College of Art. He delved into Pop Art, going against the tide of Abstraction from the US, which threatened to engulf art production in Britain. His larger painting projects were concerned more overtly with the major preoccupations of his early work. These were notably, his homosexuality and his absorption in the work and ideas of other artists, particularly Dubuffet, Bacon and Kitaj, who was an early associate at the Royal College of Art, and the writers Walt Whitman and Cavafy. Hockney had a fear of repetition and did not maintain allegiance to stylistic unity. He alternates between making formal statements about painting itself and describing content. In the 1980s his photographic works, exemplified his enquiry into the nature of visual reality, incorporating Cubist ideology and questioning the Renaissance view of perspective.

Other Masterpieces

WE TWO BOYS TOGETHER CLINGING;
1961;
ARTS COUNCIL COLLECTION, LONDON, ENGLAND

MR & MRS CLARK & PERCY;
1970–1971;
TATE GALLERY, LONDON, ENGLAND

1975–1979; oil on wood; 94.6 x 125.1 cm; Tate Gallery, London, England

Sir Howard Hodgkin's contribution to British painting is difficult to define, as his work does not correspond to any particular art movement. He studied his craft at Camberwell School of Art, London, between 1949 and 1950 and at the Bath Academy of Art, Corsham, between 1950 and 1954. One of his tutors at Bath was William Scott, whose modernist aesthetic guided Hodgkin's notions of painting toward the consideration of it as a physical object. His early interest in Indian painting has undoubtedly informed the pure brilliance of his palette. His continued commitment and indebtedness to the culture behind the art form is shown by his collection of Mughal miniatures and frequent visits to India. His extensive travels elsewhere in the world have inspired his subject matter. Hodgkin's paintings, incorporating their frames, appear purely abstract. They are, in fact, based on experiences or encounters. **Dinner at Smith Square**, for example, implies that a complete narrative, suggested by the title, is held within the layers of colour and superimposition of brush marks, which are as varied as the words within a wide vocabulary, evoking a vivid story.

Other Masterpieces

INTERIOR AT OAKWOOD COURT;
1978;
WHITWORTH ART GALLERY,
MANCHESTER,
ENGLAND

MENSWEAR;
1980–1985;
SAATCHI COLLECTION,
LONDON,
ENGLAND

Hodler Ferdinand

Born Berne, Switzerland 1853; **died** Geneva, Switzerland 1918

Lake Thun and the Stockhorn Mountains

1910; oil on canvas; 83 x 105.4 cm; Scottish National Gallery of Art, Edinburgh, Scotland

Ferdinand Hodler was, with Arnold Böcklin, the leading Swiss painter of the nineteenth century. He settled in Geneva in 1871, where he studied landscape and figure painting. His early work consists of landscapes, portraits and large allegorical and historical compositions. A visit to Paris in 1891 exposed him to the work of Corot and Courbet, but ultimately his flat, linear and sometimes decorative style owed more to Symbolism and Art Nouveau. In the 1880s Hodler's deep spirituality led him to develop a theory of Parallelism, which stressed the underlying unity rather than the diversity of all natural things. He was especially drawn to Alpine scenery and painted many views of the Swiss mountains around Lake Thun. These landscapes, from the last ten years of his life, are thought to be his finest work. The elemental, timeless quality of nature is emphasized in this full-frontal view. The blue and purple tones in which the lake, mountains and sky are rendered help to imbue the scene with a sense of harmony and order.

Other Masterpieces

THE CHOSEN ONE;
1893-1894;
KUNSTMUSEUM,
BERN,
SWITZERLAND

DAY;
c.1900;
KUNSTHAUS,
ZURICH,
SWITZERLAND

Hans **Hofmann**

Nulli Secundus

1964; oil on canvas; 213 x 131.8 cm; Tate Gallery, London, England

Hans Hofmann was an influential artist and teacher. He studied in Paris, where he met Delaunay, Matisse, Braque and Picasso. In 1915 he opened an art school in Munich. He emigrated to the USA in 1931, where he opened another art school in New York. Attended by many of the next generation of American painters, the school exercised a profound influence on the subsequent development of abstract painting.

Hofmann was a major influence on Jackson Pollock. His own work was initially representational, showing Expressionist and Fauve influences. His vigorous abstract style emerged in the 1940s. **Nulli Secundus** is a painting from the last years of his life, when he began to paint with renewed zest. The title means "second to none". Hofman always based his later work on nature, although the paintings themselves are often resolutely abstract. Built up from a series of underlying rectangles, the painting offers a curious and ambiguous sense of space. Hofmann himself believed form and colour to be inexorably linked, declaring "form only exists through colour, and colour only exists through form".

Other Masterpieces

THE PREY;
1956;
MUSEUM OF MODERN ART,
NEW YORK CITY,
USA

EXUBERANCE;
1955;
ALBRIGHT ART GALLERY,
BUFFALO,
NEW YORK STATE,
USA

Hogarth William

Born London, England 1697; **died** London, England 1764

The Countess's Morning Levée

c.1743; oil on canvas; 70.5 x 90.8 cm; National Gallery, London, England

Hogarth's work exemplifies the British taste for acerbic social satire. His painting offers valuable insights to eighteenth century society. Hogarth was apprenticed in 1712 to an engraver working in the Rococo tradition and by 1720 was earning a living illustrating books. He studied painting in his spare time at the Academy in St Martin's Lane, eager to develop an entrepreneurial market for contemporary art

by British painters. He predicted correctly that popular taste would favour topical narratives that were as critical of vanity as immorality. His series of conversation pieces and sequences of anecdotal paintings were commonly available by the early 1730s and were reproduced as engravings making them widely affordable. **The Countess's Morning Levée** is the fifth of six scenes from *Marriage à la Mode*. This is a detail of the penultimate

tableaux of unsavoury characters, each of whom plays a significant part in the collapse of a marriage doomed from the start. Like a stage set, almost every detail has some direct or symbolic bearing on the plot, referring to social and moral indiscretions of the time. Hogarth's keen observations also contributed to his success as a spontaneous and uncompromising portrait painter.

Other Masterpieces

THE GRAHAM CHILDREN;
1742;
TATE GALLERY,
LONDON,
ENGLAND

A RAKE'S PROGRESS;
c.1735;
SIR JOHN SOANE'S
MUSEUM,
LONDON,
ENGLAND

Born Asakusa, Japan 1760; **died** Honjo, Japan 1849

Katsushika Hokusai

The Great Wave of Kanagawa

c.1830; colour wood block print; 25 x30 cm; Museum of Modern Art, New York City, USA

Katsushika Hokusai was one of the most significant and creative woodblock printmakers of the first half of the nineteenth century. Recognized as a leading artist of the Ukiyo-e School, the most popular translation of Ukiyo-e being "pictures of the floating world", Hokusai's master was the eminent artist Shunsho. He worked during a period when art was made for and by the common people – artisans, traders and city dwellers. Since this work was widely available – due to its reproducibility – it was bound by the strictures of changing fashion. Popular prints featured courtesans and actors of the Kabuki theatre. Hokusai worked on such images until 1794. In 1798 he began a series of views of Edo, which formed a precursor to his serious interest in landscape. Through this subject, Hokusai exercised his artistic sensitivity and imagination, rejecting the demand for the increasing garishness of theatrical subject matter. This demand ceased with the end of the eighteenth century and Hokusai's prints, such as **The Great Wave of Kanagawa**, became sought after. It is an ingenious and dramatic scene, the fishing boat and Mount Fuji itself are rendered tiny in the presence of the wall of water, threatening to break.

Other Masterpieces

THE DREAM OF THE FISHERMAN'S WIFE;
c.1820;
BRITISH MUSEUM,
LONDON,
ENGLAND

SNOWY MORNING AT KOISHIKAWA;
c.1830;
BRITISH MUSEUM,
LONDON,
ENGLAND

Holbein Hans

Born Augsburg, Germany c.1497–1498; **died** London, England 1543

Georg Gisze

1532; oak panel; 96.3 x 85.7 cm; Staatliche Gemalde-Galerie, Berlin, Germany

Hans Holbein trained in his father's studio in Augsburg, a place famous for its goldsmiths. The Reformation had effected a crisis within the creative and decorative arts; knowledge of the Renaissance filtering into the North from Italy was welcomed by artists. By 1516 Holbein was painting portraits exquisitely rendered in a realist manner; in about 1520 he was the leading painter in Basel. However, the turmoil caused by the Reformation influenced a decline in patronage and Holbein's departure for England in 1526. A letter of recommendation from eminent scholar, Erasmus of Rotterdam, led to Sir Thomas More becoming Holbein's patron. The group family portrait that followed, of full-length figures in their own home, was a landmark in European painting. After a brief return to Basel in 1528, Holbein again worked in England from 1532. He found new patrons in the German Steelyard Merchants for whom he painted several portraits, including one of **Georg Gisze**. By 1536 he was official Court Painter to Henry VIII providing detailed and vivid records of the period. Despite various decorative and fine art commissions that resulted from court patronage he died without having used the full range of his considerable talents.

Other Masterpieces

THE AMBASSADORS,
1533,
NATIONAL GALLERY,
LONDON,
ENGLAND

ARTIST'S WIFE AND CHILDREN,
c.1528,
KUNSTMUSEUM,
BASEL,
SWITZERLAND

Born Boston, USA 1836; died Prout's Neck, USA, 1910

The Gulf Stream

1899; oil on canvas; 71.4 x 124.8 cm; Catharine Lorillard Wolfe Fund, 1906, The Metropolitan Museum of Art, New York City, USA

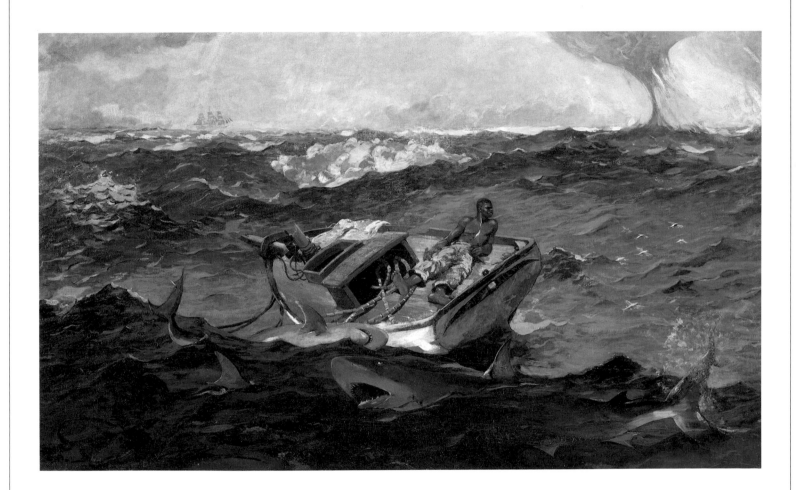

Winslow Homer's early life was spent on the New England coasts of Massachusetts and Maine. After training as a lithographer he moved to New York City in 1859, where he worked as an illustrator and war artist, spending several months with the Union army. He travelled to France and then to England, where he stayed in Tynemouth painting seascapes in watercolour. His style broadened and his brushstrokes loosened. In 1883 Homer settled in Prout's Neck, on the Maine coast. Although more tonal than the Impressionists, he observed the effects of light with equal interest. He travelled again, to the Bahamas, Florida and Bermuda, where his paintings of huntsmen, sea divers and fishermen record his fascination with man's struggle against the darker forces of nature. Watercolour studies of shark fishing and of an ominously derelict and dismasted schooner were used as the basis of **The Gulf Stream**. The painting has been described as a catalogue of marine catastrophe. A water spout compounds the danger already wrought by the hurricane which has snapped both mast and bowsprit. And, just below the surface, the sharks are waiting ...

Other Masterpieces

THE FOX HUNT;
1893;
PENNSYLVANIA
ACADEMY OF FINE ART,
PHILADELPHIA,
USA

FISHING BOATS, KEY
WEST;
1903;
METROPOLITAN MUSEUM
OF ART,
NEW YORK CITY,
USA

Hooch Pieter de

Born Rotterdam, Netherlands 1629; **died** Amsterdam, Netherlands 1684

A Woman Peeling Apples

c.1663; oil on canvas; 67.1 x 54.7 cm; Wallace Collection, London, England

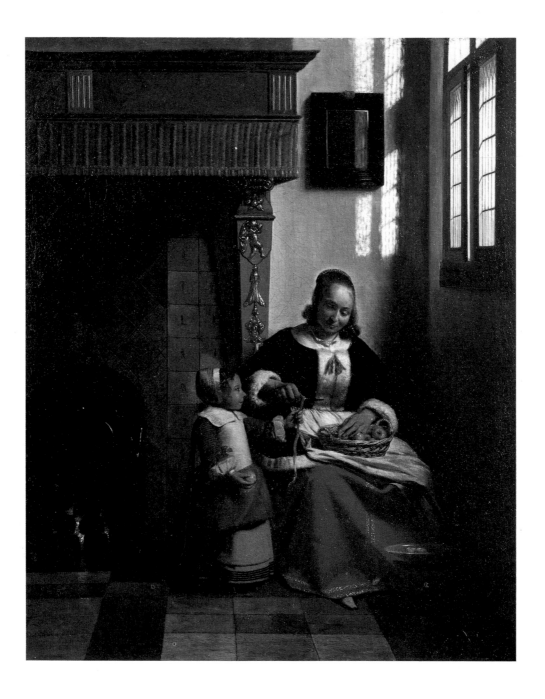

Pieter de Hooch was a contemporary of Vermeer. Both painters worked mainly in Delft where they recorded domestic scenes from middle-class life. Like Vermeer, de Hooch was particularly interested in the fall of light upon surfaces. Typically, his paintings feature either a sunny courtyard juxtaposed with a view into the shadows of a house or a dim interior lit by bright natural light falling through a door or window.

A Woman Peeling Apples is characteristic of the latter. Absorbed in her household duties the woman is watched silently by a little girl. It is a comfortable and tranquil scene in which the gloom and heaviness of the dark room is relieved by the light streaming through the window, as well as the warmth of the woman's red skirt. De Hooch moved to Amsterdam in the early 1660s and, in place of his simple interiors, began to paint grandiose scenes of Dutch high life. His art declined from this point until his death in an asylum some 20 years later.

Other Masterpieces

COURTYARD OF A HOUSE IN DELFT;
1658;
NATIONAL GALLERY, LONDON, ENGLAND

THE PANTRY;
c.1658;
RIJKSMUSEUM, AMSTERDAM, NETHERLANDS

Born Nyack, USA 1882; **died** New York City, USA 1967

Chop Suey

1929; oil on canvas; 81.3 x 96.5 cm; collection of B.A. Ebsworth, St Louis, USA

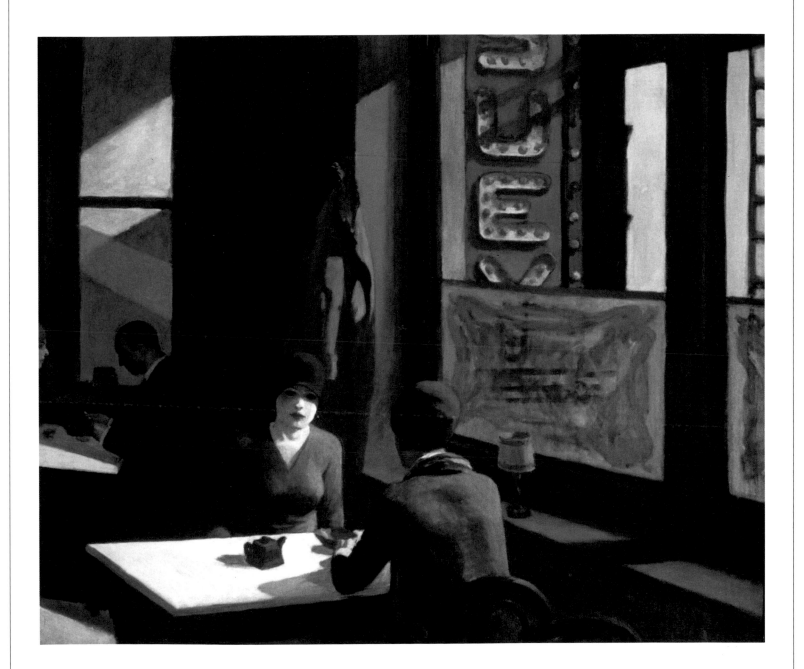

Edward Hopper is recognized as a major realist painter of the twentieth century. In 1924, while working as an illustrator, he had his first solo exhibition. He studied at the New York School of Art from 1900–1906. Hopper then visited Paris and returned there during 1909 and 1910. The European lifestyle and the art he witnessed had a major impact on his painting; he claimed that it took him ten years to get over the experience. Looking at his work, it is clear that he never really did. The influence of the French Impressionists infiltrates his composition and his focus on light effects and social scenes. Hopper established his artistic identity by utilizing the "typically American subject matter" of hotel room interiors, gasoline stations, theatre foyers, apartments and cafe bars at night. Without resorting to narrative, a sense of contemplation, quietness or non-communication is suggested. **Chop Suey** is such a picture. It has a timelessness and the pervasive air of introspection is a reflection of Hopper's own character. The interior life of the city forms the content of most of Hopper's work and has, stylistically, inspired film makers and other artists searching for an essentially American mood.

Other Masterpieces

AUTOMAT;
1927;
DES MOINES ART CENTER,
 IOWA,
 USA

ROOM IN NEW YORK;
1932;
SHELDON MEMORIAL
 ART GALLERY,
 UNIVERSITY OF
 NEBRASKA,
 LINCOLN,
 USA

Horn Rebecca

Born Michelstadt, Germany 1944

Ballet of the Woodpeckers

1986; mixed media; size variable; Tate Gallery, London, England

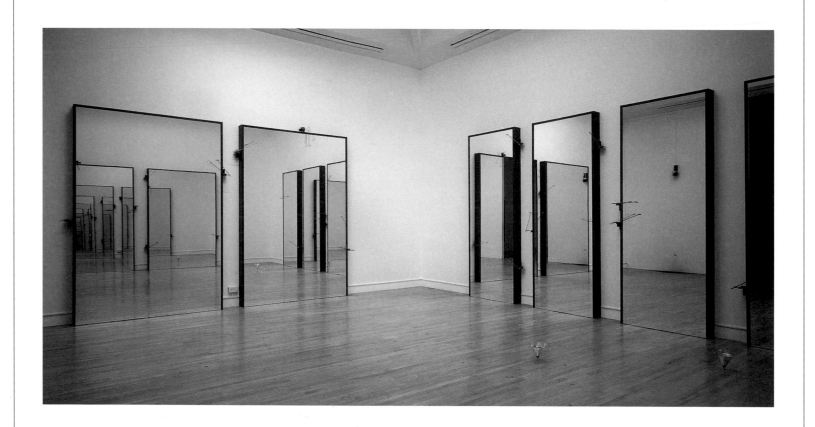

Rebecca Horn is established as one of the most imaginative artists of her generation. Her truancy from school prophesied her independence and rejection of conventional art forms. From 1964–1969 she trained at the Fine Arts Academy in Hamburg. During this period she was employing toxic materials to make her work and their effect led to prolonged illness. While confined, she designed a series of surreal clothing.

These included extensions for arms and for fingers that trailed on the floor, wings, a tall, cloth horn and a pulsating garment of veins. She transformed herself and friends into living sculptures wearing these and others on film. She continued her studies at St Martin's School of Art, London (1971–1972). Alongside her film, video and performance work she explores the possibilities of kinetic sculpture. These "symbols of people" are powerfully enigmatic

automata, which Horn describes as "melancholic actors, performing in solitude". They incorporate all manner of objects – shoes, guns, pianos, motorized blue butterfly wings – and materials with alchemical significance. **Ballet of the Woodpeckers**, a sequence of mirrors spasmodically tapped by small hammers, is like birds flying toward, or destroying, their own image. It is a potent metaphor for desire, compulsion and isolation.

Other Masterpieces

THE GOLDEN BATH;
1980;
STEDELIJK VAN
ABBEMUSEUM,
EINDHOVEN,
NETHERLANDS

ORLANDO;
1988;
TATE GALLERY,
LONDON,
ENGLAND

A Night That Never Ends

1995; oil on canvas; 152 x 122 cm; Angela Flowers Gallery, London, England

Peter Howson lives and works in Scotland. He trained at the Glasgow School of Art from 1975–1977 and 1979–1981. Here, the strong academic traditions of figurative art gave him and other painters of his generation a solid basis on which to formulate a recognized way of working. Howson was one of the driving forces behind the so-called New Image painting that revolutionized British art in the late 1980s. A return to narrative and to powerful figuration came from an acknowledgement of Glasgow's socio-economic difficulties at the time. A socialist element infiltrates Howson's painting, which tends to focus on the struggles of the working classes, depicted as a defiant proletariat. **A Night That Never Ends** is a typical example of Howson's oeuvre, a multi-figure scene comprising individuals representing "the common man". They inhabit a tough, violent world where nihilism rules. There is little hope, little sun and no joy. Howson's assured, bold technique has become gradually more formulaic, emphasizing caricature and strength of compositional structure. This lends a note of reassurance; the viewer is in no doubt that this is not the real world. It is, however, an extraordinary visualization of humanity as both feared and fearful.

Other Masterpieces

PATRIOTS;
1991;
ART GALLERY AND
 MUSEUM,
 KELVINGROVE,
 GLASGOW,
 SCOTLAND

**BLIND LEADING THE
 BLIND V;**
1991;
ANGELA FLOWERS
 GALLERY,
 LONDON,
 ENGLAND

Hunt William Holman

Born London, England 1827; **died** London, England 1910

The Scapegoat

1854; oil on canvas; 87 x 139.8 cm; Lady Lever's Art Collection, Port Sunlight, England

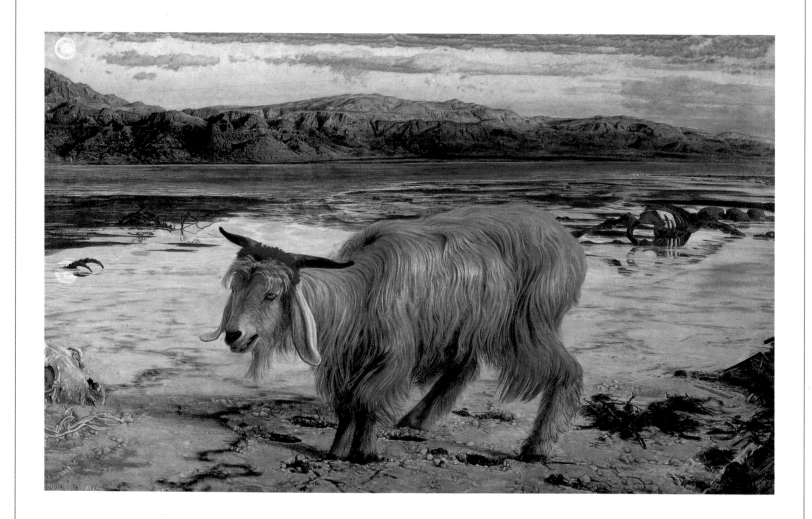

William Holman Hunt first began to study art at the British Museum and National Gallery at the age of 16. In 1844 he entered the Royal Academy where he met Dante Gabriel Rossetti and John Everett Millais. The three founded the Pre-Raphaelite Brotherhood in 1848. Hunt alone remained true to its basic principle of expressing serious moral ideas through art, combined with a truthful and realistic approach to nature. He made several trips to Egypt and Palestine from 1854 to paint religious scenes within their original location. **The Scapegoat** dates from Hunt's first trip to Palestine and shows the animal alone on the shores of the Dead Sea. Hunt believed that a realistic treatment of this biblical allegory would enhance the spiritual message. Consequently he went to great lengths to ensure that every detail in his work was historically authentic, making use of strong colours and exact realism to enhance his depiction. In later years, Hunt's obsession with accuracy as well as his dogmatic convictions grew more pronounced, and the imaginative power of his paintings declined.

Other Masterpieces

THE HIRELING
SHEPHERD;
1851;
MANCHESTER CITY ART
GALLERY,
ENGLAND

THE LIGHT OF THE
WORLD;
1854;
KEBLE COLLEGE,
OXFORD,
ENGLAND

Café Deutschland I

1978; oil on canvas; 282 x 330 cm; Galerie Michael Werner, Cologne, Germany

Jorg Immendorff is a leading German Neo-Expressionist whose artistic career began in 1961 – the same year as the Berlin Wall was constructed – with a solo exhibition in Bonn at the New Orleans Club. Beginning in 1964, he attended courses at the Kunstakademie, Dusseldorf, studying under Joseph Beuys, whose polemic and direction profoundly affected his artistic development. Immendorff's social and political concerns marked the paintings he produced at the end of the 1960s, serialized by the nonsensical LIDL slogan, referring to the world of infancy. A more overtly political element underpinned the **Café Deutschland** paintings, which referred directly to the division of Germany and the increasing polarization of society. The motifs and harsh, satirical gestures in the German Expressionist art, seventy years before, provided Immendorff with inspiration.

In addition, his experience of the realism of Renato Guttuso's **Caffé Greco** painting (1978) confirmed his approach to his subject. The high tonality, dark shadows and frenetic activity and imagery crammed into the pictorial space evoke anarchy and menace. Immendorff opened the Cafe La Paloma in Hamburg in 1984, which became a reputable exhibiting venue.

Other Masterpieces

EIGENLOB STINKT NICHT;
1983;
MICHAEL WERNER GALLERY,
NEW YORK CITY,
USA

CAFE DEUTSCHLAND HORERWUNSCH;
1983;
PRIVATE COLLECTION

Ingres
Jean-Auguste Dominique

Born Montauban, France 1780; **died** Paris, France 1867

La Grande Odalisque

1814, oil on canvas, 91 x 162cm, Musée du Louvre, Paris, France

Ingres began his artistic career as a pupil in Jacques-Louis David's studio in Paris. He won the Grand Prix de Rome, a four-year scholarship, in 1801 with a Neoclassical history painting. He painted **La Grande Odalisque** in 1814. In this, he reasserts the ideal of elegance, sensuousness and purification of line to which anatomical correctness was subservient without looking unnatural. Figure compositions and portraits were the mainstay of his oeuvre. The latter, in particular, allowed him to revel in the depiction of porcelain skin and luxurious materials and brocades and he epitomized the sumptuous lifestyle of the higher classes of nineteenth-century French society. He rarely painted landscapes. Draughtsmanship impregnated by the gothic and the archaic described his style and he was likened by one of his contemporaries to "a Chinese or Japanese artist who has strayed into Greece". After the fall of Napoleon in 1814 Ingres produced a series of small-scale paintings after medieval and Renaissance subjects and spent much of his time in Rome. He was the most admired painter of his day and was, as a teacher, one of the most influential.

Other Masterpieces

PORTRAIT OF MADAME MOITESSIER;
c.1850;
NATIONAL GALLERY,
LONDON,
ENGLAND

NUDE FROM THE BACK;
c.1815;
MUSEE DU LOUVRE,
PARIS,
FRANCE

1913; oil on cardboard; 64.5 x 53.2 cm; Private Collection

Spanish Woman with Grey Background

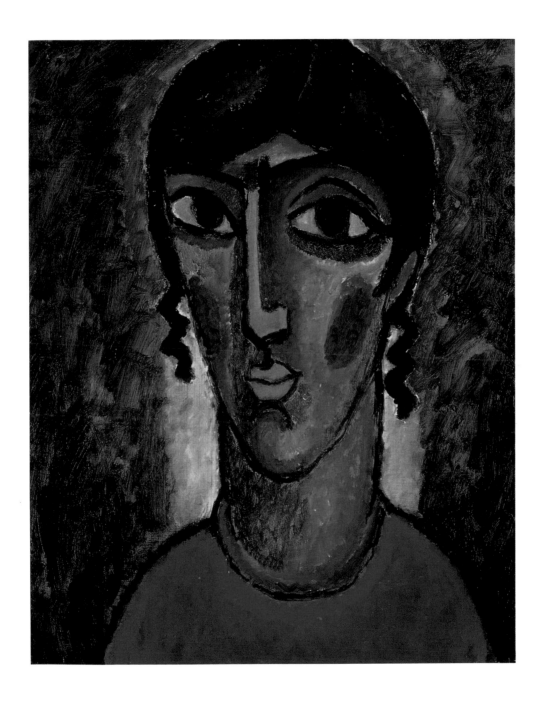

A Russian aristocrat, Alexei von Jawlensky was initially an officer in the Imperial Guard. He studied at the St Petersburg Academy before moving to Munich in 1896, where he met Kandinsky. In 1905 he travelled to Brittany and Provence. During a short stay in Paris, he worked with Matisse. Jawlensky's paintings show a mixture of influences from the naive, bold style of the Fauves to the traditional icon painting and peasant art of his native Russia. **Spanish Woman with a Grey Background** is one of a number of head-and-shoulder portraits that Jawlensky first embarked upon in 1910. Through its bold colours and expressive contours, Jawlensky reveals an interest in the universal and mystical qualities of his sitter. Like Kandinsky, he was fascinated by the relationship between colour and music, describing how "colours rang like music in his eyes". Unlike Kandinsky, however, Jawlensky never became a wholly abstract painter, preferring to pursue his meditative style of representation in portraits and landscapes. After the First World War, he settled in Wiesbaden, where he formed the Blaue Vier (Blue Four) with Kandinsky, Klee and Feininger.

Other Masterpieces

THE WHITE FEATHER; 1907; STAATSGALERIE, STUTTGART, GERMANY

PORTRAIT OF ALEXANDER SACHAROFF; 1913; STADTISCHES MUSEUM, WIESBADEN, GERMANY

A Corner of the Artist's Room

1907–1909; oil on canvas; 32 x 26.5 cm; Sheffield City Art Gallery, Sheffield, England

Gwen John studied at the Slade School of Art with her brother Augustus. She went to live in Paris in 1903 where she was taught by Whistler. A solitary and single-minded woman, she had an unhappy love affair with Auguste Rodin, whom she met in 1904. **A Corner of the Artist's Room** depicts her room at 87 rue du Cherche Midi in Montparnasse, Paris. She chose her accommodation carefully, taking into consideration the comfort of her cats as well as the view it offered. Augustus, whose own flamboyant lifestyle differed wildly from his sister's, was unhappy with her spartan choice. However, the image of her room portrayed by this canvas (she painted several versions) is of serenity and self-containment rather than neurotic, self-imposed isolation. The bright sunlight is diffused by the lace drape and attention is focused on the few possessions – a simple bunch of flowers, a wicker chair and a parasol. In 1913 John became a Catholic, declaring "My religion and my art, these are my life". She continued to live in relative isolation and painted many delicate, muted, introspective portraits, mainly of women and girls, of outstanding sensitivity. Her work is now held in higher regard than her brother's.

Other Masterpieces

SELF-PORTRAIT;
c.1900;
TATE GALLERY,
LONDON,
ENGLAND

A YOUNG NUN;
c.1920;
SCOTTISH NATIONAL
GALLERY OF MODERN
ART,
EDINBURGH,
SCOTLAND

Born Augusta, USA 1930

1962; oil on canvas with wood; 101.6 x 76.2 cm; purchased with funds provided by The Dexter M. Ferry, Jr. Trustee Corporation Fund and by Edith Ferry Hooper, Baltimore Museum of Art, Baltimore, USA

Jasper Johns is widely recognized as one of the most influential American artists of the post-war period. Following in the wake of the gestural but largely empty passions of the Abstract Expressionists, the simplicity of John's comparatively reductive art made a startling contrast. Johns settled in New York City in 1952 and met fellow artist Rauschenberg shortly after. Rather than focus on the vitality of popular culture, Johns exploited the banality of it, declaring "Take an object. Do something to it. Do something else to it". His favourite motifs were the universally familiar symbols of flags, targets, letters and numbers. Turning these into art, he provoked the viewer into considering the things the mind already knows in a different way, while highlighting the methods by which he turns such subjects into artifice. The enigmatic **Device** exemplifies Johns's techniques, which are rendered as signs and language in themselves. He is an exceptionally proficient painter and graphic artist, a master of a variety of media. His more recent work has increased in thematic and conceptual complexity, with an emphasis on more personal references.

Other Masterpieces

ZERO THROUGH NINE;
1961;
TATE GALLERY,
 LONDON,
 ENGLAND

ZONE;
1962;
KUNSTHAUS,
 ZURICH,
 SWITZERLAND

Judd Donald

Born Excelsior Springs, USA 1928; **died** New York City, USA 1994

Untitled

1972; copper, enamel and aluminium; 916 x 155.5 x 178.2 cm; Tate Gallery, London, England

Donald Judd's art training began in earnest when, in 1949, he attended the Arts Students League in New York City. During the evenings he studied philosophy at Columbia University. He graduated with an MA in art history from Columbia in 1962. He commenced his artistic career as a painter during the 1950s and his familiarity with the contemporary art world was confirmed by his employment as art critic of *Arts Magazine* from 1959. His observations of the work of emerging avant-garde artists and the development of his own work led to the realization that the two-dimensionality of painting was severely limiting and lacked specific focus. In the early 1960s, therefore, he rejected the medium to construct wall reliefs and free-standing sculpture. He developed the simplicity of the work until his sculpture was reduced to "stacks" and "progressions" – boxes and bars arranged in a mathematical sequence.. These "Specific Objects", mechanically reproduced to avoid the look of hand-made craftsmanship, quickly established him as a leader of the new Minimalist movement. **Untitled** is a typically sterile, single unit, made at a time when Judd was producing pieces in response to the context of specific environments.

Other Masterpieces

UNTITLED;
1969;
SOLOMON R.
GUGGENHEIM MUSEUM,
NEW YORK CITY,
USA

UNTITLED;
1973;
TATE GALLERY,
LONDON,
ENGLAND

Self-Portrait with Cropped Hair

1940; oil on canvas; 40 x 27.9 cm; Gift of Edgar J. Kaufmann, Museum of Modern Art, New York City, USA

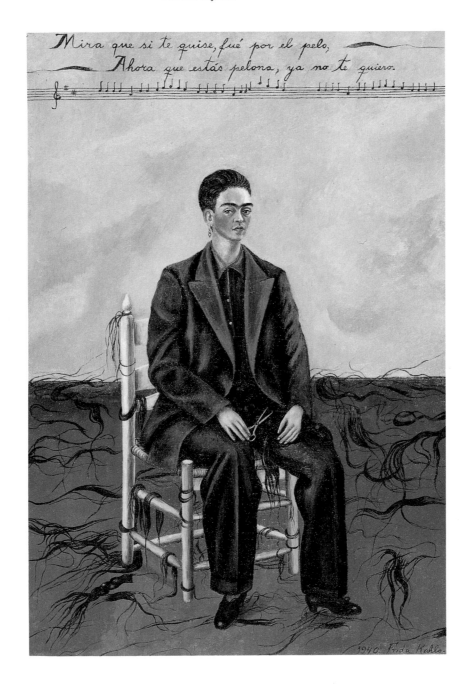

Frida Kahlo's life was transformed at the age of fifteen when a trolley car plunged into the bus in which she was a passenger. She suffered terrible injuries that served to shape her painting for the rest of her life. On small canvases and rendered with miniaturist detail, her autobiographical paintings make literal and symbolic reference to the emotional and physical pain she was had to endure. Kahlo married Mexican muralist Diego Rivera in 1929. Their stormy and tempestuous relationship led to a divorce in 1939 and reunion later in life. **Self-Portrait with Cropped Hair** was painted in response to one of Rivera's many infidelities. Kahlo represents herself in an angry and defiant mood. Dressed in a baggy man's suit she is surrounded by strands of her hair, that wriggle like snakes. The writing across the top of the painting mocks the lyrics of a popular song which declared that love was dependent upon their lover's beautiful hair. Fiercely proud, sensual and magnetic – these are all qualities associated with the legendary Frida Kahlo. Above all, however, her self-portraits provide an extraordinary insight into an intense and complex imagination.

Other Masterpieces

SELF-PORTRAIT WITH MONKEY;
1940;
COLLECTION OF MR AND MRS JACQUES GELMAN, MEXICO CITY, MEXICO

A FEW SMALL NIPS;
1935;
COLLECTION OF DOLORES OLMEDO, MEXICO CITY, MEXICO

Kandinsky Vassily

Born Moscow, Russia 1866; **died** Paris, France 1944

Improvisation 26

1912; oil on canvas; 97 x 107.5 cm; Stadtische Galerie im Lenbachshaus, Munich, Germany

Vassily Kandinsky is generally considered to be the pioneer of abstract painting. Much affected by an exhibition in Moscow of French Impressionists, he abandoned his legal career and went to Munich to study art. His early work showed a number of influences, including features of Art Nouveau, Russian folk art and the Fauves. Kandinsky was the driving force behind the formation of the Blaue Reiter group in 1912. With fellow-artists Marc and Macke, this influential group's primary commitment was to the intuitive and primitive qualities of painting, as well as to the symbolic importance of colour and line. Kandinsky began to make his first pure abstract works in 1910.

Improvisation 26 is from a series of paintings that took landscape as their starting point. Through a fluid blend of calligraphic lines and amorphous shapes, the artist expresses a sense of growing detachment from nature. The emphasis is on mood and harmony and reveals Kandinsky's fascination with the relationship between colour and music. Kandinsky taught at the Bauhaus from 1921–1933, when he left Germany for France. He was one of the most influential artists of his generation and an important art theorist.

Other Masterpieces

LANDSCAPE WITH
CHURCH;
1913;
MUSEUM FOLKWANG,
ESSEN,
GERMANY

COMPOSITION VIII NO
260;
1923;
SOLOMON R GUGGENHEIM
MUSEUM,
NEW YORK CITY,
USA

Dragon

1992; limestone and pigments; various dimensions; Installation Art Tower Mito, Mito-shi, Japan

Anish Kapoor's beautiful and contemplative abstract sculpture bridges the artistic gap between East and West. His work combines European modernist influences with the ritualistic traditions and objects associated with Hindu Tantrism. Kapoor trained at Hornsey College of Art, London from 1973–1977 and at Chelsea College of Art, 1977–1978. As an artist with both an Indian and European identity, Kapoor's work celebrates the differences and the similarities between the two. He does not approach the socio-cultural implications of his mixed identity with a political agenda. Work made during the 1980s appeared like strange fruit. Brightly coloured powdered pigment covered and settled around each piece like dust, fusing it with the floor. Later, rough-hewn stone pieces have the rich pigment clinging more closely, with gravity rather than colour being their grounding, elemental force. His organic forms, although essentially abstract, often take on a male or female identity, containing deep voids or protuberances or both. They exist as independent presences or become, like **Dragon**, comprising eleven pieces, part of a group dynamic, suggesting spiritual metaphors.

Other Masterpieces

MOTHER AS A SOLO;
1988;
COLLECTION MUSEE ST
 PIERRE,
 LYON,
 FRANCE

TURNING AROUND THE
 CENTRE;
1995;
LISSON GALLERY,
 LONDON,
 ENGLAND

Kauffman Angelica

Born Chur, Switzerland 1741; **died** Rome, Italy 1807

Self-Portrait Hesitating between the Arts of Painting and Music

1794; oil on canvas; 147 x 216 cm; reproduced by kind permission of the Winn family and the National Trust

Angelica Kauffman's father was a painter who encouraged both her artistic and musical abilities. Travelling formed part of an unorthodox upbringing that included a visit to Rome in 1763, where she established her own Rococo-inspired decorative style of portraiture. Kauffman visited Venice in 1765 and London between 1766-1981. She became a friend of Joshua Reynolds and was influenced by his classical portraits. In England, she also worked with Robert Adam on interiors and became a founder member of the Royal Academy in 1768. **Self-Portrait Hesitating between the Arts of Painting and Music** refers to the difficult decision with which she was faced when choosing between a musical and an artistic career. However, the allegorical, idealized representation of the women tends to undermine the significance of this decision for Kauffman herself. The figure representing painting points to a distant classical temple; this is a reference to the wisdom of the ancient theorists as well as to the neo-classical movement to which she belonged. Kauffman married Zucchi, an Italian decorative painter, in 1781 and settled in Rome.

Other Masterpieces

FAME DECORATING
SHAKESPEARE'S TOMB;
c.1772
BURGHLEY HOUSE
COLLECTION,
ENGLAND

PORTRAIT OF JOHANN
WINCKELMANN;
1764;
KUNSTHAUS,
ZURICH,
SWITZERLAND

208

1978–1979; slate and resin; 35.6 x 27.9 per unit, 18 units; Arts Council, London, England

Post-Partum Document VIa

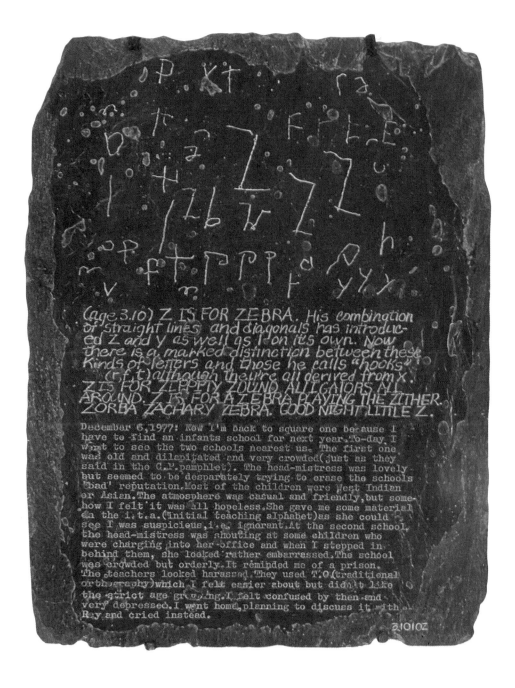

P art of the strength of the women's movement of the 1960s and 1970s, Mary Kelly progressed key developments in feminist art practice. She studied at the College of St Teresa, Winoa, Minnesota, the Instituto Pius XII, Florence, 1963–1965 and St Martin's School of Art, London 1968–1970. Her **Post- Partum Document** project spanned six years, focusing on the mother/child relationship, specifically that between her and

her infant son. She was, "concerned to deal with an area of women's experience that I felt really hadn't been spoken". Rather than construct notions of femininity via painting or sculpture, Kelly operated within a Conceptual art idiom. She distanced both herself and the viewer from the emotional intimacy of her relationship by offering a series of charts, graphs and diagrams, working like an analytical diarist, noting the feeding, growth, speech and

mark-making developments of her son. Subsequent works, **Interim** (1985), for example, represent an exploration of women's experiences in their middle years. Comprising text and imagery, this witty and humorous work accesses both the stereotypical and the specific. Kelly uses photographic images and hand-written texts to explore her own concerns and those typically assigned to women – sex, ageing, fashion and relationships.

Other Masterpieces

CORPUS (DETAIL);
1984–1985;
COLLECTION OF THE
ARTIST

GLORIA PATRI;
1992;
COLLECTION OF THE
ARTIST

Kiefer Anselm

Born Donaueschingen, Germany 1945

Parsifal III

1973; oil on paper; 299.1 x 425.8 cm; Tate Gallery, London, England

Anselm Kiefer intended to study Law and French in 1965 but became more interested in painting. Study and travel led to the production of his first important series of paintings in 1970, **Historic Emblems**. A notable period of tuition followed under his mentor Joseph Beuys from 1970 to 1972. Kiefer did not travel down the path of Minimalism and Conceptual art taken by many of the European avant-garde in the early 1970s. Instead he responded to an increasing political polarization within West Germany by reviving the large, traditional format. He dealt subtly and symbolically with his country's past, its literature and music, and the heritage of Nazism. **Parsifal III** refers to Wagner's opera and to the legends that were the composer's sources. It exemplifies Kiefer's powerful exploration of the great myths of German tradition, hinting at his interest in depicting the physical space of landscape and in architecture. This is particularly prevalent in the works referring to the influence of Caspar David Friedrich and those describing the heroic grandeur of neo-classical interiors. Kiefer's use of different materials, particularly straw and lead, remind the spectator of the physical reality of the canvas and lend metaphorical and alchemical significance.

Other Masterpieces

20 JAHRE EINSAMKEIT;
1971–1991;
MARIAN GOODMAN
 GALLERY,
NEW YORK CITY,
USA

LILITH;
1987;
TATE GALLERY,
 LONDON,
 ENGLAND

Born Dagenham, England 1935

Ken **Kiff**

Shadows (triptych)

1983–1986; acrylic on board; left and right panel, 116.8 x 88.9 cm; centre panel, 119.4 x 99 cm; Tate Gallery, London, England

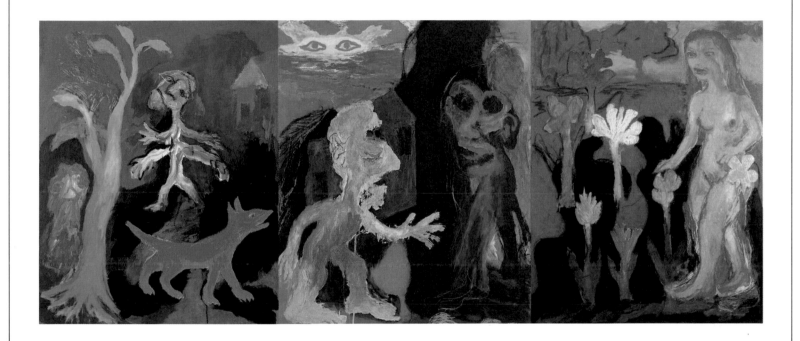

K en Kiff's work was largely ignored throughout the 1960s and 1970s, when minimal and conceptual tendencies in art were critically acclaimed. Highly imaginative and brightly coloured, Kiff's art came to prominence with the revival of figurative painting in Britain toward the end of the 1970s and during the 1980s. He is eloquent in various media including oil and acrylic paint, pastel, charcoal, woodcut and lithography, revealing himself to be a true visionary artist. The narratives in his paintings are derivative of a dream-world that is set apart from the physical reality of twentieth-century living. Kiff's imagery exists beyond an identifiable social context. However, his representation of the universal inner man is portrayed with reference to psychological and autobiographical material. This is accessed via expressionist scenes from the subconscious. In spirit he is, perhaps, closest to the Symbolist painter, Odilon Redon and, accordingly, offers motifs and colours in his pictures that are symbolic and emotionally charged. His **Shadows** triptych is an unusually sombre piece, with the shadows of the title providing a menacing presence in each scene. Together the three pictures suggest a day's journey through desires and fears, with elements of the natural world exerting vital and watchful forces.

Other Masterpieces

MAN GREETING WOMAN;
1965–1966;
ARTS COUNCIL
COLLECTION,
LONDON,
ENGLAND

ORANGE SUN, SEQUENCE NO. 187;
1973;
MARLBOROUGH FINE ART,
LONDON,
ENGLAND

Kirchner Ernst Ludwig

Born Aschaffenburg, Germany 1880; **died** Davos, Switzerland 1938

The Red Tower in Halle

1915; tempera on canvas; 120 x 90.5 cm; Museum Folkwang, Essen, Germany

German Expressionist Ernst Ludwig Kirchner met Erich Heckel and Karl Schmidt-Rottluff while studying architecture at Dresden from 1901–1905. The three founded Die Brücke in 1905 – Kirchner was the dominant force behind the group, which lasted until 1913. Inspired by Gauguin, Munch, Van Gogh and primitive art, the Brücke artists were concerned with the direct expression of human emotions. Kirchner developed an angular style that used simplified drawing and bold juxtapositions of complementary colour – a clashing mix of orange, blue, red, yellow and green. Aside from his paintings, he also produced woodcuts and coloured wooden sculpture. He moved to Berlin in 1911, where he painted a series of distorted street scenes depicting the frenzy and chaos of urban life. The red tower of the title is the focal point of an intense, exciting image. The sloping roofs and slanting streets brought up against the picture plane in sharp, distorted perspective add a dizzying sense of urgency to the picture. Kirchner suffered a nervous breakdown while serving in the First World War. He convalesced in Switzerland, producing work that drew upon the elemental force of the Alpine landscape, and which became more abstract after 1928. Kirchner committed suicide in 1938.

Other Masterpieces

STRIDING INTO THE SEA;
1912;
STAATSGALERIE,
STUTTGART,
GERMANY

BERLIN STREET SCENE;
1913;
BRUCKE MUSEUM,
BERLIN,
GERMANY

Born Cleveland, USA 1932

Ronald Brooks Kitaj

The Wedding

1989–1993; oil on canvas; 182.9 x 182.9 cm; Tate Gallery, London, England

R.B. Kitaj studied art extensively in New York, Vienna, Oxford and at the Royal College of Art, London, from 1959 to 1961. He arrived in England after travelling widely as a merchant seaman. His experience of the world made him a charismatic character among fellow students at the RCA, who were in the thralls of Pop Art. Kitaj established an enduring friendship with the artist David Hockney at this time.

The comparative superficialities of Pop did not significantly affect Kitaj's figurative work. His focus was more intellectual, looking for his subjects in his personal interests, Jewish history, the work of political activists, writers and other artists. The myriad of influences that inspired his art is complemented by the diverse imagery that appears in his oil paintings and, since 1975, pastels. His interest in the medium was instigated by a renewed admiration for Degas and the enthusiasm of his second wife, painter Sandra Fisher. **The Wedding** illustrates his marriage to her and reveals the construction of his composition. It is like a collage where the spatial relationships are disjointed and dream-like. Kitaj's later style has become more decorative, with an emphasis on flattened colour and expressive line.

Other Masterpieces

IF NOT, NOT; 1975–1976; SCOTTISH NATIONAL GALLERY OF MODERN ART, EDINBURGH, SCOTLAND

CECIL COURT, LONDON WC2 (THE REFUGEES); 1983–1984; TATE GALLERY, LONDON, ENGLAND

Klee Paul

Born Münchenbuchsee, Switzerland 1879; **died** Muralto, Switzerland 1940

The Castle in the Garden

1919–1920; 21 x 17 cm; gouache on paper; Kunstmuseum, Basel, Switzerland

Swiss-born painter Paul Klee lived in Germany for most of his life after studying in Munich. His early work consisted of etchings that showed an Expressionist influence as well as an element of fantasy, which he discovered in Blake and Beardsley. He began teaching at the Bauhaus in 1906 and was an inspirational and influential teacher. He also produced many theoretical volumes, including *Pedagogical Sketchbook* (1923). From 1911 Klee was associated with the Blue Four, namely Kandinsky, Feininger and Jawlensky. In 1914 he went to Tunisia with Macke and this visit, combined with his contact with Cubism and Robert Delaunay, was instrumental in changing his work. From then on, his work relied on a subtle and meditative arrangement of colour. Stylistically he moved freely between figuration and abstraction, the constant theme of his prodigious output being his feel for improvisation and re-invention. His sensitive, fluid and often witty paintings drew upon his love of primitive art, folk painting and children's drawings. **The Castle in the Garden** is comprised of an abstract architecture of coloured shapes. The delicate, tonal variations make up a prism through which the visible world is made remote.

Other Masterpieces

ADVENTURE OF A YOUNG LADY;
1922;
TATE GALLERY,
LONDON,
ENGLAND

AT THE SIGN OF THE HUNTER'S TREE;
1939;
KUNSTHAUS
ZURICH,
SWITZERLAND

1959; acrylic and photograph on wood; 139.7 x 119.7 cm; Tate Gallery, London, England

Yves Klein had no formal training in art. He was a jazz musician who, between 1952 and 1953 had lived in Japan, where he became a black belt in judo. In the 1950s Klein began to exhibit monochrome canvases covered in a distinctive shade of blue, which he referred to as **International Klein Blue**. This painting is one of these paintings, hence the title, **IKB 79**. The all-pervading colour is intended to act as a contemplative screen rather than to encourage the viewer to make subjective associations. Klein's minimalist exhibition of 1958 flouted every convention, presenting to the public an empty, white-washed Parisian gallery. Known as **The Void**, it was the scene of a near riot when it opened. Klein continued to shock, with his "happenings" known as **Anthropométries** 1958–1960. In these, nude models daubed in blue paint imprinted themselves on canvas to musical accompaniment – a single note sustained for ten minutes, alternated with ten minutes of silence. His works were produced using a variety of unorthodox methods, including a flame-thrower, and rainfall on to a prepared canvas. Klein died aged 34 from a heart attack. His innovatory work had a lasting impact on the development of twentieth century art.

Other Masterpieces

FIRE F 45;
1961;
PRIVATE COLLECTION,
 PARIS,
 FRANCE

TRILOGIE BLUE – OR PINK;
1960;
LOUISIANA MUSEUM
 OF MODERN ART,
 HUMLEBAEK,
 USA

Klimt Gustav

Born Baumgarten, Austria 1862; **died** Vienna, Austria 1918

Judith II

1909; oil on canvas; 178 x46 cm; Museo d'Arte Moderne, Venice, Italy

Gustav Klimt enjoyed early success as a decorative painter, working on the staircase in the Kunsthistorisches Museum in Vienna in 1891. He resigned from the conservative Viennese Artists' Association in 1897 and, with other artists, set up the Viennese Secession. Klimt was their first President. A leading Symbolist and Art Nouveau painter, he exerted particular influence on Oskar Kokoschka and Egon Schiele. Most of his portraits are of woman – often archetypal, idealized women – depicted in an array of alluring poses. His work is highly distinctive through its mosaic and decorative patterning and extensive use of gold. **Judith II** is Klimt's second version of the story of Judith and Holfernes in which Judith, a pious and courageous widow, is forced to decapitate the army commander after been given to him as a hostage.

The work caused an outcry amongst Viennese critics because of the unlikely portrayal of Judith as a femme fatale and the unmistakable eroticism of her semi-naked torso, half-closed eyes and parted lips. This is a woman whose raptuous expression suggests she has achieved orgasm at the point of Holfernes' death.

Other Masterpieces

BEECH FOREST I;
c.1902;
MODERNE GALERIE,
DRESDEN,
GERMANY

THE KISS;
1907–1908;
OSTERREICHISCHES
GALERIE,
VIENNA,
AUSTRIA

Meryon

1960–1961; oil on canvas; 235.9 x 195.6 cm; Tate Gallery, London, England

Franz Kline had much in common with the Abstract Expressionist group of artists with whom he is associated. However, in many ways, his painting was quite distinct from their work. He trained at Boston University (1931–1935) and travelled to London, where he studied painting and drawing at Heatherley's Art School. Back in New York, in 1940, he received various barroom mural commissions. It was not until 1946 that his awareness of developments in painting, specifically in the gestural works of de Kooning and the "Action Painting" of Jackson Pollock, for example, inspired him to veer toward abstraction. By 1950, he had begun producing the monumental, black and white canvases such as **Meryon**, for which he is best known. Like a small, calligraphic sketch magnified to monstrous proportions, the power of this image, typically produced with a house-painter's brush, is awesome. The white areas, the "negative" spaces, were equally as important as the black, positive blocks. However, Kline's palette was not limited to monochrome. The colourful, saturated hues he applied to some of his canvases were not merely decorative but satisfied his desire, "to feel free to work both ways".

Other Masterpieces

BLUEBERRY EYES;
1959–1960;
NATIONAL MUSEUM OF
AMERICAN ART,
SMITHSONIAN
INSTITUTION,
WASHINGTON DC,
USA

BLACK IRIS;
1961;
THE MUSEUM OF
CONTEMPORARY ART,
LOS ANGELES,
USA

Knight
Dame Laura

Born Long Eaton, England 1887; **died** London, England 1970

Ruby Loftus Screwing a Breech-Ring

1943; oil on canvas; 86.3 x 101.6 cm; Imperial War Museum, London, England

In 1890, the artist began as a full time student at Nottingham School of Art and had won silver and bronze medals for her portraiture by the age of sixteen. She lived in two artists' colonies – Staides, Yorkshire and Newlyn, Cornwall – before settling with husband, painter Harold Knight, in London in 1918. In 1927, she became the second woman to be made an Associate of the Royal Academy. She is known for her popular paintings of the circus and the ballet and was duly recognized for her technique, which satisfied conservative standards of the Academy. However, her most memorable achievements are encapsulated in the monumental painting of **Ruby Loftus Screwing a Breech-Ring**. Focusing on women's work in an armaments factory in 1941, Knight draws attention, with scrupulous detail, to the position of women in the war effort. Ruby is made a symbol of virtue and hard work, literally illuminated like a saint by her task, which was of national importance. Knight was made an official war artist in 1942 and was commissioned to paint the Nuremburg war trials in 1945. The sensitive interpretation of her lesser known works, featuring women and children, have largely been overlooked.

Other Masterpieces

THE BEACH;
1908;
LAING ART GALLERY,
NEWCASTLE-UPON-
TYNE,
ENGLAND

SELF-PORTRAIT;
1913;
NATIONAL PORTRAIT
GALLERY,
LONDON,
ENGLAND

Born Pöchlarn, Austria 1886; **died** Montreux, Switzerland 1980

Ambassador Ivan Maisky

1942–1943; oil on canvas; 120 x 76 cm; Tate Gallery, London, England

Oskar Kokoschka trained at the Vienna School of Arts and Crafts (1905–1909). Significant to his development was the artistic climate in Austria, including the recent introduction to Art Nouveau, the work of Gustave Klimt and the existence of the craft workshops "Wiener Werkstatte". In response, Kokoschka produced lithographs and posters that revealed his strong graphic sense. He began exhibiting in 1908. From the beginning he imbued his Expressionist style with a highly original imagination. The drawings he contributed to Berlin's avant-garde Der Sturm journal bear testimony to this. From 1919 to 1924 he taught at Dresden Academy, after recovering from wounds inflicted during the war. Kokoschka travelled in Europe and North America and Prague. He moved to England in 1938. **Ambassador Ivan Maisky** was the Soviet Ambassador in London from 1932 to 1943. Typical of Kokoschka's so-called "psychological portraits", the essence of the sitter's personality is extracted with a frenetic play of colourful brush marks, seemingly assembled on the canvas at random. This fresh, apparently spontaneous approach injects vitality into his subjects. Kokoschka's land and cityscapes, often seen from a high viewpoint, are equally memorable.

Other Masterpieces

CHILDREN PLAYING;
1909;
KUNSTMUSEUM,
DUISBERG,
GERMANY

VIEW OF THE THAMES;
1959;
TATE GALLERY,
LONDON,
ENGLAND

Kollwitz Käthe

Born Konigsberg, Germany 1867; **died** Moritzbur, Germany 1945

Tower of Mothers

1937–1938; bronze statue; 27 x 27.5 cx 28 cm; Baltimore Museum of Art, Maryland, USA

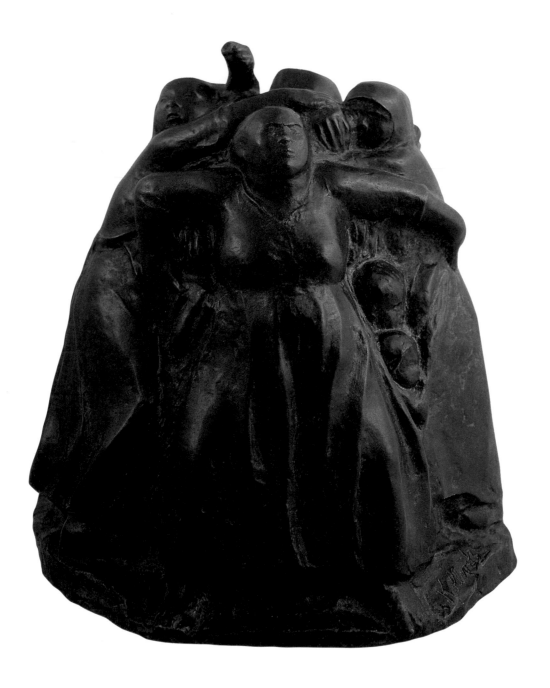

Käthe Kollwitz was a graphic artist and sculptor whose powerful work reflected her keen left-wing political sympathies. She married a doctor in 1891 and lived in a Berlin slum until it was bombed in 1943. She started to make etchings, woodcuts and lithographs that expressed her concern for the plight of those forced to live and work in inadequate social conditions. Kollwitz had her own share of human suffering – her son was killed in the First World War and her grandson in the Second – tragic events that fuelled her own pacifism. In 1933 she was expelled from the Academy in Berlin by the Nazis. In her later years she made some bronzes, including a war memorial at Essen in Flanders. Drawing upon the great strength and humanity that she found in the mother and child relationship, **Tower of Mothers** depicts an important recurring theme in her work. This small bronze provides, through its amorphous and anonymous mass of mothers protecting their children, a solid and authentic expression of empathy in a largely uncaring and alienated society.

Other Masterpieces

PIETA;
1937–1938;
KATHE KOLLWITZ,
BERLIN,
GERMANY

WAR MEMORIAL;
1932;
DIXMUIDEN,
FLANDERS,
NETHERLANDS

Born Rotterdam, Netherlands 1904

1966–1967; oil on canvas; 152.4 x 121.9 cm; Tate Gallery, London, England

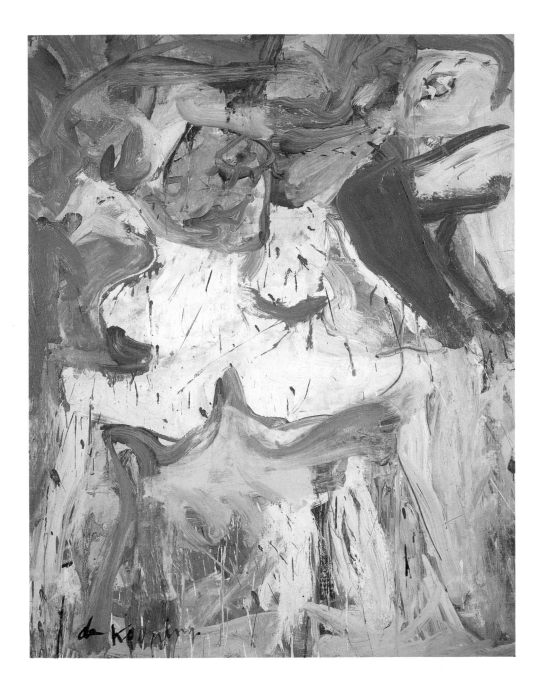

Willem de Kooning was apprenticed to a firm of commercial artists at the age of twelve. In 1925, he received his diploma from the Rotterdam Academy of Fine Arts and emigrated to America. He set himself up in New York, where the skills he had acquired enabled him to work as a house painter and commercial artist. He met and established a firm friendship with the Armenian artist, Arshile Gorky. They shared a studio and by 1936 de Kooning was painting full time. Gorky's involvement with the Surrealist movement exerted a notable influence on de Kooning's work. Black and white paintings of the late 1940s gave way to a series of paintings of women. Although he was respected by fellow artists, it was not until the early 1950s that de Kooning's paintings began to sell. The energetic, gestural qualities of paintings such as **The Visit** have established de Kooning as a notable figure among the Abstract Expressionists. Veering on abstraction, they transform the figure while retaining classical elements. De Kooning remained faithful to the interpretation of identifiable subject matter – the figure or landscape. Even his latest reductive paintings derive from his experience of man's relationship with nature.

Other Masterpieces

ROSY-FINGERED DAWN AT LOUSE POINT; 1963; STEDELIJK MUSEUM, AMSTERDAM, NETHERLANDS

WOMAN I; 1950–1952; THE MUSEUM OF MODERN ART, NEW YORK CITY, USA

Koons Jeff

Born York, USA 1955

Rabbit

1986; stainless steel sculpture; 104 x 48 x 30.5 cm; Saatchi Collection, London, England

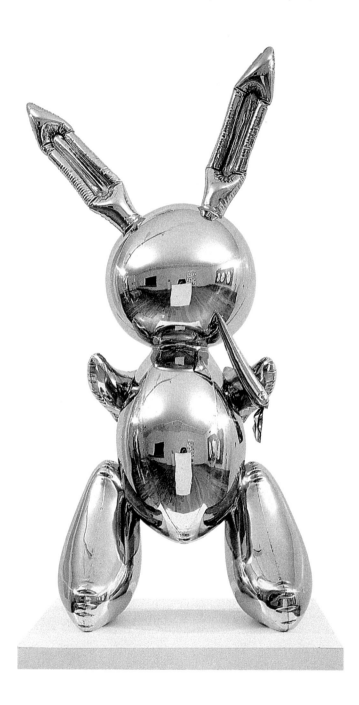

Jeff Koons' art could be said to epitomize late 1980s consumerist kitsch. A disciple of Duchamp's ideology concerning the ready-made, he came to fame with his frank presentations of consumer items, vacuum cleaners and basket-balls. Also ornaments were reproduced, not by Koons himself, but by traditional craftsmen. These are often alarmingly outsized or rendered in materials that either blatantly mimic or deliberately subvert the original. **Rabbit**, for example, is fashioned on a toy balloon, which succumbs to touch and is essentially fragile. As an artwork it is hard, precious and iconic, shiny and expensive. Sculptures of cultural celebrities followed. From 1989–1991 Koons worked with his wife Ilona Staller "La Cicciolina" to produce the **Made in Heaven** project. Sculptures, paintings, posters and magazine photo-pieces depict the couple's sexual love. It is an uninhibited series that is shocking in its flagrant depiction of carnal activity. It at once mocks and becomes the pornography, labelled as eroticism, which is a traditional motif, intrinsic to art history. In spite of the often shocking content of Koons' work, it is a potent reminder that the human condition is frail, subject to materialism, narcissism and sentimentality.

Other Masterpieces

MICHAEL JACKSON AND BUBBLES;
1988;
SONNABEND GALLERY,
NEW YORK CITY,
USA

POPPLES;
1988;
JEFF KOONS
PRODUCTIONS,
USA

1971; oil on board; 1687 x 214 cm; Tate Gallery, London, England

Children's Swimming Pool After Afternoon

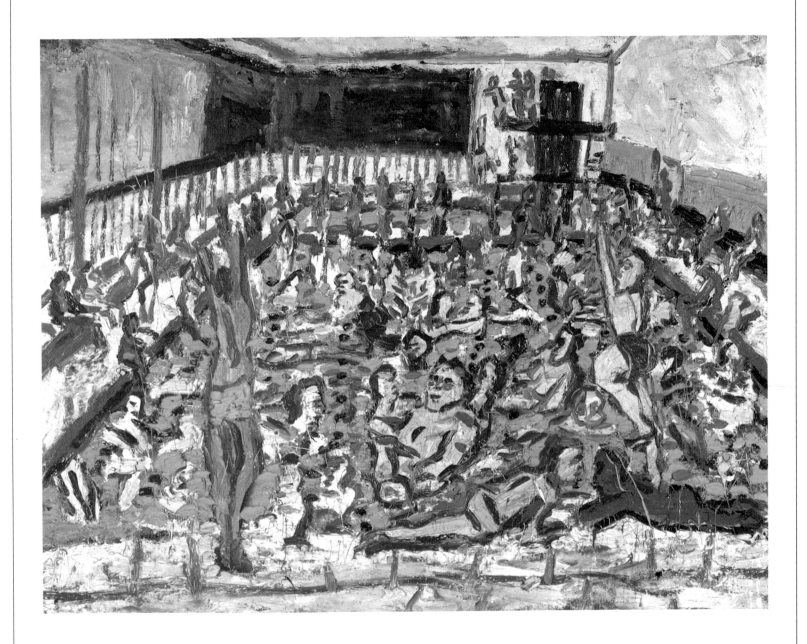

Leon Kossoff was one of seven children born to Russian-Jewish immigrant parents. Based on his immediate environment, his lustrous paintings tacitly acknowledge his origins. Speaking about his work, in 1974, he suggests that images of the city that fill his pictures similarly infuse his mind, "like a faintly glimmering memory of a long forgotten, perhaps never experienced, childhood". He attended David Bomberg's evening classes at the Borough Polytechnic from 1950 to 1952 and studied at St Martin's College of Art, the Royal College of Art and Chelsea School of Art, finishing his formal art training by the mid-1950s. He had his first solo exhibition in 1957 and joined the London Group of artists in 1962. Stylistically similar to the work of Frank Auerbach, Kossoff's range of subject matter is also confined to his locality, friends and trusted models. Kossoff's thick, syrupy paint surface is the result of many layers of chalky coloured impasto. It is difficult to distinguish where drawing ends and painting begins. **Children's Swimming Pool After Afternoon** is typical of Kossoff's monumental appraisal of a complex subject, challenging in its perspectival depth and changing light effects.

Other Masterpieces

BOOKING HALL, KILBURN UNDERGROUND;
1987;
TATE GALLERY, LONDON, ENGLAND

BETWEEN KILBURN AND WILLESDEN GREEN, WINTER EVENING;
1992;
SCOTTISH GALLERY OF MODERN ART EDINBURGH, SCOTLAND

Kounellis Janis

Born Piraeus, Greece 1936

Untitled

1983; pen and ink on paper; 35.6 x 43 cm; Tate Gallery, London, England

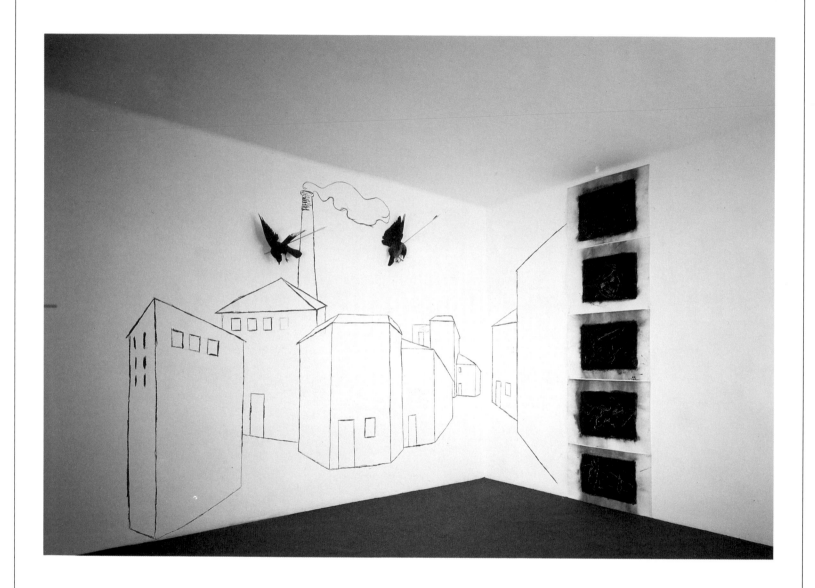

Aged twenty, Janis Kounellis moved from Greece to Rome where he studied at the Accademia delle Belle Arti and became familiar with the work of modern Italian painters such as Alberto Burri and Lucio Fontana. In 1958, he embarked on a series of large paintings on paper that used graphic signs, numbers and letters. Two years later, these formed the basis for his first solo exhibition in Rome, where Kounellis literally accompanied his work by chanting notations derived from his paintings. In 1966, he started to make three-dimensional work in the form of installation and performances. In 1969, he tethered twelve horses to the Galleria L'Attico in an enquiry into the nature of certainty and chance. His temporary installations used commonplace but unusual sculptural materials such as cotton, coal and fire. In the late 1960s, he became the leading figure in Arte Povera, a post-minimalist art movement associated with the production of works from freely-available materials. In the late 1970s, Kounellis introduced classical motifs into his work. His recent large-scale, site-specific installations have made use of roughly-hewn wood, charcoal and bells, referencing a nostalgia for a historical and cultural past. He lives and works in Rome.

Other Masterpieces

UNTITLED;
1980;
SONNABEND GALLERY,
NEW YORK CITY,
USA

UNTITLED;
1979;
TATE GALLERY,
LONDON,
ENGLAND

1985; photographic silk screen/vinyl; 43 x 82.6 cm; Mary Boone Gallery, New York City, USA

We Don't Need Another Hero

Barbara Kruger's feminist art is based upon the striking juxtaposition of text and photographic imagery, powerfully rendered in a propagandist poster format. In 1965, she began studying fine art at Parsons School of Design and the School of the Visual Arts, New York. She became disillusioned with her short-lived employment as a graphic designer for Condé Nast but the commercial spirit lived on in her own work.

Her characteristic bombardment of the viewer with overt instructions and authoritative statements is exemplified by **We Don't Need Another Hero**. Such strident imagery has graced billboards, shopping bags – "I Shop Therefore I Am", matchboxes, T-shirts and gallery installations. Similar to Jenny Holzer's digitized messages of "universal truths", Kruger's line of communication has a dictatorial, pedantic spirit, visualized in the manifesto style of Russian Constructivism, in black and white, and often, red. The effect that the media has on our lives and its infiltration into our urban environment, with hidden codes and cryptic suggestions, is the substance of her work. It is "seeing how culture exists".

Other Masterpieces

UNTITLED;
1991;
MARY BOONE GALLERY,
NEW YORK CITY,
USA

UNTITLED;
1985;
TATE GALLERY,
LONDON,
ENGLAND

Landseer Sir Edwin

Born London, England 1802; **died** London, England 1873

Monarch of the Glen

1850; oil on canvas; 166.4 x 171.4 cm; Dewar House, London, England

Sir Edwin Landseer was an infant prodigy who first exhibited at the Royal Academy at the age of 12. He enjoyed a successful career based upon paintings that lent their animal subjects a range of human expressions and virtues. His brother Thomas was an engraver whose many prints of Landseer's work helped to increase their popularity. Queen Victoria's favourite painter, he was knighted in 1850. **Monarch of the**

Glen is Landseer's best known painting. It is a large work, which not only shows great skill in its rendition of a stag, but which embodied certain human virtues considered important in the Victorian age. The stag is the personification of nobility and heroism. The Scottish highland setting, already popularized by the novels of Sir Walter Scott, was given added status through Queen Victoria's residence there. Landseer's

work has lost some of its appeal in the twentieth century, apart from accusations of sentimentality, the paintings have been attacked on the grounds that they frequently depict and often glorify the bloodsport of deer-hunting. Landseer also worked on several sculptures, including the lions at the foot of Nelson's Column.

Other Masterpieces

THE OLD SHEPHERD'S CHIEF MOURNER;
1837;
VICTORIA AND ALBERT MUSEUM, LONDON, ENGLAND

DIGNITY AND IMPUDENCE;
1839;
TATE GALLERY, LONDON, ENGLAND

Peter Lanyon

Lost Mine

1959; oil on canvas; 183.2 x 152.7 cm; Tate Gallery, London, England

Peter Lanyon's home had, since the 1880s, been attracting the attention of artists who relished the light, land and seascape views of the Cornish town of St Ives. Lanyon, credited as a major painter of the St Ives School, attended the Penzance School of Art and, briefly, the Euston Road School in London. In 1939, the migration of artists to his locality brought him into contact with Ben Nicholson, Barbara Hepworth and Naum Gabo.

This impacted on Lanyon's work and he rejected landscape studies in favour of making abstract, three-dimensional constructions. These and his free-standing sculptures subsequently influenced the direction of his painting. His response combined together the romantic lyricism of the Cornish landscape and abstraction. With a loose, expressive technique, he aimed to represent a spatial structure describing the complete experience

of being in the landscape, rather than an observation from a single viewpoint. He exhibited his work in New York in 1959 and made friends with American Expressionists Kline and Rothko. **Lost Mine** dates from this time and has similar qualities to the work of his counterparts in the States. In the same year he took up gliding, literally giving a new angle on his landscape visions; it proved a fatal activity.

Other Masterpieces

PORTHLEVEN;
1951;
TATE GALLERY,
LONDON,
ENGLAND

BOJEWYAN FARMS;
1951–1952;
BRITISH COUNCIL
COLLECTION,
LONDON,
ENGLAND

La Tour **Georges de**

Born Vic-sur-Seille, France 1593; died Lunéville, France 1652

The Magdalene with Nightlight

c.1650; oil on canvas; 128 x 94 cm; Musée du Louvre, Paris, France

It is believed that Georges de la Tour lived and worked for most of his life in the Duchy of Lorraine. Little is known of his life, although he did enjoy the patronage of the Duke of Lorraine from 1623. Curiously, he was completely forgotten until his belated rediscovery in 1915. La Tour is now greatly admired for his religious and genre paintings, particularly the nocturnal scenes, which often make use of a candle or lamp as a single light source. **The Magdalene with Nightlight** is a prime example of a candlelit scene whose dramatic shadows recall the work of the great Italian master, Caravaggio. The sombre and monumental mood of the painting is enhanced through the use of smooth and simplified forms. The Magdalene is dressed in everyday, humble clothing and appears lost in thought. There is a quiet mysticism to the work, despite the presence of the ghoulish skull. Although there is uncertainty over the dating and attribution of some of his work, his classically inspired simplicity has prompted comparisons with Piero della Francesca and Poussin.

Other Masterpieces

PENITENT ST PETER;
1645;
CLEVELAND MUSEUM
OF ART,
OHIO,
USA

ST JEROME;
1635;
MUSEE DE GRENOBLE,
FRANCE

Charles William Lambton

1825; oil on canvas; 137.2 x 111.8 cm; Private Collection, London, England

Thomas Lawrence was an infant prodigy. His talent for portraiture first became apparent when he used to make likenesses of his father's guests at the family's hostel in Devizes. At the age of 18, he was a student at the Royal Academy and met Joshua Reynolds, the most fashionable portrait artist of the day. His portrait of Queen Charlotte, shown at the Academy in 1790 confirmed his reputation. He was appointed painter to the King on the death of Reynolds in 1792. **Charles William Lambton** is one of the best-known of his portraits of children. It reveals Lawrence's pleasing sense of design and the dexterity and fluidity of his brushwork. Lawrence was essentially a Romantic artist who recorded the charmed life of the aristocracy of which he became part. As a contemporary remarked, "this is the merit of Lawrence's painting – he makes one seem to have got into a drawing room in the mansion of the blest, and to be looking at oneself in the mirror". His dazzling style, however, eventually fell out of favour and his reputation declined after his death.

Other Masterpieces

QUEEN CHARLOTTE;
1789–1790;
NATIONAL GALLERY,
LONDON,
ENGLAND

PIUS VII;
1819;
COLLECTION OF HER
MAJESTY THE QUEEN,
LONDON,
ENGLAND

Léger Fernand

Born Argentan, France 1881; **died** Gif-sur-Yvette, France 1955

The Construction Workers

1951; oil on canvas; 160 x 200 cm; Pushkin Museum, Moscow, Russia

Léger studied architecture at Caen and painting at the Académie Julien from 1903. He became part of the Cubist circle in Paris, working alongside Braque and Picasso in about 1910. After the First World War, the dynamism of machinery and the geometrical shapes making its components influenced Léger's robotic figures, clean lines and pure colours in his compositions. From 1920 his tubular metallic and abstracted forms entered into designs for the Swedish Ballet and actual objects made the first abstract film, *La Ballet Mécanique*, on which he collaborated with Man Ray in 1924. He spent the years of the Second World War in the United States teaching at Yale University, focusing on acrobats and cyclists as subjects, rendering them static and unlikely candidates for the movement they suggested. **The Construction Workers** was painted after his return to France, illustrating the technical achievements of the people. It is a highly stylized, idealistic image of the working man in harmony with modern technology and nature. Leger offers a stoical vision lacking in subtlety but befitting an appropriate description of him as the "Primitive" of the machine age.

Other Masterpieces

STILL LIFE WITH A BEER
 MUG;
1921–1922;
TATE GALLERY,
 LONDON,
 ENGLAND

TWO WOMEN HOLDING
 FLOWERS;
1954;
TATE GALLERY,
 LONDON,
 ENGLAND

Lieder ohne Worte

c.1860–1861; oil on canvas; 101.6 x 62.9 cm; Tate Gallery, London, England

The first third of Frederic Leighton's life was spent travelling in Europe, studying and painting in Florence, Frankfurt and Paris. This intellectual and charismatic aesthete settled in London in 1860 and by 1879 had become President of the Royal Academy. **Lieder Ohne Worte** (Song Without Words) is a masterpiece produced shortly after Leighton's arrival in England. It heralded a change of mood in British Painting. Titled after a popular Mendelssohn piano piece, the picture emulates the ideals of the Aesthetic Movement, as expounded by Whistler, and proclaimed a Classical revival. It is distinct from the moralistic, religious overtones underlying the harsh realism of the Pre-Raphaelite Brotherhood. The languid mood of the composition is complemented by the decorative aspects of the design and the carefully orchestrated colour harmonies. These essentially abstract qualities were intended to function like those of music. Leighton and artists Edward Poynter, Albert Moore and Alma-Tadema became known as the Olympians, referring to their god-like status in artistic society. In spite of adhering to an aesthetic formula, Leighton's focus on the drama and romance of Classical and ancient Greek subjects and his renditions of sensual women and sumptuous draperies undoubtedly contributed to his popularity.

Other Masterpieces

THE CAPTIVE ANDROMACHE;
c.1865;
MANCHESTER CITY ART GALLERIES, MANCHESTER, ENGLAND

THE GARDEN OF THE HESPIRIDES;
1882;
LADY LEVER ART GALLERY, PORT SUNLIGHT, ENGLAND

Lely Sir Peter

Born Soest, Westphalia 1618; **died** London, England 1680

Two Ladies of the Lake family

c.1660; oil on canvas; 127 x 181 cm; Tate Gallery, London, England

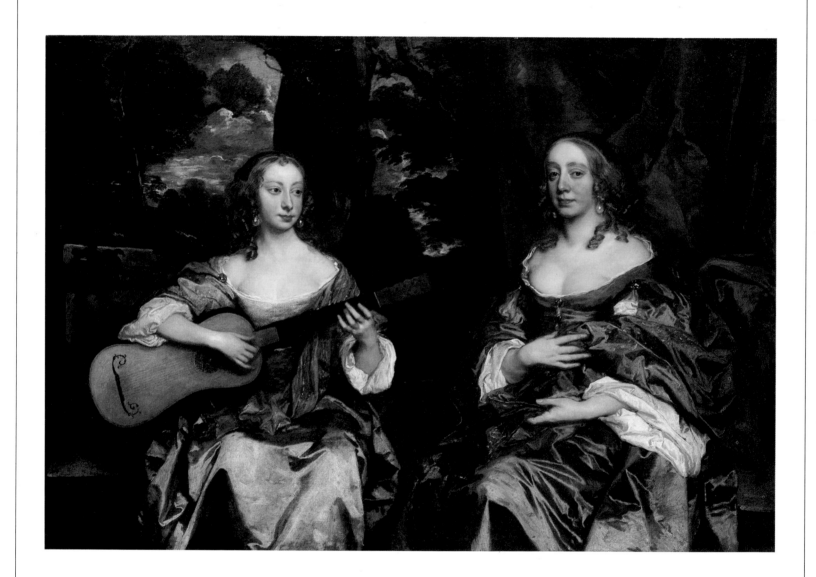

Born Pieter van der Faes, the artist studied in Haarlem. After moving to London in the early 1640s, Lely was chiefly associated with the British school. His early work consisted of historical paintings and a few religious works. Following the death of Anthony van Dyck in 1641, Lely found favour with King Charles I and painted a number of portraits of him and his family during their imprisonment at Hampton Court.

Lely survived under the repressive Puritan rule and, with the Restoration of the monarchy in 1660, became a leading painter to Charles II, concentrating on portraits depicting the sumptuous lifestyle enjoyed by those at the court. One of the most successful portraitists of the seventeenth century, Lely's work remained highly influential until the opposing tradition – represented by Hogarth – came to prominence in the eighteenth century.

Revealing a mastery of harmonious composition, Lely's portrait of **Two Ladies of the Lake Family** captures the sensuous elegance of the members of the aristocratic circle within which he moved. In this eloquent and enticing image, Lely directly appeals to the viewer by emphasizing the voluptuousness of the sitters, the high colours and realistic illusion.

Other Masterpieces

FLAGMEN (SERIES);
1666;
NATIONAL MARITIME
 MUSEUM,
 LONDON,
 ENGLAND

THE WINDSOR BEAUTIES
 (SERIES);
1665;
HAMPTON COURT,
 LONDON,
 ENGLAND

Leonardo da Vinci

Cartoon for Virgin and Child with St Anne

1499–1500; charcoal on tinted paper; 141.5 x104.6 cm; National Gallery, London, England

Painter, sculptor, draughtsman, writer, architect, inventor, scientist, musician – Leonardo da Vinci was the most accomplished Renaissance artist. The illegitimate son of a Florentine notary, Leonardo's extraordinary artistic ability allegedly so impressed his master, Verrochio, that he gave up painting. Leonardo spent 17 years in Milan from 1482, working mainly for the Duke of Milan. He then returned to Florence, where he painted the renowned Mona Lisa between 1503–1506. His last years were spent in triumph at the French court of Francis I. One of the most important works in the National Gallery's collection, **Cartoon for Virgin and Child with St Anne** is kept in a darkened room to prevent it from fading. Cartoons were preparatory large-scale drawings to be transferred to a wall or canvas as a guide to the final painting. This cartoon was never actually transferred. Covering eight sheets of paper, it is drawn in charcoal with white chalk highlights. The extraordinary feature of this work is the intense interplay of emotion within the tightly knit group of figures. Leonardo's particular skill was to endow his mainly religious subjects with a spirituality and enigmatic beauty unsurpassed in the history of fine art.

Other Masterpieces

MONA LISA;
1503–1506;
MUSEE DU LOUVRE,
PARIS,
FRANCE

VIRGIN OF THE ROCKS;
BEFORE 1483;
MUSEE DU LOUVRE,
PARIS,
FRANCE

Lewis Percy Wyndham

Born Nova Scotia, Canada 1882; **died** London, England 1957

A Reading of Ovid (Tyros)

1920–1921; oil on canvas; 165.2 x 90.2 cm; Scottish National Gallery of Modern Art, Edinburgh, Scotland

Wyndham Lewis was the formidable energy behind the British Vorticist movement. After the breakdown of his parents' marriage, in 1893, he lived in London with his mother. He studied for three years, from 1898, at the Slade School of Art and then spent six years travelling around Europe. In 1911 he joined the Camden Town Group and, in 1913, the Omega Workshops. In 1914, the avant-garde magazine, *Blast*, of which Lewis was editor, published his Vorticist manifesto. This was the literary counterpart of the modern, emphatically mechanistic paintings he was producing at the time. The war, in which Lewis served as both active participant and, later, official war artist, quelled the power of the Vorticist movement. Lewis's success as a writer also gained momentum, earning praise from the poet T.S. Eliot. **A Reading of Ovid (Tyros)** is one of a series of mythological paintings containing robotic figures, leading up to his move in 1939 to the United States and Canada. It represents a partial and diluted version of Lewis's earlier explorations of an advanced, modernist visual language, reflecting the machine technologies of the age. Lewis became blind in 1951 and devoted his creative energies to art criticism and teaching.

Other Masterpieces

THE DANCERS;
1912;
MANCHESTER CITY ART
 GALLERIES,
 MANCHESTER,
 ENGLAND

A BATTERY SHELLED;
1918;
IMPERIAL WAR MUSEUM,
 LONDON,
 ENGLAND

Born Hartford, Connecticut, USA 1928

1972; enamel on metal; 160 x 305.4 cm; Tate Gallery, London, England

Two Open Modular Cubes

Sol Le Witt's position as a sculptor was central to the Minimal and Conceptual art movements in New York during the 1960s. After completing his studies at Syracuse University, graduating in 1949, he eschewed the artistic trend toward Abstract Expressionism to concentrate on developing an intellectual approach to sculptural construction. Paradoxical elements in the two-dimensional work of Jasper Johns proved influential. Johns's art, concerning issues of perception, repetition and language, fed into Le Witt's. His earliest works focused on the relationship between the idea and its physical realization through process. Cerebral, non-referential sculpture remains at the root of his production. Early hybrid wall structures began to extend further into space to develop into the free standing format, of which **Two Open Modular Cubes** is a prime example. His use of the cube as a primary unit, and of the grid, was inspired by the emerging New Mathematics, which introduced diagrammatic methods, the matrix and sets etcetera, into mathematical study. By the 1970s, Lewitt's inert, monumental structures had become part of a range of media that included drawings, prints, wall drawings and artist's books. "Seriousness and it's claim to modernity", was his work's strength.

Other Masterpieces

3X3X3;
1969–1983;
CREX COLLECTION,
SCHAFFHAUSEN,
SWITZERLAND

COMPLEX FORM #6;
1988;
NATIONAL MUSEUM OF
JAPAN,
TOKYO,
JAPAN

Lichtenstein Roy

Born New York City, USA 1923

Whaam!

1963; acrylic on canvas; 172.7 x 406.4 cm; Tate Gallery, London, England

Roy Lichtenstein created the imagery that has the widest appeal of the work produced by the American Pop artists during the 1960s. His name has become synonymous with the "comic strip" canvases with which he launched his career in 1962. His tuition began at the Art Students League in 1939. Studies at the Ohio State University were interrupted by a period spent serving with the US Army from 1943–1946.

He began exhibiting in 1949, with paintings inspired by American history and Cubism. Later, he moved into Abstract Expressionist mode. It was not until he came into contact with experimental artist Allan Kaprow, while teaching at Rutgers University in the early 1960s, that he developed an interest in consumer culture and "Happenings". The cheap printing methods of comic production and the stylized drawing of the melodramatic

narratives that proliferated these publications became Lichtenstein's main source of inspiration. **Whaam!** epitomizes this genre in which the crises of war, the pain of love and the horror of explosions become removed from reality. The meticulous reproduction of the printed dots highlights the artificiality of the episode described and the limitations of both the comic medium and the two-dimensionality of paint on canvas.

Other Masterpieces

M-MAYBE (A GIRL'S
PICTURE);
1965;
MUSEUM LUDWIG,
COLOGNE,
GERMANY

BIG PAINTING NO.6;
1965;
KUNSTSAMMLUNG
NORDRHEIN-
WESTFALEN,
DUSSELDORF,
GERMANY

Max Liebermann

Terrace at the Restaurant Jacob in Niestedten on the Elbe

1902; oil on canvas; 70 x 100 cm; Kunsthalle, Hamburg, Germany

Painter and graphic artist Max Liebermann studied in Amsterdam and Paris. One of the first German artists from his generation to respond to foreign painters, he was influenced by Courbet, Millet and the landscape painters of the Barbizon school. On his return to Germany in 1878 he became the leading German Impressionist. Liebermann painted scenes of peasants and elderly people. The influence of Impressionism on his predominantly realistic landscape style can be seen in **Terrace at the Restaurant Jacob in Niestedten on the Elbe**. In this painting, the sunlight filtering through the dark canopy lighting the sketchy background figures is reminiscent of Renoir. The colours, however, are more tonal and the overall effect is less spontaneous than works by his French Impressionist counterparts. Liebermann founded the Berlin Secession in 1899 and became its President. Although he was an important intermediary between the new painting in France and the older narrative tradition in Germany, his work was quickly made to look outmoded. He was a supporter of the conservative tradition against which Nolde and members of Die Brücke revolted.

Other Masterpieces

THE PARROT KEEPER;
1902;
MUSEUM FOLKWANG,
ESSEN,
GERMANY

SCWEINMARKT IN HAARLEM;
1891;
STADTISCHE
KUNSTHALLE,
MANNHEIM,
GERMANY

Limbourg
Paul, Jean and Herman de

Born Limbricht, Netherlands c.1385; **died** Netherlands c.1416

January (from the Très Riches Heures du Duc de Berri)

1413–1416; manuscript; 29 x 21 cm; Musée Condé, Chantilly, France

Paul, Jean and Herman de Limbourg were introduced to the rich world of the Burgundian dukes by their uncle, Malouel, who was court painter in the late 1300s. In Paris they were apprenticed as goldsmiths but by 1411 were working as book illuminators for the bibliophile, the Duke of Berry. It was in the duke's employ that they produced what is now considered to be the greatest achievement of the International Gothic Style, the **Très Riches Heures**. This page from the illuminated devotional *Book of Hours* describes the duke's secular, festive activity in the month of January. It reveals how the aims of painting were moving away from traditional depiction of religious subjects. No longer was the interest solely in telling a sacred story, but rather attempting to represent man in his environment. Here the Limbourgs capture the gaiety of a medieval banquet scene. The duke sits in profile against a white firescreen whilst the High Steward orders on the next course. The Limbourgs and their patron died of the plague in about 1416; the book was never finished.

Other Masterpieces

BELLES HEURES;
c.1408–1409;
METROPOLITAN MUSEUM
OF ART,
NEW YORK CITY,
USA

FEBRUARY: TRES RICHES
HEURES;
c.1413;
MUSEE CONDE,
CHANTILLY,
FRANCE

c.1485; oil and tempera on poplar; 203.2 x 186.1 cm; National Gallery, London, England

Virgin and Child with Saint Jerome and Saint Dominic

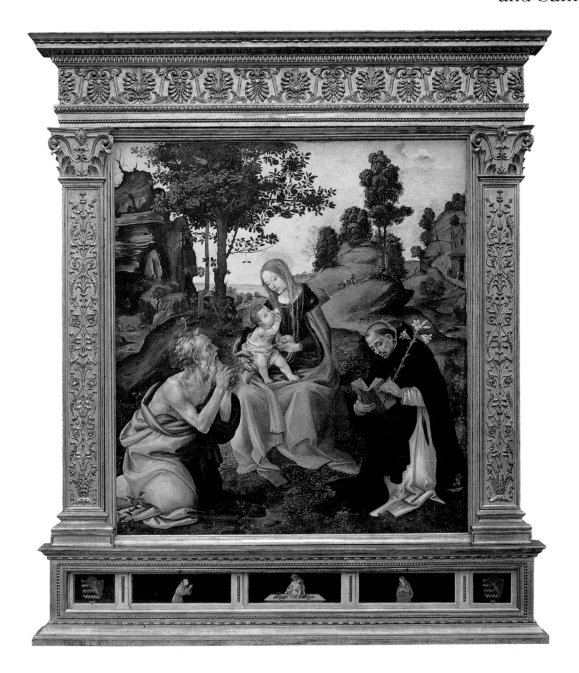

Filippino was the son of Fra Filippo Lippi, who trained him. At the age of twelve he set off for Florence, and within a couple of years was working alongside Botticelli, whom his father may have taught. His major commissions include the completion of Brancacci Chapel frescoes, the **Vision of Saint Bernard**, and the fresco cycles at the Strozzi and Caraffa Chapels. He enjoyed great fame during his lifetime but

ultimately his style of painting, marked by a linear clarity, fell out of fashion, to be replaced by the dramatic eccentricities of the Mannerist painters. The **Virgin and Child with Saint Jerome and Saint Dominic** altarpiece comes from a Florentine chapel dedicated to St Jerome. It was unusual for the Virgin and Child to be located in such an expansive landscape as this, but the artist's father, Fra Filippo Lippi, had a penchant for

similarly bleak settings which may have informed his choice. Most notable is Filippino's masterful rendition of facial expressions and his skill in finely painted textures, both of which are traditionally associated with northern schools.

Other Masterpieces

**VISION OF SAINT
 BERNARD;**
c.1484;
BADIA,
 FLORENCE,
 ITALY

**ADORATION OF THE
 MAGI;**
c.1496;
GALLERIA DEGLI UFFIZI,
 FLORENCE,
 ITALY

Lippi Fra Filippo

Born Florence, Italy c.1406; **died** Spoleto, Italy 1469

The Celebration of the Relics of Saint Stephen

1452–1466; fresco; Prato Catherderal, Prato, Italy

Fra Filippo Lippi was an orphan who was put into a monastery in his teens, but was temperamentally unsuited for monastic life – he was tried for fraud, and also abducted a nun who bore him a son, Filippino. In the 1420s he worked with Masaccio painting the Brancacci Chapel. In Lippi's early works, such as **The Relaxation of the Carmelite Rule**, the heaviness of the figures, derived from Masaccio, is clearly evident, but this was soon to be overlaid by a more descriptive and decorative tendency. Both Fra Angelico and Lippi knew of Netherlandish painting and made oblique references to specific northern features in their own work. **The Celebration of the Relics of Saint Stephen** shows attendance at a celebration of St Stephen, Christianity's first martyr. This saint was stoned to death for blasphemy after claiming to see the figure of Jesus in the sky. The beatific choristers are portrayed in an unidealized way. His playful studies of the Virgin and Child were particularly highly thought of, and set the style for the next half century.

Other Masterpieces

TARQUINIA MADONNA;
1437;
NATIONAL MUSEUM,
ROME,
ITALY

THE ANNUNCIATION;
c.1430;
SAN LORENZO,
FLORENCE,
ITALY

Born Smolensk, Russia 1890; **died** Moscow, Russia 1941

Victory Over the Sun

1923; colour litho on paper; 51.1 x 42.9 cm; Tate Gallery, London, England

Other Masterpieces

In 1909 the Italian Futurists published their manifesto in the Parisian newspaper, *Le Figaro*. Their ideas filtered to Russia and the artist Malevich and his followers, one of whom was Lissitzsky, responded with ideas of their own. Lissitzky studied engineering and architecture from 1909–1914. After being a painter, illustrator and designer of Soviet flags, he taught with Malevich at Vitebsk and at art workshops in Moscow. He arrived in

Berlin in 1921 and set up exhibitions of art by the post-revolutionary avant-garde, working also as a writer and designer for international magazines. His achievements acted like a campaign to forge links between artists in Russia and in the West, between Weimar's De Stijl and Constructivism. His own **Proun** paintings, Proun being an anacronym signifying "for the new art" express his vision of a world of physics inspired by modern

spiritualist thought. They were produced at the same time as **Victory Over the Sun**, which suggests similar concerns. His work was intended to be a catalyst to encourage "the broad aim of forming a classless society". His publications include *Die Kunstismen*, with Hans Arp, an issue of *Merz* magazine, with Schwitters, other books and independent contributions.

BEAT THE WHITES WITH THE RED WEDGE;
1919–1920;
LENIN LIBRARY,
MOSCOW,
RUSSIA

PROUN R.V. N. 2;
1923;
KUNSTMUSEUM MIT
SAMMLUNG SPRENGEL,
HANOVER,
GERMANY

Long Richard

Born Bristol, England 1945

Norfolk Flint Circle

1990; flint; 8 metres in diameter; installation view: Tate Gallery, London, England

Richard Long is known globally for his environmental art, which is relayed into a gallery context via photographs, texts, statements, stone installations and wall paintings. He was educated at the West of England College of Art, Corsham (1962–1965) and St Martin's School of Art, London (1966–1968). Like American Land Artist Robert Smithson, Long has stretched the boundaries of conventional art practice to integrate natural elements into his work. His use of the Earth goes far beyond the wildest, romantic imagination of traditional landscape artists, referencing both Conceptualist and Minimalist ideas. Distance, time and place also play a major part in his work. He has made several "walking sculptures" by travelling between specified places, here and abroad, on foot. The visible "results" of these landscape forays have been charted for exhibition.

More tangible evidence of his interventions are the materials he collects from various locations for formal exhibition. **Norfolk Flint Circle** is such a piece. The contrived arrangement is suggestive of the order man seeks to impose on nature. However, the circular shape, which Long also uses in wall-paintings made with his hands and mud, for example, is a universal organic symbol of regeneration, harmony and fecundity.

Other Masterpieces

SPRING CIRCLE;
1992;
BRITISH COUNCIL
 COLLECTION,
LONDON,
ENGLAND

A HUNDRED MILE WALK;
1971–1972;
TATE GALLERY,
LONDON,
ENGLAND

1338–1340; fresco; detail; 300 x 700 cm; Palazzo Pubblico, Siena, Italy

Good Government (detail)

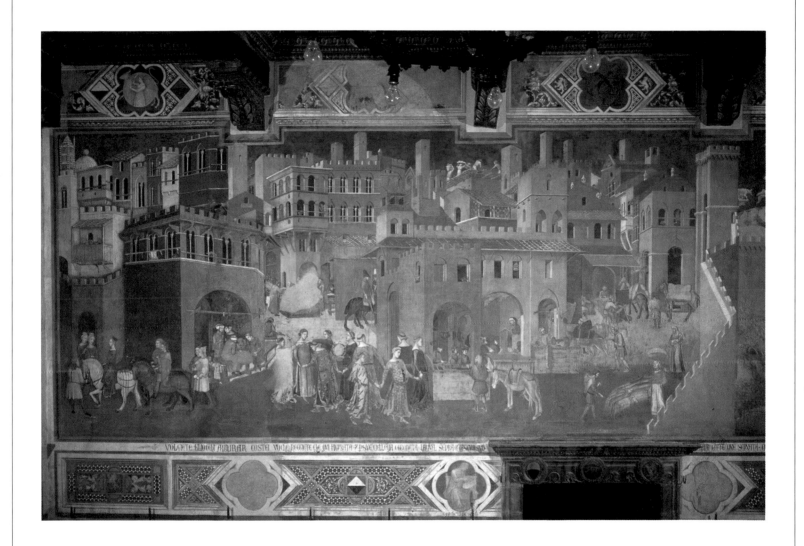

Ambrogio Lorenzetti's and his brother Pietro's lives are not well-documented although they are both known to have perished in the Black Death plague of 1348. Both were believed to have been pupils of the great Sienese decorative master Duccio, although the solidity of their figures and the narrative qualities of their work show a greater debt to Giotto. Through their connections to Giotto and Duccio, the brothers also provide a link between the hitherto separate Schools of Siena and Florence. Ambrogio was the more accomplished artist of the two. His innovative fresco series **Good and Bad Government** was painted for the Town Hall in Siena between 1338–1340. The panel reproduced here is a detail of this large allegorical work and records the streets of Siena with a mastery of perspective unusual for its time. The clusters of small figures engaged in conversation were also a significant advance in naturalism for the early fourteenth century. The depth, balance and detail of the overall composition indicate the extraordinary range of Ambrogio Lorenzetti's fertile imagination.

Other Masterpieces

THE PRESENTATION IN
THE TEMPLE;
1342;
GALLERIA DEGLI UFFIZI,
FLORENCE,
ITALY

THE ANNUNCIATION;
1344;
PINACOTECA,
SIENA,
ITALY

Lowry
Lawrence Stephen

Born Manchester, England 1887; **died** Glossop, England 1976

Going to the Match

1746; oil on panel; 25.3 x 47 cm; Private Collection

In 1909, Lowry and his parents moved to Pendlebury, Salford, which was then a busy and unkempt region of the great Lancashire cotton-manufacturing complex. For some years after 1910, Lowry was employed as a rent collector in Manchester. He claimed that contact with working-class life was to inform his art. At the Manchester Municipal College of Art, Lowry drew from life in a traditional manner, producing refined,

naturalistic works that offer no inkling of the dramatic change that was to come. In 1915, intense dislike of the Salford area developed into an obsession with the scenery, mills and collieries that made the urban environment and the people who lived and worked within it; a painting style was consolidated that remained virtually unchanged for nearly fifty years. **Going to the Match** is typical of the thickly painted, lugubrious imagery that

established Lowry's reputation. The painting epitomizes the mood of the Depression in the 1920s and 1930s in the stark depiction of trudging masses of match-stick figures. Lowry provides a satirical, evocative view of the proletariat on a day out of their factories, which is as acute for its time as Hogarth's or Bruegel's own visions were for theirs.

Other Masterpieces

COMING FROM THE MILL;
1930,
SALFORD ART GALLERY,
ENGLAND

OUTPATIENTS, ANCOATS HOSPITAL;
1952,
WHITWORTH ART
GALLERY,
MANCHESTER,
ENGLAND

Born Lessines, Belgium 1898; **died** Brussels, Belgium 1967

1928; oil on canvas; 115.6 x 81.3 cm; Tate Gallery, London, England

The Reckless Sleeper

René Magritte initially worked in wallpaper design and fashion advertising. His early paintings were inspired by Futurism and Cubism but, under the influence of de Chirico, he turned to Surrealism in 1925. Between 1927 and 1930 Magritte worked in Paris with the other Surrealists. He then settled in Brussels for the rest of his life. He painted convincing illusionistic images in a flat, deadpan style of disturbing clarity. His paintings presented a range of bizarre juxtapositions of ordinary objects in strange and incongruous surroundings. **The Reckless Sleeper** exploits the ambiguity of dreams, typically making use of unexpected distortions of size and scale as well as humour. Magritte frequently featured paintings within paintings in his work, as well as names and labels to question the relationship between painted and real objects. In his absurd and unnerving world, there are many recurring images, such as men with bowler hats and fish with human legs. Magritte was not widely known until after the Second World War. His work became familiar through its use in advertising and graphic design; he is now one of the most popular painters of the twentieth century.

Other Masterpieces

TIME TRANSFIXED;
1939;
THE ART INSTITUTE OF
CHICAGO,
USA

PROMENADES OF
EUCLID;
1955;
MINNEAPOLIS INSTITUTE
OF ARTS,
MINNESOTA,
USA

Malevich Kasimir

Born Kiev, Ukraine 1878; **died** Leningrad, Russia 1935

Dynamic Suprematism

1915; oil on canvas; 60 x 73 cm; Tate Gallery, London, England

Kasimir Malevich went to Moscow in 1905, where his work developed under the influence of French Post-Impressionism. He was invited to take part in Larionov's first Knave of Diamonds exhibition. Malevich visited Paris in about 1912 and returned full of enthusiasm for Cubism. Declaring that he wished to "free art from the burden of the object", he invented a new movement called Suprematism, which was a purer form of Cubism. In 1915, he exhibited thirty-six abstract works including the infamous **Black Square** – literally just that. In later Suprematist works, Malevich moved away from his stark minimalism to introduce colour, depth and, occasionally, softer forms. **Dynamic Suprematism** is an example of a cool, coloured, geometric work in which the abstract forms combine and overlap without any emotional distraction.

In 1918, a painting of a white square on a white ground became the logical extension of his non-objective art. Realizing that there was nowhere further for him to go, he stopped painting and turned to writing and teaching. In the 1920s he developed three-dimensional sculptures, important to the growth of Constructivism.

Other Masterpieces

WOMAN WITH BUCKETS;
1912;
MUSEUM OF MODERN ART,
NEW YORK CITY,
USA

SUPREMATISM: YELLOW
AND BLACK;
1916–1917;
RUSSIAN MUSEUM,
LENINGRAD,
RUSSIA

Born Philadelphia, USA 1890; **died** Paris, France 1976

1938; oil on canvas; 60 x 73 cm; Tate Gallery, London, England

B orn Emmanuel Radnitsky, Man Ray moved to Brooklyn in 1897, adopting the name by which he is known in 1905. He abandoned formal training but studied art during the evening while undertaking a variety of jobs as a commercial artist. His visits to Alfred Stieglitz's 291 gallery led to his experiments in photography. In 1914, he moved to an artists' colony in Ridgefield, New Jersey where he met Marcel Duchamp. Together, they

and Picabia founded the New York Dada movement. Man Ray began to produce "aerograph" paintings – made using an airbrush on photographic paper. He co-founded the Société Anonyme in 1920, but left for Paris shortly afterward. He remained there until 1940, becoming established as a successful portrait and fashion photographer. He was instrumental in the development of Surrealism out of Dada, exhibiting in the first Surrealist exhibition in

Paris in 1925. **Pisces** is a classic manifestation of Man Ray's involvement with the movement. Continuing experimentation with the photographic medium led to the "Rayograph" and, later, "solarizations". He also produced avant-garde films and constructed Dada objects. From 1940 he lived in Hollywood, returning to Paris in 1952. He described his life's work as, "The pursuit of liberty and the pursuit of art".

Other Masterpieces

**EROTIQUE VOILEE
(MERET OPPENHEIM A
LA PRESSE);**
1933;
MUSEE NATIONAL D'ART
MODERNE,
PARIS,
FRANCE

TIRED MANNEQUIN;
1927;
GALERIE ALAIN PAVIOT,
PARIS,
FRANCE

Manet Edouard

Born Paris, France 1832; **died** Paris, France 1883

The Balcony

1868–1869; oil on canvas; 170 x 124.5cm; Musée d'Orsay, Paris, France

Manet was concerned to rid the painted interpretation of contemporary life of artifice and contrived effects and admired the revolutionary changes brought to painting by Courbet. He abandoned his law studies to train in the studio of Thomas Couture from 1850–1856. Like Courbet, Manet copied from Old Masters in the Louvre rather than rely on traditional teaching methods. Although Manet's paintings were controversial, their subjects were free of social satire. Paintings made around 1865, such as **Le Déjeuner Sur l'Herbe** and **Olympia** were rejected by the official Salon and caused a scandal when exhibited at the Salon des Réfusés. The frank depiction of naked women in compositions that were inspired by Italian masters but which contravened academic rules was unacceptable. Manet's unconventionally high-key, freely handled paint and suppression of half-tones, in favour of direct lighting and harsh contrasts, added to the offence. **The Balcony** is an unorthodox composition, cut almost in half by the bright-green linear construction of the framework in the immediate foreground. It is like a snap taken with a flash-bulb, immediate and offering little sense of spatial recession while giving an exciting sense of real life as Manet saw it.

Other Masterpieces

BAR AT THE FOLIES-BERGERE;
1881–1882;
COURTAULD INSTITUTE
 GALLERIES,
 LONDON,
 ENGLAND

LA MUSIQUE AUX
TUILERIES;
1862;
NATIONAL GALLERY,
 LONDON,
 ENGLAND

c.1465; distemper on canvas; 68 x 81 cm; Pinacoteca di Brera, Milan

ndrea Mantegna was the pupil and adopted son of archaeologist and painter, Squarcione, who inspired his early interest in ancient artifacts and sculpture. He married into the eminent Bellini family in about 1453. In 1459, he became the court painter to Ludovico Gonzaga in Mantua, and stayed in the service of the family until his death. For the interiors of the ducal palace, he created the decorative series

The Triumph of Caesar, which is strewn with classical ruins. **The Dead Christ** features a dramatic close-up of a cadaver. The mourners are extraneous figures in this painting; through dramatic foreshortening the viewer is placed in an unusual position at the feet of the corpse. The choice of viewpoint, the carefully planned elements such as the draped shroud, the stony colour of the skin and above all the posture of the body all

emphasize the feeling of complete stillness. Mantegna worked within the tradition of Masaccio, but modelled his figures by layering washes of thin tempera. This was a Venetian technique, suiting the damp northern climate better than fresco painting.

Other Masterpieces

MADONNA DELLA VITTORIA;
c.1495;
MUSEE DU LOUVRE,
PARIS,
FRANCE

AGONY IN THE GARDEN;
c.1460,
NATIONAL GALLERY,
LONDON,
ENGLAND

Mapplethorpe Robert

Born New York City, USA 1946; **died** Boston, USA 1989

Calla Lily

1988; photograph; Estate of Robert Mapplethorpe

Robert Mapplethorpe is recognized as a photographer of outstanding technical ability – and notoriety. His homoerotic imagery and representations of sexuality through portraiture have established him as one of the most controversial artists to come to prominence during the 1970s and 1980s. From 1963 to 1970 he studied at the Pratt Institute, New York. In his earliest work he was "playing with charged imagery"; he was also assembling sculptural pieces from banal or found objects and collage. Experiments with Polaroid photographs followed, the seriality of images being as important as each composition itself. Through such explorations of the medium he developed a mastery of technique that enabled him to concentrate on his primary interest, which was to make pornographic imagery artistically beautiful. The similarity of approach by other gay artists, such as David Hockney and the illustrator Tom of Finland, encouraged Mapplethorpe to realize his idealized, romanticized preoccupation with erotic fantasy images. He specialized in stereotypical visions of male sexuality in addition to "straight" portraits of known individuals – Lord Snowdon and Louise Bourgeois, for example. His pictures of flowers, such as **Calla Lily** are astonishing portrayals of natural beauty, often depicted as sexually charged as his human subjects.

Other Masterpieces

EASTER LILIES;
1979;
ESTATE OF ROBERT
MAPPLETHORPE

DERRICK CROSS;
1983;
ESTATE OF ROBERT
MAPPLETHORPE

Born Munich, Germany 1880; **died** Verdun, France 1916

Foxes

1913; oil on canvas; 88 x 266 cm; Kunstmuseum, Düsseldorf, Germany

Franz Marc began to develop his academic, naturalistic style after visiting Paris in 1903 and 1908. In 1910 he became friends with Macke, who introduced an Expressionist sense of strong colour into his work. Marc was a founding member of Der Blaue Reite group in Munich in 1911. A deeply religious man, his painting was a vehicle for his spiritual values. He chose to depict animals believing that, unlike human beings, they experienced nature as a whole and were in harmony with it. In a notebook of 1911 he questioned if there can be "a more mysterious idea for the artist than how nature is reflected in the eye of an animal?" **Foxes** was painted in 1913, by which time Marc's ideas about the unity and rhythm of the natural world had strengthened. In the painting there is little distinction between the foxes' bodies and the surrounding space. The geometric grid of the fragmented picture surface also reflected Marc's awareness of the recent developments in Cubism in Paris. His later work is almost entirely devoid of representational content. Franz Marc was killed in action in the First World War.

Other Masterpieces

BLUE HORSES;
1911;
MINNEAPOLIS INSTITUTE
OF ARTS,
USA

FOREST WITH SQUIRREL;
1913;
KUNSTHAUS,
ZURICH,
SWITZERLAND

Martin John

Born Haydon Bridge, England 1789; **died** Douglas, England 1854

Sadak in Search of the Waters of Oblivion

1812; oil on canvas; 76.2 x 63.5 cm; Southampton City Art Gallery, England

John Martin's excessively dramatic and apocalyptic visions of landscape as the backdrop for cosmic or biblical happenings seem to have been designed with Hollywood epics in mind. These spectacular, melodramatic scenes made an impact on the Romantic imagination, appealing more to literary circles than being directly influential in the visual arts. From 1811 Martin exhibited at the Royal Academy and came to attention with **Joshua Commanding the Sun to Stand Still** (1816). He illustrated Milton's *Paradise Lost* in 1827 and was described as "the poet's painter". Engravings of his grandiose compositions were widely circulated across Europe, his reputation being particularly high in France where he received a gold medal from Charles X in 1829. **Sadak in Search of the Waters of Oblivion** is a typical canvas, illustrating an awesome vision of towering rocks and cathartic light effects. Martin's virtuoso handling and capacity for illustrating fantastical scenes, rendering them convincing, is extraordinary. The almost imperceptible presence of diminutive man is highly evocative and must have fired the imagination of God-fearing spectators.

Other Masterpieces

DESTRUCTION OF SODOM AND GOMORRAH;
c.1850;
LAING ART GALLERY, NEWCASTLE-UPON-TYNE,
ENGLAND

THE GREAT DAY OF HIS WRATH;
c.1853;
TATE GALLERY, LONDON,
ENGLAND

1342; tempera on panel; 49.6 x 35.1 cm; Walker Art Gallery, Liverpool, England

Christ Discovered in the Temple (detail)

After his teacher, Duccio, Martini was the most significant Sienese master of the fourteenth century. Unlike Duccio, who gave a solid, sculptural quality to his figures, Martini developed the International Gothic Style, with its emphasis on graceful, flowing lines and two-dimensionality. He won numerous commissions, including the prestigious frescoes for the Palazzo Pubblico at Siena and a painting of St Louis of Toulouse for his patron, the King of Anjou. With his brother-in-law, Lippo Memmi, he painted arguably his finest piece, **The Annunciation** of 1333. By 1340, he was established in the Franco-Italian enclave in Avignon – then the Papal seat – where he painted the unusual **Christ Discovered in the Temple** (detail). Mary and Joseph had spent several days frantically looking for Jesus, finally discovering him in the Temple where he had been discussing religion with the Elders. Here, Simone attributes human emotion to sacred characters. Mary reasons with Jesus who, with arms folded, listens demurely but with a hint of defiance. Martini arranges the figures within this awkwardly shaped panel with the utmost ease and simplicity, creating a religious painting that is at once beautiful and moving.

Other Masterpieces

THE ANNUNCIATION;
c.1333;
GALLERIA DEGLI UFFIZI,
 FLORENCE,
 ITALY

PORTRAIT OF
GUIDORICCIO DA
FOGLIANO;
1328,
PALAZZO PUBBLICO,
 SIENA,
 ITALY

Masaccio Tommaso

Born San Giovanni, Val d'Arno, Italy 1401; **died** Rome, Italy 1428

Adam and Eve Banished from Paradise

1424–1428; fresco; 214 x 90 cm; Brancacci Chapel, Santa Maria de Carmine, Florence, Italy

In importance, Masaccio is ranked alongside Donatello and Brunelleschi. It is uncertain who his teacher was. The artist Masolino came from the same Florentine parish and, being twenty years older, was in a position to teach him. However, there is little stylistic evidence of his influence. This is a fragment from the Brancacci Chapel, which Masaccio painted with Masolino. Because the artists shared the same Christian name (Thomas), nicknames were coined and Tomasso di Giovanni became Big Tom or "Masaccio". **Adam and Eve Banished from Paradise** shows Masaccio's main innovations. Primarily, his figures are solid, sculptural and imbued with an extraordinary intensity – the hopeless gesture of Adam being especially dramatic. Masaccio understood that the fall of light originating from one source could help define volume: here it casts a shadow behind Adam and Eve. He had also learnt the unifying device of a single-point perspective, perhaps from Brunelleschi. Furthermore, he had no interest in charming the viewer – his work is consistently austere and direct. Had he lived longer, his work may have mellowed, but within two months of his second trip to Rome he was dead, aged twenty-seven. Some believe he was poisoned.

Other Masterpieces

THE VIRGIN AND CHILD; c.1426; NATIONAL GALLERY, LONDON, ENGLAND

THE TRINITY WITH THE VIRGIN AND ST JOHN; 1425; SANTA MARIA NOVELLA, FLORENCE, ITALY

La Danse

1910; oil on canvas; 260 x 391 cm; Hermitage, St Petersburg, Russia

Henri Matisse originally trained as a lawyer, turning to art whilst recovering from appendicitis. Initially seduced by the Impressionists and, in particular, by Cézanne, Matisse brought together a circle of like-minded artists who became known as the Fauves (the Beasts) after their sensational exhibition of 1905. These early paintings revealed an intuitive and explosive colour sense which was to become the defining feature of Matisse's long career. Believing art to be "something like a good armchair in which one rests from physical fatigue", he was dedicated to producing work that expressed a harmony close to a musical composition. There are two versions of **La Danse**, originally produced with another enormous panel entitled **Musique** for a Russian collector. Dance was a popular topic at the time as Diaghilev and the Russian Ballet had just visited Paris. Despite, or because of, the simplification of colour, form, and line, the figures appear to be full of life. Matisse made sculptures, designed sets and costumes and illustrated books. He was also an important graphic artist who, in his bed-ridden final years, evolved his own method of arranging cut-out paper shapes. He is indisputably the greatest decorative artist of the twentieth century.

Other Masterpieces

THE RED STUDIO;
1911;
MUSEUM OF MODERN ART,
NEW YORK CITY,
USA

POLYNESIE, LA MER;
1946;
MUSEE MATISSE,
NICE,
FRANCE

Matta Roberto

Born Santiago, Chile c.1912

Abstraction

c.1940; oil on canvas; 96.5 x 132 cm; Private Collection

Roberto Sebastian Echaurren Matta trained as an architect in Santiago and under Le Corbusier in Paris . He turned to painting in 1937 and quickly became involved with the Surrealist movement in which he remained a prominent figure until he broke contact in 1947. Matta emigrated to America in 1939. The impact of his solo show at the Julien Levy Gallery in 1940 on American experimental artists was enormous. The automatism of Matta's organic surrealism provided a radical alternative to, and its inventiveness surpassed, the achievements of the academic European surrealism of Dalí, Magritte and Tanguy. During the 1940s, along with André Breton, Matta became one of the most influential émigré artists in New York, with creative implications for the development of Abstract Expressionism. His morphological paintings, such as **Abstraction**, combine ambiguous elements from the unconscious with landscapes from a volatile, futuristic dream-world. The cataclysmic, explosive meetings between brilliant highlights and thunderous shadows suggest cosmic violence, indefinable but evocatively wrought by abstract means. Matta's work became more dynamic, developing into "transparent cubism". From the mid-1940s he reintroduced the figure into increasingly mechanistic imagery.

Other Masterpieces

INVASION OF THE NIGHT;
1941;
JACQUELINE-MARIE ONSLOW FORD BEQUEST,
SAN FRANCISCO, USA

DISASTERS OF MYSTICISM;
1942;
ESTATE OF JAMES THRALL SOBY,
NEW CANAAN, CONNECTICUT, USA

Born Seligenstadt, Germany c.1433; **died** Bruges, 1494

1474–1479; tempera on oak panels; 193.5 x 194.7 cm; Memling Museum, Bruges, Belgium

The Mystic Marriage of St Catherine

Hans Memling was a pupil of Rogier van der Weyden. He entered the painter's guild in Bruges, the great centre of the medieval corporations, in 1467. Some measure of his success can be gleaned from the fact that by 1480 he was one of the largest taxpayers in the city. He produced calm and devotional pictures full of a gentle piety, characterized by their rich texture and strong hues. His paintings combined elements of work by both van der Weyden and Hugo van der Goes, and they were well liked by the rich middle class of the time. A strong Italian influence is evinced in **The Mystic Marriage of St Catherine** through the use of landscape as a backdrop to the central scene. This serves to unify the different parts of the painting, and emphasizes the contrasting formal presence of the classical columns. St Catherine of Alexandria is thought to have lived in the fourth century. The infant Christ turns toward her and places a ring on her finger, while St John the Baptist on the left, and St John the Evangelist on the right, look on.

Other Masterpieces

DIPTYCH OF MARTIN VAN NIEUWENHOVE; 1487; HOSPITAL MUSEUM, BRUGES, BELGIUM

THE DONNE TRIPTYCH; c.1477; NATIONAL GALLERY, LONDON, ENGLAND

Mengs
Anton Raphael

Born Aussig, Germany 1728; **died** Rome, Italy 1779

Maria Amalia of Saxony, Queen of Spain

undated; oil on canvas; 154 x 110 cm; Museo del Prado, Madrid, Spain

Mengs established a prodigious reputation when he was taken to Rome in 1741 and made Court Painter at Dresden in 1745. However, it was not until he had met and absorbed the theories of his friend Johann Winckelmann that he achieved acclaim as the leading exponent of Neoclassicism. This attribution is now in doubt, however the importance of his influence remains undisputed. Mengs' treatise on *Beauty in Painting* was published in 1762, only for it to be plagiarized and published in 1760 by an Englishman, Daniel Webb. He is best known for his ceiling painting **Parnassus** (1761) at the Villa Albini Rome. Breaking away from the illusionism of the Baroque, the surface is treated as in relief, with drawings after the Antique, and as if seen from the spectator's eye-level. Other frescoes include those for the Royal Palaces in Madrid, which Mengs made as Court Painter to Charles III; in this medium he was soon to be surpassed by Tiepolo. His portraits are perhaps more memorable. **Maria Amalia of Saxony** is a typical example of his eloquent, straightforward approach to the depiction of individual characters.

Other Masterpieces

MARIA LUISA OF
PARMA;
MUSEO DEL PRADO,
MADRID,
SPAIN

PARNASSUS;
1761;
VILLA ALBANI,
ROME,
ITALY

Born Milan, Italy 1925

Mario Merz

1977–1985; mixed media; 259 x 500 cm; Tate Gallery, London, England

Do We Turn Around Inside Houses

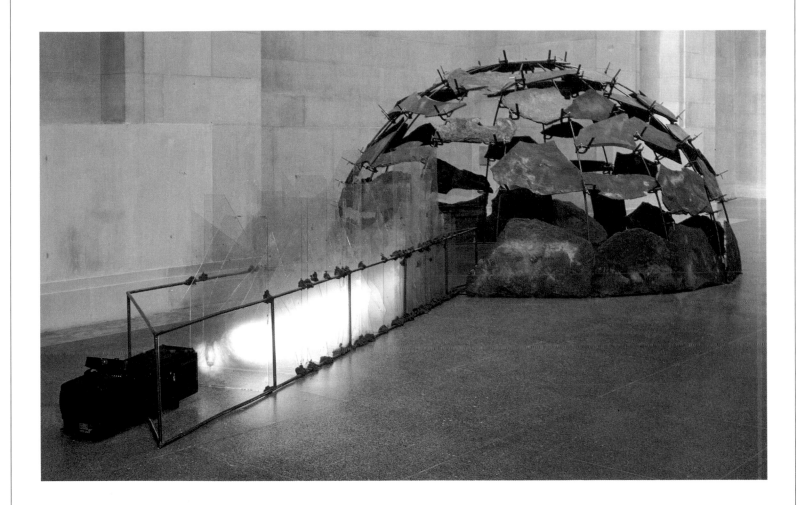

Mario Merz made a radical artistic response to the social and political unease in Europe and America toward the end of the 1960s until the mid-1970s. In common with other Italian artists, such as Kounellis, Pascali, Paolini and Fabro, Merz re-examined and reinterpreted methods of sculptural construction. His use of banal, cheap or found objects and materials distinguished him as a leading exponent of Arte Povera (Poor Art). Referencing the principles of Duchamp and Beuys, his work was a gesture toward changing the status of art from marketable commodity to a means of expression that focused on society and its survival. The rejection of classical traditions freed Merz to symbolize fundamental and universal concerns via a diversity of form and content. **Do We Turn Around Inside Houses** employs a variety of unusual elements to engender a reconsideration of how we construct our lives. The beauty of the installation belies the humble nature of the materials; the construction offers associations of shelter that are symbolic rather than practical. The path to security, despite being transparent, is blocked and fraught with difficulties and inherent danger.

Other Masterpieces

FIBONACCI TABLES;
1974–1976;
TATE GALLERY,
LONDON,
ENGLAND

IGLOO DI PETRA;
1982;
RIJKSMUSEUM,
KROLLER-MULLER,
OTTERLO,
NETHERLANDS

Michelangelo Buonarroti

Born Caprese, Italy 1475; **died** Rome, Italy 1564

Sistine Chapel : The Last Judgement

1536–1541; fresco; 14.8 x 13.30 m; Sistine Chapel, The Vatican, Rome, Italy

Michelangelo was a draughtsman, sculptor, painter, poet and architect whose many talents helped to establish the Renaissance in Florence. He learnt the skill of fresco painting from Ghirlandiao to whom he was apprenticed in 1488. His genius emerged in early works such as the **Pietà** of St Peter's in Rome and a large marble David for the city of Florence. Pope Julius II commissioned Michelangelo to decorate the ceiling of the Sistine Chapel in the Vatican in 1508. It took four years to complete. For much of his time, Michelangelo was forced to lie flat on his back, his face too close to the ceiling to facilitate a proper overview. The fresco of **The Last Judgement** was commissioned for the altar wall of the Sistine Chapel in 1534. This detail reveals Michelangelo's extraordinary ability to realize the human form. The perfect muscular bodies have a sculptural weight, which is enhanced by the depth of the surrounding space. The mood and tone of this piece is altogether darker than the ceiling frescos – it is a nightmarish vision of pandemonium, where the good are rewarded and the bad are damned.

Other Masterpieces

DAVID;
1501–1504;
ACCADEMIA,
FLORENCE,
ITALY

THE CREATION OF ADAM;
1508–1512,
SISTINE CHAPEL CEILING;
THE VATICAN,
ROME,
ITALY

Sir John Everett # Millais

The Blind Girl

1856; oil on canvas; 82 x 60.8 cm; Birmingham City Museums and Art Gallery, Birmingham, England

John Everett Millais' prodigious talent meant that at the age of 11 he was the Royal Academy's youngest ever student. Together with Holman Hunt and Rossetti, he founded the Pre-Raphaelite Brotherhood in 1848. Until the 1850s, Millais' work, with its intensity of feeling, brilliant colour and minutely observed detail, closely followed Pre-Raphaelite principles. He painted **The Blind Girl** near Winchelsea in the summer of 1854, using models to complete the figures. This poignant painting manages to avoid sentimentality in its depiction of a blind girl unable to appreciate the intense beauty of the sky before a storm. The emotional force of the painting is reinforced by the closeness of the relationship between the girl and her younger companion, as well as by the unity of the figures with their natural surroundings. In the late 1850s Millais style changed.

Declaring that he had a family to support, he moved away from the Pre-Raphaelite principle of expressing serious moral concepts to satisfy a puplic demand for popular storytelling. Technically brilliant, he developed into a fashionable and prosperous Victorian painter.

Other Masterpieces

AUTUMN LEAVES;
1856;
MANCHESTER CITY ART
GALLERY,
ENGLAND

OPHELIA;
1852;
TATE GALLERY,
LONDON,
ENGLAND

Millet Jean François

Born Gruchy, France 1814; **died** Barbizon, France 1875

The Angelus

1857–1859; oil on canvas; 55.5 x 66 cm; Musée d'Orsay, Paris, France

Jean François Millet was born into a family of peasant farmers near Cherbourg. He trained locally as a painter and then went to Paris in 1837 to study under Delaroche. His early work comprised of conventional portraits and fashionable eighteenth century pastoral scenes. However, in 1848 he chose to exhibit **The Winnower**, a painting depicting peasant life, at the Paris Salon. It was the first of many rural scenes based on memories of his own childhood. Criticized for allowing socialist concerns to infiltrate his art, Millet stated that it was "the human side" of life that he wished to portray. In 1849 he moved to Barbizon where he remained for the rest of his life, painting labourers going about their daily business. In **The Angelus**, his best-known work, Millet chose to celebrate a dignified, hard-working couple at work in the fields – their heads bowed in an expression of devotion in the face of nature. Depicting his human figures with a classically sculptural simplicity, Millet's concern was to show the pair in harmony with their peaceful and unchanging rural existence.

Other Masterpieces

THE WINNOWER;
1848;
MUSEE D'ORSAY,
PARIS,
FRANCE

THE GLEANERS;
1857;
MUSEE DU LOUVRE,
PARIS,
FRANCE

Shoes

1985; oil on canvas; 176.5 x 226 cm; Tate Gallery, London, England

After studying at the Université de la Sorbonne, Paris (1977–1978), Lisa Milroy went on to develop her skills at St Martin's School of Art and then Goldsmiths' College, London, (1979–1982). Although, from **Shoes**, Milroy would seem to work within a still-life tradition of figurative painting, her concerns are more focused on the formal, abstract qualities of pictorial construction. Milroy is known for her large canvases featuring the representational depiction of multiple objects – tyres, shirts, lightbulbs, fans, etc. They are produced from the recollection of experience rather than photographic sources and reflect an interest in the notion of collecting, of arrangements and systems. The grid format has been retained in more recent paintings, based on Milroy's travels abroad. Although these indicate a naturalistic approach to her interpretation of other worlds and other cultures, they are, in fact, evidence of her development of compositional structure. Her slick, colourful descriptions of window displays, landscapes and buildings elude specificity and detailed examination. Their painterly eloquence is sufficiently evocative to goad us into believing otherwise.

Other Masterpieces

LIGHTBULBS;
1988;
TATE GALLERY,
LONDON,
ENGLAND

STAMPS;
1986;
BRITISH COUNCIL
COLLECTION,
LONDON,
ENGLAND

Miró Juan

Born Montroig, Spain 1893; **died** Palma, Spain 1983

Painting 1927

1927; oil and gouache on canvas; 97.2 x 130.2 cm; Tate Gallery, London, England

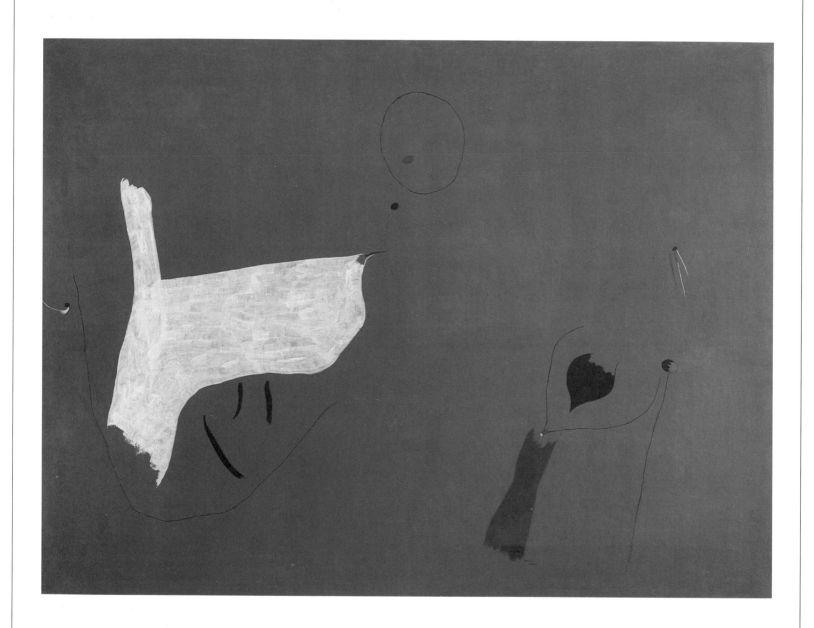

Juan Miró trained in Barcelona at the School of Fine Art and the Academy Cali. His early work showed a diverse mixture of influences from Catalan art to Cézanne and the Fauves. In 1920, he settled in Paris where he was inspired by his Spanish compatriots, Pablo Picasso and Juan Gris. During the 1920s, his poetic and primitive style was strengthened by a close association with the Surrealists. He signed their manifesto in 1924 and contributed to their exhibitions, sharing their determination to liberate on canvas the unconscious mind from logic and reason. His playful, emblematic **Painting 1927** makes use of simplified semi-abstract forms sparsely dotted on a single, flat blue ground. This minimal composition of lines, shapes, signs and dots of colour recalls prehistoric cave paintings. The lurid background to the work appears to have been painted with the water-soluble blue paint often used on the outside of houses in Spain and Portugal. In 1940, Miró returned to Spain, where he lived mainly in Majorca. He produced ceramics in the 1950s, worked on murals in the USA and ceramic wall decorations in Paris. His highly personal, mythological imagery inspired American artists such as Arshile Gorky and Alexander Calder.

Other Masterpieces

HARLEQUINADE;
1924–1925;
ALBRIGHT-KNOX GALLERY,
BUFFALO,
NEW YORK STATE,
USA

THE BEAUTIFUL BIRD
REVEALS THE DAWN
TO A PAIR OF LOVERS;
1941;
MUSEUM OF MODERN ART,
NEW YORK CITY,
USA

Born Dresden, Germany 1876; **died** Worpswede, Germany 1907

Self Portrait with Blue Irises

1906–1907; painting on board; 38 x 24 cm; Folkwang Museum, Essen, Germany

P aula Becker learnt to draw and paint while being encouraged by relatives and friends. From 1893–1895 she attended the Association of Berlin Women Artists. In 1898, she moved to an established artist's colony in Worpswede and became a friend of the poet Rainer Maria Rilke. Her early work concentrated on landscapes and earthy representations of peasant life. In Paris in 1900, she became acquainted with the work of Cézanne, Gauguin, Van Gogh and Rodin. During the following year she married widower Otto Modersohn, eleven years her senior. In her later, mainly portrait, work she was concerned to convey feeling; there is a quieter, introspective quality to her painting that separates it from the harsh colour and violent distortions of other Expressionists. **Self Portrait with Blue Irises**, with its simplified forms and restrained use of colour, is a striking image of self-possession and vulnerability. It becomes all the more poignant having the knowledge of Modersohn-Becker's tragic personal history. In 1906, she escaped from her oppressive marriage and returned to Paris; in 1907 she gave birth to her daughter Mathilde and died after childbirth of an embolism.

Other Masterpieces

OLD PEASANT WOMAN
PRAYING;
c.1905–1907;
DETROIT INSTITUTE OF
ARTS,
DETROIT,
USA

KNEELING GIRL IN
FRONT OF A BLUE
CURTAIN;
1907;
LANDSEMUSEUM,
OLDENBURG,
GERMANY

Modigliani Amedo

Born Leghorn, Italy 1884; **died** Paris, France 1920

Jeanne Hébuterne with White Collar

1919; oil on canvas; 139.7 x 116.8 cm; Private Collection

After studying in Venice and Florence, Amedo Modigliani went to Paris in 1906. He never completely aligned himself with any particular movement but his work displayed a diverse range of influences including Cézanne, the Fauves, African sculpture and Cubism. His superb skills as a draughtsman owed more to his Italian heritage, especially to Botticelli and the Mannerists. Modigliani met Brancusi between 1910 and 1913 and, fascinated by sculpture, started to carve. He was forced to abandon sculpture for painting in 1915 when stone dust damaged his lungs, which were already weakened by tuberculosis. The last few years of his life became legendary. Poverty-stricken he lived with artist friends in Montparnasse, his dissolute life ending when his declaration "I am going to drink myself to death" became a self-fulfilling prophesy. This wistful portrait is of **Jean Hébuterne**, his mistress. Pregnant with their second child, she committed suicide the day after Modigliani died. It is a portrait characteristic of the Modigliani woman, displaying a pronounced oval face, a long neck and sloping shoulders. Through her dark almond eyes and small pursed mouth, he conveys the impression of a graceful and vulnerable person.

Other Masterpieces

HEAD;
c.1911–1912,
TATE GALLERY,
LONDON,
ENGLAND

RECLINING NUDE;
c.1919;
MUSEUM OF MODERN ART,
NEW YORK CITY,
USA

Sil I

1933; oil on silberit; 50 x 20 cm; National Gallery, Edinburgh, Scotland

László Moholy-Nagy was a sculptor, painter, designer and photographer. Originally a law student, he went to Berlin after the First World War. Influenced by Lissitzky and Russian Constructivism, Moholy-Nagy's paintings made use of collage and photomontage. He became interested in the pictorial possibilities of new materials, especially translucent and transparent plastics. From 1923 to 1928 he taught at the Bauhaus, where he was able to further his experiments in a number of different media, including film, theatre, photography and industrial design. In 1928 he returned to Berlin to work as a designer of film and stage sets. He spent two years in London from 1935, where he produced documentary films and designed cinematic special effects. In 1937 he settled in Chicago where he led the New Bauhaus and founded the Institute of Design. Moholy-Nagy's significance lay in his constant experimentation with complex ideas and new materials. **Sil I** shows his concern with dynamic relationships of form in space. A delicate web of strings highlights the interaction between three geometric objects, which rotate like planets.

Other Masterpieces

COMPOSITION A II;
1924;
GUGGENHEIM MUSEUM,
NEW YORK CITY,
USA

JEALOUSY;
1930;
GEORGE EASTMAN HOUSE,
ROCHESTER,
NEW YORK STATE,
USA

Mondrian Piet

Born Amersfoort, Netherlands 1872; **died** New York City, USA 1944

Composition with Red, Yellow and Blue

c.1937–1942; oil on canvas; 73.7 x 69.2 cm; Tate Gallery, London, England

Piet Mondrian's early landscape paintings owed much to the bright, colourful work of Matisse and Van Gogh. In 1909 Mondrian moved to Paris where he experienced the work of the Cubists and was influenced by the simplified geometric shapes and tight structures he discovered in their paintings. **Composition with Red, Yellow and Blue** is comprised of coloured rectangles intersected and divided by a flat grid of black lines. It is part of a series of geometric paintings in which Mondrian attempted to shut out all reference to the outside world, in a desire to achieve what he called "universal harmony". It is in his use of contrasting primary colours through both balanced vertical and horizontal forms, that he fulfils this aim. Mondrian's importance lies in his development of "pure" abstraction. He was a founding member of the *De Stijl* journal of 1917, which helped spread his artistic theories. However, it would be wrong to conclude that his paintings can be seen merely as a series of formal experiments. By reducing painting to its most basic elements, Piet Mondrian achieved a simple purity and spirituality that radiated throughout the twentieth century.

Other Masterpieces

STILL LIFE WITH GINGER JAR II;
1911;
GEMEENTEMUSEUM,
THE HAGUE,
NETHERLANDS

BROADWAY BOOGIE WOOGIE;
1942–1943;
THE MUSEUM OF MODERN ART,
NEW YORK CITY,
USA

Born Paris, France 1840; **died** Giverny, France 1926

c.1916–1919; oil on canvas; 200 x 200 cm; Musée d'Orsay, Paris, France

Blue Waterlilies

Claude Monet was born in Paris but educated at Le Havre, on the northern French coast, where he was encouraged to turn away from portraiture to paint directly from nature. In the 1860s he met Pissarro, Sisley, Renoir and Manet in Paris. These friendships combined to create a new direction in art for the first Impressionist exhibition of 1874. The aim of this movement was to produce paintings entirely faithful to reality – to make an exact analysis of tone and colour as well as capture the reflections on the surfaces of objects. Monet was dedicated to the study of light and its changing effect on nature. He settled at Giverny, north-eastern France in 1883, where he created a beautiful garden filled with elaborate arrangements of plants and flowers. Here, in the 1890s, he began to paint subjects in series recording the varying light conditions at different times of the day. In this painting **Blue Waterlilies**, from the most famous of all his series the **Waterlilies**, the shimmering pools are secondary to the atmosphere that envelops them. Suffused in light, the painting surrounds and submerges the spectator and is all the more astonishing with the knowledge that Monet's eyesight was failing. He was to die blind.

Other Masterpieces

GARE ST LAZARE;
1877;
MUSEE DU LOUVRE,
PARIS,
FRANCE

ROUEN CATHEDRAL;
1894;
MUSEE DU LOUVRE,
PARIS,
FRANCE

Moore Henry

Born Castleford, England 1898; **died** Much Hadham, England 1986

Mother Preparing Child for Bath

c.1944; pencil, white wax crayon watercolour wash, coloured crayon, pen and black ink; 41.6 x 50.2 cm; Private Collection

Moore trained in Leeds, where he met Barbara Hepworth, and at the Royal College. He taught there between 1925 and 1932 and at Chelsea School of Art through the 1930s. Moore gradually revised his early rejection of traditional, classical sculpture as a result of travelling to Paris and Italy in 1925. He had originally been impressed by the "barbaric" vitality of African wood carvings and pre-Columbian sculpture.

Intrinsically, non-Western, constructive qualities infuse his work, which combines geological and human forms. He defined "truth to material" as a primary aim, seeing the artistic contemplation of realistic beauty as a digression. From 1928 he received public commissions which alternately attracted controversy and admiration. His international reputation was established in the 1940s, by which time, after the bombing of his studio,

he had moved to Hertfordshire. Moore's **Shelter** drawings, made as an official war artist, offer a unique interpretation of the search for refuge from the Blitz. Drawing was an essential and integral aspect of Moore's practice and **Mother Preparing Child for Bath** exemplifies the graphic, generic forms that inform and typify his sculptural work. Arguably, he remains the most important British sculptor of this century.

Other Masterpieces

RECLINING FIGURE;
1929;
LEEDS CITY ART GALLERY,
LEEDS,
ENGLAND

FAMILY GROUP;
1950;
MUSEUM OF MODERN ART,
NEW YORK CITY,
USA

1946; oil on canvas; 37.5 x 45.7 cm; Tate Gallery, London, England

Giorgio Morandi remained at a distance from most of the frenzied artistic developments of the twentieth century. He never left Italy. He studied in Bologna where he had a fleeting association with the Futurists, taking part in their first International Exhibition in Rome in 1914. In 1918 he was influenced by de Chirico's metaphysical work and briefly introduced a few surreal elements into his paintings. Apart from a few early landscapes, Morandi's work consisted almost entirely of still life. This contemplative **Still Life**, with its huddled collection of bottles and bowls is a quintessential Morandi. The delicate austerity of the simple composition is reinforced by a restrained use of colour. In his single-minded devotion to his subject matter, as well as his subtle, sparse and serene arrangements, Morandi's still life has echoes of both Chardin and Cézanne. The cool, classical spirit infusing his work can also be traced to the fourteenth century artist Piero della Francesca. Held in great esteem by the younger generation of Italian artists, Morandi taught at the Bologna academy from 1930. He was also an accomplished engraver.

Other Masterpieces

METAPHYSICAL STILL
LIFE;
1919;
COLLECTION DR EMILIO
JESI,
MILAN,
ITALY

STILL LIFE;
c.1957;
HAMBURGER
KUNSTHALLE,
HAMBURG,
GERMANY

Moreau Gustave

Born Paris, France 1826; **died** Paris, France 1898

Salomé Dancing before Herod

1876; oil on canvas; 143.5 x 104.3 cm; University of California, Los Angeles, USA

Gustave Moreau lived the life of a recluse, secluded from the outside world in his Montmartre studio. An academic painter, he believed that art should not merely describe the material world which he saw as being unduly concerned with the idea of progress. He painted elaborate biblical and mythological fantasies which, due to their displacement in time, seemed rather remote and uninteresting. **Salomé Dancing**

Before Herod was his greatest success. It was greatly admired by the novelist Huysmans for its decadent mood. Exhibited at the Paris Salon in 1876, the painting subscribes entirely to Moreau's view that "I believe only in what I do not see and solely in what I feel." He paints the scene with an obsessive, descriptive attention to detail, the rich colours and intricate surface giving the work symbolic rather than literal truth. He was

associated with the Symbolist movement and also had an influence on Surrealists. Between 1892 and 1898, Moreau established a reputation as an intelligent and sympathetic teacher at the Ecole des Beaux-Arts, where he counted Rouault and Matisse amongst his pupils. His greatest legacy, most obviously apparent in his watercolours, was his jewel-like use of colour.

Other Masterpieces

HERCULES AND THE
HYDRA OF LERNA;
1876;
ART INSTITUTE OF
CHICAGO,
USA

THE UNICORNS;
c.1885;
GUSTAVE MOREAU
MUSEUM,
PARIS,
FRANCE

1874; pastel on card; 73 x 92 cm; Musée du Petit Palais, Paris, France

Berthe Morisot came from a wealthy and cultured family who recognized her precocious talent. She studied at the Ecole des Beaux-Arts between 1856–1859 and from 1860 under Corot. Her early landscapes were exhibited at the Salon and had a freshness due to being painted out-of-doors. Increasingly, she painted simple domestic scenes observed directly from her own life, such as her sister by a cradle, or women quietly reading. Morisot was introduced to Manet by Fantin-Latour during a visit to the Louvre in 1868. Their close friendship was critical to the development of their respective artistic careers. She posed for Manet's painting **The Balcony** later that year. The first woman to join the Impressionists – another was Mary Cassatt – Morisot exhibited in seven of the eight Impressionist exhibitions. Manet adopted a lighter Impressionist palette under her influence, abandoning his strong use of black. Morisot married Eugène, Manet's brother, in 1874. **In a Park** is a charming and intimate portrayal of middle-class life which, despite its delicacy, manages to avoid excess sentiment. Morisot frequently painted young girls – there are numerous portraits of her daughter – expressing her interest in the transition from girlhood to womanhood.

Other Masterpieces

THE CRADLE;
1872;
MUSEE D'ORSAY,
PARIS,
FRANCE

LA LECTURE;
1869–1870;
NATIONAL GALLERY OF
ART,
WASHINGTON DC,
USA

Motherwell Robert

Born Aberdeen, USA 1915; **died** New York City, USA 1991

Open No. 122 in Scarlet + Blue

1969; acrylic drawing on canvas; 213.4 x 254 cm; Tate Gallery, London, England

obert Motherwell was unusual among the New York artists in that he was a true academic, possessing a rational mind that has suffused his art with an ordered, contemplative stillness. He had studied philosophy before embarking on serious artistic studies in the form of art history at Columbia University. He became a professional painter in 1941, after having become acquainted with the Surrealists and involved in their work, Roberto Matta's in particular. Motherwell is credited with being one of the initiators of the Abstract Expressionist movement. The informal art school he founded with fellow painters, Mark Rothko among them, called The Subjects of the Artist, was a significant development. The concerns of the Symbolists were of interest to Motherwell and his own work appropriates their ideology of equivalences between colour, sound, sensation and memory. Beyond his extensive series of Elegy paintings, including **Elegy to the Spanish Republic 34**, his tranquil abstracts, such as **Open No. 122 in Scarlet + Blue**, are described by the artist as, "not hard-edge paintings, but romantic ones – essences".

Other Masterpieces

1898; print on paper; 55.2 x 72.7 cm; Victoria and Albert Museum, London, England

F Champenois, France 1898

Alphonse Mucha trained and worked in Munich, Vienna and Paris. He produced a broad range of work during his career but came to international prominence through his poster designs. **F Champenois, France 1898** is a prime example of his linear-based, decorative style. A product of Art Nouveau, the image features a beautiful woman surrounded by a swirling, circular design. Mucha's women, unusually for Art Nouveau, are not depicted as *femmes fatales*, but as the gentle, graceful, idealized version of femininity shown here. In this pale, neutrally-toned work, the figure appears entwined by tendrils against the soft background of flowers. Many of Mucha's best-known designs featured the actress Sarah Bernhardt, for whom he was also employed to design sets, costumes and jewellery. After several visits to the USA, he successfully built up a following there. In 1922, he returned to his native Czechoslovakia and continued to work there until his death in 1939. His prolific output of posters, drawings, wallpaper, furniture, stage sets, stained-glass work and jewellery featured in a major retrospective of his work at the Grand Palais in Paris in 1980.

Other Masterpieces

SALON DES CENTS;	GISMONDA;
1896;	1894;
MUCHA FOUNDATION,	MUCHA FOUNDATION,
PRAGUE,	PRAGUE,
CZECH REPUBLIC	CZECH REPUBLIC

Munch Edvard

Born Lote, Norway 1863; **died** Oslo, Norway 1944

Puberty

1894; oil on canvas; 151.5 x 110 cm; Nasjonalgalleriet, Oslo, Norway

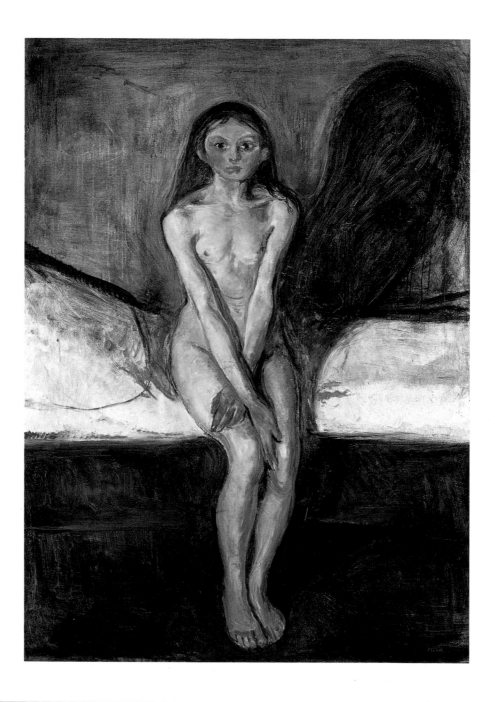

Edvard Munch was an exponent of the Nordic spirit and possessed an artistic vision that communicated the exploration of anxiety and anguish. His work gave meaning to the notion of Expressionism for Northern European artists. He studied in Oslo and travelled across Europe until 1908 when he returned to Norway. He suffered from bouts of mental illness, which could account for the extraordinary quality of his art. Munch

was impressed by the work of contemporary French artists he encountered on his travels. He felt particular empathy with the work of van Gogh and Gauguin. The emotive nature of the former and the visionary, decorative elements of the latter are evident in Munch's strange, dreamlike images. His affinity with the Symbolist movement focused his ideas accordingly into paintings, etchings lithographs and woodcuts. In these he

explored the power of colour and form as effective compositional and symbolic tools. Life, love and death were recurring subjects, often focusing on women as powerful, enigmatic creatures. **Puberty** is an alluring, enigmatic picture laced with unease. The viewer becomes intruder and the naked girl, haunted by a great, sinister shadow, eyes us with trepidation, covering herself awkwardly from our gaze.

Other Masterpieces

THE SCREAM; 1893; NASJONALGALLERIET, OSLO, NORWAY

ASHES; 1894; NASJONALGALLERIET, OSLO, NORWAY

c.1670–1675; oil on canvas; 146 x 108 cm; Alte Pinakothek, Munich, Germany

Bartolomé Estebán Murillo spent nearly all his life in Seville. He started his career painting pictures to be sold at fairs. In 1648 he visited Madrid, where he met Velázquez. In 1660, Murillo was one of the founders of the Seville Academy and became its first President. He made his reputation with a series of paintings documenting the lives of Franciscan saints for the Franciscan monastery in Seville. His religious paintings display a pious devotion and tenderness distinct from the harsh realism of his contemporaries, Ribera and Velázquez. His mature work comprised genre scenes featuring saints, beggar boys and fruit-sellers, having a softness and sweetness bordering on sentimentality. **Children Playing with Dice** is one of his more unembroidered paintings. Nowadays it could be considered uncomfortable viewing as a rather provocative, sexualized image of young boys. Murillo was hugely popular during his lifetime, working in a large studio to cater for the demand for his work. By the nineteenth century, his work was considered cloying and his reputation declined.

Other Masterpieces

THE TWO TRINITIES;
c.1675–1682;
NATIONAL GALLERY,
LONDON,
ENGLAND

SELF-PORTRAIT;
c.1670–1673;
NATIONAL GALLERY,
LONDON,
ENGLAND

Nash Paul

Born London, England 1889; **died** Boscombe, England 1946

Harbour and Room

1932–1936; oil on canvas; 91.4 x 71.1 cm; Tate Gallery, London, England

Paul Nash studied at the Slade School from 1910 to 1911. Primarily a landscape painter, his early visionary drawings of faces superimposed on the landscape were influenced by Rossetti. Nash made his reputation as an official war artist during the First World War. In the 1920s and 1930s he was influenced by the Surrealists. Through its confusion of interior and exterior space as well as through the mysterious, lurking presence of the black boat, **Harbour and Room** has a distinctly surreal feel. It clearly shows the influence of de Chirico, whose work he saw in London in 1928. Nash was one of the founders in 1933 of Unit One, an avant-garde group of British artists that included Ben Nicholson and Henry Moore among its members. During the Second World War, Nash once again worked as an official war artist. In his later landscape work he evolved a complex symbolism. Not content with recording the surface of the natural world, he wanted to penetrate beneath to express its spiritual essence. He also worked as a photographer, writer, book illustrator and a designer of textiles and scenery.

Other Masterpieces

DEAD SEA;
1940–1941;
TATE GALLERY,
LONDON,
ENGLAND

LANDSCAPE OF THE VERNAL EQUINOX;
1944;
SCOTTISH NATIONAL
GALLERY OF MODERN
ART,
EDINBURGH,
SCOTLAND

1985; colour video monitors; Tate Gallery, London, England

Good Boy, Bad Boy

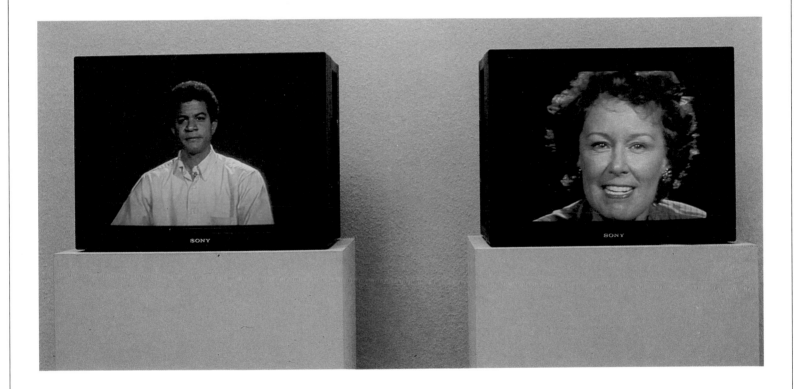

Bruce Nauman read mathematics and physics before studying art at the University of Wisconsin, graduating in 1964. He continued his art training at the University of California. Although he began as a painter, after 1965 he rejected the medium to work in film, performance and sculpture. He is regarded as a leading Post-Minimalist artist, concerned more with the activity of production than with the finished object.

His first solo exhibition in New York, in 1968, revealed his preoccupation with the body, shown in what is typically associated with Nauman – neon sculpture. During the 1970s, these concerns were extended beyond the body and into more conceptual realms of behavioural and sociological issues. In the mid-1980s his thematic focus was on notions of power and sex. The "animated" neon sculptures take on a Pop-inspired, satirical edge. Nauman's inventiveness made him one of the most influential American artists of the 1970s and 1980s. **Good Boy, Bad Boy** is a video-piece of two actors reciting the same string of statements, unsynchronized. The force of each respective statement depends upon the gender and the tone of voice of the actor. It epitomizes Nauman's interest in the manipulation of language and experience.

Other Masterpieces

CORRIDOR WITH MIRROR AND WHITE LIGHTS;
1971;
TATE GALLERY,
LONDON,
ENGLAND

HUMAN NATURE/KNOWS DOESN'T KNOW;
1983–1986;
FROHLICH COLLECTION,
STUTTGART,
GERMANY

Newman Avis

Born London, England 1946

The Day's Residues VI

1982; drawing on paper; 101.5 x 136.8 cm; Tate Gallery, London, England

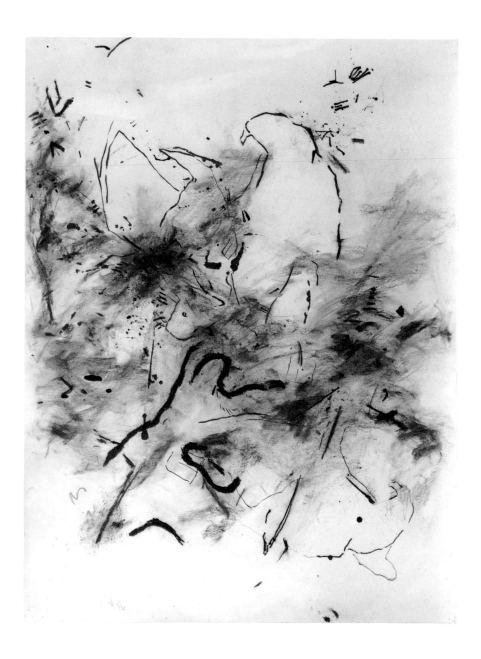

Since 1982, Avis Newman has made drawing the central concern of her art practice. During the early 1980s, her mixed-media work, including **The Day's Residues,** drew upon a profusion of broken lines, marks and scratches to create an imaginary space that referenced the pre-linguistic world of cave paintings. Through symbolic reference to humans, animals and birds, the artist described how she wished to "suggest the mobility of the image and that ambiguity of form which one experiences in dreams". These discordant works were pieced together from fragments, the exposed, areas of paper or canvas ensuring that the work was open and not closed to meaning. In her **Webs (Backlit)** series from 1994, Newman extended her metaphorical enquiry into animal and human forms, presenting a series of stretched and unstretched canvases in which the image of a spider's web is of key importance. The web is alternately revealed and obscured through layers that form the surface of the work, alluding to the problematic nature of representation and acknowledging the gap between idea and realization. Newman has also made a series of boxed works containing natural matter such as feathers, pebbles and sand.

Other Masterpieces

SCULPTURE OF ESSENTIAL MOVEMENT;
1989;
TATE GALLERY,
LONDON,
ENGLAND

WEBS (BACKLIGHT) V;
1994;
LISSON GALLERY,
LONDON,
ENGLAND

Born New York City, USA 1905; **died** New York City, USA 1970

Moment

1946, oil on canvas; 76.2 x 40.6 cm; Tate Gallery, London, England

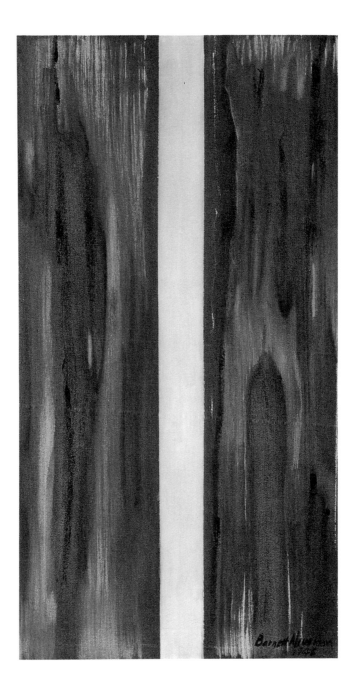

Barnett Newman trained in New York. He attended classes at the Art Student's League, while also studying at the City College. In the 1930s, he painted in an Abstract Expressionist style. However, although closely associated with other members of this movement, his own work gradually began to change, rejecting their characteristically loose, painterly technique in favour of a stricter, more rigorous approach to abstraction. By 1948, he was working on monochrome canvases, interrupted only by the presence of one or more bands, travelling vertically from one edge of the canvas to the other. Known as "zips", these became the trademark of Newman's large, abstract paintings, providing a contemplative focus on the vast fields of colour and effectively opening out the space. Despite their minimalist appearance, paintings like **Moment** are suffused with sublime mysticism, drawing upon vast concepts like creation and creativity. Between 1958 and 1962 Newman painted solely in black and white. In the late 1960s he employed colours of exceptional purity and depth. His late work was prolific and, from 1965, included a small number of large, steel sculptures. Newman was a radical influence on younger American artists such as Larry Poons and Jasper Johns.

Other Masterpieces

ADAM;
1951–1952;
TATE GALLERY,
LONDON,
ENGLAND

**WHO'S AFRAID OF RED,
YELLOW AND BLUE
III;**
1966–1967;
STEDELIJK MUSEUM,
AMSTERDAM,
HOLLAND

Nicholson Ben

Born Denham, England 1894; **died** London, England 1982

December 1951 – St Ives – Oval and Steeple

1951; oil and pencil on board; 50 x 66.5 cm; Bristol Art Gallery, Bristol, England

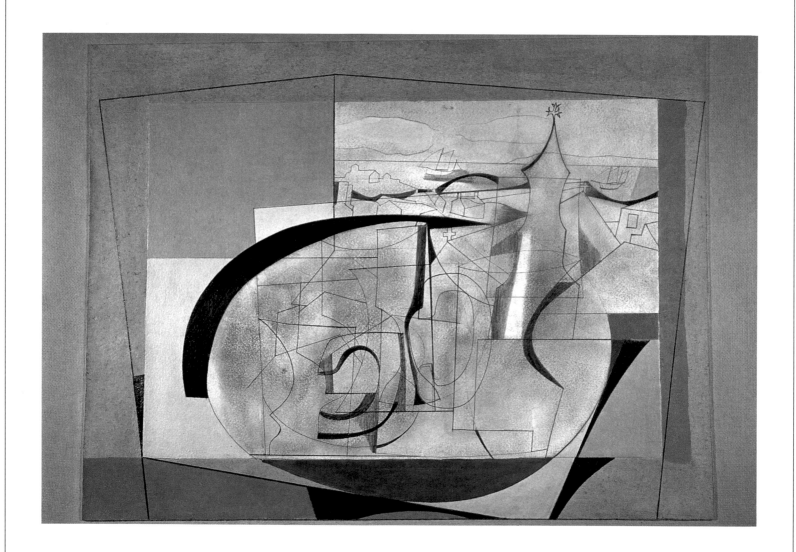

Ben Nicholson's only formal training was undertaken between 1910–1911 at the Slade School of Art, London, where he befriended Paul Nash. His visits to Paris in the 1920s and 1930s were a seminal influence on his own work, due to his contact with such significant artists as Picasso, Arp, Brancusi and Braque. His white relief pictures and later hard-edged geometrical paintings and reliefs of the early 1940s reveal an original application of his grasp of Cubist principles. The impact that Mondrian's calculated abstracts had on Nicholson was absorbed and is echoed in the simple shaped blocks of pure colour that reinforced the structural strength of his refined pictorial design. At the outbreak of the Second World War, Nicholson and his second wife, sculptor Barbara Hepworth, moved to St Ives, in Cornwall, which was becoming the centre of an artistic community. The local environment acted as a catalyst for the return of figuration to his work. By 1951, when his marriage ended and he moved to Switzerland, these elements were becoming more subtle, as in **December 1951 – St Ives – Oval and Steeple**. This elegant composition of line and colour is characteristic of Nicholson's understated sophistication and of his contribution to British abstraction.

Other Masterpieces

WHITE RELIEF;
1935;
IVOR BRAKA LTD,
LONDON,
ENGLAND

A WINDOW IN
CORNWALL;
c.1942;
WHITWORTH ART
GALLERY,
MANCHESTER,
ENGLAND

Sidney Nolan

Burke and Wills Expedition "Gray Sick"

1949; ripolin enamel and oil on hardboard; 92 x 120 cm; Private Collection

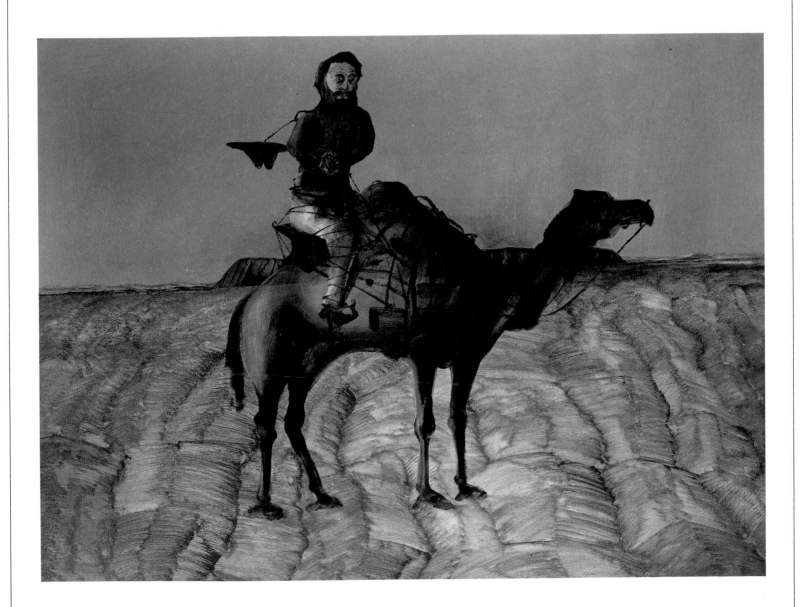

Sidney Nolan contributed significantly to the development of Pop art. His work came to prominence on the London art market shortly after the Second World War. Before the 1940s, Nolan had primarily been an abstract painter. However, his fascination with the exploits of the Australian outlaw Ned Kelly provided the inspiration for a series of paintings featuring the antics of this Antipodean anti-hero. The naive and comic style of Nolan's paintings belied a more serious concern with issues of Australian nationalism. This, and the **Burke and Wills** series of paintings, reference a culture mindful of territorial disputes between white settlers and indigenous Aborigines. The paintings that followed in the 1950s also appeared ahead of their time, being an eclectic mix of figuration and abstraction, handled in brash colours and with paint applied in the characteristic, gestural fashion of the Expressionists. Landscape remained a central concern and was interpreted as a wasteland inhabited by alien beings; strange amorphous figures, with shapes for heads and daubs for limbs, which populated spaces devoid of naturalistic elements.

Other Masterpieces

KELLY, SPRING;
1956;
ARTS COUNCIL OF
ENGLAND COLLECTION,
LONDON
ENGLAND

THE LEDA SUITE;
1961;
TATE GALLERY,
LONDON,
ENGLAND

283

Nolde Emil

Born Schleswig-Holstein, Germany 1867; **died** Seebüll, Germany 1956

The Sea B

1930; oil on canvas; 73.7 x 101 cm; Tate Gallery, London, England

Emil Nolde was born into a peasant family and originally trained as a woodcarver. After studying in Munich, Nolde was invited to become a member of Die Brücke in 1906. Although also associated with the artist's group Der Blaue Reiter, Nolde was essentially a solitary artist whose particular brand of sensual Expressionism, with its spontaneous use of colour, was very much his own. He was a prolific artist who painted figurative subjects, including theatre audiences, dancers and religious works. He also painted landscapes, seascapes, gardens and flowers. His energetic, primitive style was characterized by its use of violent colour, simplified drawing and wild brush marks. **The Sea B** depicts a windswept seascape typical of the flat coastline around the German-Danish border where Nolde lived for most of his life. The sea was an elemental force for Nolde, who saw, "...it not from the beach or from a boat but as it exists in itself, devoid of any reference to man, eternally in motion, ever changing". Nolde travelled to Russia and to the South Sea islands. After the Second World War he lived like a recluse, completing his series **Unpainted Pictures** in secret, apparently still fearing persecution by the Nazis.

Other Masterpieces

MEETING ON THE BEACH;
1921;
NOLDE FOUNDATION,
SEEBULL,
GERMANY

**EVENING LANDSCAPE,
NORTH FRIESLAND;**
1920;
NOLDE FOUNDATION,
SEEBULL,
GERMANY

1931; oil on canvas; 92.2 x 61.3 cm; Art Institute of Chicago, USA

Cow's Skull with Calico Roses

Georgia O'Keeffe was one of the pioneers of modernism in the USA. She was part of a group of artists associated with Alfred Stieglitz, an American photographer and art dealer, who imported avant-garde European art into the USA at the beginning of the twentieth century. She married Stieglitz in 1924. In the 1920s she made a series of precise, clearly defined paintings featuring the skyscrapers of her native New York. With its clinical interest in the rhythm of geometric structures, and the lack of any human interest or social comment, her work was defined by a new term, "Precisionist". Throughout her career, O'Keeffe moved effortlessly in and out of abstraction. Indeed, there is no real distinction between her abstract and figurative works – both feature enlarged, simplified, sculptural forms often derived from nature. From the 1930s, she spent each winter in New Mexico where she painted the desert landscape. **Cow's Skull with Calico Roses** features a surreal juxtaposition of dry, bleached bones and flowers. The clear-cut realism of the folds and crevices, swelling forms and hidden hollows allows for a powerful, sexual interpretation.

Other Masterpieces

BLACK IRIS;
1926;
METROPOLITAN MUSEUM
OF ART,
NEW YORK CITY,
USA

THE MOUNTAIN, NEW
MEXICO;
1931;
WHITNEY MUSEUM OF
AMERICAN ART,
NEW YORK CITY,
USA

Oldenburg Claes

Born Stockholm, Sweden 1929

Soft Drainpipe – Blue (Cool) Version

1967; acrylic on canvas and metal; 259.1 x 187.6 cm; Tate Gallery, London, England

Claes Oldenburg was a principal American Pop artist dominating the New York art scene in the 1960s. "Without the intention of making art," Oldenburg claimed to, "use naive imitation," of reality. His work, combining elements of painting and sculpture, is overtly humorous. He transformed common objects by enlarging their scale to outlandish proportions and altering their familiar material state.

Oldenburg emigrated to Chicago at the age of five. He graduated from Yale University in 1950 and went on to study at the Art Institute of Chicago, before moving to New York in 1956. Here he came into contact with artists producing and participating in "Happenings". By 1960, he was constructing sculptural pieces based on consumer items. In 1961, he opened "The Store" in a vacant shop, where his replicas of food and clothing

were appropriately displayed. Such imitations had developed into the "soft" sculptures by 1962 – such as **Soft Drainpipe** – for which he is best known. For public art commissions from 1965 he realized colossal versions of everyday objects – a lipstick and a peg to name two. Our reaction to these works is bound up with our realization that the absurdity of Oldenburg's creations are safely locked in an art arena.

Other Masterpieces

LUNCHBOX;
1961;
LOUISIANA MUSEUM OF
MODERN ART,
HUMLEBAEK,
USA

GIANT THREE-WAY PLUG,
SCALE B, 2/3;
1970;
TATE GALLERY,
LONDON,
ENGLAND

Born Gomel, Russia 1922

Yaksi Juice

1965; acrylic on canvas; 152.4 x 203.2 cm; collection of Williiam Farley III, Chicago, USA

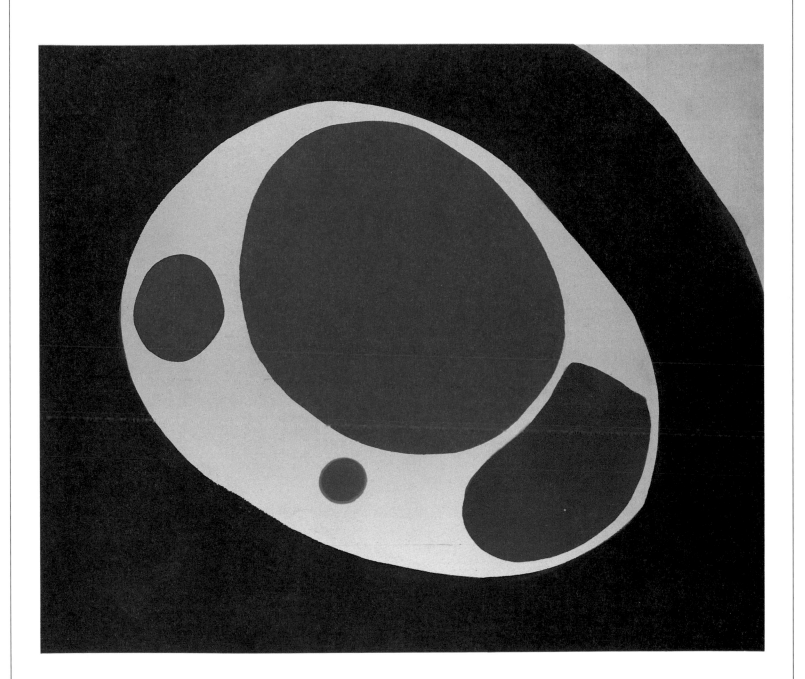

Jules Olitski is one of a group of painters whom theorist Clement Greenberg called "Post-Painterly Abstractionists". Olitski, with Helen Frankenthaler, was a major figure in the movement that followed Abstract Expressionism. Olitski studied art in New York and Paris, thereby absorbing both American and European avant-garde influences. The American colour-field paintings and thick abstracts by Hans Hofmann are of particular relevance. Unlike some of his contemporaries, who were seduced by the lure of popular culture to develop Pop Art, Olitski made, in effect, a critical reappraisal of Abstract Expressionist achievements. During the 1960s, this took the form of paintings comprising coloured stains, often with Pop titles. In 1964, he began making sprayed paintings. **Yaksi Juice** fills the vision of the spectator with overwhelming colour sensation. With reference to an apparent lack of aesthetic content, Olitski has redressed the balance in recent works, manufacturing thickly textured abstracts since the 1970s.

Other Masterpieces

THIGH SMOKE;
1966;
FIRST NATIONAL BANK
 ART COLLECTION,
 SEATTLE,
 USA

PINK-GREY II (PRINT);
1970;
TATE GALLERY,
 LONDON,
 ENGLAND

Opie Julian

Born London, England 1958

H

1987; mixed media sculpture; 131.5 x 219 x 285 cm; Tate Gallery, London England

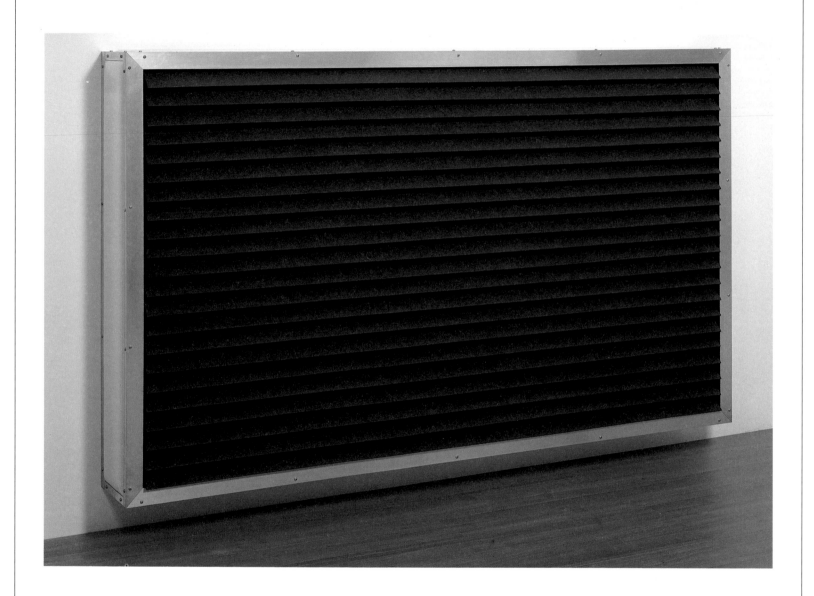

Julian Opie's work is a stylish exploration of the relationship between everyday objects and environments with which people interact, and the objects we label as art. This forms part of a discussion that has informed artistic practice since Marcel Duchamp, but which came to renewed prominence during the early 1980s in the light of Conceptual art developments of the 1970s. **H** appears like an industrially produced heating vent, or ventilation grille. In the contexts in which such a structure might ordinarily appear – an office or factory setting – it would largely be ignored, serving a purely utilitarian function. Within a gallery or museum it fulfils a different purpose. It draws attention to itself as an autonomous art object for contemplation rather than to satisfy any notion of its practical purpose. Our relationship to it is completely altered.

H is one of a series of works that duplicates the materials and form of industrially made partitions and office furnishings. This complements earlier hand-painted sculptures of domestic objects. Experiments with colour and computer animation have informed Opie's more recent works, which inquire further into the experience of urban existence.

Other Masterpieces

MAKING IT;
1983;
TATE GALLERY,
LONDON,
ENGLAND

IMAGINE YOU CAN ORDER THESE (1);
1992;
BRITISH COUNCIL
COLLECTION,
LONDON,
ENGLAND

Meret **Oppenheim**

Object, Fur Breakfast

1936; fur covered cup, saucer and spoon; overall height 7.3 cm; Museum of Modern Art, New York City, USA

eret Oppenheim lived with her grandparents in Switzerland during the First World War. In 1932, she went to Paris and studied at the Académie de Grande Chaumière. She was introduced, by Giacometti and Arp, to the Surrealist movement and modelled for Man Ray. Her own surrealist objects were included in the Surrealist exhibition of 1933. In 1936, she achieved widespread acclaim for her **Object,**

Fur Breakfast. She purchased the cup and saucer from the Uniprix department store and covered it in fur from a Chinese gazelle. It was first exhibited in the Charles Ratton Gallery in Paris. This mundane, domestic object is transformed into a fetish item by the application of the fur, the absurd conjunction of materials giving rise to a wealth of associated sexual meanings. Regarded nowadays as the archetypal

Surrealist object, this unique work has an anarchic, iconic power derived partly from its unexpected dislocation. Another emblematic piece, **The Governess (My Nurse)**, presented shoes trussed up like a roll of lamb on a platter. Oppenheim also organized events. In 1959, she staged a banquet in which a naked woman was placed at the centre of the table as an ironic reference to male sexual fetishism.

Other Masterpieces

THE GOVERNESS (MY NURSE);
1936;
MODERNA MUSEET,
STOCKHOLM,
SWEDEN

RED HEAD, BLUE BODY;
1936;
MUSEUM OF MODERN ART;
NEW YORK CITY,
USA

Oulton Thérèse

Born Shrewsbury, England 1953

Deposition

1989; oil on canvas; 195.6 x 177.8 cm; Tate Gallery, London, England

Thérèse Oulton is a significant contributor to the development of abstract painting in Britain. She studied at St Martin's School of Art (1975–1979) and at the Royal College of Art in London (1980–1983). As a response to the emotional void left by the intellectual ravages of Minimalism and Conceptualism of the 1960s and 1970s, a new generation of artists sought to put figuration and romanticism back into art. Scottish painters took the lead with the former, English with the latter. Oulton, like painters Ian McKeever and Christopher Le Brun, follows in the romantic landscape tradition, taking the achievements of J.M.W. Turner as her cue. However, her intricate abstract paintings, often with evocative titles, take the genre to new heights. They have the sensual intensity of Turner without specifying a place or time, focusing on the interior world of nature. They appear like the tiniest fragment of a landscape – rock strata or plant organisms – magnified to monumental proportions. In **Deposition**, Oulton has interwoven layers of luscious oil paint like a delicate, complex skein of jewel colours. The rhythms and harmonies structuring the painting keep the eye dancing around the composition, searching for new details to enjoy.

Other Masterpieces

MORTAL COIL;
1984;
BRITISH COUNCIL
 COLLECTION,
LONDON,
ENGLAND

SMOKESCREEN;
1989;
TATE GALLERY,
 LONDON,
ENGLAND

Polaris

1990; video sculpture; 142.25 x 142.5 x 58.4 cm Dorothy Goldeen Gallery,
Santa Monica, California

Nam June Paik studied music and musical theory in Tokyo, graduating in aesthetics. Toward the end of the 1950s he travelled to Germany where he encountered John Cage and began his career as a composer and performer of avant-garde music. His activities achieved attention via his involvement in the early 1960s with the group of conceptual artists and poets who formed the Fluxus movement. The extravagant performance pieces he created were the beginnings of his exploration into the visual potential of music. He moved to New York in 1964 and has since become widely recognized for his large-scale, often overwhelming sculptures constructed from television sets and video monitors. By experimenting with this medium he fused art with modern communications technology, while resisting the elitism and ideology which attached itself to fine art production. His innovative work appeals to a wide audience. **Polaris** uses flashy, computer-driven electronics to make a statement. The artist incorporates imagery that combines the past with the present and the East with the West, referring to contemporary themes confronting global culture and civilization.

Other Masterpieces

FIN-DE-SIECLE II;
1989,
WHITNEY MUSEUM OF
AMERICAN ART,
NEW YORK CITY,
USA

**V-MATRIX WITH BEUYS'
VOICE AM SEIBU;**
1983–1988,
SEIBU MUSEUM,
DUSSELDORF,
GERMANY

Palmer Samuel

Born London, England 1805; **died** Reigate, England 1881

A Hilly Scene

c.1826–1828; tempera on paper and wood; 20.6 x 13.7 cm; Tate Gallery, London, England

Samuel Palmer was a child prodigy who first exhibited landscape drawings at the Royal Academy when he was fourteen years old. He was introduced to the great visionary artist William Blake in 1824, a meeting that significantly intensified Palmer's already mystical imagination. After a move to Shoreham, in Sussex, in 1826, Palmer produced a number of small ink and wash landscapes, as well as several oil paintings, that are now generally regarded as his best work. **A Hilly Scene** shows a nocturnal and mysterious scene that, in his own words, reveals "a mystic glimmer" behind the hills. His imaginative, lyrical landscapes relied on the Pantheistic idea of the unity in all things. Palmer's depiction of sheaves of corn and trees abundant with fruit symbolized the idea that the way to salvation was through a simple life led in harmony with nature. In Shoreham, Palmer became the central figure of a group known as the Ancients. He returned to London in 1835, after which he acquired a reputation as a conventional, academic painter. His early work was rediscovered in the 1930s and 1940s and influenced several painters, Graham Sutherland and Paul Nash in particular.

Other Masterpieces

IN A SHOREHAM
 GARDEN;
c.1829;
VICTORIA AND ALBERT
 MUSEUM
LONDON,
ENGLAND

COMING HOME FROM
 EVENING CHURCH;
1830;
TATE GALLERY,
LONDON,
ENGLAND

Born Edinburgh, Scotland 1924

Wittgenstein in New York

1964; pen and ink on paper; 76.3 x 53.8 cm; Tate Gallery, London, England

Paolozzi is generally recognized as a sculptor belonging to the Pop Art movement in Britain. Born in Scotland of Italian parents, Paolozzi graduated from evening classes in Edinburgh to studying in London at St Martin's School of Art and the Slade School. He finished in 1947 and for the next two years lived in Paris where he came into contact with numerous notable artists. On returning to London he shared a studio with sculptor William Turnbull. From 1951 he undertook many public art commissions in Britain and abroad and taught textile design and sculpture, as well as in the ceramics department of the Royal College of Art. Paolozzi possesses diverse technical skills. These are reflected in his complex sculptural constructions, reliefs developed from eclectic sources and 2D works such as **Wittgenstein in New York**. In wood, plaster and on paper he continually recomposes and reorders shapes that have been created, altered and found. Maquettes are reproduced on a large scale, often in bronze. They comprise a conglomeration of influences from Classicism to Constructivism, Cubism to Futurism, and are a mixture of the organic and the mechanical, the representational and the abstract.

Other Masterpieces

THE WEALTH OF
NATIONS;
1993;
DRUMMOND HOUSE,
EDINBURGH,
SCOTLAND

MOSAICS;
1980;
TOTTENHAM COURT ROAD
TUBE STATION,
LONDON,
ENGLAND

Parmigianino Francesco

Born Parma, Italy 1503; **died** Casalmaggiore, Italy 1540

Madonna with Saint Zacharias

c.1530; oil on canvas; 73 x 60 cm; Galleria degli Uffizi, Florence, Italy

An artist who displayed his prodigious talent at an early age, Francesco Parmigianino took his name from Parma, his birthplace. He was a contemporary of Correggio, who also worked in Parma for much of his life. Both men separately worked on commissions for the frescoes in the chapels of St Giovanni Evangelista. Parmigianino went to Rome in 1523. Here his dramatic and intense style, with its propensity for distortion, started to reveal a softer and more graceful influence from Raphael and Michelangelo. He moved to Bologna four years later, when Rome was sacked by German troops. Returning to Parma in 1531, the last ten years of his life were spent in bitter dispute over his failure to complete frescoes for the church of Sta Maria della Steccata. **Madonna with Saint Zacharias** reveals, through its flowing robes and disproportionate group of figures, the Mannerist elongation of forms for which Parmigianino is renowned. The unusual and imaginative composition includes the remarkable portrait of the old man to the right of the painting, sitting staring into space as spectator to the scene rather than active participant.

Other Masterpieces

SELF-PORTRAIT IN A CONVEX MIRROR; 1524; KUNSTHISTORISCHES MUSEUM, VIENNA, AUSTRIA

MADONNA WITH THE LONG NECK; c.1535; GALLERIA DEGLI UFFIZI, FLORENCE, ITALY

Born Warlingham, England 1908

Victor Pasmore

1950; oil on canvas; 81.3 x 100.3 cm; Tate Gallery, London, England

Spiral Motif in Green, Violet, Blue and Gold: The Coast of the Inland Sea

While employed in clerical work during the day, Victor Pasmore studied art in the evenings at St Martin's School of Art, London, "painting cubist pastiche". In 1932, he joined the London Artists' Association, run by the Bloomsbury Group, and was elected to the avant-garde London Group. Through this he made contact with artists William Coldstream and Claude Rogers. Together, they formed the Euston Road School in 1937. Throughout the 1940s, Pasmore worked in a naturalistic way, producing sensitive portraits and atmospheric landscapes. However, towards the end of the decade he moved to an abstract mode of expression, influenced by his contemporaries and inspired, not by Picasso's art, but by his spirit of artistic independence. Pasmore began reformulating the idea of "basic form" as used by the Bauhaus. With Richard Hamilton at Newcastle University, he developed a radical way of teaching art, known as Basic Design. Pasmore painted **Spiral Motif in Green, Violet, Blue and Gold: The Coast of the Inland Sea** around the time that he was in St Ives, Cornwall. "The Inland Sea" refers to "the coast of subconscious experience", revealing Pasmore's confidence in abstraction as "a modern romanticism".

Other Masterpieces

THE PARK;
1947;
SHEFFIELD CITY ART
GALLERIES,
SHEFFIELD,
ENGLAND

**THE SNOWSTORM
(SPIRAL MOTIF IN
BLACK AND WHITE);**
1950–1951;
ARTS COUNCIL OF
ENGLAND COLLECTION,
LONDON,
ENGLAND

Patenier Joachim

Born Netherlands c.1485; **died** Antwerp, Belgium 1524

Charon Crossing the River Styx

c.1520; oil on canvas; 64 x x103 cm; Museo del Prado, Madrid, Spain

Patenier is notable for producing some of the first Flemish paintings in which landscape takes precedence over figures. He was described by Dürer, whom he met in 1521, as a "good landscape painter" and many works have been attributed to, but few signed by him. Very little is known about his early life. He became a member of the Antwerp guild in 1515 and collaborated with a number of artists, either painting landscape backgrounds for them or having them paint figures into his work. Specific narrative made the subjects of his paintings but it is the environments in which the unfolding of respective stories take place which dominate. Scenes such as **Charon Crossing the River Styx** reveal Patenier's attention to detail, which is a mixture of imaginative fantasy and of observation from nature. It has a quality which owes something to the strangeness of Bosch and offers a panoramic view that foreshadows the achievements of Claude. His precision and attention to systematic colouring in order to describe depth and recession is evidence of his importance in developing the formal elements in the depiction of landscape as a subject in its own right.

Other Masterpieces

Osten

1980; acrylic on canvas; 250 x 400 cm; Galerie Michael Werner, Cologne, Germany

Born Ralf Winkler, A R Penck never received formal art training. In his early oil paintings he focused on interior and exterior scenes from urban life. He also painted a number of portraits. He was a friend of the artist Georg Baselitz, who moved to West Berlin in 1956. In 1961, the year that the Berlin Wall was built, Penck experienced an artistic and political crisis when he was blocked from studying and rejected from the army on the grounds that he was "anti-social". In 1964, he was allowed some freedom by the East German authorities and set up his own studio. **Osten** is a lively, structured painting using signs within a given framework. His primitive style is based on a complex pattern of symbols, in which a stick-man represents the human race. The interplay of symbols, numbers, letters and patterns alludes to a reading of society that forever remains disturbingly incomplete and incomprehensible. Unsurprisingly, given the underground nature in which he had to live his life, much of his work appears coded and mysterious. In 1980, Penck was finally able to leave East Germany and now lives in London.

Other Masterpieces

CROSSING;
1963;
STADT AACHEN,
 NEUE GALERIE,
 SAMMLUNG LUDWIG;
GERMANY

METAPHYSICAL PASSAGE
 THROUGH A ZEBRA;
1975;
STADT AACHEN,
 NEUE GALERIE,
 SAMMLUNG LUDWIG,
 GERMANY

Picabia Francis

Born Paris, France 1879; **died** Paris, France 1953

Portrait of a Doctor

1935–1938; oil on canvas; 92 x 73 cm; Tate Gallery, London, England

Francis Picabia's diversity as an artist has distinguished him as an influential figure in the history of twentieth-century art; he is accredited as being the originator of Pop Art. He studied at the Ecole des Beaux-Arts and the Ecoles des Arts Decoratifs in Paris and has the distinction of having painted the first abstract painting in 1908, before Kandinsky in 1910. The attempt to inject lyricism into the dry, intellectualism of Cubism was a preoccupation among artists circa 1910. With these considerations in mind, Picabia came into contact with Duchamp and together they contributed to founding the Section d'Or (Golden Section). His association with Duchamp developed into an involvement with the anarchistic Dadaist movement. He was highly active both in Europe and America, publishing periodicals and journals in addition to promoting events and producing his own work. Picabia also associated with the Surrealists in Paris after 1919. **Portrait of a Doctor** contains elements that could be attributed to either tendency although the surreal nature of the image is a particular feature. Its meaning is obscure and appropriate for the artist, who declared that, "Our heads are round so that thoughts can change direction".

Other Masterpieces

OTHER MASTERPIECES
ICI, C'EST ICI
STIEGLITZ;
1915;
THE METROPOLITAN
MUSEUM OF ART,
NEW YORK CITY,
USA

CONVERSATION I;
1922;
TATE GALLERY,
LONDON,
ENGLAND

1906; oil on canvas; 244 x 234 cm; Museum of Modern Art, New York City, USA

Les Demoiselles d'Avignon

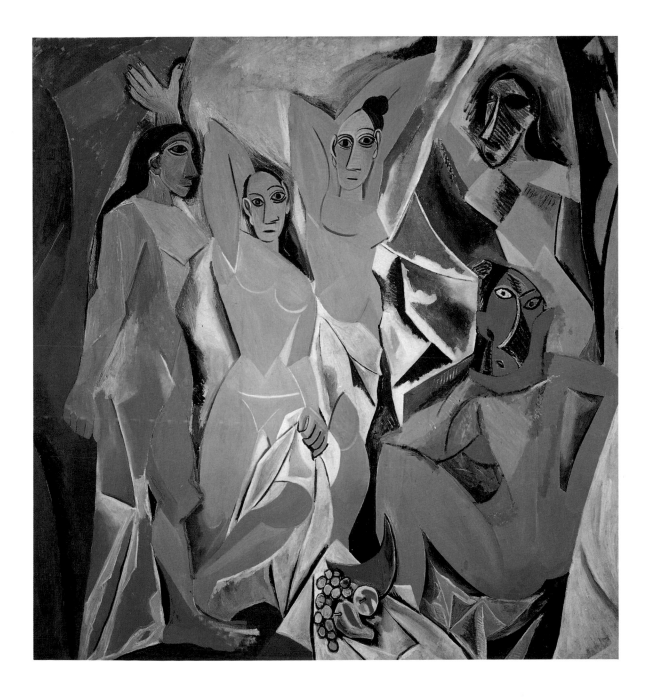

Pablo Picasso's painting **Les Demoiselles d'Avignon**, marks the beginning of Cubism, a revolutionary artistic movement initiated by Picasso and his fellow artist Georges Braque. Picasso first started work on this painting in his Parisian studio in 1906. The final composition shows clearly the influence of both Cézanne, who had famously declared that all nature was based on the sphere, the cylinder and the cone, and the simplified forms that Picasso had found in African art. The right-hand side of the painting, in particular, with its flat shapes and mask-like heads, shows what a dramatic break with tradition this was. Although Picasso is primarily associated with Cubism, his so-called Blue Period, with its melancholic depiction of lowlife, was another significant early phase in his development. From 1914 onward, his work evolved in many other directions. Paintings, drawings, collages, etchings, sculptures, stage designs and ceramics were produced at an astonishing rate with subjects as diverse as classical mythology and the horrors of war. After exhibiting with the Surrealists in 1925, he continued to experiment with characteristic energy and confidence until his death, aged ninety two, in 1973. He was indisputably a genius and the founder of modern art.

Other Masterpieces

GUERNICA;
1937;
CENTRO DE ARTE REINA
SOFIA,
MADRID,
SPAIN

WEEPING WOMAN;
1937;
TATE GALLERY
LONDON,
ENGLAND

Piero della Francesca

Born Borgo Sansepolcro, Italy c.1419; **died** Borgo Sansepolcro, Italy 1492

Resurrection

c.1463; fresco; 225 x 200 cm; Pinacoteca Sansepolcro, Italy

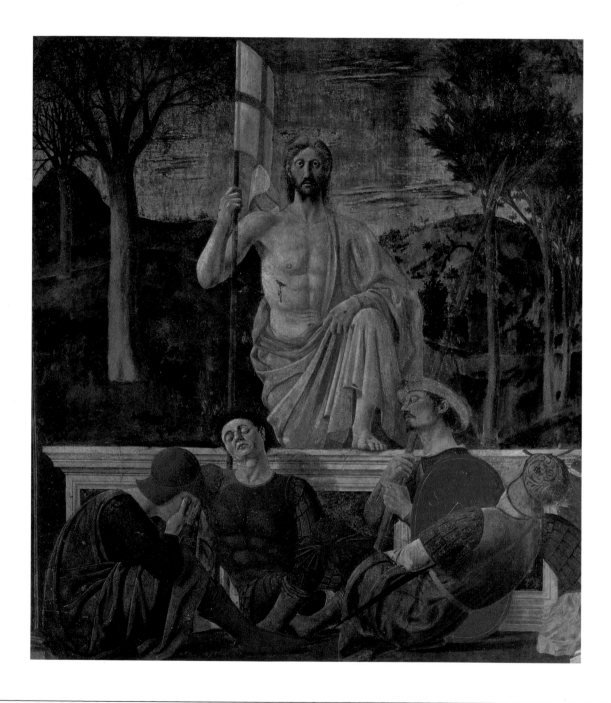

The career of Piero della Francesca began in Florence as an assistant to Veneziano, but he spent most of his time in his home town of Borgo, where he was a town councillor. He was influenced by the achievements of his artistic predecessors and contemporaries such as Masaccio, Uccello and Donatello; his own fascination with mathematics became his unique contribution. In the 1470s, he stopped painting, dedicating his time instead to writing two treatises on geometry and perspective. There is a timeless, serene air to his paintings, and it seems fitting that he often delayed completing commissioned work. In **Resurrection** he paints Christ as a robust and muscular man, and the moment of his triumphal return to life, in a solemn and calm manner. This austere mood is increased by the use of pale, fresco colours and soft lighting. There is little to divert attention away from the direct gaze of Christ. Although well-known in his lifetime, Piero della Francesca's art was neglected until the nineteenth century, when his reputation as one of the greatest painters of the early Renaissance was established.

Other Masterpieces

THE BAPTISM; c.1450; NATIONAL GALLERY, LONDON, ENGLAND

CONSTANTINE'S DREAM; c.1460; SAN FRANCESCO, AREZZO, ITALY.

Piero di Cosimo

A Satyr Mourning Over a Nymph

c.1496; oil on poplar; 65.4 x 184.2 cm; National Gallery, London, England

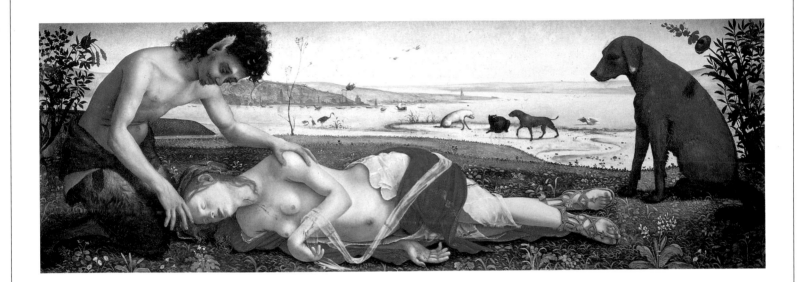

A pupil of Cosimo Rosselli, Piero di Cosimo adopted his master's Christian name. He was influenced by Leonardo da Vinci and Signorelli but painted allegories and classical myths in a singular, imaginative style consistent with contemporany accounts of him as an eccentric and a recluse. Vasari, in his fifteenth-century account of artists's lives, for example, records Piero's extreme love of nature and his unlikely diet of hard-boiled eggs as evidence of his idiosyncratic tendencies. In **A Satyr Mourning Over a Nymph**, Piero di Cosimo depicts the personal tragedy of infidelity and jealousy of a young couple, believed to have been Cephalus and Procris. While his handling of their suffering is tender and convincing, the painting is equally remarkable for the artist's rendition of the effects of natural light and his keen observation of animals. The depiction of the faithful dog is particularly impressive. The painting, which is on wood, was probably designed to adorn a bench or a chest in a Florentine town house. He also painted a few religious works, and worked on designs for festivals, masques and processions.

Other Masterpieces

FIGHT BETWEEN THE LAPITHS AND THE CENTAURS;
c.1507;
NATIONAL GALLERY,
LONDON,
ENGLAND

IMMACULATE CONCEPTION;
c.1507;
GALLERIA DEGLI UFFIZI,
FLORENCE,
ITALY

Piper John

Born Epsom, England 1903; **died** Fawley, England 1992

St Mary Port, Bristol

1940; oil on canvas; 76.2 x 63.5 cm; Tate Gallery, London, England

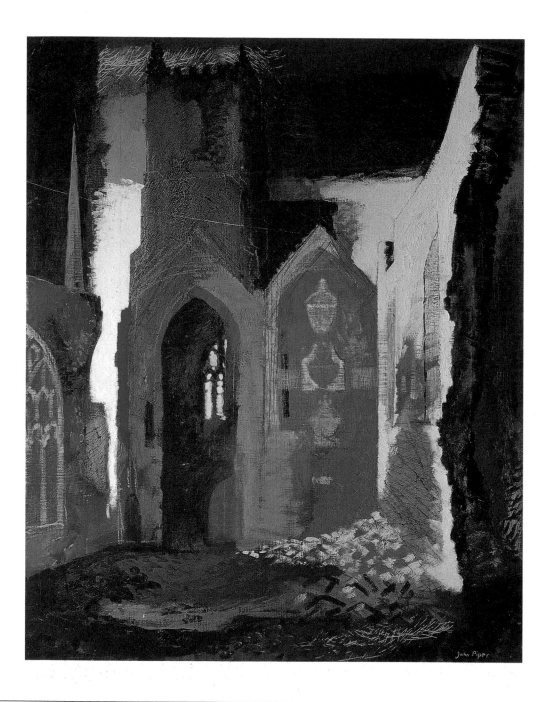

John Piper began his career as clerk in his father's firm of solicitors. After his father died, in 1926, he studied at the Richmond School of Art, and then at the Royal College of Art in 1927. A member and secretary of the Seven and Five Society of artists, he exhibited abstract sculpture with the group from 1934. Piper helped to produce Axis, the review of abstract art, the editor of which, Myfanwy Evans, became Piper's second wife in 1937. This pioneering publication attracted contributions from eminent art theorists, historians and avant-garde artists of the day. It, and associated papers, contributed to the rise of landscape art in the English tradition, taking into account recent European artistic developments, most notably Surrealism. Piper incorporated romanticism and nostalgia into his work, sharing in the spirit of work by Sutherland and Nash. Via his experimentation with collage, he returned to a representational mode of working. **St Mary Port, Bristol** is moody rather than naturalistic. This "neo-picturesque", serene but sombre image of church ruins is a composite of numerous techniques and reveals Piper's versatility. It also reflects his interest in architecture and his confirmed religious beliefs.

Other Masterpieces

ABSTRACT I;
1935;
TATE GALLERY,
LONDON,
ENGLAND

SEATON DELAVAL;
1941;
TATE GALLERY,
LONDON,
ENGLAND

Born St Thomas, West Indies 1830; **died** Paris, France 1903

1877; oil on canvas; 65.5 x 81 cm; Musée d'Orsay, Paris, France

The Vegetable Garden with Trees in Blossom, Spring, Pontoise

In order to achieve his ambition of becoming an artist, Camille Pissarro moved to Paris at the age of twenty four. Here he worked under Corot, who advised him to paint directly from nature and to, "...study light and tonal values". Despite earning praise for his early landscapes, Pissarro was poverty-stricken and made his living painting fans and blinds. From the late 1860s he was a leading Impressionist – he helped organize all eight of their exhibitions and was the only one to participate in them all. He and Monet were both in London during the Franco-Prussian War, the two men admiring the work of Constable and Turner. From 1872 until 1884 Pissarro lived at Pontoise, working directly on out-of-doors paintings. In this painting, **The Vegetable Garden with Trees in Blossom, Pontoise**, he successfully evokes the atmosphere of a soft spring afternoon, achieving great luminosity through small dabs of pure colour. Pissarro influenced Cézanne, who worked with him at Pontoise between 1872–1877. Never seen as the most innovative of the Impressionists, Pissarro was nonetheless described in a pamphlet published in 1878 as, "the most naturalist of them all. He sees nature and simplifies it through its most permanent aspects". Gradually his eyesight failed; he died blind.

Other Masterpieces

LOWER NORWOOD, LONDON;
1870;
NATIONAL GALLERY, LONDON, ENGLAND

PLACE DU THEATRE FRANCAIS;
1898;
COUNTY MUSEUM OF ART, LOS ANGELES, CALIFORNIA, USA

Polke Sigmar

Born Olesnica, Poland 1941

Paganini

1982; acrylic on fabric; 200 x 450 cm; Thomas Ammann Collection, Zürich, Switzerland

Sigmar Polke grew up in East Germany. After moving with his family to West Germany, settling in Willich, he studied glass painting from 1959 to 1960 at Düsseldorf-Kaiserwerth and then transferred to the Academy of Art. With fellow student Gerhard Richter he formulated a Pop-inspired "Capital Realist" anti-style of art, appropriating the pictorial short-hand of advertizing. The anarchistic element of the work Polke developed was largely engendered by his mercurial approach. His irreverence for traditional painting techniques and materials and his lack of allegiance to any one mode of representation has established his now-respected reputation as a visual revolutionary. **Paganini**, an expression of "the difficulty of purging the demons of Nazism" – witness the "hidden" swastikas - is typical of Polke's tendency to accumulate a range of different mediums within one canvas. It is not unusual for Polke to combine household materials and paint, lacquers, pigments, screen-print and transparent sheeting in one piece.
A complicated "narrative" is often implicit in the multi-layered picture, giving the effect of witnessing the projection of a hallucination or dream through a series of veils.

Other Masterpieces

GIRLFRIENDS;
1965;
COLLECTION FROEHLICH,
STUTTGART,
GERMANY

SWIMMING POOL;
1988;
COLLECTION FROEHLICH,
STUTTGART,
GERMANY

c.1471–1472; engraving on paper; 38.3 x 59 cm; Cleveland Museum of Art, Ohio, USA

Battle of the Ten Nudes

With his younger brother, Piero, Antonio Pollaiuolo maintained one of the most successful workshops in Florence during the second half of the fifteenth century. It produced a wide range of art forms including tapestry designs, sculpture, metalwork and paintings. Among the most prestigious commissions were a silver reliquary for the Florentine Baptistery and the bronze tombs for Pope Sixtus IV and Pope Innocent VIII in St Peter's, Rome. The high quality engraving, **Battle of the Ten Nudes**, is a good example of Antonio's abiding passion for anatomical study and his skilled draughtsmanship; this is represented by his depiction of figures in vigorous action. According to the treatise of humanist and architect Alberti, painting should be divided into contour, composition and light – contour being the clear delineation between figures, and composition the way individual elements fit together. When the latter was applied to anatomy, Alberti allegedly advized artists to draw the skeleton first, add the muscles next and then pad out with flesh and skin. This engraving epitomizes Alberti's theories and, along with other works, awarded Antonio the reputation of being the precursor to Leonardo.

Other Masterpieces

MARTYDOM OF SAINT
SEBASTIAN;
1475;
NATIONAL GALLERY,
LONDON,
ENGLAND

TOMBS OF POPES SIXTUS
IV AND INNOCENT
VIII;
1493 AND 1492–1498;
ST PETER'S CHURCH,
ROME,
ITALY

Pollock Jackson

Born Cody, USA 1912; **died** Long Island, USA 1956

Yellow Island

1952; oil on canvas; 143.5 x 185.4 cm; Tate Gallery, London, England

Jackson Pollock's early landscapes were characteristic of the American romantic realism of the 1930s. By the end of the 1940s, he was painting in a completely abstract manner, producing canvases covered with dripped paint. The central figure in a movement known as Abstract Expressionism, Pollock saw painting as a spontaneous activity, believing that the canvas should express directly the artist's emotions.

The picture was not painted: it "happened". To quote Pollock, "The painting has a life of its own. I only let it come through". Typically, Pollock would let the paint fall from the brush or vessel on to a huge canvas laid on the floor. The result was a network of coloured lines of extraordinary delicacy and complexity. **Yellow Island** reveals a darker, more melancholic side to the artist. Executed on the floor, using black paint on

raw, unprimed canvas, this particular picture is from a series that was thought by critics to indicate Pollock's dependence on alcohol. Pollock's concept of "action painting" as something into which one threw one's whole body contributed hugely to the rise of modern American painting. His early death, in a road accident in 1956, has added to his legendary reputation.

Other Masterpieces

SUMMERTIME:
 NUMBER 9A;
1948;
TATE GALLERY,
 LONDON,
 ENGLAND

PASIPHAE;
1943;
MUSEUM OF MODERN ART,
 NEW YORK CITY,
 USA

Pontormo's master was Andrea del Sarto whom he surpassed in his vigorous and original treatment of religious subjects. Pontormo transformed late Classicist style into dramatic Mannerist art. Reverential themes become vehicles for transporting vibrant colouring and theatrical compositions almost to the realm of fantasy. An accumulation of incongruous elements form **Joseph in Egypt**. Witness the unreal and unbelievable mixture of architectural styles, strange depiction of space and the almost living statues. Pontormo's compositions tend to overwhelm the spectator by the amount of activity and complicated rhythms set by figure groups. Each portion within the frame is busy, with no respite from colours and gestures jostling for attention. In contrast his portraits have strength and clearly defined focus. The robust modelling of his figures and clearly cut folds of his drapery owes something to Michelangelo, seen most clearly in Pontormo's last and greatest commission, the decoration of the choir of San Lorenzo in Florence. The high-key, nervously energetic quality of Pontormo's painting compensates for his reputedly introspective, melancholic personality. His work provides an antidote to the comparatively stilted, formal quality characterising the Classical art which preceded his.

Other Masterpieces

VISITATION,
1530–1532,
PIEVE DI SAN MICHELE,
CARMIGNANO,
ITALY

DEPOSITION,
1526–1528,
CAPPONI CHAPEL,
CHURCH OF STA
FELICITA,
FLORENCE,
ITALY

Poussin Nicholas

Born Les Andelys, France c.1593; **died** Rome, Italy 1665

The Rape of the Sabines

c.1638; oil on canvas; 96.5 x 109.5 cm; Musée du Louvre, Paris, France

Poussin is considered as the leading exponent of French Classicist painting. He settled in Paris 1612. Rather than being influenced by artists still working in a sixteenth century Mannerist vein, he focused instead on emulating the Antique and studying Classical works of the Renaissance. He paid particular attention to Raphael and to Roman statuary and reliefs, In 1623 Poussin travelled, via Venice, to Rome. Through his contact with the poet Marino, he began working under the patronage of Cardinal Baberini. Poussin avoided current Baroque tendencies and after 1630 concentrated on mythological subjects, developing to maturity the Classical style for which he is best known. The Venetian painters, particularly Titian, influenced his colouring, injecting verve and vibrancy into sublime, pastoral scenes. In a different mood, works made from the late 1630s, such as **Bacchanal** and **The Rape of the Sabines**, illustrate a predilection for more complicated pageantry and austerity. Formal compositional construction identifies Poussin's growing preference for imbuing his vision with the Classicist spirit. In the late 1640s he applied these academic design principles to landscape paintings which mark an achievement that became an entire genre for his counterpart, Claude Lorraine.

Other Masterpieces

THE WORSHIP OF THE GOLDEN CALF;
c.1635,
NATIONAL GALLERY,
LONDON,
ENGLAND

ORPHEUS AND EURYDICE;
c.1650,
MUSEE DU LOUVRE,
PARIS,
FRANCE

Pierre Puvis de Chavannes

Poor Fisherman

1881; oil on canvas; 155 x 192.5 cm; Musée d'Orsay, Paris, France

uvis de Chavannes was a leading decorative muralist. He produced his images on canvases, in flat fresco pigments, which were then affixed to the walls. His subjects tended to be abstracted from the Antique or allegorical themes, devoid of literary references. Simpler, poetic works, **Poor Fisherman**, for example, are more evocative than his monumental frieze projects. The theme of fishing and fishermen recurs in his work. The mood dictating the message of **Poor Fisherman** is difficult to interpret and a melancholic atmosphere pervades the consciously non-naturalistic scene. This is enhanced by anaemic colours which are typical of works from 1880s onward, dominated by a single tone. This two-dimensionality and high horizon-line is a precursor of Picasso's calm Blue Period. Puvis de Chavannes justified his methods by stating that "Painting is not merely an imitation of reality, but a parallel with nature". In spite of being critically underrated and described as a thinker, not a painter, he won the respect of numerous artists with a variety of aims and ideologies from Seurat to Toulouse-Lautrec. The expressive qualities of his work were of particular interest to Synthetist and Symbolist artists.

Other Masterpieces

LE BOIS SACRE CHER AUX ARTS ET AUX MUSES;
1883–1884;
PALAIS DES ARTS,
LYONS,
FRANCE

THE INSPIRING MUSES;
1893–1895;
BOSTON PUBLIC LIBRARY,
BOSTON,
USA

Raphael (Raffaello Sanzio)

Born Urbino, Italy 1483; **died** Rome, Italy 1520

La Belle Jardinière

1508; wood panel; 122 x 80 cm; Musée du Louvre, Paris, France

The son of a painter, Raphael worked with the successful Umbrian painter Perugino at an early age. Raphael's feeling for colour and his ability to convey a sense of emotional tranquillity through his work led to his talent being quickly recognized. Younger than Leonardo and Michelangelo, Raphael identified the enormous contribution these artists were making in Florence and, in 1504, went there to study. From Leonardo he absorbed a sense of composition and drawing skills, and further strengthened his work through a close examination of Michelangelo's dynamic figures. By 1508, Raphael was much in demand and received his most prestigious commission to date, namely the decoration of the papal apartments of Pope Julius II in the Vatican. Over the next twelve years – until his premature death from fever caused the entire papal court to plunge into grief – Raphael's great achievements were much celebrated and admired. **La Belle Jardinière** is one of his many depictions of the **Madonna and Child**. In this harmonious composition the figures unite, combining grandeur, grace and a sense of calm. The relaxed serenity of this work typifies Raphael's many evocations of the classical "Golden Age".

Other Masterpieces

SAINT CATHERINE OF ALEXANDRIA; c.1507–1508; NATIONAL GALLERY, LONDON, ENGLAND

BALDASSARE CASTIGLIONE; c.1515; MUSEE DU LOUVRE, PARIS, FRANCE

The Red Painting

1953; oil, fabric and paper on canvas; 179.5 x 122 cm; Private Collection

Robert (born Milton) Rauschenberg's art has more to do with leaping the boundaries of art in the spirit of Dada than it has to do with the Abstract Expressionist movement in America with which he is associated. More significant than his attendance at the Art Institute in Kansas City from 1946–1947, and at the Academie Julian in Paris in 1948, were the periods spent studying under the "hard edge" abstract painter Josef Albers at Black Mountain College. His contact here with the experimental composer John Cage proved influential; Rauschenberg collaborated on "Happenings" and sought to expand the possibilities of his visual art beyond traditional painting or assemblage. The all-white and the all-black series of paintings that were included in his first exhibitions at the beginning of the 1950s were the minimal antithesis of work that was shortly to follow. All manner of ephemera were combined with three-dimensional objects and painting to produce unsettling, controversial works, the significance of which was formulated largely by the spectator. In **The Red Painting**, for example, the dripping paint, sodden material and awkward juxtaposition of the various elements has a more resounding impact than the overriding colour.

Other Masterpieces

CANYON;
1959;
SONNABEND COLLECTION,
NEW YORK CITY,
USA

BED;
1955;
COLLECTION OF MR AND
MRS LEO CASTELLI,
NEW YORK CITY,
USA

Redon Odilon

Born Bordeaux, France 1840; **died** Paris, France 1916

The Red Sphinx

c.1910; oil on canvas; 100 x 80 cm; Private Collection, Switzerland

Odilon Redon experienced an unhappy childhood after an early illness led to him being brought up by his uncle. His attempt to train as an architect was thwarted and his artistic development was slow, largely the result of time spent in the studio of Bresdin, a printmaker based in Bordeaux. From the 1870s until the 1890s Redon worked almost exclusively in black and white. His early efforts were comprised of charcoal drawings and etchings that looked to the landscape for inspiration to express his intense and mournful vision. He developed a distinctive, spiritual and symbolic art drawing upon a broad range of sources, including the unconscious, philosophy, literature and Charles Darwin's theories of evolution. After the publication of the Symbolist Manifesto in 1886 he became, with the writer Mallarmé, one of the leading Symbolists. During the 1890s Redon began to explore new media such as oils and pastels and introduced colour to his work. By the turn of the century the work of this hitherto little known artist, in particular his decorative, colourful flower-pieces, was much in demand. **The Red Sphinx** is a bizarre hybrid, typical of his poetic style that proved especially influential to the Surrealists.

Other Masterpieces

SITA;
c.1893;
THE ART INSTITUTE OF
CHICAGO
USA

FLOWER CLOUDS;
c.1903;
THE ART INSTITUTE OF
CHICAGO,
USA

The Dance

1988; acrylic on paper; 212.6 x 274 cm; Tate Gallery, London, England

Paula Rego came to London in the early 1950s and began studying, "unofficially" as an art student at The Slade School in London. Here she met and fell in love with painter Victor Willing whom she later married. Under his influence, Rego learned to draw whatever came into her head. Such spontaneous activity became directed to the production of expressionist pictures and collages. The death of her father in 1966 and the progressive illness of Willing delayed her own artistic development. In 1976 Rego received a grant to illustrate a series of Portugese fairy-tales. At the same time Jungian therapy had encouraged her thoughts back to childhood themes. Stories became her art. Compositions of the early 1980s are like overloaded cartoons, colourfully packed with the energy of animals and creatures engaged in frenetic activity. Her work has become a more formal interpretation of the complications inherent in human relationships and associated symbols and metaphors. The vivid imagery of **The Dance**, for example, is inspired by Portugese folk art and the caricatured figures and compositional format have their roots in classicism. The traditions of nineteenth century illustrations inform her bold paintings which have a disquieting atmosphere and subversive narrative.

Other Masterpieces

RED MONKEY BEATS HIS WIFE;
1981;
THE ARTIST'S COLLECTION

THE POLICEMAN'S DAUGHTER;
1987;
SAATCHI COLLECTION, LONDON, ENGLAND

Rembrandt (Harmensz van Rijn)

Born Leyden, Netherlands 1606; **died** Amsterdam, Netherlands 1669

The Anatomy Lesson of Dr Tulp

1632; oil on canvas; 169.5 x 216 cm; Mauritshaus, The Hague, Netherlands

One of the greatest artists of all time, Rembrandt van Rijn trained principally in Amsterdam before working as an independent master in Leyden. His early paintings were of figures depicted in a biblical or philosophical context. He moved to Amsterdam in 1631–1932, where he received his first portrait commission. He made his name with this group portrait, **The Anatomy Lesson of Dr Tulp**. Unsparing in its depiction of the dissection of a human corpse, the boldly-lit composition is given added potency through the enrapt group of notables, each one a fully realized individual.

The culmination of this lucrative phase of his career was **The Night Watch**, a group portrait of the militia's defence of Amsterdam. Rembrandt's fortune declined after 1642. He received no significant portrait commissions and experienced great financial difficulties, which led to bankruptcy in 1656. In later years he reverted to biblical subjects. His many self-portraits produced at every stage of his career provide an analytical account of his life. He had the incomparable ability to capture the outward appearance of his subjects, while laying bare the inner truth of their character. It is this understanding of humanity that makes his work so unique.

Other Masterpieces

PORTRAIT OF THE ARTIST; c.1665; KENWOOD HOUSE, LONDON, ENGLAND

A WOMAN BATHING IN A STREAM; 1654; NATIONAL GALLERY, LONDON, ENGLAND

Born Bologna, Italy 1572; **died** Bologna, Italy 1642

undated; oil on canvas; 268 x 170 cm; Pinacoteca Nazionale, Bologna, Italy

Massacre of the Innocents

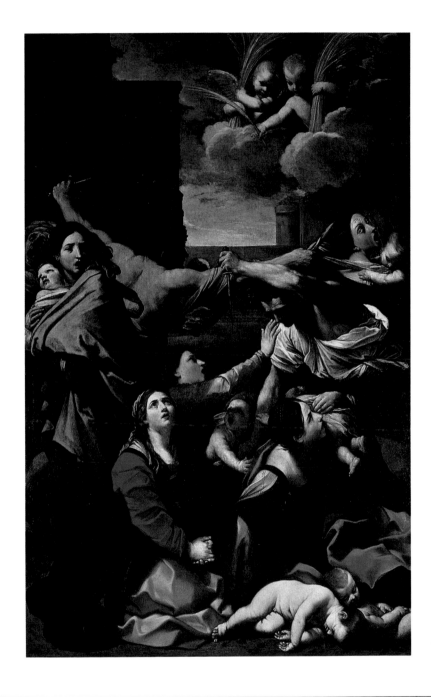

Guido Reni trained at the Carracci Academy in Bologna, Italy. Here his work benefited from the special emphasis that was placed on drawing from life. He visited Rome in 1600, where Raphael exerted a significant influence. Reni painted graceful reworkings of ancient and classical themes, distinguished mainly by the refined beauty of his colouring. He reputedly remarked that, "the only paintings that were beautiful and perfect were those that continued to grow on one as one viewed them day after day". He could well have been referring to his own work, **Massacre of the Innocents**. The melodramatic nature of this powerful composition has – due to the studied concentration of upturned faces and the folds of draperies – a static, almost frozen, beauty. Reni was an eccentric whose allegedly modest character did not temper his penchant for expensive clothes nor gambling. He became the most important painter in Bologna after Ludovico Carraci's death in 1619 and managed a large and busy studio. Reni enjoyed a great reputation in eighteenth and early nineteenth century, which only declined after Ruskin launched an attack on the pious sentimentality of his religious works.

Other Masterpieces

CRUCIFIXION OF ST PETER;
1603;
VATICAN,
ROME
ITALY

AURORA;
1613–1614;
CASINO ROSPIGLIOSI,
ROME,
ITALY

Renoir
Pierre Auguste

Born Limoges, France 1841; **died** Cagnes, France 1919

Les Parapluies

1881–1886, oil on canvas, 180.3 x 14.9 cm, National Gallery, London, England

Renoir is often criticized and dismissed as a "chocolate-box" painter of frivolous themes, using the techniques of the Impressionists to depict light-hearted scenes of contemporary life. However, his importance lies in his skillful, innovatory use of a rainbow palette, which discounted the inclusion of black, to interpret his subjects. This he does with a fresh, sincere feeling for beauty, light and sparkling colours, often portrayed under the effects of dappled sunlight. At the age of 13 Renoir was a porcelain painter, an occupation which, no doubt, influenced the decorative, charming qualities of his canvases. These underwent considerable stylistic change during his life-time. By 1870 he was a leading member of the Impressionists, unusually focusing on figure compositions. The gaiety of crowds at social gatherings was his forte. **Les Parapluies** took a number of years to realize, comprising a range of handling and fashions dating from slightly different periods. The movement set by the rhythm of the umbrellas is grounded by the little girl's gaze meeting ours. The composition is further balanced by the rather pensive young woman with the band-box.

Other Masterpieces

AT THE MOULIN DE LA GALETTE;
1876;
JOHN HAY WHITNEY COLLECTION,
NEW YORK,
USA

THE BATHERS;
c.1918;
MUSEE DU LOUVRE,
PARIS,
FRANCE

Nelly O'Brien

c.1762–1764, oil on canvas, 126.3 x 110 cm, Wallace Collection, London, England

Joshua Reynolds was the first president of the Royal Academy, founded in 1768. His greatness resides less in his abilities as a painter than in the subsequent impact of his artistic ideology – via his famous Discourses – and in his success in raising the status of the artist. Reynolds was brought up in an atmosphere of learning, establishing himself as a portraitist in Devon after a period of training in London. From 1750–1752 his studies in Italy of great Renaissance masters set the tone for his future artistic practice and theoretical concerns. His aim was to express the rational ideal as the basis of aesthetic judgement, rather than perpetuate the Romantic movement in painting. The classical dignity that permeated his portraits complemented the Grand Manner doctrine, which became his war cry of "reason and philosophy". His academic considerations pronounced the supremacy of noble and sublime interpretation as opposed to depiction of the natural and the particular – as Hogarth had done. **Nelly O'Brien** is a generous painting, full of character and sensitivity. Such portraits of women and of children show Reynolds at his most responsive.

Other Masterpieces

PORTRAIT OF MISS BOWLES WITH HER DOG; 1775; WALLACE COLLECTION, LONDON, ENGLAND

CAPTAIN ROBERT ORME; 1756; NATIONAL GALLERY, LONDON, ENGLAND

Richier Germaine

Born Grans, France 1904; **died** Montpelier, France 1959

Water

1953–1954; sculpture on bronze; 144.1 x 62.3 cm; Tate Gallery, London, England

Germaine Richier was primarily a sculptor, although she also made engravings, book illustrations and ceramics. From 1925–1929, Richier trained as a carver under Bourdelle in Paris. Briefly influenced by Surrealism, she began to make bronze figurative sculptures that, with their spindly limbs, were not entirely dissimilar to those by Giacometti, also a pupil of Bourdelle. However, Richier developed an increasingly idiosyncratic style, using sculpture to represent ambivalent, amorphous, asexual beings whose bodies at once suggested human, animal, plant and insect life. Through battered and lacerated surfaces, Richier suggested a morbid concern with decay and decomposition. In **Water** she has created a metaphor to express her deep fears and anxieties. The human figure alone seems incapable of containing her charged emotions – a woman depicted as a water carrier becomes a vessel of both emptiness and retention. Richier's feeling for sculpture as an emotional site, as well as her emphasis on the space between and around the solid forms, have contributed significantly to a reputation that has grown steadily since the Second World War.

Other Masterpieces

THE ANT;
1953;
PRIVATE COLLECTION,
SCOTLAND

THE BULLFIGHT;
1953;
PEGGY GUGGENHEIM
COLLECTION,
VENICE,
ITALY

318

Born Dresden, Germany 1932

Abstraktes Bild

1990; oil on canvas; 250 x 350 cm; Private Collection

Gerhard Richter first worked as a painter of stage sets and then as an advertizing designer, among other jobs. He studied as a painter in Dresden and Dusseldorf until the early 1960s, when his paintings were mainly figurative. In 1962, he produced a series of blurred, indistinct paintings based on photographic images from newspapers and magazines. Always concerned with the narrow distinction between photography and painting, Richter's work constantly operates on the borderline – whether between abstraction and figuration or between colour and monochrome. Tending to produce work in a series, Richter's oeuvre includes minimalist abstractions of great emotional weight, such as **Colour Streaks**, 1968, and aerial photographs of cities transformed by expressionistic brushstrokes into abstract paintings such as the **Townscape** series, 1968-1973. Since the late 1970s, he has produced a number of huge canvases such as **Abstraktes Bild** that, through their virtuoso technique and distanced subject matter, explore the role of the artist. A versatile and surprising painter, Richter's consistent ability to reinvent the medium poses important questions about the nature and value of painting in the twentieth century.

Other Masterpieces

STAG;
1963;
STAATLICHE MUSEUM
 PREUSSISCHER
 KULTURBESITZ,
 NATIONALGALERIE,
 BERLIN,
 GERMANY

ABSTRACT PAINTING NO
 439;
1978;
TATE GALLERY,
 LONDON,
 ENGLAND

Riley Bridget

Born London, England 1931

In Attendance

1994; oil on linen; 165.5 x 22.7 cm; Collection of the Artist

Bridget Riley is the most important exponent of Op art in Britain. The term Op art came into use around 1965 following the exhibition "The Responsive Eye" in New York. It describes a type of abstract art that works directly on visual perception, producing an optical illusion that allows the work to vibrate. Riley studied at Goldsmiths' College of Art (1949–52) and the Royal College of Art (1952–5), where her

contemporaries were Peter Blake and Joe Tilson. Influenced by the Futurists Boccioni and Balla, and the American colour-field painters, she began to develop her optical work in the early 1960s. Initially she worked in black and white, but started to use colour in 1966. Her contribution to the Musem of Modern Art's exhibition of Op art "The Responsive Eye" (one of her paintings was used on the catalogue cover) attracted

international attention. Three years later, in 1968, she won the International Prize for Painting at the Venice Biennale. **In Attendance** is a dazzling piece that appears to pulsate. It uses repeated bands of singing colour that subtly vary in tone and measure to enhance the overall pattern.

Other Masterpieces

CATARACT 3;
1967;
BRITISH COUNCIL,
LONDON,
ENGLAND

FISSION;
1963;
MUSEUM OF MODERN ART,
NEW YORK CITY,
USA

Born Guanajuato, Mexico 1886; **died** Mexico City, Mexico 1957

1929–1930; fresco; Palacio Nacional, Mexico City, Mexico

Court of the Inquisition (detail)

After studying art in Mexico and Madrid, Diego Rivera travelled to Europe and settled in Paris in 1911. Here he made contact with Picasso and contributed to Cubism, producing paintings inspired by Braque and Gris. He returned to his native country via Italy where he studied fresco paintings of the early Renaissance and ancient murals at Pompeii. In Mexico in 1921 he became an active participant in the revolutionary movement. As a member of an artists' commune, Rivera produced mural art for the walls of ministries, hospitals, colleges and schools. After the overthrow of the regime, in between bouts of falling out of favour with the left-wing – and his wife, artist Frida Khalo – Rivera continued to receive ministry commissions to celebrate the achievements of the revolution. The mural, **Court of the Inquisition**, represents the Madero revolution of 1910 and the Holy Inquisition trials, which made Mexican history between 1571 and 1820. Rivera rejected the advanced techniques he had assimilated in Europe to create simple forms and bold colours that contributed to the vitality of the national spirit, being popularly regarded as art for the people.

Other Masterpieces

WORKERS OF THE REVOLUTION;
1929;
PALACIO NACIONAL,
MEXICO CITY,
MEXICO

ZAPATISTA LANDSCAPE – THE GUERRILLA;
1915;
MUSEO NACIONAL DE
ARTS (INBA),
MEXICO CITY,
MEXICO

Rodin Auguste

Born Paris, France 1840; **died** Meudon, France 1917

Eternal Spring

1898; bronze sculpture; 4.64 cm; Musée Rodin, Paris, France

Rodin studied under the Classicist master Horace Lecoq de Boisbaudran from 1854–1857. He then worked as an ornamental mason having failed to gain entry to the Ecole des Beaux-Arts. Drawing from sculpture in the basements of the Louvre confirmed his allegiance to the art which led him to be the most celebrated sculptor of the French Romantic School. He underwent a religious crisis in 1862, which caused him to work solely within a secular context. He encountered the work of Michelangelo on a visit to Italy in 1875, whose work, he claimed, freed him from academicism. His control of the effects of light and shade, his love of expressive movement and character and awareness of the bony structures beneath skin enabled Rodin to model figures of startling realism; pieces such as **Eternal Spring** caused a sensation. In addition to free-standing sculpture he completed numerous commissions of statues, portraits, gates and monuments and made designs for other works. His prolific graphic work was also extraordinary. By 1900 the reputation of his exemplary skill and craftsmanship was internationally established but still subject to controversy. He exerted powerful and lasting influence on successive generations.

Other Masterpieces

THE KISS;
1886;
TATE GALLERY,
LONDON,
ENGLAND

THE HAND OF GOD;
c.1898;
MUSEE RODIN,
PARIS,
FRANCE

Born Dalton-le-Furness, England 1734; **died** Kendal, England 1802

Lady Isabella Hamilton

1777; oil on canvas; 213.4 x 137.2 cm; Private Collection

After a brief apprenticeship to a cabinet-maker, George Romney trained as a painter in Kendal. His early education in the mixture of pigment was important to his established reputation as a colourist. He moved to London from the north of England in 1762. Romney's intention was to become a historical painter in the Grand Manner and he visited Italy between 1773 and 1775, where he became familiar with the work of Raphael, Titian and Correggio. On his return to England, he developed the style of portraiture for which he is best known. His success ranked him alongside Reynolds and Gainsborough, although Romney never enjoyed the distinction of being admitted to the Royal Academy. Around 1781, he became infatuated with Emma Hart, later Lady Hamilton, Admiral Nelson's mistress and went on to paint over fifty sensitive and delicate paintings of her. This painting, **Lady Isabella Hamilton** is one of his only full-length portraits. Romney's reputation rests on his portraits of fashionable society. His aspiration to paint grandiloquent historical and literary subjects was never realized. Illness and an ever decreasing number of commissions forced his return to Kendal in 1798, where he died four years later.

Other Masterpieces

MRS MARK CURRIE;
1789;
TATE GALLERY,
LONDON,
ENGLAND

RICHARD CUMBERLAND;
c.1776;
NATIONAL PORTRAIT
GALLERY,
LONDON,
ENGLAND

Rosa Salvator

Born Naples, Italy 1615; **died** Rome, Italy 1673

Landscape with Mercury and the Dishonest Woodman

c.1649; oil on canvas; 125.7 x 202.1 cm; National Gallery, London, England

Salvator Rosa was a larger-than-life character whose versatility led to a number of occupations, including those of poet, musician, actor, etcher and painter. He trained in Naples, where he produced small-scale battle scenes and landscapes of his native countryside. He worked for a while in Rome, as well as at the Medici court in Florence between 1640 and 1649. Rosa became best-known for his turbulent, dramatic and, at times, highly theatrical landscapes. **Landscape with Mercury and the Dishonest Woodman**, with its depiction of twisted tree stumps and a stormy sky, reveals Rosa's rejection of the eighteenth century pursuit of ideal beauty in favour of the picturesque. The sublime, savage beauty of this essentially Romantic landscape contrasts with the cool, harmonious Classicism exemplified by such contemporaries as Poussin and Claude. Rosa also became known for his depictions of the macabre and, in particular, of witchcraft. His successful etching career was launched in the 1660s. Horace Walpole unwittingly provided a memorable epitaph for Rosa when, in describing an Alpine journey in 1739, he wrote, "Precipices, mountains, torrents, wolves, rumblings – Salvator Rosa".

Other Masterpieces

SELF PORTRAIT;
c.1645;
NATIONAL GALLERY,
LONDON,
ENGLAND

THE BAPTIST IN THE
WILDERNESS;
c.1650;
GLASGOW ART GALLERY,
GLASGOW,
SCOTLAND

1962; oil on canvas with hardboard; 96 x 92 cm; Private Collection

Homage to Kiesler's Endless House

J ames Rosenquist is a leading American Pop artist, taking as his cue advertising and consumerism on a mass scale. After winning a scholarship to attend the Minneapolis School of Art, he studied at the University of Minnesota, graduating in 1954. Further training at the Art Students League in New York brought him into contact with, among others, Jasper Johns and Robert Rauschenberg. With like minds, these artists drew upon the culture of their everyday lives. Rosenquist's work as a commercial artist, painting billboards and signs, informed his art, particularly the large-scale landscape format that was a feature of the advertizement hoardings that dominated Times Square in New York. Although essentially a formalist, in that he constructed his pictures from "traditional" drawing and painting techniques, the dynamism of his imagery, as seen in **Homage to Kiesler's Endless House** set him apart from easel painters. Working from collages comprising a conglomeration of photographs, adverts and pictures, Rosenquist enlarges and emphasizes details, significant words and images, approximating and subverting the notion of the American Dream.

Other Masterpieces

THE LIGHT THAT WON'T FAIL I;
1961;
HIRSHHORN MUSEUM, SMITHSONIAN INSTITUTION, WASHINGTON DC, USA

F–111;
1965;
PRIVATE COLLECTION, NEW YORK CITY, USA

Rossetti Dante Gabriel

Born London, England 1828; **died** Birchington-on-sea, England 1882

Beata Beatrix

c.1864–1870; oil on canvas; 86.4 x 66 cm; Tate Gallery, London, England

Dante Gabriel Rossetti was the son of a Dante scholar and the brother of poet Christina Rossetti. Prodigiously talented as a poet and painter, Rossetti received tuition from John Sell Cotman, before studying under Holman Hunt from 1848. In the same year, Rossetti, with Millais and Holman Hunt, founded the Pre-Raphaelite Brotherhood. However, Rossetti's essentially romantic imagination set him apart from the earnest and more literal endeavours of the other two and their mutual association was short-lived. Between 1850 and 1860 he worked mainly in watercolour, and pen and ink, choosing to depict medieval subjects. **Beata Beatrix** is an idealized, spiritual and symbolic portrait of Rossetti's beautiful wife, Elizabeth Siddal. The couple married in 1860 but she died tragically two years later of narcotic abuse. Rossetti's haunting memorial to his dead wife is expressed through a parallel with the story of Dante and Beatrice. His later paintings on Arthurian and Dantesque themes used Jane Morris, wife of William Morris, as his model. With their pale, intense faces and luxurious hair, both Elizabeth and Jane represented, for Rossetti, an ideal of feminine beauty that came to define the notion of an archetypal Pre-Raphaelite woman.

Other Masterpieces

GIRLHOOD OF MARY
 VIRGIN;
1849;
TATE GALLERY,
LONDON,
ENGLAND

FOUND;
1853;
BIRMINGHAM MUSEUMS
 AND ART GALLERY
BIRMINGHAM,
ENGLAND

Susan Rothenberg

Vertical Spin

1986–1987; oil on canvas; 360.7 x 285.7 cm; Tate Gallery, London, England

S usan Rothenberg's paintings and prints occupy the space between abstraction and figuration. In the 1970s, she became known for her mostly monochrome series of horses. Through flattened forms and simplified outlines, she revealed an interest in the mythic power of the equine form. In the 1980s, her archetypal images of horses gave way to various representations of the human figure. However, the introduction of the body, or its fragmented parts, was again symbolic, rather than specific or personal. There is an open-ended, unconscious element to much of Rothenberg's work, which accords perfectly with her own statement that, "most of my work is not run through a rational part of my brain". **Vertical Spin** is from a series of twelve paintings Rothenberg made over a period of two and a half years. It features the upward flight of a dancer and attempts to pinpoint the actual positions of the body in time and space. In reference to this painting, the artist acknowledged the difficulties of depicting movement. Her later paintings, with their loose, painterly marks, reveal a Neo-Expressionist influence.

Other Masterpieces

BUTTERFLY;
1976;
SPERONE WESTWATER,
NEW YORK,
USA

BEGGAR;
1982;
WILLARD GALLERY,
NEW YORK,
USA

Rothko Mark

Born Dvinsk, Russia 1903; **died** New York City, USA 1970

Red on Maroon

1959; oil on canvas 266.5 x 239 cm; Tate Gallery, London, England

Mark Rothko went to the USA from Russia when he was ten years old. During the 1950s and 1960s he became one of the leading figures of Abstract Expressionism. Principally self-taught, he was initially inspired by Expressionism and Surrealism. His mature work dates from 1948. A characteristic Rothko painting features a series of mainly rectangular shapes built up from the successive applications of washes.

The edges of the shapes are deliberately blurred, which gives the image a gentle, oscillatory quality. He utilized a restricted palette, focusing on colours close together in the range, such as brown and red, or grey and blue. **Red on Maroon** is one of nine canvases that currently occupy a designated space within the Tate Gallery. Originally designed for the Seagram Building's restaurant in New York, Rothko presented the series to the Tate

shortly before his death. The simplified shapes, like dark clouds, are suspended in shallow space, providing the viewer with a focus for meditation as well as a screen on to which to project experience. The sombre colour was believed to be a reflection of his depressed state of mind. He committed suicide in 1970.

Other Masterpieces

RED, WHITE AND BROWN;
1957;
KUNSTMUSEM,
BASEL,
SWITZERLAND

ORANGE, YELLOW ORANGE;
1969;
MARLBOROUGH-GERSON GALLERY,
NEW YORK CITY,
USA

1930; gouache on paper; 28.5 x 22 cm; Private Collection

Bust of a Woman Wearing a Necklace

Georges Roualt trained in a stained-glass workshop, where he developed a feeling for strong colours and bold outlines. In 1892, he studied under Gustave Moreau at the Ecole des Beaux-Arts where he met Matisse. This led to a brief association with the Fauves, but Roualt's dark, sombre art was very different from the colourful and decorative paintings produced by the circle of artists around Matisse. Initially an ardent Catholic, Roualt experienced a crisis of artistic and religious confidence in 1902. Surveying the world around him, he looked to people existing on the margins of society, such as clowns and prostitutes, to express his Old Testament vision of a world fallen from grace. His harsh, violent style, with its dark outlines and distorted forms, revealed an admiration for Goya. The expressionistic **Bust of a Woman Wearing a Necklace** is a typical Roualt portrait; the black outlines helping to give structure to the woman's head and shoulders. Dramatic intensity is given to the composition through the touches of red on the lips, in the hair and around the throat. From 1940, Roualt painted exclusively religious themes. His prodigious output included book illustrations, ceramics, tapestry and stage-set designs.

Other Masterpieces

CIRCUS PERFORMER;
1905–1906;
MUSEE DE GRENOBLE,
FRANCE

THE THREE JUDGES;
1913;
TATE GALLERY,
LONDON,
ENGLAND

Rousseau Henri (Le Douanier)

Born Laval, France 1844; **died** Paris, France 1910

The Snake Charmer

1907; oil on canvas; 169 x 189.5 cm; Musée National d'Art Moderne, Paris, France

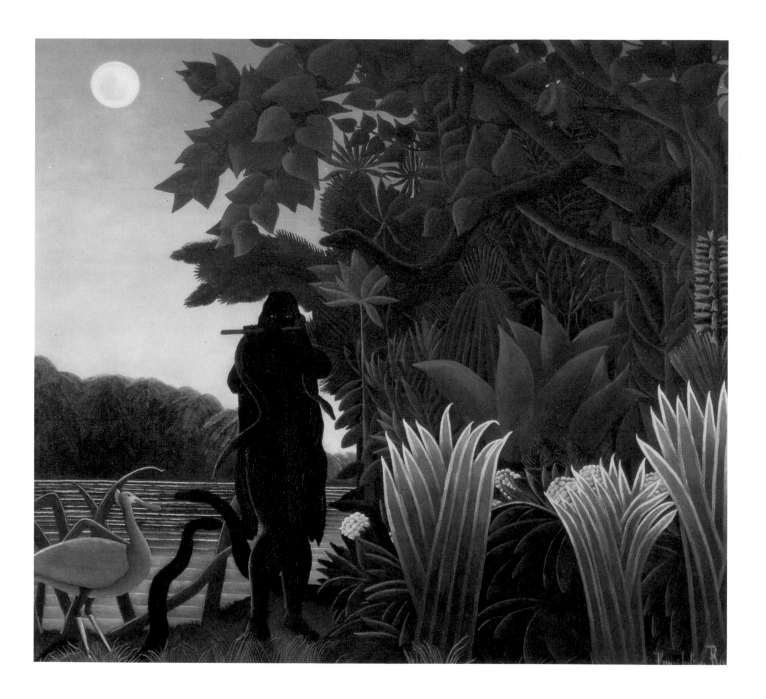

Henri Rousseau gained his nickname "Le Douanier" because he began to paint while working for the Paris customs office. He retired from the service in 1885 and devoted his life to his art, producing naive and direct paintings of great sophistication. Although untrained, Rousseau had great faith in his own abilities. From 1886, he exhibited almost every year at the Salon des Indépendants, a place where artists could show their work without being subjected to a selection procedure. Picasso was particularly impressed by his talent, holding a banquet in his honour in 1908. Rousseau's paintings use flat, clear colours, which he sharply defined with a simplified outline. He is best known for his jungle scenes, which he claimed were the product of a trip to Mexico, but were more likely derived from studying animal and plant life at the zoo and the botanical gardens in Paris. **The Snake Charmer** is a late and accomplished work that, through its exotic mystery, reveals a more conscious side to his primitive art. The furtive atmosphere is created through the presence of the unlikely inhabitant and the haunting stillness of the darkened mass of vegetation.

Other Masterpieces

SURPRISED! (TROPICAL STORM WITH A TIGER);
1891;
NATIONAL GALLERY,
LONDON,
ENGLAND

THE SLEEPING GIPSY;
1897;
MUSEUM OF MODERN ART,
NEW YORK CITY,
USA

Samson and Delilah

c.1609; oil on wood; 185 x 205 cm; National Gallery, London, England

Although Rubens studied art under mediocre masters he had sound knowledge of Latin, the classics and major European languages. His letters reveal him to have been an antiquarian, businessman and diplomat; as the latter his artistic career gained a momentum which established him as one of the greatest painters of his age. He entered the Antwerp Guild of St Luke in 1598 and went to Italy in 1600. His work as Court Painter put him in a privileged position to admire Titian's and Raphael's paintings in royal collections. While in Italy his studies of the Antique and of the High Renaissance inspired his own work on his return to Flanders in 1608. **Samson and Delilah**, reveals these sources in the observation of contrast between youth and age, between Delilah's pale and soft body and Samson's dark and muscular back. The impression made upon him by Caravaggio is evident in the dramatic lighting effects and theatrical staging within the composition. It is a more powerful and poignant image than his familiar, fleshy Bacchanalian paintings. Rubens continued to charm various European monarchs, collecting major commissions until his death. His achievements mark a high point in Baroque painting.

Other Masterpieces

LIFE OF MARIA DE MEDICI; 1622; MUSEE DU LOUVRE, PARIS, FRANCE

AN AUTUMN LANDSCAPE WITH A VIEW OF HET STEEN; c.1636; NATIONAL GALLERY, LONDON, ENGLAND

Ruisdael Jacob van

Born Haarlem, Netherlands 1628; **died** Amsterdam, Netherlands 1682

An Extensive Landscape with a Ruined Castle and a Church

c.1665–1670; oil on canvas; 109 x 146 cm; National Gallery, London, England

Regarded as the greatest of all Dutch landscape painters, it is believed that Jacob van Ruisdael was taught by his father and by his uncle Salomon van Ruysdael. He became known in the late 1640s for his panoramic views of the flat fields of his native countryside. However, in the course of a prolific career, he chose to paint a wide range of landscapes, including beaches, seascapes, forests, hills and rivers. He travelled to Germany in the early 1650s, where he was inspired to depict the more rugged terrain. By 1657, he had settled in Amsterdam, where he lived for the rest of his life. **Landscape with a Ruined Castle and a Church** probably depicts a view of an area to the east of Amsterdam. Ruisdael is less concerned with topographical accuracy than with depicting the subtle atmospheric effects. The sky dominates this painting and, through his mastery of perspective, the blustery clouds seem to sweep over our heads. He exercised a major influence both on his Dutch contemporaries and later English landscape artists such as Gainsborough and Constable.

Other Masterpieces

THE JEWISH CEMETERY;
c.1660;
DETROIT INSTITUTE OF
ARTS,
DETROIT,
USA

A WATERFALL;
LATE 1660s;
DULWICH PICTURE
GALLERY,
LONDON,
ENGLAND

Ledger

1982; enamel, acrylic and metal; 76.2 x 71.1 mm; Tate Gallery, London, England

Robert Ryman is credited with having bridged the gap between Abstract Expressionism and Minimalism. A leading figure in American abstract painting, with his "white" canvases he has pushed out the boundaries of picture-making by focusing on light, material and surface as his subjects. He reduces the painting's content to a specific enquiry, in which the medium and the meaning of painting itself become the act of intellectual and physical creativity. He studied at Tennessee Polytechnic from 1948–1949 and at the George Peabody College for Teachers, in Nashville, until 1950. In 1952 he moved to New York City, making a living as a gallery attendant at the Museum of Modern Art. The process of painting has been, from the start of his career, a central concern. Ryman's exploration of the variety of visual effects made possible by combining different materials is seemingly inexhaustible. The numerous ways in which he applies his concoctions and displays them continues to be a preoccupation. The square format, shown in **Ledger**, painted in pigmented shellac (or enamelac), became fixed in the late 1950s and the whiteness dominated by the mid-1960s. According to Ryman, "White enables other things to become visible".

Other Masterpieces

DELTA III;
1966;
HALLEN FUR NEUE KUNST,
 SCHAFFHAUSEN,
 GERMANY

SURFACE VEIL III;
1971;
SOLOMON R.
 GUGGENHEIM MUSEUM,
 NEW YORK CITY,
 USA

Sargent John Singer

Born Florence, Italy 1856; **died** London, England 1925

Luxembourg Gardens at Twilight

1879; oil on canvas; 64.7 x 91.4 cm; Philadelphia Museum of Art, Philadelphia, USA

John Singer Sargent was born in Italy to American parents, studied in Paris and eventually settled in England. His cosmopolitan background encouraged an urbane style most commonly revealed in his numerous portraits of fashionable society. In 1880, he visited Spain where Hals and Velasquez were important to the development of his considerable technical facility. He studied in Paris for ten years, leaving in 1884 after his Salon portrait of **Madame Gautreau** was criticized for its sexually provocative nature. The following year, Sargent founded the New English Art Club in London. **Luxembourg Gardens at Twilight**, with its soft, atmospheric haze, is an example of a painting in which Sargent emulated the light effects of the French Impressionists. While admired for its technical mastery, his work is often seen only as superficially impressive. However, aside from his portraits, he painted some remarkable watercolour landscapes, as well as murals for public buildings in Boston and, in 1918, a huge, tragic painting entitled **Gassed** as part of his role as an official war artist.

Other Masterpieces

ENA AND BETTY, DAUGHTERS OF ASHER AND MRS WERTHEIMER; 1901; TATE GALLERY, LONDON, ENGLAND

GASSED; 1918; IMPERIAL WAR MUSEUM, LONDON, ENGLAND

1917; oil on canvas; 100 x 170.2 cm; Osterreichisches Galerie, Vienna, Austria

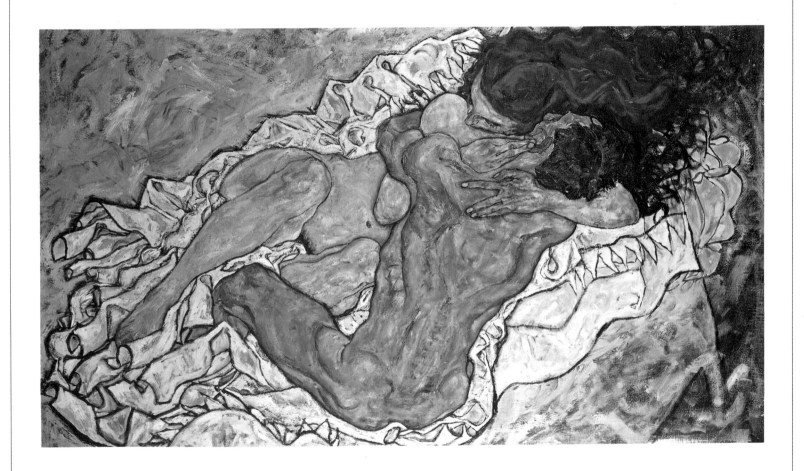

Egon Schiele was a chief exponent of the ideology of the Vienna Secession which took hold c.1908. Founded in 1897 by Gustave Klimt, this avant-garde artists' organization and exhibiting society introduced Modernism into Austrian art. It focused on using traditional painting subjects as vehicles for the expression of mood and emotion. Schiele applied this and the influence of Freudian psychology to his portraits. His complex personality, imbued with sexual anxiety and fear of death, inform often explicit images of young women and of himself. Haunted eyes and emaciated limbs and torsos of semi-clad or naked figures are rendered in memorable watercolour drawings. Schiele treated the medium unconventionally. Natural colour is dramatized, pigments bleed together and are mottled, barely contained by expressive outlines. Sexual tension is ever-present as is the suggestion of abuse, self-inflicted or otherwise. In **The Embrace**, the lovers appear loveless and lifeless, bound up in resignation to mortality. Schiele married in 1915 and his painting seemed to respond to this stability by becoming brighter and more sensuous. It is tantalizing to speculate how his work would have developed had he survived the influenza epidemic of 1918.

Other Masterpieces

NUDE SELF-PORTRAIT; 1910; GRAPHISCHE SAMMLUNG ALBERTINA, VIENNA, AUSTRIA

RECLINING WOMAN; 1917; PRIVATE COLLECTION

Schmidt-Rotluff Karl

Born Rottluff, Germany 1884; **died** Berlin, Germany 1976

Lofthus

1911; oil on canvas; 87.2 x 95.8 cm; Kunsthalle, Hamburg, Germany

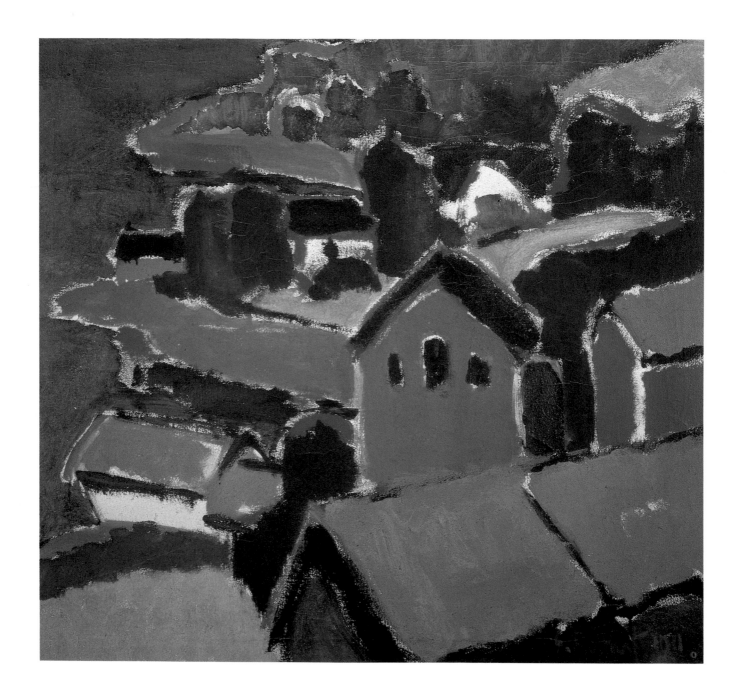

Karl Schmidt-Rottluff studied architecture in Dresden, where he met painters Heckel and Kirchner. With these two artists he founded Die Brücke (the Bridge) group in 1905. They were joined later by Nolde and Pechstein, and shared a common studio but failed to produce a clear declaration of intent. Committed to nature as the main source of inspiration, their paintings were distinguished by a simplification of form and colour, revealing an admiration for Cezanne, Gauguin, Van Gogh, Munch and African art. Schmidt-Rottluff stayed with the group until it dissolved in 1913. Uninhabited landscapes were his most common theme, although his work includes figure pictures, portraits and still life. **Lofthus** reveals his Expressionistic style, using flat planes of contrasting, raw colour. In 1906, he stayed with Nolde on the island of Alsten in Norway in order to experience the inhospitable and forbidding side of nature. He moved to Berlin in 1911, where he was influenced by African sculpture, producing several carvings and woodcuts. Declared degenerate by the Nazis in 1941, he was barred from painting until 1945.

Other Masterpieces

PORTRAIT OF ROSA SCHAPIRE; 1911; BRUCKE MUSEUM, BERLIN, GERMANY

BURSTING DAM; 1910; BRUCKE MUSEUM, BERLIN, GERMANY

1982; collage on wood; 274 x 366 x 28 cm; Tate Gallery, London, England

Humanity Asleep

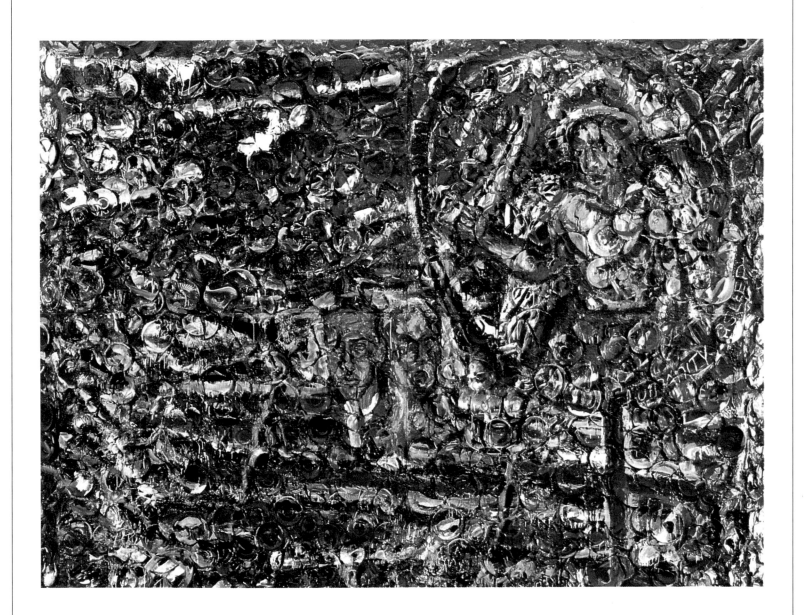

Julian Schnabel trained at the University of Texas between 1969 to 1972 and started exhibiting in 1976. He is best known for working on a monumental scale, with an inventive, bravura approach to painting and a skill for self-promotion and marketing. A celebrity on the New York gallery scene in the late 1980s, his work is appropriately theatrical. In a bid to challenge previous limits set on painting he redefined the term Action Painting, stretching it to incorporate an essentially physical approach to creating an image. He moved away from gesture to concentrate on surface, treating the thick support of the painting without reverence. In 1979 he began plastering broken crockery over tactile paint, making the surface appear fragmented and restless. These, such as **Humanity Asleep** works are literally volatile, and are already causes for concern to the conservators of collections where they are held. As a complement to these he also made large-scale paintings on velvet. Schnabel created monolithic, isolated imagery bearing disparate references to Classicism, mythology and history, in addition to associations with love, romance and optimism. Ultimately, his work exudes his love for the act of painting itself.

Other Masterpieces

ST FRANCIS IN ECSTASY;
1980;
MARY BOONE GALLERY,
NEW YORK CITY,
USA

THE JUTE GROWER;
1980;
MARY BOONE GALLERY,
NEW YORK CITY,
USA

Schwitters Kurt

Born Hanover, Germany 1887; **died** Ambleside, England 1948

Chocolate

1947; collage and oil on canvas; 44 x 39 cm; Private Collection

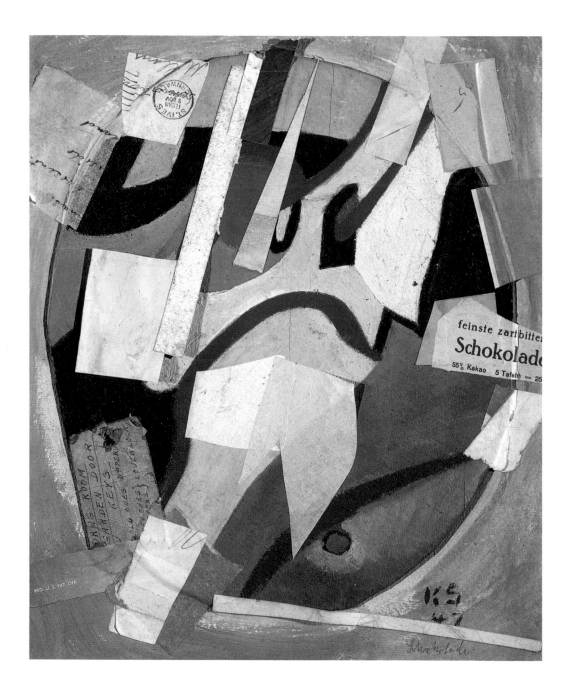

Kurt Schwitters worked as an artist, writer, architect, typographer and publisher. These various interests were reflected in a multi-media approach to his art. His early interest in Cubism was quickly superseded by an association with the leading Dadaists Hausmann, Hoch and Arp. In 1918, Schwitters was one of the founders of the Dada group in Hanover. As part of a Dadaist anti-art statement, he made collages and montages out of a combination of unrelated discarded elements, objects and materials. His aim was to disrupt the acceptance of bourgeois values while producing a new construction from the disparate, disordered fragments. His random assortments utilized bits of torn-up paper, bus tickets, chicken wire and even the wheels of a pram.
Chocolate makes use of a chocolate wrapping and the postmark torn from a letter.

Schwitters referred to his assemblages as "Merz". This was also the title of a Dadaist magazine he ran from 1923 to 1932. Around 1920, he started to build his first "Merzbau", a huge construction of refuse designed to fill a whole building. Exile in Norway was followed in 1940 by flight to England after the German invasion.

Other Masterpieces

SPRING PICTURE;
1920;
KUNSTMUSEUM,
 BASEL,
 SWITZERLAND

LE POINT SUR LE I;
1939;
MUSEE NATIONALE D'ART
 MODERNE,
 PARIS,
 FRANCE

Paul

1984; relief and oil on canvas; 259 x 320 cm; Tate Gallery, London, England

Sean Scully grew up in London, attended Croydon College of Art from 1965–1968 and then Newcastle University until 1972. He studied at Harvard University from 1972–1973, moving to America in 1975. His work charts a complex mix of British and American influences. On the one hand his art is related to the cool, Conceptual and Minimal experiments of the 1970s, combined with the achievements of British artists such as Noel Forster and Joe Tilson. On the other hand, it carries romantic, symbolic essences of the American Abstract Expressionists, particularly Barnett Newman and Mark Rothko. In spite of **Paul** having the hallmarks of the minimal approach, the tangibility of the painting's relief construction would suggest that modernist, traditional forces are at work. The triptych format, one Scully uses often, is evocative of devotional art from the beginnings of art history. However, the slightly awkward joining of the three canvases brings our attention back to the material reality of the piece. **Paul**, dedicated to the artist's son who died in 1983, is an economically conceived, grounded composition, painted with gestural marks. It complies with Scully's view of abstraction that "It's the spiritual art of our time".

Other Masterpieces

THE FALL;
1983;
TATE GALLERY,
LONDON,
ENGLAND

WHITE WINDOW;
1988;
TATE GALLERY,
LONDON,
ENGLAND

Serra Richard

Born San Francisco, USA 1939

Fulcrum

1987; steel; 18 metres high; Broadgate Complex, London, England

Richard Serra trained at the Universities of California, Berkley, Santa Monica and Yale, paid for by funds made while he was working in steel factories. He spent 1965–1966 in Europe, producing an exhibition in Rome. The abstract sculpture he was making was fashioned from unlikely materials - rubber and neon tubing. He then made the transition to molten lead as the substance of his "process art". In 1969, lead was also the basis for Serra's **One Ton Prop (House of Cards)**. This is the earliest piece that is recognizable as quintessentially his. The four plates balance precariously against one another, held in place by the force of gravity. By 1970, Serra was employing steel as his material to create so-called "anti–environments". His sculptural pieces of "engineering" have since grown in scale and these, such as **Fulcrum**, the sculpture at Broadgate, London, have found their metier in public spaces. The siting and contextual specificity of Serra's monstrous and yet graceful work has been a major preoccupation. However, his sited pieces, intended to be "a field force" by which "space is discerned physically", have been controversial, due to popular scepticism about their safety because of their lack of conventional construction.

Other Masterpieces

BELTS;
1966–1967;
SOLOMON R.
 GUGGENHEIM MUSEUM,
 NEW YORK CITY,
 USA

FLOOR POLE PROP;
1969;
ONNASCH COLLECTION,
 BERLIN,
 GERMANY

Bathers at Asnières

1884; oil on canvas; 201 x 300 cm; National Gallery, London, England

Georges Seurat studied at the Ecole des Beaux-Arts where he was a disciplined and academic student. A master draughtsman, he studied Ingres's drawings and familiarized himself with Chevreul's book on colour. Dedicated to the pursuit of order in painting, he evolved his own colour theory known as Divisionism. This involved applying a multitude of tiny dots of colour directly on to the canvas, to be mixed by the eye rather than on the palette. It was a method that also became known as Pointillism. In his first major work, **Bathers at Asnières**, there was initially little evidence of his new technique. However, Seurat reworked parts of it three years later, modifying details such as the bather's orange hat and areas of water. The painting is the result of careful planning – he made over twenty preparatory studies in pastel and in oil. His observation of ordinary people relaxing was considered subversive in its day and the canvas was rejected by the Salon. Unlike the Impressionists, who aimed to capture the flickering movement of light, Seurat aimed for a static, almost frozen quality, which has prompted comparisons with great masters such as Poussin and Piero della Francesca.

Other Masterpieces

SUNDAY AFTERNOON ON THE ISLAND OF GRANDE JATTE; 1884–1886; ART INSTITUTE OF CHICAGO, USA

THE CAN-CAN; 1889–1890; RIJKSMUSEUM KROLLER-MULLER, OTTERLO, NETHERLANDS

Sherman Cindy

Born Glen Ridge, USA 1954

Untitled #122

1983; colour photograph; 221 x 147 cm; Saatchi Collection, London, England

Cindy Sherman graduated from the State University College at Buffalo, New York State in 1976. She moved to New York City in 1977. Sherman's significance lies in her capacity to reinvent herself as both subject, object and artist. As a photographer, she has elevated the photographic medium to fine art status. Her black and white **Untitled Film Stills** from the late 1970s are the works that established her reputation and with which she is most commonly associated. These are generic movie stills, of a recognizable style – Hitchcock or Scorcese – scrupulously detailed but not identifiable as a film with a particular title. Each is a carefully reconstructed scene with herself as actor, director and cameraman. Subsequent series of works develop this theme of fantasy and disguise with the camera as voyeur. Sherman's technical skills are flawless, making the unrealities she constructs completely believable. **Untitled #122** comes from the fashion series of 1983–1984 and still retains the spirit of cinematic heroism from earlier work. Since the late 1980s, Sherman has also used food, vomit, prostheses and other materials to create evocative fairytale, disaster, horror and sex pictures in which neither she nor other humans feature.

Other Masterpieces

UNTITLED FILM STILL #54;
1980;
METRO PICTURES,
NEW YORK CITY,
USA

UNTITLED #225;
1990;
METRO PICTURES,
NEW YORK CITY,
USA

Walter Richard # Sickert

c.1889; oil on canvas; 76.5 x 63.8 cm; Tate Gallery, London, England

Minnie Cunningham at the Old Bedford

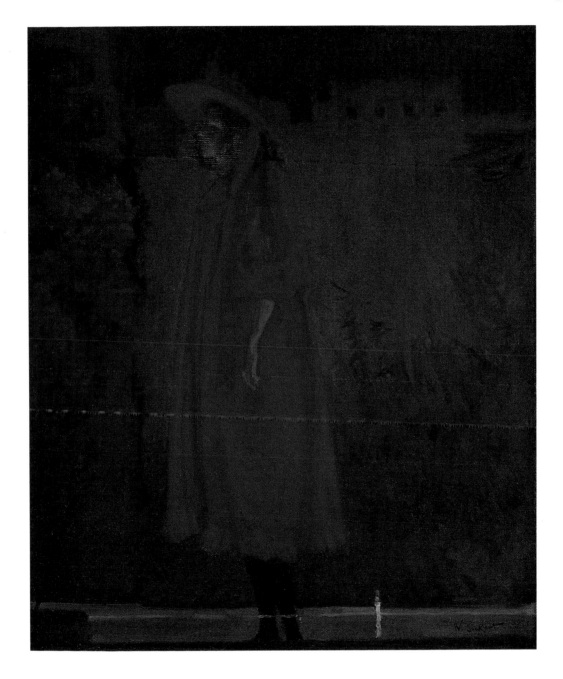

In 1868 Walter Sickert's family moved permanently to London. After a brief career as an actor, Sickert studied at the Slade School of Art from 1881–1882. He was a pupil and studio assistant of Whistler, whose limited tonal range later influenced Sickert's palette. In 1883 he met Degas in Paris. This lifelong friendship reinforced his earlier interest in the theatre and it became a staple theme of his work. Sickert joined and exhibited with the New English Art Club in 1888. Between 1895 and 1905 he divided his time between working in Dieppe and Venice. Back in London, he linked the artistic activities in London and developments in France, proving influential to the Camden Town Group and The London Group. The strength of his views and his importance as a teacher were considerable and sustained. His scenes of intimacy within domestic interiors were often misinterpreted as sordid and the low-key, naturalistic colours in dim light seen as dull. In tonal contrast his painting, **Minnie Cunningham at the Old Bedford** is typical of numerous works that focused on stars of the music hall. In later works his touch and palette became lighter and his composition more reliant on photographs.

Other Masterpieces

LA HOLLANDAISE NUDE;
c.1906;
TATE GALLERY,
LONDON,
ENGLAND

ENNUI;
c.1914;
TATE GALLERY,
LONDON,
ENGLAND

Sisley Alfred

Born Paris, France 1839; **died** Moret-sur-Loing, France 1899

The Bark During the Flood at Port-Marly

1876; oil on canvas; 50.5 x 61 cm; Musée d'Orsay, Paris, France

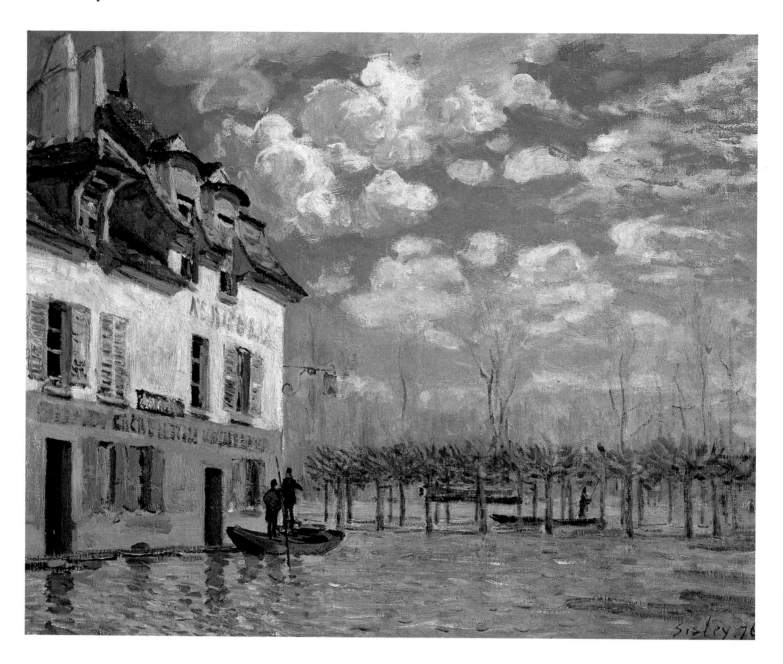

lfred Sisley was born in Paris to British parents. His early work showed the influence of Corot in its feeling for tonal values expressed through a sober palette of browns, greys and greens. From 1862, he studied under Gleyre in whose studio he met Monet and Renoir and painted with them near Fontainebleau. Under their influence, his palette lightened and his brushstrokes became freer. He showed with the Impressionists from 1874 and is regarded by many as the most consistent member of the group. He was almost exclusively a landscape painter, his best work displaying a subtle evocation of atmosphere. He visited Britain several times between 1871 and 1897, where he painted at Hampton Court, in the London suburbs and in Wales. **The Bark During the Flood at Port-Marly** is one of three pictures on the same subject that Sisley painted in 1876. These are now regarded as his masterpieces. Revealing a typical Impressionistic awareness of light, Sisley is concerned with capturing transient reflections in the limpid water. After his father's death, Sisley spent much of his life in poverty. He never quite achieved the success or renown of many of his Impressionist colleagues.

Other Masterpieces

WOODEN BRIDGE AT ARGENTEUIL;
1872;
MUSEE DU LOUVRE,
PARIS,
FRANCE

SNOW AT VENEUX-NADON;
1879–1882;
MUSEE DU LOUVRE,
PARIS,
FRANCE

Pierre Soulages

Painting 23 May 1953

1953; oil on canvas; 194.9 x 130.2 cm; Tate Gallery, London, England

Pierre Soulages was mainly self-taught. His diverse, seminal influences included prehistoric and medieval art, Romanticism and van Gogh. His mature style developed on his return to Paris after military service in the Second World War. His innovatory, abstract work established him as one of the leading members of the post-war School of Paris. Soulages worked in the direction of what has become known as "physic improvisation". His expressive, intense and dynamic paintings are disciplined through the intersection of dark, heavy bars or bands. On to this monumental scaffolding Soulages applies contrasting strokes from an unchanging, almost monochromatic, palette of black, grey, ochre and white. As a result, his sculptural paintings, such as **Painting 23 May 1953**, have a depth and illumination that is enhanced by the freedom and vitality of his brushstrokes. He was one of a number of European painters whose work was defined in 1952 by the term Art Informel. This was as an acknowledgement of the movement toward spontaneous abstract painting that took place in the 1940s and 1950s. Soulages also worked as a theatrical designer. In 1959, he travelled to Japan. He continues to live and work in Paris.

Other Masterpieces

PAINTING;
1953;
GUGGENHEIM MUSEUM,
NEW YORK CITY,
USA

PAINTING;
1956;
MUSEUM OF MODERN ART,
NEW YORK CITY,
USA

345

Soutine Chaim

Born Smilovitch, Lithuania 1893; **died** Paris, France 1943

Flayed Ox

1926; oil on canvas; 72.5 x 50 cm; Kunstmuseum, Bern, Switzerland

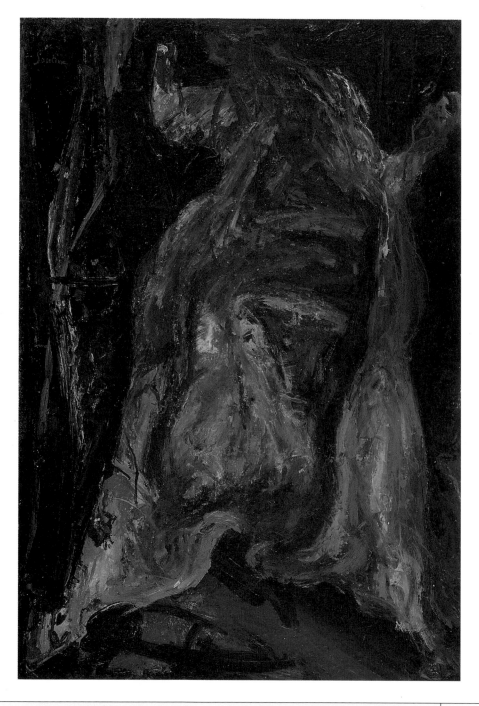

Chaim Soutine came to Paris in 1913 after studying at Vilno. Alongside other expatriate painters, Chagall and Modigliani, who became his friend, he injected a different mood into the art of the School of Paris. Soutine's Expressionist work is akin to the bravura of The Fauves, led by Matisse and the German Expressionism of Nolde. However, he admired the old, rather than the modern, masters. More emotional than intellectual, Soutine's art was a passionate expression of his sincere response to life as he saw it. Intense and gruesome, fervently wrought through lurid colour and wild, convulsive brushmarks of impasto, **Flayed Ox** is typical of Soutine's painting. It was inspired by Rembrandt's treatment of the same subject, worked from life. The artist was somewhat of a recluse, whose driving passion was the act of creativity. Contemporary accounts of him describe his uncleanliness and lack of discipline. The dead birds and fleshy carcasses he loved to recreate in oils often rotted in his studio, much to his neighbours' distress. Although he was reluctant to promote and exhibit his work, the support of his patrons secured the reputation of his art, which proved influential during the 1930s, particularly in America.

Other Masterpieces

PAGEBOY AT MAXIM'S;
1927;
ALBRIGHT–KNOX ART
 GALLERY,
 BUFFALO,
NEW YORK STATE,
USA

PORTRAIT OF
 MODIGLIANI;
1917;
NATIONAL GALLERY,
WASHINGTON DC,
USA

Born Cookham, England 1891; **died** Cookham, England 1959

Sir Stanley Spencer

1923–1927; oil on canvas; 274.3 x 548.6 cm; Tate Gallery, London, England

The Resurrection, Cookham

Although Stanley Spencer trained at the Slade School of Art in London, from 1909–1912, his art reveals him to be an individual spirit, untouched by avant-garde developments of the time. If he looked to art of the past it was, perhaps, to the Pre-Raphaelite Brotherhood. Not only did he share a stylistic affinity, but the religious concerns of the Brotherhood are reflected in Spencer's idiosyncratic painting. He spent his life in Cookham, devoting his art to describing the village and his personal experiences of the characters who populated it. His paintings translated sacred incidents and biblical stories into happenings within his local environment. **The Resurrection, Cookham** is a good example of his artistic inclinations and a monumental work. Characteristically, it was painted piecemeal over a complete drawing. Spencer himself is depicted several times, as is his first wife, Hilda Carline. His relationship with her lingered long after he entered into a second marriage with Patricia Preece; Spencer's communications even continued beyond Hilda's death via love letters. His controversial personal life and his experiences of the war fuelled passionate, memorable pictures that are heightened by distortion.

Other Masterpieces

DOUBLE NUDE PORTRAIT: THE ARTIST AND HIS SECOND WIFE; 1936; TATE GALLERY, LONDON, ENGLAND

DECORATIVE MURALS; 1926–1934; WAR MEMORIAL CHAPEL, BURGHCLERE, HAMPSHIRE, ENGLAND

Spero Nancy

Born Cleveland, USA 1926

Codex Artaud

1970; painting and collage on paper; 61 x 48 cm; Galerie Rudolf Zwirner, Cologne, Germany

Cette chair qui ne se
touche plus dans la
vie

Artaud

Nancy Spero trained at the Art Institute of Chicago before attending the Ecole des Beaux-Arts in Paris from 1949–50. After living in the USA, Greece and Italy she moved to Paris, France in 1959, where she had her first solo exhibition in 1962. Spero returned to the USA in 1964. Actively opposed to the Vietnam War, her work began increasingly to document her social and political concerns. From 1969 to 1972 she worked on the **Codex Artaud** series, a cycle of thirty-four drawings on paper scrolls. The preoccupation of this and other key works is the abuse and torture of women in domestic life as well as in the wider political sphere, such as in work and war. Spero uses cut-and-pasted scraps of paper, fragments of typewritten script and disembodied parts of the female figure to reference women throughout history. Her obsessive documentary style leaves space for viewers to draw their own conclusions. In 1971 she helped to found AIR, the first co-operative gallery for women in New York. In 1978, Spero introduced a stamping technique into her drawings and she has made extensive use of this in her work since then. She lives and works in New York.

Other Masterpieces

THE TORTURE OF WOMEN;
1976;
JOSH BAER GALLERY,
NEW YORK CITY,
USA

MARLENE, LILITH, SKY, GODDESS;
1989;
ANTHONY REYNOLDS GALLERY,
LONDON,
ENGLAND

Born St Petersburg, Russia 1914; **died** Antibes, France 1955

1951; oil on canvas; 30 x 97 cm; Fukuoka Museum, Japan

Rectangles, Jaunes et Verts

Nicholas de Staël studied in Brussels, from where he travelled to Italy, Holland, Spain and North Africa. He went to Paris in 1932 from where he joined the Foreign Legion at the outbreak of war. Resettled in Paris in 1943, de Staël renewed contact with Braque and studied under Léger. By the end of the decade, he had established himself as a leading abstract painter. Although his works were considered non-representational they had a tangible sense of form, indicative of their closeness to the natural world. Through the introduction of simplified images from nature – such as the sun and the sea – he attained a near-perfect balance between abstraction and figuration. De Staël's dense and richly worked surfaces were built up through layers of paint: sensuous, impasto canvases revealed his enjoyment of the act of painting itself.

Rectangles, Jaunes et Verts is constructed with simple blocks of colour on a monochrome ground. Unexpectedly, spatial qualities and an atmospheric depth emerge through the abstract ensemble. De Staël's later paintings returned to a more recognizable form of representation. He committed suicide at the age of 41.

Other Masterpieces

THE ROOFS;
1952;
MUSEE NATIONAL D'ART
MODERNE,
PARIS,
FRANCE

MARATHON;
1948;
TATE GALLERY,
LONDON,
ENGLAND

Steen Jan

Born Leyden, Netherlands c.1625; **died** Leyden, Netherlands 1679

Skittle Players

c.1660–1663; oil on oakwood; 33.5 x 27 cm; National Gallery, London, England

Jan Steen worked in various Dutch towns including Leyden, The Hague, Delft and Haarlem. He painted humorous subjects drawn from the life of the peasant and middle classes, subjecting his biblical paintings to the same everyday treatment. Unsurprisingly, given that he leased a brewery in Delft and kept an inn in Leyden, he mostly represented tavern scenes. However, many of these provided him with the opportunity to depict a large, festive, social gathering rather than celebrate bucolic revelry. Indeed, he sometimes used these works to moralize, relying on humour to leaven his essentially serious message. Steen was the son-in-law of Jan van Goyen and painted a few landscapes in his style. He also painted some portraits and featured some delightful collections of still life within his larger genre paintings. **Skittle Players** does not appear to have any didactic purpose. It is a cheerful scene of people taking advantage of a sunny day to relax and enjoy themselves. The harmonious composition reveals Steen's remarkable skills as a colourist.

Other Masterpieces

THE EFFECTS OF INTEMPERANCE; c.1663–1665; NATIONAL GALLERY, LONDON, ENGLAND

THE MORNING TOILET; 1663; RIJKSMUSEUM, AMSTERDAM, NETHERLANDS

1887; oil on canvas; 36.8 x 54.6 cm; Private Collection

Beach at Etaples

Philip Wilson Steer studied at Gloucester School of Art in 1882, leaving for Paris later in the same year. Like his close friend, Sickert, he was an English artist who looked to the French for inspiration. In Paris he discovered Impressionism, in particular the works of Degas and Monet. He returned to England in 1884 and, with Sargent and Sickert, helped found the New English Art Club in 1886. In 1889, Steer was one of the members who exhibited separately under the title "The London Impressionists". **Beach at Etaples** is one of a number of beach scenes and seascapes that are generally regarded as his most accomplished work. This painting, with its poetic and melancholic atmosphere, helped Steer gain his reputation as the best of the English Impressionists. He taught at the Slade for thirty-one years. His later work was more conventional, revealing the influence of Constable and Gainsborough. He also made increasing use of watercolour, his lyrical style derived in part from Turner. Steer went blind in the last few years of his life.

Other Masterpieces

GIRLS RUNNING:
WALBERSWICK PIER;
1894;
TATE GALLERY,
LONDON,
ENGLAND

THE HORSESHOE BEND
OF THE SEVERN;
1909;
CITY ART GALLERY,
MANCHESTER,
ENGLAND

Stella Frank

Born Malden, USA 1936

Agbatana II

1968; acrylic; 305 x 458 cm; Musée d'Art et d'Industre, St Etienne, France

Frank Stella studied at the Phillips Academy in Andover from 1950–1954 and went on to Princeton University. He graduated in 1958 and settled in New York, working as a house painter. His artistic path led straight to abstraction, admiring as he did the work of European art, particularly that of the Bauhaus and specifically the "hard-edge" abstract painter, Josef Albers. Stella's approach to the abstract image was initially systematic and largely monochromatic – influenced to an extent by the **Flags** and **Targets** series of Jasper Johns. Stella's **Striped** and then **Black Paintings**, first shown in 1959, were the antithesis of gestural Abstract Expressionism; they heralded the arrival of Minimalism. Although **Agbatana II** would seem to follow this ordered pattern in a multicoloured way, it was in fact painted at a time when Stella had begun to develop the decorative potential of abstraction. Aping the swirls and accidental marks made by freehand painting, he cut out shapes and constructed them into reliefs of day-glo and metallic colours. Since the mid-1970s, Stella's work has exaggerated the effusive pigment and glitter – see the **Exotic Birds** series – and has explored the dissolution of the distinction between sculpture and painting.

Other Masterpieces

TUXEDO PARK JUNCTION;
1960;
STEDELIJK VAN ABBEMUSEUM, EINDHOVEN, NETHERLANDS

HAREWA;
1978;
GABRIELE HENKEL COLLECTION (COURTESY OF HANS STRELOW), DUSSELDORF, GERMANY

Born Grandia, North Dakota, USA 1904; **died** New Windsor, USA 1980

1953; oil on canvas; 235.9 x 174 cm; Tate Gallery, London, England

Untitled 1953

Clyfford Still studied in Washington before moving to San Francisco in 1941. He was an influential teacher at the California School of Fine Arts from 1946 to 1950, and became a leading Abstract Expressionist. Within this disparate movement, his work was most closely associated with the large monochromatic canvases produced by Rothko and Newman. He shared their interest in the single unified shape and the expressive potential of colour. Where Still differed from these artists was in the thick application of his paint. **Untitled 1953** has this tactile and sensuous quality. The sheer physicality of the work is overwhelming. A yellow gash and a small smudge of red are the only disturbances to the evenly coloured but richly wrought surface. Having gained a reputation as an artist somewhat prone to pretension and mystification, Still himself wrote of this work that, "the yellow wedge at the top is a reassertion of the human context – a gesture of rejection of any authoritarian rationale or system of politico-dialectical dogma". Still spent the last twenty years of his life as a virtual recluse in Maryland.

Other Masterpieces

NO 1;
1941;
COLLECTION EJ POWER,
LONDON,
ENGLAND

JAMAIS;
1944;
PEGGY GUGGENHEIM
COLLECTION,
VENICE,
ITALY

Stubbs George

Born Liverpool, England 1724; **died** London, England 1806

Lion Devouring a Horse

1763; oil on canvas; 69.2 x 103.5 cm; Tate Gallery, London, England

George Stubbs was the most celebrated animal painter of his day. However, it would be more accurate to say that he was a painter of nature, as landscape and environmental details were scrutinized with as much attention as the animal subjects that proliferate his canvases. Largely self-taught, he was renowned for his observational skills, imagination and sensitivity. He had established himself as a portrait painter in Leeds while studying anatomy at York. A visit to Italy, in 1754, enabled him to absorb the influence of Renaissance and antique art, which was to inform his own work. He settled in London in 1759 and in addition to experimenting with enamel paint on earthenware, proceeded to produce the "animal history" paintings for which he is best known. Perhaps the most famous of these is **Lion Devouring a Horse**. This is reputedly based on a dramatic scene witnessed by Stubbs while in Italy. It could be, however, that this is an exaggerated account of Stubbs's study of a classical sculpture of the same subject in the Palazzo dei Conservatori in Rome. In spite of the somewhat contrived, artificial proportions and expressions of the creatures, the painting must have been startling to contemporary eyes.

Other Masterpieces

MARES AND FOALS IN A RIVER LANDSCAPE;
c.1763–1768;
TATE GALLERY,
LONDON,
ENGLAND

PORTRAIT OF A YOUNG GENTLEMAN OUT SHOOTING;
1781;
TATE GALLERY,
LONDON,
ENGLAND

Born London, England 1903; **died** London, England 1980

1940; gouache, ink and watercolour on paper; 80 x 54.6 cm; Tate Gallery, London, England

Devastation: House in Wales

Graham Sutherland abandoned a career in railway engineering to study at Goldsmiths' College of Art in London, specializing in etching. By the late 1920s, he had developed an enthusiasm for the visionary artist Samuel Palmer. In response Sutherland's own work reflected the dreamlike, pastoral qualities of the earlier romantic. The print market collapsed due to the Wall Street Crash in 1929 and,

fortuitously for Sutherland, this inadvertently influenced his decision to become a painter. His first visit to Pembrokeshire in 1934 marked the beginning of a love affair with the county's landscape. His compositions are bold perceptions of the natural world, abstracting forms and colours to startling effect. His admiration for Picasso who, he claimed, possessed the "true idea of metamorphosis", guided his own concept of

emphasizing nature's personality. He was employed during the war years as an official war artist and responded to dramatic scenes of human endeavour and devastation as in **Devastation: House in Wales.** Sutherland's work retains references to the strangeness of Surrealism but it is to his beginnings as a printmaker that his painting owes its most enduring influence.

Other Masterpieces

**TAPESTRY DESIGN,
CHRIST THE
REDEEMER;**
1952;
COVENTRY CATHEDRAL,
COVENTRY,
ENGLAND

RED LANDSCAPE;
1942;
SOUTHAMPTON ART
GALLERY,
SOUTHAMPTON
ENGLAND

Tanguy Yves

Born Paris, France 1900; **died** Woodbury, Connecticut, USA 1955

Dehors

1929; oil on canvas; 116 x 89 cm; Private Collection

Yves Tanguy spent his late teens and early twenties as both an officer at sea and in military service. Despite such an unprepossessing start, on his return to Paris in 1922, he taught himself to sketch and paint. His enthusiasm gathered momentum in part due to the impact made upon him by the work of de Chirico. He came into contact with Andre Breton in 1925 and joined the Surrealist circle of artists. His own painting developed the biomorphic style of the movement, recalling the landscapes of his childhood vacations and suggesting the marine imagery and oceanic depths that featured in his past. In **Dehors**, amorphous forms rather than abstract shapes float in a subconscious sea; an imaginary space becomes a place within a dream, at once beautiful and disconcerting. Tanguy emigrated to America in 1939. He married painter Kay Sage in 1940 and they settled in Woodbury in 1942. A darker tonality pervades his later works; bony forms and pseudo-rock formations proliferate, seen in Daliesque, illusionistic perspective.

Other Masterpieces

THE RAPIDITY OF SLEEP;
1945;
THE ART INSTITUTE OF
CHICAGO,
CHICAGO,
USA

THE INVISIBLES;
1951;
TATE GALLERY,
LONDON,
USA

A Little Night Music

1946; oil on canvas; 41 x 61 cm; Private Collection

Dorothea Tanning worked as a librarian before briefly studying art at Knox College, Illinois. Desperate to escape the narrow confines of her home town, twenty-year-old Tanning left for Chicago, where she took evening classes at art school. In 1936 she moved to New York, where she found work as a commercial artist. Her meticulous and detailed canvases, with their elaborate depictions of childhood fantasies and nightmares brought her into contact with the Surrealists; she married Max Ernst in 1946. As a female Surrealist, Tanning used her reconstruction of the dream world to explore her own sexuality. **A Little Night Music** is an image resonant with nubile sexuality. Two girls are featured on an upstairs landing; their dresses cut to ribbons and their long hair streaming. A giant sunflower blocks the staircase, its petals discarded. The image is static, as if frozen in time, recalling, perhaps, memories of a distant childhood. Later work, from the mid 1950s onward, focuses on roundly modelled parts of the body – limbs, heads and torsos – which merge with the picture space, appealing to a sense of touch as well as to sight.

Other Masterpieces

A VERY HAPPY PICTURE;
1948;
MUSEE NATIONALE D'ARTE
 MODERNE,
 PARIS,
 FRANCE

A FAMILY PORTRAIT;
1957;
MUSEE NATIONALE D'ART
 MODERNE,
 PARIS,
 FRANCE

Tapies Antonio

Born Barcelona, Spain 1923

Violet Grey with Wrinkles

1961; mixed media; 200 x 176 cm; Scottish National Gallery, Scotland

Antoni Tapies was a self-taught Catalan artist who abandoned his law studies and began to paint in 1946. Coming from Barcelona, the left-wing Catalonian capital, it was significant that he produced a radical abstract art that lacked overtly political implications, apart from his own liberalism. Tapies reacted against the academic legacy of Dali's Surrealism and of geometrical abstraction in Europe and America. However, Surrealism's philosophical depth was of importance, as were the free, lyrical aspects of art by Joan Miró, Mark Tobey and Robert Motherwell. **Violet Grey with Wrinkles** typically reveals the influence of the French "matter painters", most importantly Fautrier. In the employment of unusual, tactile substances – marble dust, pigment and varnish – Tapies' informal, abstract canvases are reminiscent of Dubuffet and are similar in spirit to those of the Italian artist, Alberto Burri. The inscribed and marked surfaces are richly layered, often incorporating objects, cloth, signs and symbols – the cross, the foot, hands and doors for example. Such inclusions satisfy Tapies's concern that for him, "a work of art must contain a vision of the world...having a philosophy is not enough".

Other Masterpieces

PERFORATED BODY;
1956–1958;
PANZA COLLECTION,
MILAN,
ITALY

PEINTRE GRISE ET VERTE;
1957;
TATE GALLERY,
LONDON,
ENGLAND

Born Kharkovsk, Russia 1885; **died** Novodevichye, Russia 1953

The Sailor

1911–1912; tempera on canvas; 71.5 x 71.5cm; State Russian Museum, St Petersburg, Russia

Vladimir Tatlin was a painter, designer and maker of abstract constructions. He was the founder of Constructivism, a movement concerned with sculpture developed from collage as practiced by the Cubists. From 1909–1911 Tatlin attended painting classes in Moscow and combined painting with his life as a merchant sailor, which undoubtedly provided the inspiration for **The Sailor**. In 1913–1914 he earned enough money as a folk musician to go to Paris where he worked in Picasso's studio and was heavily influenced by the latter's experiments in analytical Cubism. From these he derived his first abstract Constructions using diverse media and non-art materials. Moving out of an arena of suggestion and illusion and into the world of real objects, time and space, he worked in close contact with other visual and literary artists.

The political ideas resulting from the war in 1914 and the revolution in 1917 had their effect on the artistic community. Many of them adopted the Bolshevik, Communist cause and **Tatlin's Monument To The Third International** was an elaborate, architectural sculpture which appropriated this as its theme. It remains a potent motif for the Constructivist movement which crystallized in 1922.

Other Masterpieces

COUNTER RELIEF;
1915;
RECONSTRUCTION
1966–1970;
ANNELY JUDA FINE
ART,
LONDON,
ENGLAND

LETATLIN;
1929–1931;
RECONSTRUCTION,
1969;
MODERNA MUSEET,
STOCKHOLM,
SWEDEN

Tiepolo
Giovanni Battista

Born Venice, Italy 1696; **died** Madrid, Spain 1770

America (detail)

1751; fresco; Residenz, Würzburg, Germany

Tiepolo was the sparkling star of eighteenth century decorative painting in Italy. He was a virtuoso master of the fresco medium, sought after not only in Italy but also in Germany and Spain. Tiepolo brought imagination and Baroque grandeur to the frivolous Rococo spirit and infused it with sound pictorial composure, gleaned from his knowledge of Rubens, Rembrandt and Durer. The influence of the Venetian masters Veronese and Tintoretto is also prevalent in the eloquence and drama with which Tiepolo imbues his large-scale compositions. As a colourist, Tiepolo is unsurpassed, progressing from the rather dark tonality of his early works to his characteristically sunny palette from the early 1730s. At the peak of his career, in 1750, Tiepolo was commissioned to decorate the Würzburg Palace, the Prince Archbishop's residence. **America** is one of Tiepolo's allegorical interpretations of the four continents, decorating the grand staircase of the palace. This exotic scheme is a tour-de-force, full of vigour and creative originality and is considered the masterpiece of Tiepolo's maturity. In the last years of his life the rising popularity of Neo-Classicism caused the decline of Tiepolo's career but did not affect its lasting impact.

Other Masterpieces

CLEOPATRA'S BANQUET; c.1750; PALAZZO LABIA, VENICE, ITALY

MARRIAGE OF FREDERICK BARBAROSSA AND BEATRICE OF BURGUNDY; c.1750; RESIDENZ, WURZBURG, GERMANY

J acopo Tintoretto is thought to have studied briefly under Titian, the great Venetian master. In Venice in 1548, a year when Titian was out of the city, Tintoretto made his name with **Miracle of Saint Mark freeing the Slave**, a fine example of a Mannerist painting with its vivid colouring, distorted figures and foreshortening. After this success, he began decorating the interiors of churches and

Scuole – that of Saint Rocco being his greatest achievement. His work was invariably completed with great speed, in part due to his large workshop in which he employed Marietta, his highly talented daughter. In order to construct his compositions he would set up a miniature stage in a box. Into this he would position maquettes, and experiment with artificial light to observe the play of shadow on form. In **The Last Supper**,

a late painting, the central drama is almost perpendicular to the picture plane. There are numerous light sources, incidental characters and dramatic gestures, presenting an intense, chaotic and lively scene. In his desire to capture the thrill and excitement of this spiritual occasion he has used dark tones punctuated by the odd patch of bright colour.

Other Masterpieces

MIRACLE OF SAINT MARK FREEING THE SLAVE; 1548; GALLERIA DELL'ACCADEMIA, VENICE, ITALY

THE ASCENSION; c.1576-81; SCUOLA DI SAN ROCCO, VENICE, ITALY

Titian
Tiziano Vecellio

Born Pieve di Cadore, Italy c.1487; **died** Venice, Italy 1576

Danae Receiving the Shower of Gold

1545–1546; oil on canvas; 210 x 172 cm; Museo e Gallerie Nazionali di Capodimonte, Naples, Italy

After an early training in a mosaicist's workshop, Titian came under the strong influence of Giorgione. After Giovanni Bellini's death, he was appointed Painter to the Venetian Republic and was revered as highly as his southern contemporary, Michelangelo. Titian twice refused invitations to Rome, but at the age of sixty he agreed to spend eight months as a guest of the Vatican. In Rome he made the first version of **Danae Receiving the Shower of Gold** for the Pope's grandson and eight years later he made this, the second version, for King Philip of Spain. That two powerful patrons had no qualms about an artist replicating the same subject matter and composition suggests that painting was now being judged on aesthetic grounds, not for its narrative content or interpretation. Ostensibly there is little difference between the two, but his painting technique is dramatically different – sharp outlines are replaced by softer brushstrokes. This picture epitomizes the Venetian High Renaissance style, characterized not just by draughtsmanship but by the free handling of paint. Titian's overriding contribution was his innovatory approach to subject matter and the oil medium. He extended the emotional range of his work through his warm, rich palette.

Other Masterpieces

THE RAPE OF EUROPA;
c.1562;
GARDNER MUSEUM,
 BOSTON,
 USA

PRESENTATION OF THE
 VIRGIN;
c.1538;
GALLERIA
 DELL'ACCADEMIA,
 VENICE,
 ITALY

Woman at her Toilet

1896; oil on cardboard; 67 x 54cm; Musée d'Orsay, Paris, France

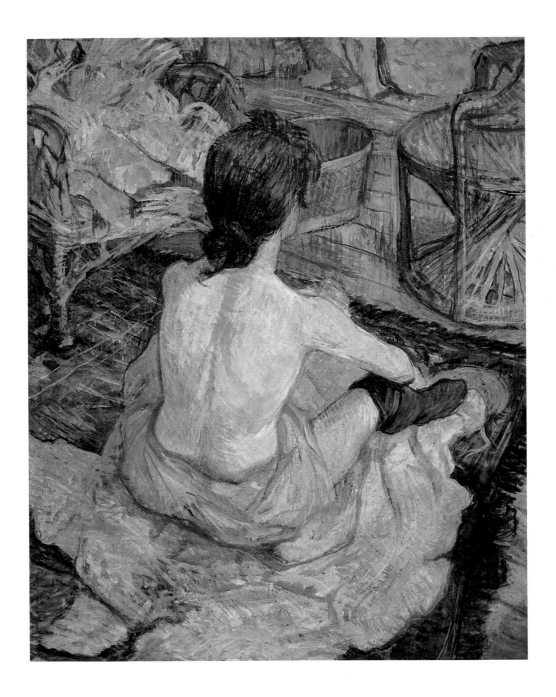

Toulouse-Lautrec was born into an aristocratic family. He began to study art in Paris in 1882 and was working in a studio in Montmartre by 1885. He became part of an artistic circle which included Impressionists and Post-Impressionists. The local theatres, café-cabaret bars, the circus and low-life scenes of prostitution provided subject matter which he translated into paintings and lithographs. From 1888 he was critically acclaimed and exhibited regularly at the Salon des Indépendants from 1889, working under the influence of Degas, and of alcohol, which was to cause his death. From 1890, the Moulin Rouge informed the work for which he is most popularly known. His paintings and particularly his posters advertising the Moulin's dancers and performers, confirmed his reputation as an artist of wit, movement and energy. He was a master of characterization and a major influence on upgrading the poster to an art-form. **Woman at her Toilet** is an unusually tender painting, probably of a prostitute as he disliked posed models. It shows his draughtsmansip and rapid brushwork at its best, the chalkiness of the paint on cardboard being reminiscent of pastel.

Other Masterpieces

AT RUE DES MOULINS;
1894;
MUSEE TOULOUSE-
LAUTREC,
ALBI,
FRANCE

AT THE MOULIN ROUGE;
1892;
ART INSTITUTE OF
CHICAGO,
USA

Turner
Joseph Mallord William

Born London, England 1775; **died** London, England 1851

Norham Castle: Sunrise

1845; oil on canvas; 90.8 x 121.9 cm; Tate Gallery, London, England

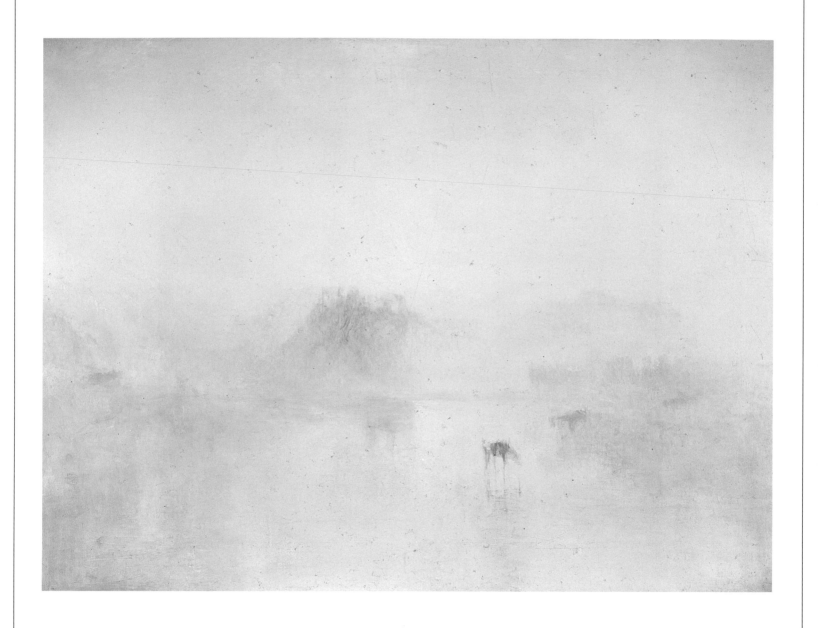

Joseph Mallord William Turner was, with Constable, one of two outstanding geniuses of British painting in the nineteenth century. He started drawing as a child and was admitted into the Royal Academy School in 1789. A master of topographical drawing, he began to make sketching tours from 1792, filling his sketchbooks with reminders of places that would later feature in his large-scale landscape compositions.

He travelled around Britain and then to Paris, Switzerland and Venice. Turner's oil and watercolour landscapes referred to mainly historical and seascape scenes; he rarely featured human figures, preferring to focus on the natural elements. These romantic landscapes showed the influence of Claude and Dutch seventeenth century marine painters. Works from 1830 onward are almost exclusively concerned with light. Turner visited Norham

Castle in Northumberland several times and first exhibited a watercolour of the same composition in 1798. **Norham Castle: Sunrise**, is one of the most spare of all his oil paintings – it presents an infinity of space in which the cool grey-blue castle appears like a chimera. Constable's description, "he seems to paint with tinted steam," seems especially apt for a work that comes close to abstraction. Turner greatly influenced the Impressionists.

Other Masterpieces

THE FIGHTING TEMERAIRE;
1838;
NATIONAL GALLERY,
LONDON,
ENGLAND

SUNRISE WITH SEA MONSTERS;
c.1845;
TATE GALLERY,
LONDON,
ENGLAND

Cy **Twombly**

Nini's Painting

1971; oil-based house paint, wax crayon and lead pencil on canvas; 250.3 x 300.4 cm;
Private Collection

C y Twombly is an original talent whose independent spirit and vision has formulated an art that is definable neither by style nor artistic movement. He spent from 1948 to 1952 training at the Boston Museum of Fine Arts, the Art Students League in New York and finally, at the invitation of his peer and friend Robert Rauschenberg, at Black Mountain College. Here he was taught by Robert Motherwell and Franz Kline. He travelled with Rauschenberg and moved to Rome in 1957, leaving only for short periods to work in New York. His early work reflected the influence of those around him. The open, expansive gestures of the Abstract Expressionists appealed to him, particularly the graphic elements in the work of Kline. However, unlike his contemporaries, popular culture did not interest him as a subject worthy of artistic exploration. He looked instead to the classical art of the Renaissance, Greek mythology and Roman antiquity. His mature paintings reflected these interests without offering descriptive references to form or narrative. As **Nini's Painting** shows, his artistic language is formulated from a wide vocabulary of pencil lines, paint marks and chalk scribbles to create a rich, multi-layered image, full of vital energy and cryptic symbols.

Other Masterpieces

EMPIRE OF FLORA;
1961;
MARX COLLECTION,
 BERLIN,
 GERMANY

UNTITLED;
1968;
MUSEUM OF ART,
 RHODE ISLAND SCHOOL
 OF DESIGN,
 PROVIDENCE,
 RHODE ISLAND,
 USA

Uccello Paolo

Born Florence, Italy c.1396; **died** Florence, Italy 1475

Battle of San Romano

c.1450–1460; tempera on panel; 182 x 323 cm; Galleria degli Uffizi, Florence, Italy

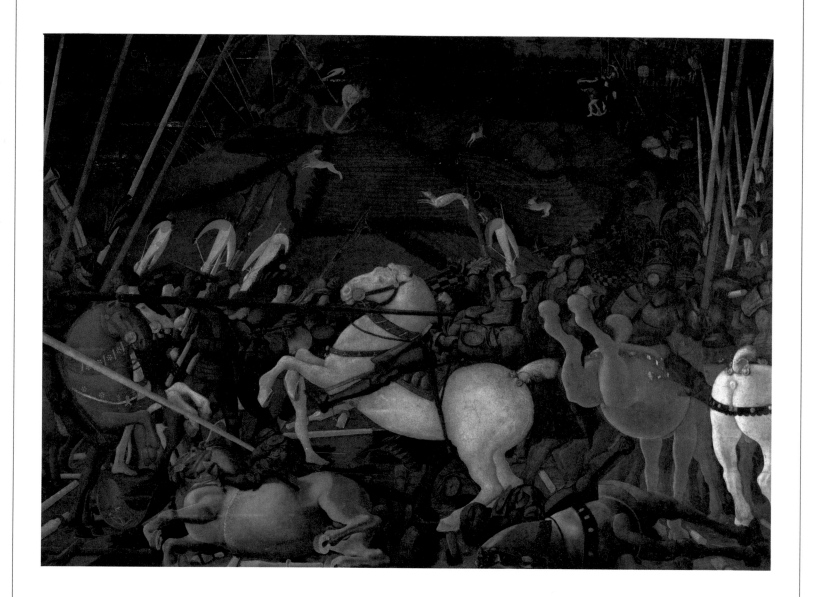

Uccello was the son of a barber-surgeon called Paolo di Dono, but may have taken his name from his love of birds – uccello means bird in Italian. He was an apprentice to the sculptor, Ghiberti, from c.1407 to 1414 and then left to join the guild of the Medici e Speciali. The **Battle of San Romano** is one of three panels commissioned by the Medicis. It depicts the rout of San Romano of June 1, 1432. For the year prior to this date, the Sienese had been ravaging Florentine territory and finally at this battle, the Florentines were victorious. Uccello's, interpreting the hostilities, works are an unusual marriage of old and new. The strong decorative element, with the patchwork of hills in the background, the flora and fauna and the frieze-like battle scene itself are all reminiscent of medieval tapestries. However, our overriding impression is of an artist who revelled in exploiting the novel rules of perspective and who was particularly preoccupied with foreshortening. Ultimately, it is for this that we remember Uccello. According to Vasari, Uccello ended his days, "solitary, eccentric, melanchol[ic] and poor". It was a sad demise for a master of pictorial liveliness, hitherto unknown.

Other Masterpieces

ST GEORGE AND THE DRAGON;
c.1450s;
NATIONAL GALLERY,
LONDON,
ENGLAND

THE DELUGE;
c.1445;
CHIOSTRO VERDE OF
SANTA MARIA
NOVELLA,
FLORENCE,
ITALY

L'impasse, Cottin

c.1910; oil on canvas; 540 x 730 cm; Tate Gallery, London, England

Maurice Utrillo was the illegitimate son of the painter, Suzanne Valadon. An alcoholic and a drug addict, he was reputedly encouraged to paint by his mother during one of his several admissions to a sanatorium. He had his first exhibition at the Paris Salon in 1909. His early work was affected by the Impressionists, in particular Pissarro but were characterized by, in Utrillo's own words, "a wild thirst for reality".

His intense vision, paradoxically, was largely the result of copying Parisian street views from postcards. Mainly concentrated on the area around Montmarte, he did much to establish the area's romantic image. The paintings produced between 1909 to 1916 are known as his "white period" because of their distinctive pale tones. **L'impasse, Cottin** is almost monochromatic. The darkened windows and empty doorways give the picture a

haunting atmosphere and emotional flatness. By the 1920s, Utrillo was introducing richer colours into his work. Highly popular, his paintings were the subject of numerous forgeries and imitations. He turned to religion in his later years.

Other Masterpieces

LA PLACE DU TETRE;
c.1910;
TATE GALLERY,
 LONDON,
 ENGLAND

**STREET IN A PARIS
 SUBURB WITH TREES;**
c.1920–1923;
WALLRAF-RICHARTZ-
 MUSEUM,
 COLOGNE,
 GERMANY

Valadon Suzanne

Born Bessines near Limoges, France 1867; **died** Paris, France 1938

Self Portrait

1883; pastel on paper; 45 x 32 cm; Musée Nationale d'Art Moderne, Paris, France

Suzanne Valadon moved to Paris as a child and from an early age made her living as an acrobat, dressmaker and artist's model. She posed for Puvis de Chavannes, Renoir, Toulouse Lautrec and Degas, who encouraged her to draw. Valadon started to paint in 1909. Her work, featuring still life and figure subjects, retained a strong linear quality. Her primitive, decorative style was later influenced by both Matisse and Derain. She was keenly aware of the dichotomy involved in being both an artist and a model. In 1927, she produced a poster for a Parisian benefit dance. As the back view of a naked woman holding up a palette, the image called into question the role of the female nude as object for the male artist. In the assertive **Self Portrait** (1883) seen here, Valadon centres on her determined facial expression. A renowned beauty, she depicts her own heavy jawline and dark features with unerring realism. Her treatment of herself is in stark contrast to the idealized version of femininity presented in the many paintings for which she posed.

Other Masterpieces

NU A LA COUVERTURE RAYEE;
1922;
PETIT PALAIS,
PARIS,
FRANCE

NU A LA PALETTE;
1927;
MUSEE NATIONALE D'ART MODERNE,
PARIS,
FRANCE

1951; oil on canvas; 55.9 x 61 cm; Tate Gallery, London, England

Keith Vaughan received no formal art training and struggled throughout his artistic life to find his own visual language. He had an interest in visual art theorists and the artistic and the literary achievements of the French. This was qualified by the challenge to resolve the conflict between the formal and the humanistic, expressive elements of painting. He sought to arrange non-precise forms, focusing almost exclusively on the depiction of male nudes. From the 1950s this preoccupation is realised via classical compositions orchestrated by Vaughan's talent as a colourist. His paintings of bathers, such as **Small Assembly of Figures** acknowledge Cézanne as a lifelong source of admiration. Vaughan produced his most striking pictures during the 1960s. In other figure compositions, each group becomes a solidly wrought monolith of flesh; a palette of warm blues, lilacs and pinks supersedes the brown and olive tones dominating earlier works. His dalliance with photography materializes on canvas in cropped figures, profiles and silhouettes. His works do not narrate the trauma of his personal life but are transmutations of the sexual tensions, which dictated it and which undoubtedly culminated in his suicide in 1977.

Other Masterpieces

LANDSCAPE WITH FIGURES;
1971;
PRIVATE COLLECTION

LANDSCAPE WITH FIGURE;
1957;
ARTS COUNCIL COLLECTION, ENGLAND

Velasquez Diego Rodriguez de Silva y

Born Seville, Spain 1599; **died** Madrid, Spain 1660

An Old Woman Cooking Eggs

1618; oil on canvas; 99 x 169 cm; National Gallery of Scotland, Edinburgh, Scotland

The son of Portuguese parents, Diego Velasquez trained in the academy of Francisco Pacheo, and married his daughter. By 1617 he had set up as an independent master. Velasquez became court painter to Philip IV in Madrid at the age of 24, and retained the position for the rest of his career. He was granted permission from the king to travel and went to Italy twice. On his second visit, in 1650, he painted the celebrated portrait of **Pope Innocent X**. His grand and graceful paintings of the Spanish royal family and the life of the court are distinguished by their profound feeling for humanity. Drawn toward human suffering, his portraits of court jesters and dwarves are, in particular, notable for both their compassion and absence of sentiment. **An Old Woman Cooking Eggs** is a detailed, realistic, early genre painting that was completed before his court appointment. The impassive stare of an elderly woman and her young companion contribute to perceptive character studies, which Velasquez has treated in a dignified and sympathethic manner. The realism of the dramatically lit composition is further heightened through the finely observed accoutrements – from the heavy pots and jugs to the eggs frying in the pan.

Other Masterpieces

THE ROKEBY VENUS;
c.1648;
NATIONAL GALLERY,
LONDON,
ENGLAND

LAS MENINAS;
c.1656;
MUSEO DEL PRADO,
MADRID,
SPAIN

Born Delft, Netherlands 1632; **died** Delft, Netherlands 1675

1666; oil on canvas; 120 x 100 cm; Kunsthitorisches Museum, Vienna, Austria

Jan Vermeer is regarded as one of the greatest seventeenth-century Dutch artists – second only in importance to Rembrandt. Little is known of his early life; it seems unlikely that he left his native city of Delft. His early work typically focused on domestic interiors featuring women engaged in a number of everyday tasks, such as writing letters, pouring milk and playing music. An unusual aspect of his compositions is the degree to which the protagonists in his scenes are self-absorbed. Vermeer married into a wealthy Catholic family and had eleven children. He worked in a large room in the house, and produced a small number of exquisitely rendered paintings. He resisted selling them whenever he could, which suggests he had, for a time at least, a private income; however; when he died suddenly, aged 43, he was in great debt. In **The Painter in his Studio**, the brocade curtain is pulled back to reveal a painter in his studio – this may even be a self portrait. It records a timeless but intimate moment; the objects, furnishings and people are rendered with clarity and sensitivity, all enveloped in the clarity of cool, pearlized light.

Other Masterpieces

VIEW OF DELFT;
c.1660;
MAURUTSHUIS,
THE HAGUE,
NETHERLANDS

WOMAN READING A
LETTER;
1662–1663;
RIJKSMUSEUM,
AMSTERDAM,
NETHERLANDS

Veronese Paolo Caliari

Born Verona, Italy 1528; **died** Venice, Italy 1588

Family of Darius before Alexander the Great

1565–1570; oil on canvas; 236 x 474 cm; National Gallery, London, England

Veronese was brought up in Verona on the mainland territory of Venice, where he would first have experienced the Mannerist style, which had spread north through central Italy. He was particularly influenced by Titian, Raphael, Michelangelo and Parmigianino. At the age of twenty five he painted the ceiling for the Doge's Palace in Venice, and by 1560 had made his first visit to Rome. In 1573, he produced his infamous and hedonistic **Feast in the House of Levi**, which he was forced to defend in front of the Inquisition. In Veronese's assured historical, religious and allegorical paintings he seems to relish depicting large masses of people. In **Family of Darius before Alexander the Great**, the incident – in which Darius's mother begs Alexander for mercy – is witnessed by figures peering over the balcony. Veronese's real interest appears to be in the production of a splendidly coloured theatrical scene with a Palladian backdrop, rather than the dramatic nature of his heroic subject matter. Veronese was noted for his command of pagentry and drama and his brilliance as a colourist and here the remarkable warmth of his palette helps to convey the sense of a clear, bright day.

Other Masterpieces

FEAST IN THE HOUSE OF LEVI;
1573;
GALLERIA DELL'ACCADEMIA,
VENICE,
ITALY

THE MARRIAGE AT CANA;
c.1563;
MUSEE DU LOUVRE,
PARIS,
FRANCE

Marie-Elizabeth-Louise # Vigée-Lebrun

1789; oil on canvas; 130 x 94 cm; Musée du Louvre, Paris, France

Portrait of the Artist and her Daughter

Elizabeth Vigée-Lebrun was taught by Louis Vigée, her father, a Parisian portraitist working in pastels. He died when she was fifteen, by which time her growing reputation allowed her to support her family. In 1776, she married picture dealer Jean-Baptiste Lebrun. Her highly successful career led to a friendship with Queen Marie-Antoinette, whom she portrayed many times. Vigée-Lebrun fled the French Revolution in 1789 and travelled across Europe before finally settling back in Paris in 1814.

Her many charming and delicately executed portraits were produced during the Rococo period. **Portrait of the Artist and her Daughter** should be seen in the context of new eighteenth century ideas centring on the notion of the family, encouraging women to place greater emphasis on the emotional bond between mother and child. In this informal portrait the artist depicts the loving embrace between mother and child.

A dedicated artist, Vigée-Lebrun's memoirs revealed that she continued working, "in the intervals between labour pains," during the birth of her daughter.

Other Masterpieces

SELF PORTRAIT IN A STRAW HAT;
AFTER 1782;
NATIONAL GALLERY,
LONDON,
ENGLAND

HUBERT ROBERT;
1788;
MUSEE DU LOUVRE,
PARIS,
FRANCE

Viola Bill

Born New York City, USA 1951

Nantes Triptych

1992; video and mixed media; Tate Gallery, London, England

Bill Viola graduated from Syracuse University's Experimental Studios of the Department of Visual and Performing Arts in 1973. His first experiments with Super-8 film and with black and white video date back to 1970. Proceeding from single-screen video and video and sound-based installations he has become known for his monumental pieces incorporating computer-controlled discs and state-of-the-art techniques. These resulted partly from studying new developments in video technology in Japan 1980–1981. His works are completely absorbing, often literally encapsulating the viewer in an experience that controls the visual and aural senses. In the **Nantes Triptych**, three large screens almost fill the viewer's field of vision with the crucial human concerns and actual moments of birth (the artist's son) and death (the artist's mother). Between the two is an enigmatic, dreamlike sequence of a clothed figure plunging into watery depths. It is a moving and disturbing meditation on states of consciousness and being and illustrates Viola's contemplation on the "philosophical mind-body problem coming to a crescendo as an ecological drama..."

Other Masterpieces

TINY DEATHS;
1993;
EDITION 1: MUSEE D'ART
CONTEMPORAIN DE
LYON,
FRANCE

ROOM FOR ST JOHN OF
THE CROSS;
1983;
MUSEUM OF
CONTEMPORARY ART,
LOS ANGELES,
USA

Born Paris, France 1876; **died** La Tourilliere, France 1958

c.1906; oil on canvas; 48 x 56 cm; Musée Nationale d'Art Moderne, Paris, France

Landscape with Red Trees

The son of Flemish parents, Maurice de Vlaminck was an athletic and enthusiastic individual who took part in cycle races and earned his living mainly as a musician. He taught himself to draw and paint and was proud of the fact that he had never set foot in the Louvre. His friendship with André Derain dates from about 1900. They shared a studio together at Chatou, near Paris. Vlaminck was very impressed by the 1901 Van Gogh retrospective in Paris and adopted the Dutch-born artist's use of strong colours and turbulent brushstrokes. He took part in the Fauves exhibition of 1905 at the Salon d'Automne. Painting was, for Vlaminck, a spontaneous, passionate and physical act. His belief that, "instinct is the foundation of art", meant that intense colour, often applied direct from the tube, predominates his mainly landscape compositions. **Landscape with Red Trees** distorts basic perspective, the vertical trunks of the trees adding excitement and expression to the overall composition. His later works, showing the influence of Cézanne, are more subdued in colour. After serving in the First World War, he lived and worked in virtual isolation in rural France.

Other Masterpieces

THE RIVER;
1910;
NATIONAL GALLERY,
WASHINGTON DC,
USA

SUMMER LANDSCAPE;
1905-1906;
COLLECTION DR A
WILHELM
BETTENINGEN,
BASEL,
SWITZERLAND

Femme Lisant, le Soir

c.1895; oil on canvas; 50.8 x 60.9 cm; Private Collection

Edouard Vuillard studied in Paris, completing his training at the Académie Julian where he met Pierre Bonnard with whom he shared a studio. Both artists were enthused by Sérusier's exposition of a new theory based on Gaugin's expressive use of colour and, in 1889, joined the Nabis artist's group. Vuillard painted intimate introspective, domestic scenes, revealing through his small brushstrokes and broken surfaces a feeling for textures and patterning. His mother was a dressmaker and he grew up surrounded by rolls of patterned material. He made use of bold colours but his close tonal range meant that the overall effect was often muted. **Femme Lisant, le Soir** is a small work – both in terms of its actual size and in its portrayal of an everyday subject. A corner of the room is further enclosed by the walls, furniture and a clutter of objects. In this indistinct scene, a woman sits reading in the lamplight and there is a subtle tension due to the ambiguity associated with her mysterious identity. Vuillard's later works were more naturalistic, due in part to the impromptu photographs he took to capture spontaneous impressions of his family and home life.

Other Masterpieces

MOTHER AND CHILD;
c.1899;
GLASGOW MUSEUM AND
 ART GALLERY
 GLASGOW,
 SCOTLAND

ARTIST'S MOTHER AND
 SISTER IN STUDIO;
c.1900;
MUSEUM OF MODERN ART,
 NEW YORK CITY,
 USA

Born Devonport, England 1855; **died** Madron, France 1942

St Ives

c.1928; oil on drawing on board; 25.7 x 38.4 cm; Tate Gallery, London, England

Alfred Wallis worked as a Cornish fisherman from 1880. In 1925, grieving and lonely after the death of his wife, he started to paint. By this time he was in his sixties. He was discovered by Ben Nicholson and Christopher Wood in 1928 and his primitive style had a big impact on the art movement that sprang up around the St Ives painters in Cornwall. His scenes of fishing life, with harbours, ships and lighthouses, were not drawn directly from life but from his memories and experiences. In **St Ives**, Wallis surveys the promontory from a high viewpoint. Appropriately, for a painting of a fishing village, the work is painted in oil and ship paint. Painted on a rough, cut-out piece of board, the work has a feeling of commemoration about it, enhanced by a directness normally associated with children's drawings. Its simple, clean lines make effective use of strong colour and white. Despite becoming the best-known British naive artist, Wallis was poverty-stricken and died in a workhouse.

Other Masterpieces

THE OLD HOUSES, ST
IVES;
c.1928;
TATE GALLERY,
ST IVES,
CORNWALL,
ENGLAND

WRECK OF THE ALBA;
1938;
TATE GALLERY,
ST IVES,
CORNWALL,
ENGLAND

Warhol Andy

Born Pittsburgh, USA 1928; **died** New York City, USA 1987

Mao

1972; etching on paper; 91.4 x 91.4 cm; Wallace Collection, London, England

Andy Warhol, (originally Warhola) is the most famous of the American Pop artists. He was a legend in his own lifetime and remains a cult figure, more because of the persona he manufactured than because of the artistic merit of his ideas. The notion of mass production is at the heart of Warhol's work – even that of the human icons of popular culture. Having grown up in a generation where anything and everything became freely available on the open market, the multiple-item-stacked drugstore shelves became Warhol's visual resource. He studied at the Carnegie Institute of Technology in Pittsburgh, Pennsylvania from 1945–1949 and then moved to New York. He had various jobs including that of illustrator, window display designer and commercial artist; he received the Art Directors Club Medal in 1952 and 1957 for his advertising art. From 1960, Warhol's interest in film making and in silk-screen printing collided with his exploration of popular culture and consumer items. From Coca Cola bottles and Elizabeth Taylor to Campbell's Soup cans and the Electric Chair, such icons were mechanically reproduced in series with colour variations – as in the case of **Mao**.

Other Masterpieces

MARILYN (SERIES OF
TEN SCREEN PRINTS
ON PAPER);
1967;
TATE GALLERY,
LONDON,
ENGLAND

**GREEN COCA-COLA
BOTTLES;**
1962;
WHITNEY MUSEUM OF
AMERICAN ART,
NEW YORK CITY,
USA

c.1718; oil on canvas; 67.3 x 92.5 cm; Wallace Collection, London, England

The work of Antoine Watteau provides a singularly distinctive precedent to the visual and decorative art known as Rococo. He is credited with creating a Parisian style and is classed alongside Chardin as a key figure among pre-Revolutionary French artists of the period. Watteau settled in Paris in 1702, and until 1708 studied under decorative painter Claude Gillot. Watteau adopted Gillot's predilection for painting scenes for the commedia dell'arte. Theatrical costume and poetic characters recur in Watteau's paintings, leading to his title of "peintre de fetes galantes". He gained access to Rubens' decorations in the Luxembourg Palace and studied collections of work by Flemish and Italian masters. Rubens, Veronese and the Venetians had notable influence on his style, particularly in his use of colour. This incorporated a systematic method of mixing pigment optically on the canvas, which was to be developed later by Seurat. **The Music Party** is a typical example from Watteau's oeuvre. He renders an imaginative, ideal scene of life exquisitely, tinged with sadness. It is believable rather than superficial, full of the gravity and grace of serious skill, rather than the frivolous spirit of true Rococo which was to follow.

Other Masterpieces

THE EMBARKATION FOR
CYTHERA;
1717;
MUSEE DU LOUVRE,
PARIS,
FRANCE

ENSEIGNE DE GERSAINT;
1719;
STAATLICHE MUSEEN,
BERLIN,
GERMANY

Weyden Rogier van der

Born Tournai, Belgium 1400; **died** Bruges, Belgium 1464

Portrait of Antoine de Bourgogne

c.1460; oil on canvas; 37 x 27 cm; Musee Royaux des Beaux-Arts, Brussels, Belgium

The pre-eminent artist of mid-fifteenth century Flanders, Rogier van der Weyden is believed to have begun his career as an apprentice to Robert Campin. He later became Town Painter of Brussels from 1433 to 1464. As such, he would have been in charge of a workshop with at least four or five apprentices producing numerous designs for altarpieces and sculptures. He was the originator of a style of portraiture in which individual complexities were reduced to standard types, easily recognizable by the contemporary viewer. This technique, evident here in the plainness and flatness of the portrait, culminated in the work of Hugo van der Goes. Van der Weyden used slightly tinted layers of primer to soften the intensity of his colours. His simple, emotional style was popular in Italy, where many artists, such as Cosima Tura, were influenced by him. **Antoine de Bourgogne,** the illegitimate son of Philip the Good, was born in 1421; in this portrait he is in his mid-30s. Here, Van der Weyden emphasizes the characteristics thought to signify good breeding – fine bone structure and sensitive features.

Other Masterpieces

DEPOSITION;
c.1435;
MUSEO DEL PRADO,
MADRID,
SPAIN

BRAQUE TRIPTYCH;
c.1452;
MUSEE DU LOUVRE,
PARIS,
FRANCE

Nocturne in Blue and Gold

c.1872–1875, oil on canvas, 67.9 x 50.8 cm, Tate Gallery, London, England

From 1851 to 1854 Whistler studied at West Point Military Academy, in New York State and worked as a Navy cartographer before going to study painting in Paris in 1855. He became one of a circle of Realist artists after meeting with Fantin-Latour and Courbet in 1858. He made copies in the Louvre and developed enthusiasm for Oriental art and decoration, being particularly impressed by Japanese prints. He brought these interests with him when he settled in London in 1859. Rather than perpetuate an English tradition of narrative painting he concentrated on the aesthetic formulation of pictorial composition itself as the subject of his work. Such arrangements came out of the harmonious juxtaposition of tones and colours; the comparison with music was intentional and made clear in the titles of his paintings. **Nocturne in Blue and Gold** is described in subtle tones and simple, flat forms in an unmistakably Japanese manner. Ruskin was appalled by Whistler's work accusing him of "flinging a pot of paint in the public's face". However, Whistler's belief in "art for art's sake", expounded in his Ten O'Clock Lecture, first delivered in 1855, was taken seriously and his painting emulated by successive generations.

Other Masterpieces

ARRANGEMENT IN GREY AND BLACK;
1871;
MUSEE DU LOUVRE,
PARIS,
FRANCE

SYMPHONY IN WHITE NO II;
1864;
TATE GALLERY,
LONDON,
ENGLAND

Whiteread Rachel

Born London, England 1963

Untitled (House)

1993; London, England, demolished

R achel Whiteread studied at Brighton Polytechnic from 1982–1985 and then at the Slade School of Art in London until 1987. **Untitled (House)** is her most controversial and yet most respected sculptural piece. A concrete cast of the complete interior of a terraced dwelling, doomed to demolition, it is a ghostly, yet tangible manifestation of the air that was once breath and the silence that was the stuff of its rooms. The sculpture, in Bow, London, was itself demolished in 1993. The memory of Whiteread's achievement lives on as an immovable monument in art history. The artist casts the interior spaces that were once occupied by human domestic activity or emotional emptiness. These negative areas – the hiding place under the bed, the secret, musty atmosphere inside a wardrobe, the seductive, vacant bath – are transformed into positive, inert lumps of past lives. Whiteread sculpts the intangible; she reveals the gaps in which memories are hidden as solid testimonies to life's events. Rubber casts of mattresses proliferate Whiteread's earlier work, as do plaster casts of her own body. The themes of containment, protection and the vulnerability of our fragility as mortal beings are a source of potent, powerful expression.

Other Masterpieces

GHOST;
1990;
SAATCHI COLLECTION,
LONDON,
ENGLAND

UNTITLED (BATH);
1990;
SAATCHI COLLECTION,
LONDON,
ENGLAND

Receiver

Born Blackburn, Lancashire, England 1948

1988; oak and galvanized steel, beeswax and pigment; 195.5 x 139.7 x 99 cm; Tate Gallery, London, England

Alison Wilding trained at Ravensbourne College of Art from 1967 to 1970 and the Royal College of Art, London, 1970–1973. Her sculptural work has gradually gained appreciation since the early 1980s. At this time she began concentrating on the production of objects for exhibition rather than her environmental installation pieces of the 1970s. However, the contextual element of displaying her large and small scale sculpture has remained a concern; this is integral to her exploration of relationships between forms and their occupation of space. Like her contemporary, Richard Deacon, she employs a wide variety of materials – stone, metal, wood, polypropylene, paint, rubber, cloth and wax – in a precise and measured way. More stylish than organic, Wilding's work often incorporates two interdependent forms in each piece. **Receiver** is an example of this.

The soft femininity of the carved oak vessel sits at the foot of the harsh, galvanized steel tower. The incongruous juxtaposition of such contrasting pieces brings into focus their respectively different command of space. Their "marriage" extends this inquiry in an understated way that is both eloquent and beautiful.

Other Masterpieces

BLUE SKIES;
1987;
PRIVATE COLLECTION ON
LOAN TO
SOUTHAMPTON ART
GALLERY
SOUTHAMPTON,
ENGLAND

STAIN;
1991;
KARSTEN SCHUBERT
GALLERY,
LONDON,
ENGLAND

Wilkie Sir David

Born Fife, Scotland 1785; **died** at sea off Malta 1841

The Bride at her Toilet

1838; oil on canvas; 97.2 x 122.6 cm; National Gallery of Scotland, Edinburgh, Scotland

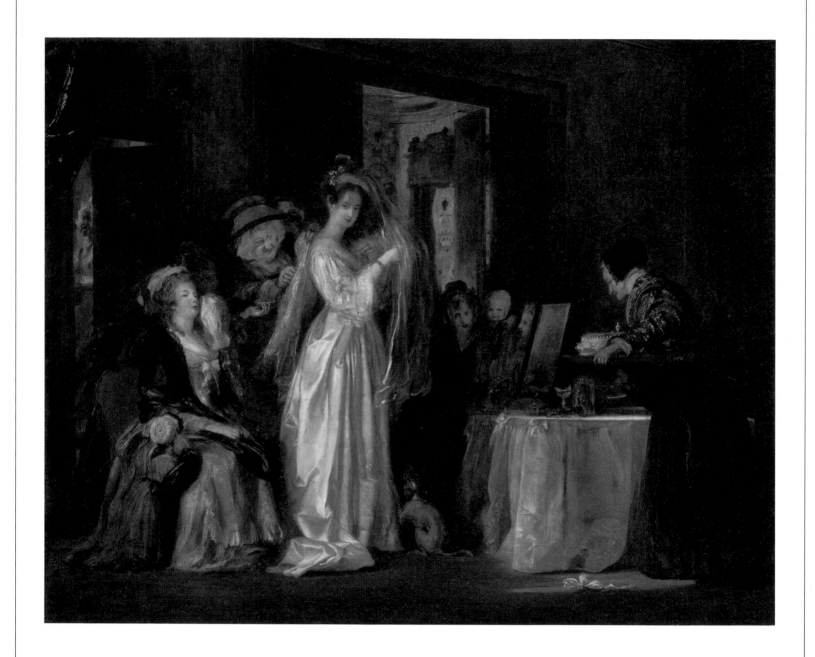

David Wilkie was the son of a minister in Fife and first studied in Edinburgh. In 1805, he entered the Royal Academy school in London and the following year exhibited **Village Politicians** at the Academy. This work set his style for the next twenty years, establishing him as a popular genre painter whose narrative paintings were crammed full of lively and often humorous incident. His pictures of Victorian life generally expressed a moral lesson and were strongly influenced by scenes of peasant life in the seventeenth century Dutch genre paintings of David Tenier and Adriaen van Ostade. **The Bride at her Toilet** is a typically moralizing domestic scene, contrasting the innocent, virginal figure in white with her huddle of fussing, female attendants. From 1825 Wilkie travelled to Italy and Spain, where his style and subject matter broadened under the influence of Velasquez and Murillo. Back in England, he became painter to the king in 1830 and was knighted in 1836. He died at sea on his return from a research trip to the Middle East. Turner commemorated him in his work **Peace: Burial at Sea**.

Other Masterpieces

THE BLIND FIDDLER;
1806;
TATE GALLERY,
 LONDON,
 ENGLAND

THE LETTER OF
 INTRODUCTION;
1813;
NATIONAL GALLERY OF
 SCOTLAND,
 EDINBURGH,
 SCOTLAND

20:50

1987; used sump oil and steel; dimensions variable; Saatchi Collection, London, England

Richard Wilson studied at the London College of Printing from 1970–1971. He then went on to Hornsey College of Art. Since graduating with an MA from Reading University in 1976, he has exhibited his sculptural/installation art with Matt's Gallery in London. As a work that has a strong and lasting impact, Wilson's **20:50** is unsurpassed. Not only does it physically completely occupy one of the spaces of the Saatchi Gallery where it is now installed, but it also disorientates the senses and has a strong odour. The layer of 2,500 gallons of used, black sump oil gives the illusion of great depth, not of viscous fluid but of emptiness falling away from beneath the feet. Edging gingerly along the walkway leading into the work one feels as if one is stepping into the void; it is almost a leap of faith. The notion of the paradox is a thematic element of Wilson's work. The tenuous ways in which we live and manage our lives and the structures we create to house ourselves and our possessions – caravans, conservatories and greenhouses – and the importance we attach to them, are seen by Wilson as inventions worthy of exploration and transformation.

Other Masterpieces

HIGH RISE;
1989;
SAATCHI COLLECTION,
LONDON,
ENGLAND

FACELIFT;
1991;
SAATCHI COLLECTION,
LONDON,
ENGLAND

Witz Konrad

Born Constance, Germany c.1400; **died** Basel, Switzerland c.1444

Miraculous Draught of Fishes

c.1444; oil on canvas; 123 x 154 c,; Musée d'Art et d'Histoire. Geneva, Switzerland

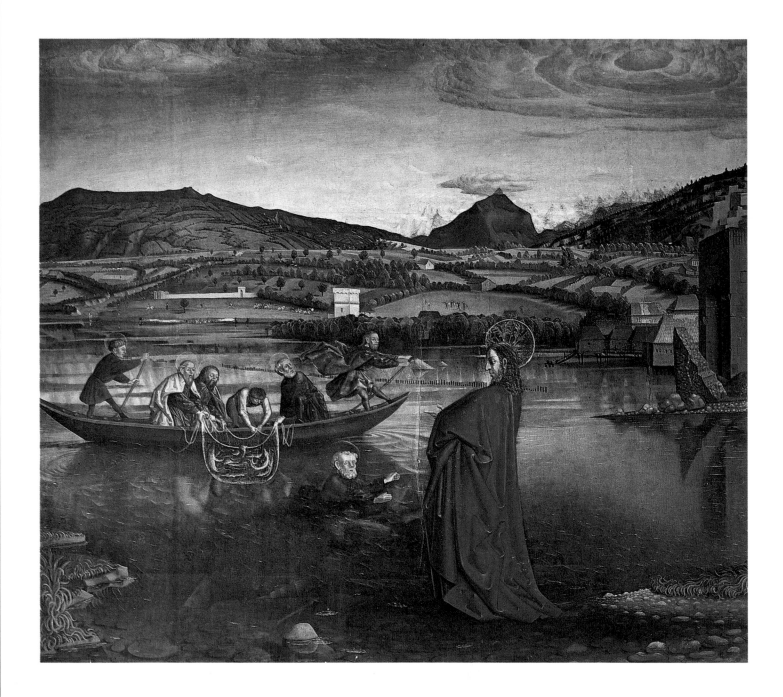

itz was brought up in Constance but from 1434 spent most of his working life in Basel. Very little is known about his life and only one painting, **Miraculous Draught of Fishes**, is signed and dated. It was one of four painted for two wings of a Redemption altarpiece for St Peter's Cathedral in Geneva, most probably commissioned by a cardinal. This is an extraordinarily inventive interpretation of the well-known biblical story. Christ dispassionately surveys the disciples as they struggle to haul in their catch. The most significant aspect of the painting is Witz's clear observation of the surface beneath the shallow water; this was the first identified attempt at such an optical illusion. Art historians also believe it to be one of the first paintings of a recognizable landscape, that of Lake Leman in Switzerland. Witz's naturalistic treatment of this subject was advanced for its time. His revolutionary, realist way of seeing gave solidity and and human substance to revered religious characters. Such an approach evinces Witz's knowledge of the achievements of other artists, van Eyck being one.

Other Masterpieces

SAINT BARTHOLOMEW;
c.1435;
MUSEUM OF FINE ARTS,
BASEL,
SWITZERLAND

SAINT MAGDALEN AND SAINT CATHERINE;
c.1480;
STRASBOURG MUSEUM,
FRANCE

Don Juan

1944–1945; watercolour and chalk on paper; 12.6 c 10 cm; Private Collection

Wols was born in Germany but lived in France from the mid-1930s onward. His artistic potential was recognized by Moholy-Nagy, who encouraged him to study at the Bauhaus. From 1932 he earned his living as a photographer in Paris. After the Second World War, he produced illustrations for Jean-Paul Sartre and Simone de Beauvoir, who recognized his talent for producing detailed and obsessive images of the unconscious. His mature work, especially drawings and watercolours from the early 1940s, assimilate Surrealist notions of automatism, a process exploiting the subconscious, and biomorphism, using forms derived from organic shapes. **Don Juan** is a delicate work from this period. The pinkish colour and spidery lines combine in a small, evocative image that is both fluid and exact. A work rich in associations, the title suggests that we are witness to the mating ritual of tiny creatures observed through a microscope. Wols died aged thirty-eight, the result of a dissolute and poverty-stricken life. Posthumously, his reputation grew and his work influenced the development of French abstract art in the 1950s.

Other Masterpieces

UNTITLED;
1944-1945;
TATE GALLERY,
LONDON,
ENGLAND

COMPOSITION;
1947;
MUSEUM OF MODERN ART,
NEW YORK CITY,
USA

Woodrow Bill

Born Henley-on-Thames, England 1948

Self-Portrait in the Nuclear Age

1986; shelving unit, wall map, coat, globe, acrylic paint; 205 x 145 x 265 cm;
Saatchi Collection, London, England

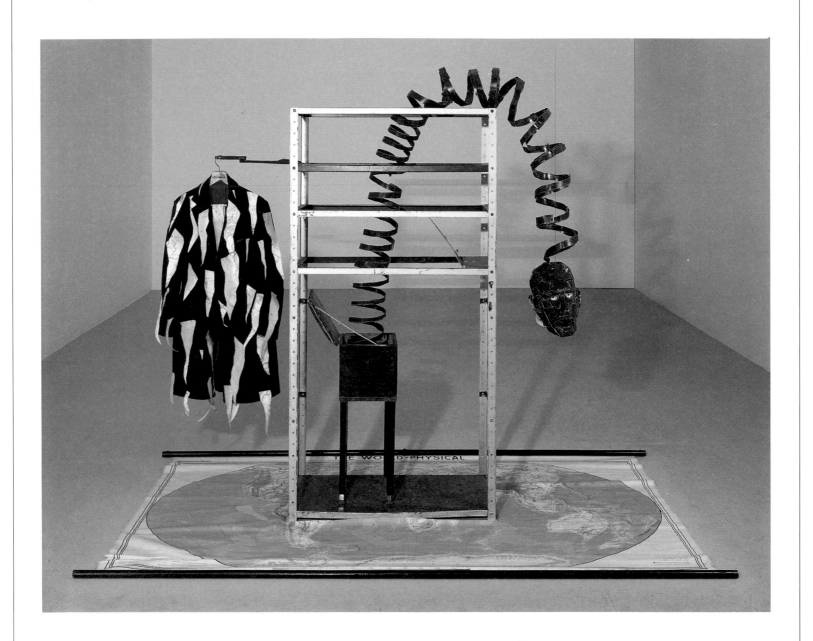

Bill Woodrow's work is a combination of wit and technical skill. Like Tony Cragg and David Mach, other sculptors who came to prominence in the 1980s, Woodrow's art is his appropriation of banal objects, domestic appliances and materials and their subsequent metamorphosis. His work possesses a sardonic humour in the way that outmoded items, electric fires and washing machines, for example, are magically fashioned into something else, as if metal and wire become origami paper. The combined spirits of Arte Povera and of Pop Art are resurrected to comic effect in Woodrow's work. However, a more serious interpretation could be implied in the ingenious way that Woodrow makes a moral point. He seems to suggest that the greed with which we cram consumer products into our lives outweighs notions of recycling and the harm we do to the environment. The transformation of materials in **Self-Portrait in the Nuclear Age** hints at destruction and mutation. The jack-in-a-box is a surprise laced with black humour and a warning that literally balances over our world. Woodrow's more recent, larger scale work points to more universal themes concerning, for example, wealth and the pursuit of power.

Other Masterpieces

TWIN-TUB WITH GUITAR;
1981;
TATE GALLERY,
 LONDON,
 ENGLAND

LIFE ON EARTH;
1983;
NATIONAL GALLERY OF
 CANADA,
 OTTAWA,
 CANADA

Joseph Wright

1768; oil on canvas; 182.9 x 243.9 cm; National Gallery, London, England

Experiment with an Air Pump

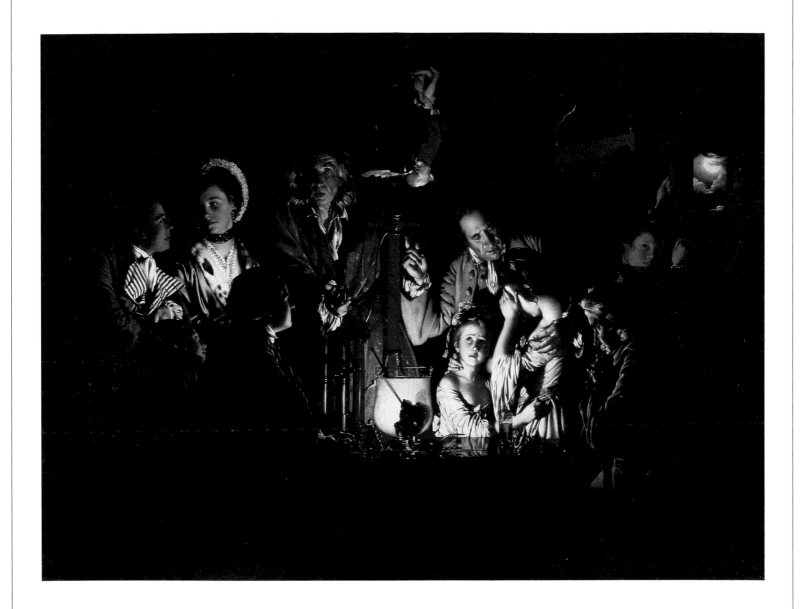

A s Joseph Wright lived and worked in the Midlands town of Derby he became known as "Wright of Derby". He was the first British painter of significance from outside London, although his training in the 1750s took place in the capital. He first came to prominence as a portrait painter. In Derby he found admirers among industrialists and inventors, Arkwright and Wedgwood became his patrons and, from the 1760s, his paintings commented upon the scientific advances made by the emerging Industrial Revolution. He specialized in extraordinary light effects, his candlelit scenes recalling the work of Dutch artists such as Honthorst. **Experiment with an Air Pump** is generally regarded as his finest work. In the painting, the lamplight dramatically highlights a domestic interior, revealing a mixture of awe, fascination and fear in the faces of the assembled group. Wright visited Italy between 1773-1775, where he witnessed an eruption of Vesuvius, as well as a grand, theatrical firework display. Toward the end of his career, he became increasingly interested in painting the English landscape.

Other Masterpieces

A PHILOSOPHER GIVING
A LECTURE ON THE
ORRERY;
c.1763–65;
DERBY MUSEUM AND ART
GALLERY,
DERBYSHIRE,
ENGLAND

THE ACADEMY BY
CANDLELIGHT;
1769;
ROYAL COLLEGE OF
SURGEONS,
LONDON,
ENGLAND

Wyeth Andrew

Born Chadds Ford, USA 1917

Up in the Studio

1965; watercolour; 43.1 x 60.6 cm; Museum of Modern Art, New York City, USA

Andrew Wyeth was tutored solely by his father, N C Wyeth, a well-known illustrator, who taught his son to draw from casts, skeletons, still life and the life model. Andrew did not develop his own inimitable style until after his father's death in a level crossing accident. The emotional impact of this personal tragedy precipitated the change in his work. He had always been especially drawn to landscape, particularly the Brandywine Valley around his home, but his range broadened to include the study of people and their emotions. His work has a compelling, highly-detailed realism, which can be traced back to Winslow Homer and Thomas Eakins, but conveys a distinct sense of lugubrious wistfulness. In **Up in the Studio**, a drybrush watercolour, Wyeth uses the frame of his panel as a compositional device. The cropping of the lower edge, combined with the lines of the floor and window, draw the viewer into this private, isolated space. The subdued colours are characteristic of Wyeth's work and were achieved by grinding his own pigments from a range of earth and mineral colours. He paints in one of two media – drybrush or tempera – both methods being painstaking and slow.

Other Masterpieces

CHRISTINA'S WORLD;
1948;
MUSEUM OF MODERN ART,
NEW YORK CITY,
USA

THAT GENTLEMAN;
1960;
DALLAS MUSEUM OF FINE
ART
TEXAS,
USA

Born London, England, 1871; **died** Dublin, Ireland, 1957

1950; oil on canvas; 61 x91.5 cm; Private Collection

The Rogue's March

Brother of the poet W B Yeats, Jack Yeats is recognized as the foremost Irish painter of the twentieth century. From 1879–1887 he lived with his grandparents near Sligo on the West Coast of Ireland. He studied in London but settled permanently in Ireland in 1910. His mature pictures of the early 1920s describe the activities and character of the ordinary people there. Although he claimed that Goya and Sickert were the only painters he admired, his painting is fluid and Expressionistic, boldly handled and courageously coloured. The outlines around his figures serve to reinforce form and character, almost to the point of caricature. By 1925 his manner had changed. Colours were lighter and shapes more loose. In the 1930s his technique became increasingly dynamic and fragmentary, charged with the energy of his subjects – sometimes imaginary from Irish history, at other times describing real life. The misfits, gypsies, tramps and musicians who populated the bars, pantomimes, beaches and circuses provided the vitality on which Yeats thrived. **The Rogue's March** demonstrates his gift for balancing figures within the landscape of their environment, affected by atmosphere and the elements. Samuel Beckett accordingly acclaimed him as a "supreme master".

Other Masterpieces

THE TWO TRAVELLERS;
1942;
TATE GALLERY,
 LONDON,
 ENGLAND

A STORM;
1936;
WADDINGTONS GALLERY,
 LONDON,
 ENGLAND

Zoffany Johann

Born Frankfurt, Germany 1733; **died** London, England 1810

The Bradshaw Family

1769; oil on canvas; 162.1 x 175.3 cm; Tate Gallery, London, England

German-born Johann Zoffany studied in Rome before settling in England in 1761. His work found favour with King George III and he painted numerous elegant and flattering portraits of the royal family. He was one of the original members of the Royal Academy and, in 1771, painted a group portrait of the Academy's leading artists. In addition to portraits, he painted conversation pieces, an eighteenth-century group portrait, often of a family, engaging in conversation within a domestic or landscape setting, and theatrical scenes depicting a dramatic moment in a play. Zoffany was encouraged in these stage representations by his patron, the actor David Garrick. **The Bradshaw Family** is a conversation piece in which various members of the family are shown relaxing on their land. Painted with grace, fluency and vigour, it has a sense of characterization inspired by the work of Hogarth, but lacking the latter's satirical edge. In 1772, he went to Italy and spent some years in Florence. He also increased his income considerably by painting portraits of the aristocratic members of Indian society between 1783–1789.

Other Masterpieces

QUEEN CHARLOTTE AND HER TWO ELDEST CHILDREN;
1766–1767;
ROYAL COLLECTION, WINDSOR, ENGLAND

THE ACADEMICIANS OF THE ROYAL ACADEMY;
1772;
ROYAL COLLECTION, WINDSOR, ENGLAND

Born Fuente de Cantos, Spain 1598; **died** Madrid, Spain 1664

Still Life

c.1658; oil on canvas; 46 x 84 cm; Museo del Prado, Madrid, Spain

Francisco de Zurbarán's apprenticeship was undertaken in Seville, where he met Velázquez and became one of the city's official painters. His commission to decorate the king's palace in Madrid was most probably the result of his continuing friendship with the older, and more successful, Spanish artist. Zurbarán was chiefly a portrait painter and his religious subjects, depicting meditating saints, found favour in southern Spain's many monastic and church institutions. From 1628, he worked on a number of paintings to be sent to monasteries in the Spanish colony of Guadalupe. After 1640 his austere, harsh, hard-edged style was unfavourably compared to the sentimental religiosity of Murillo and Zurbarán's reputation declined. In 1658, he moved to Madrid in search of work and renewed his contact with Velázquez. Zurbarán died in poverty and obscurity. **Still Life** is one of the few masterly compositions that he produced of the subject. Four simple pots and bowls – strangely arranged along a line in the foreground – glow, backed by deep shadow. With the composition stripped to the bare minimum, this still life remains a meditative and mystical work of great beauty.

Other Masterpieces

SAINT MARGARET OF ANTIOCH; c.1630–1634; NATIONAL GALLERY, LONDON, ENGLAND

ST SERAPION; 1928; WADSWORTH ATHENAEUM, HARTFORD, USA

Gallery Guide

Antwerp
Koninklijk Museum voor Schone Kunsten
Leopold de Waelplein
B-2000 Antwerp
Belgium

Amsterdam
Stedelijk Museum
Paulus Potterstraat 13
1071 CX Amsterdam
Netherlands

Baltimore
Baltimore Museum of Art
Art Museum Drive
Baltimore
MD 21218
USA

Basel
Kunstmuseum
St-Alban-Graben 16
4010 Basel
Switzerland

Bedford
Cecil Higgins Art Gallery and Museum
Bedford
MK40 3NY
England

Berlin
Staatliche Museen zu Berlin
Preussischer Kulturbesitz
Arnimallee 23/27
14195 Berlin
Germany

Birmingham
City of Birmingham Museum & Art Gallery
Chamberlain Square
Birmingham
B3 3DH
England

Bologna
Pinacoteca Nazionale
Via Belle Arti 56
40126 Bologna
Italy

Bonn
Städtisches Kunstmuseum
Bonn
Friedrich-Ebert-Allee 2
53113 Bonn
Germany

Bristol
City Museum and Art Gallery
Queens Road
Bristol
BS8 1RL
England

Bruges
Memlingmuseum
Mariastraat 38
8000 Bruges
Belgium

Brussels
Musées Royaux des Beaux-Arts de Belgique
Rue de la Reference, 3
1000 Brussels
Belgium

Cambridge, UK
Kettle's Yard
Castle Street
Cambridge
Cambridgeshire
CB3 0AQ
England

Cambridge, USA
Fogg Art Museum
Harvard University
32 Quincy Street
Cambridge
MA 02138
USA

Chantilly
Musée Condé
Château
60631 Chantilly
France

Chicago
Art Institute of Chicago
111 S. Michigan Avenue
Chicago
IL 60603-6110
USA

Cleveland
Cleveland Museum of Art
11150 East Boulevard
Cleveland
OH 44106
USA

Cologne
Michael Werner Gallerie
Gertruden Strasse 24-28
Cologne 50667
Germany

Gallerie Rudolf Zwirner
Albertusstr. 18
Cologne 50667
Germany

Dresden
Staatliche Kunstsammlungen Dresden
Theaterplatz 1
01067 Dresden
Germany

Düsseldorf
Kunstmuseum
Ehrenhof 5
40479 Düsseldorf
Germany

Edinburgh
National Gallery of Scotland
The Mound
Edinburgh
EH2 2EL
Scotland

Essen
Museum Folkwang
Goethestrasse 41
45128 Essen
Germany

Florence
Galleria Degli Uffizi
Piazzale Degli Uffizi
50122
Florence
Italy

Mueso di San Marco dell'Angelico
Piazza San Marco 1
50121 Florence
Italy

Museo dell'Opera di Santa Maria del Fiore
Piazza Duomo 9
50122 Florence
Italy

Museo Nazional del Bargello
Via Del Proconsolo 4
50122 Florence
Italy

Museo di Brancacci Chapel
Santa Maria del Carmine
Piazza del Carmine
50124 Florence
Italy

Fontainebleau
Musée National de Château
77300 Fontainebleau
France

Fukuoka
Fukuoka Prefectural Museum of Arts
5-2-1 Tenjin
Chuo-ku
Fukuoka
Japan

Geneva
Musée d'Art et d'Histoire
2 Rue Charles Galland
1211 Genevre 3
Switzerland

Glasgow
Hunterion Art Gallery
University of Glagow
Glasgow
G12 8QQ
Scotland

The Hague
Mauritshuis
Korte Vijverberg 8
2513 AB
The Hague
Netherlands

Hamburg
Hamburger Kunst Halle
Glockengiesserwall
20095 Hamburg
Germany

Leeds
City Art Gallery
The Headrow
Leeds
LS1 3AA
England

Leipzig
Museum Der Bildenden Künste
Beethovenstr. 4
04107 Leipzig
Germany

Leuven
Museum Voor Religieuzs Kunst
Sint-Pieterskert Grote Markt
3000 Leuven
Belgium

Liège
Musée d'Art Modern et d'Art Contemporain
Parc de la Bouverie 3
4020 Liège
Belgium

Liverpool
Walker Art Gallery
William Brown Street
Liverpool
L3 8EL
England

London
Arts Council Collection
14 Great Peter Street
London
SW1P 3NQ
England

Courtauld Institute Galleries
Somerset House
Strand
London
WC2R 0RN
England

Harold Samuel Collection, Corporation of London
Guildhall Library and Art Gallery
Guildhall
Aldermanbury
London
EC2P 2EJ
England

Imperial War Museum
Lambeth Road
London
SE1 6HZ
England

Kenwood House
Hampstead Lane
London
NW3 7JR
England

National Gallery
Trafalgar Square
London
WC2N 5DN
England

Royal Academy of Arts
Burlington House
Piccadilly
London
W1V 0DS
England

Tate Gallery
Millbank
London
SW1P 4RG
England

Victoria & Albert Museum
South Kensington
London
SW7 2RL
England

Wallace Collection
Hertford House
Manchester Square
London
W1M 6BN
England

Madrid
Museo Nacional del Prado
Paseo del Prado
28014
Madrid
Spain

Manchester
Manchester City Art Gallery
Mosley Street
Manchester
M2 3JL
England

Whitworth Gallery
University of Manchester
College
Oxford Road
Manchester
M15 6ER
England

Melbourne
National Gallery of Victoria
180 St Kilda Road
Melbourne
Victoria
Australia

Meudon
Musée Rodin
Villa Des Brillants
19 Avenue August-Rodin
92190 Meudon
France

Mexico City
Museo del Placio de Bellas Aries
Av Juarez Y Angela Peralta
Colonia Centro
06050 Mexico, D. F.
Mexico

Milan
Civica Galleria D'Arte Moderna
Villa Reale
Via Palestro 16
20121
Milan
Italy

Pinacoteca di Brera
Via Brera 28
20121
Milan
Italy

Moscow
Pushkin Museum
Izobrazitelnych Iskusstv
Ul Volchonka 12
121019 Moscow
Russia

Mülheim-an-der-Ruhr
Städtisches Museum
Viktoriarl 1
45468 Mülheim-an-der-Ruhr
Germany

Munich
Alte Pinakothek
Bayerische
Staatsgemäldesammlungen
Barerstr. 27
80333
Munich
Germany

Naples
Museo Nazionale di Capodimonte
Palazzo Reale di
Capodimonte
80136 Naples
Italy

New York City
Metropolitan Museum of Art
100 Fifth Avenue
NY 10028
USA

Museum Of Modern Art
11 West 53rd St
New York 10019
New York
USA

Oslo
Nasjonalgealleriet
Universitetsgata 13
0033 Oslo
Norway

Paris
Musée National d'Art Moderne
Centre Georges Pompidou
75191 Paris
France

Musée du Louvre
Place du Carousel
75041 Paris
France

Musée d'Orsay
62 Rue de Lille
75007 Paris
France

Musée du Petit Palais
1 Avenue Dutuit
75008 Paris
France

Philadelphia
Philadelphia Museum of Art
26th St & Benjamin Franklin
Parkway
PA 19130
USA

Port Sunlight
Lady Lever Art Gallery
Port Sunlight
L62 5EQ
England

Poznan
Museum Narodowe
Al. Marcinkowskiego 9
61-745 Poznan
Poland

Rome
Monumenti Musei E Gallerie Pontificie
1-00120 Vatican City
Rome
Italy

St Louis
St Louis Art Museum
Forest Park
Mo 63110
USA

St Petersburg
State Russian Museum
Ul Inzenernaja 4
St Petersburg
Russia

Hermitage
Dworzowaja Nabereshnaja
St Petersburg
Russia

San Diego
San Diego Museum of Art
Balboa Park
1450 El Prado
CA 92101
USA

Sheffield
Sheffield City Art Galleries
Surrey Street
Sheffield
S1 1XZ
England

Siena
Museo dell'Opera del Duomo
Pinacoteca Nazionale
Via San Pietro 29
53100 Siena
Italy

Museo Civico
Piazza del Campo Palazzo
Pubblico
53100 Siena
Italy

Southampton
Southampton City Art Gallery
North Guild
Civic Centre
Southampton
SO14 7LP
England

Stuttgart
Galerie der Stadt
Schlosspl 2
70173
Stuttgart
Germany

Valencia
I.V.A.M. Centre Julid Gonzalez Coll.
c/o Guillem de Castro 118
Valencia 46003
Spain

Venice
Galleria dell'Accademia
Campo della Carita
30121
Venice
Italy

Museo d'Arte Moderna Ca Pesaro
S. Stae
Canale Grande
Venice
Italy

Vienna
Albertina
Graphische Sammlung
Augustinerstr 1
1010 Vienna
Austria

Kunsthistorisches Museum Wien
Burgring 5
1010 Vienna
Austria

Osterreichische Galerie
Schloss Belvederf
Prinz-Eugen-Str 27
1037 Vienna
Austria

Washington DC
Hirshhorn Museum
Smithsonian Inst.
Seventh St & Independence
Avenue S.W.
Washington D.C. 20560
USA

Wiesbaden
Museum Wiesbaden
Friedrich-Ebert-Allee 2
65185
Wiesbaden
Germany

Würzburg
Residenz Würzburg
c/o Sailobund
Gartenverwaltung Würzburg
Residenzpl 2
97070 Würzburg
Germany

Zürich
Ammann Coll.
Restelbergstrasse 97
CH-8044 Zürich
Switzerland

Index